the
Starry Wisdom

CREATION ONEIROS

CREDITS

The Starry Wisdom
A Tribute To H P Lovecraft
D M Mitchell (editor), Alan Moore, & Others
ISBN 978-1-902197-29-6
Published 2010 by Creation Oneiros
First published 1994 by Creation Books
Reprinted 1996, 2003
www.creationbooks.com
Copyright © D M Mitchell and individual contributors 2010
Design: The Tears Corporation
A Butcherbest Production

acknowledgements

The publishers wish to extend deepest thanks to all the people and organisations who have made the compilation and publication of this book possible. Special thanks to: Ramsey Campbell, John Coulthart, Mick & Simon Dwyer, Dave Mitchell, Alan Moore, Peter Smith.

Front cover art by John Coulthart; back cover art by Peter Smith.

Additional artwork: John Coulthart (pages 12, 176); C. G. Brandrick (page 40); Robert Taylor (page 164). Pages 156 and 196: artist unknown.

Additional copyright details:

"Prisoner Of The Coral Deep" copyright © 1967 by J G Ballard, from the collection *The Day Of Forever*; reproduced by permission of the author care of Margaret Hanbury.

"The Night Sea-Maid Went Down" copyright © 1972 by Brian Lumley; first appeared in *The Caller Of The Black* by Brian Lumley (Arkham House, 1972).

"Potential" copyright © 1973 by Ramsey Campbell; Introduction copyright © 1994 by Ramsey Campbell.

"Wind Die You Die We Die" copyright © 1974 by William S Burroughs, from *Exterminator!* (John Calder, 1974).

contents

Introduction by Ramsey Campbell 5

Foreword by D M Mitchell 7

Recognition by Alan Moore 9

Lovecraft In Heaven by Grant Morrison 13

Extracted From The Mouth Of The Consumer, Rotting Pig by Michael Gira 20

Wind Die You Die We Die by William S Burroughs 26

The Night Sea-Maid Went Down by Brian Lumley 31

A Thousand Young by Robert M Price 41

Hypothetical Materfamilias by Adèle Olivia Gladwell 52

Teenage Timberwolves: Black Dead Bones Of Idiot Bill
 by James Havoc & Daniele Serra 61

Prisoner Of The Coral Deep by J G Ballard 65

Black Static by David Conway 70

Potential by Ramsey Campbell 87

Walpurgisnachtmusik by Simon Whitechapel 94

This Exquisite Corpse by C G Brandrick & D M Mitchell 102

The Call Of Cthulhu by John Coulthart & H P Lovecraft 105

The Courtyard by Alan Moore 137

From This Swamp by Henry Wessells 147

Red Mass by Dan Kellett 151

Meltdown by D F Lewis 157

The Sound Of A Door Opening by Don Webb 165

Beyond Reflection by John Beal 173

The Dreamers In Darkness by Peter Smith 177

Sex-Invocation Of The Great Old Ones (23 Nails) by Stephen Sennitt 182

Zaman's Hill by Alan Moore 185

Ward 23 by DM Mitchell 187

Appendices:

Cthulhu Madness by Phil Hine 197

Reluctant Prophet by Stephen Sennitt 200

Fractals, Stars And Nyarlathotep by John Beal 204

introduction
ramsey campbell

NEARLY sixty years have passed since H P Lovecraft died, yet this book would not exist without him. Why does Lovecraft matter so much?

Let me try, as seems perennially necessary, to strip away some of the misconceptions about Lovecraft the mythologer. Most of the accusations his detractors make are not so much wrong as negligible. Yes, he had a fondness for certain (such as "certain") words. Yes, characterisation in his tales was usually functional at best, and those few characters who spoke tended less to converse than to monologise. Yes, his prose tended to grow empurpled as the tale progressed. But that, as the late Fritz Leiber noted, is an aspect of the way Lovecraft orchestrated his prose, treating phrases as material to be developed or augmented on each repetition, and that technique looks absurd only when separated from its function within the structure of the Lovecraftian weird tale – which is to say, within one of the most important forms the field has yet produced.

Let me be clear. Lovecraft is important not because of the number of good writers he influenced – after all, he influenced many more bad ones, and is doing so still – but for his own achievements. He achieved far more with his invented mythos than anyone else did, because for him it was a metaphor for the indescribable. It was misused by almost all his imitators, who attempted to fill in the gaps by describing what he left out; I was one such. It was only one way he united the British and American traditions of the field, taking Blackwood and Machen across the Atlantic to be joined with Poe and Chambers in his work. What he sought in all these writers, but seems never to have given himself enough credit for achieving, is that finest quality of terror which is awe. He tried to build on those qualities he most valued in the field. His achievement was to take his genre forward, but most of his imitators try and drag it back.

Not so with the contributors to the present volume, some of whom might never have expected to appear in such a book. I've no reason to think that J G Ballard, to whom I was once introduced and who may well have taken my gawping admiration for rudeness, considered his lyrical story Lovecraftian, but its millennial nostalgia certainly is. Burroughs has fun with pulp in very much the way Lovecraft parodied such stuff in his letters. There are some expected names here: could the book exist without Brian Lumley dredging up another denizen of the abyss, or omit that Lovecraftian theologian Robert M. Price? The latter shows us the reverse of Lovecraft's celibacy and atheism with tongue firmly in cheek – his own, one hopes – and other writers

bounce their fiction off the Old Gent too. "Noxiously hideous" was a phrase Lovecraft once used to praise a tale, and he would have been well rewarded in this book. He might have found so much sex disconcerting, but sex was an element in the tales by Arthur Machen he admired; indeed, Sennitt revives Machen's notion of self-love as the darkest form of sexuality. Anyone who feels that Lovecraft's fiction was secretly about sex will find much to convince them in Whitechapel's tale.

Standard occultism and surrealism failed to impress Lovecraft much either. However, I think he might have found some of the occult tales in this book imaginatively appealing. They suggest more than they show, perhaps especially to those of us with little knowledge of the subject. So personal are the symbols in Havoc's tale that I for one feel as though they may be based in real magic. The Kellett tale also reverberates with the occult, approached via surrealism, a medium in which Lewis swims freely and which Gira uses to reflect the cosmic. Its influence is also to be found in Brandrick's and Mitchell's exquisite corpse of a tale. Of course surrealism has something in common with dreams, and Lovecraft had plenty of time for them. His greatest nightmare, to judge from the way he depicted it, was chaos, but some of our contributors outdo his depictions thereof.

Perhaps there are at least as many ways to convey the various Lovecraftian qualities as there are contributions to this volume. Smith revives the prose poem, a form Lovecraft found congenial. The eerie nostalgia of Gladwell's enigma might have resonated in Lovecraft's skull. Webb's playfulness is a way of touching on beauty and terror. Wessels' ecological preoccupations may initially seem out of place, but not when we see him apply them to the kind of landscape Lovecraft loved. Beal opens his imagination for us to search for traces of the theme of our book. My own tale strikes me as eloquently auto-biographical in its portrait of a grey-suited clerk skulking at the edge of vast experiences, but to some extent that description could be applied to Lovecraft too. Some writers seek to communicate as directly as possible the visions which concerned him in his fiction: Moore and Mitchell with their apocalypses, and Conway with an authentically Lovecraftian marriage of contemporary science and the cosmic, and Morrison, whose tale reads like experiencing the Mythos for the first time. As for Coulthart, his version of 'The Call of Cthulhu' awed me when I first saw it, and it awes me still. Had he lived to see it I feel sure that Lovecraft would have been delighted.

So how might he have responded to the book as a whole? He would certainly have been astonished to find himself so influential. If the book encourages more readers to discover or rediscover his work, its worth will be all the greater. The weird tale cannot grow and develop if it loses its awareness of its roots.

<div align="center">

–Ramsey Campbell
Wallasey, Merseyside
6 March 1994

</div>

foreword
d m mitchell

MY intentions in presenting this volume were not to collect a series of escapist fantasies, nor were they in fact primarily literary. It is true that areas of this book fall within the traditional fields of sci-fi, horror and fantasy, but I stress that this is merely a side product. I do not, however, wish to deprecate the efforts of devotees who have dedicated so much work to raising the public's awareness of H P Lovecraft's abilities and achievements. At the same time, Lovecraft has suffered much at the hands of unmindful critics and even more from uninspired and talentless imitators. For my part, the preoccupation with literary talent and academic respectability is besides the point.

My aim is to dig deeper, to bypass the superficial and access the subterranean channels of archetype and inspiration with which Lovecraft was connected. The current of semi-occult symbolism and shamanic imagery inhabiting his writings did not originate in his conscious, rational mind any more than that of William Blake or Antonin Artaud. Lovecraft's direct ancestors have been frequently acknowledged (Machen, Poe, Blackwood etc), but we can also see in retrospcct how his contemporaries were simultaneously, yet unknown to him, working with aspects of the same primal material in many diverse ways. One need only look at Lautréamont's *Maldoror* with its delirious visions of flying octopi and imbecile gods, at the lurid polytheistic systems of Aleister Crowley and Helena Blavatsky, and especially at Artaud's stage scenario *There Is No More Firmament*.

I feel the man's essential vision is being missed and devalued in favour of his lesser creations: the overtly hierarchical 'Mythos'. It's important to realise that this vision was *received*, usually involuntarily – medium-istically and shamanically, normally in dreams. While working in the field of 'pulp' fiction with genres which he, himself, deemed unworthy, he crafted morbid and disturbing allegories of social and biological upheaval; – cryptically prophetic and spiritually exploratory; – this latent content of his work now needs excavating.

In the cases in this book where the 'Mythos' has been utilised, it has been used only in passing – in the same informal way in which Lovecraft himself intended. To present "a kind of shadowy phantasmagoria which may have the same sort of vague coherence as a cycle of traditional myth or legend". For this reason, I have chosen Brian Lumley's *Night That Sea-Maid Went Down* with its overtones of ecological rape, rather than his more formal fantasies with literal depictions of the Mythos deities. Somehow his Cthulhu stories impress me as being less

Lovecraftian than tales such as his excellent *Fruiting Bodies*. Similarly, we have Ramsey Campbell's *Potential*, which owes so much to Lovecraft yet contains no direct references to his pantheon, and Robert Price's *A Thousand Young* where the name-dropping occurs only peripherally but where Lovecraft's influence is perhaps the strongest.

A large part of Lovecraft's driving force came from the *frisson* he experienced between the patriarchal vision of order, logic and reason to which he adhered, and the intruding chaotic, female forces from 'outside' – forces both disruptive and ultimately redeeming. This paradox was, for him, never resolved and I am of the opinion that his occasional misogyny and ill-considered racism both sprang from this gulf between these antagonistic sides of his personality.

At first glance, especially to 'hard-core' Lovecraftians, the connection between some of the pieces herein may seem tenuous. Look a little deeper and you will see the themes of myth and magick intruding into normal, mundane life. Man is seen from a universal perspective – his anthropocentricity torn to shreds. Visions of cosmic alienation, metamorphic desire, mutating sexuality – all direct or indirect descendants of his vision.

Creation Books' challenging publishing programme has granted me a platform I wouldn't have found anywhere else. Hopefully, this book will not be seen as an attack on the efforts of messrs Joshi, Price *et al*, but as a complementary and parallel current leading to strange and fascinating waters.

Something that pleasantly surprised me when I embarked on this project was the fact that, independently of me, so many other people were re-evaluating Lovecraft's work and reaching the same or similar conclusions. Alan Moore, Stephen Sennitt, Don Webb, Grant Morrison – all have intimated to me that they believe Lovecraft's work should undergo this transformation.

The stars are right.

The Old Ones are returning.

I would especially like to thank the following people:

James Williamson, Robert Price, Ramsey Campbell, Peter Smith, Steve Sennitt, Peter Gilmore, Simon Evans, & my children – lots of rainbows!

–David M Mitchell
Macchu Pichu 1994

recognition
alan moore

Heat, fierce and lurid, cooks the hunched hotel-room shadows into boiling ink. Old water spits and sizzles from the radiator joints, their copper fittings thick as vertebrae and leaking dirty steam. A blind is drawn across the room's one window closing out the Boston night, adorned with faded robins, bleached vines and the memory of flowers. Here is the ragged wheeze of sulphur-bitten lungs. Here are the woman's muffled squeals, made down her nose.

The sallow, vaguely foreign-looking manager is standing by the wardrobe, queerly still, gas-mantle stuttering on the wall behind him splashing careless light upon his back, a yellow urinary glaze upon his oiled black hair, its slick topography. His Easter Island face is lost in shadow, save there, where the gaslight catches on his glistening cheek and errant muscle twitches. By the door, the Cuban maid turns off her hearing aid and swallows hard against the parching heat. She grips the tunic of the bell-boy beside her, digging four grey nails into his sleeve while he sips hesitantly from a pale blue cocktail cigarette that's balanced in the other hand. His uniform, a threadbare Burgundy, is tainted with a sickly orange by this wan, uneven light and half unbuttoned down the front, blotched dark with gin. Stood in the juddering mantle-glow, their shadows cringe amongst the huge primeval flowers disfiguring the sweltered wallpaper. They stare towards the bed.

The Devil, red as tamarind, kneels in a rose of sweat-fogged sheets between the woman's arsenic-whitened thighs. His hairless body glistening as though freshly painted, one raw hand about each of her ankles where damp mocha hose is bunched. Her hands are bound with salmon shreds of nightgown to the condensation-beaded metal of the bed-head, fingers opening and closing like the thin limbs of albino crabs kept too long from the light. Balled up into a fist of silk her underwear is crammed into her mouth so that her cheeks bulge like an infant's. One suspender, spittle-silvered, has escaped the parted lips to trail across her chin.

He pulls her onto Him, onto His frilled crustacean shaft and her vagina steams. Convulsed by great magnetic shudders He is roaring, snorting like a murdered horse as He ejaculates, an orgasm of jewels that floods her womb with Turquoise, Jade and Chrysolite. Salt streams of Beryl and Jacinth run down between her legs, the blue-ticked mattress turned to a cathedral-glass of brilliant stains. The bell-boy clears his throat.

Up in the hotel room above, the travelling salesman, Winfield Lovecraft, kneels there with his ear pressed to the radiator pipe and hears it all. Behind clenched eyelids, luminous

paretic visions swarm; provide the feverish tableaus that he cannot see. He listens while the devil and the hotel staff take turns to fuck his wife. Tears big as thunder-spots fall from his burning cheeks to splash against the flecked linoleum. This is his punishment: he'd never dreamed that Susan might be hurt.

Those long and cock-sore weeks, what was a man to do? A wife who sat there at her bedroom mirror working creams into the skin beneath her cheek-blades, face already pallid, clay-like. She refused to touch him. On the road, the women hoboes sat astride his lap for cigarettes, and farmer's daughters, just like in the jokes. One night in Marblehead that waitress with the bruised and skinny legs, not quite fifteen, had let him take her face down on a sprawling, dog-eared tumble of *Judge* magazines stacked underneath the stairs, exquisitely cross-hatched caricatures imprinted faintly in reverse upon her sweat-glazed belly, on her breasts.

Downstairs the chanted protest of the bedsprings is commenced once more and viral imagery is seething in the dark behind the salesman's eyelids, overlays of spirochetal consciousness; alien signals flickering along the raddled spine. He rises, stumbles to the window in his shirt-sleeves, pant suspenders trailing in loose intestinal loops to either side. Hooking his nicotined fingers underneath the jamb he wrenches up the heavy glass, dust-frosted on the one side, rain-smeared on the other; bows a slurred screech from the sash, its single vocal cord.

The third-floor prospect overlooks the rear of the hotel, dog-trodden yards where toppled refuse bins lay beached in typhous dunes, the tidal debris lapping all about them: bottle glass that glints up from drenched cinder like a constellation fallen on hard times; suggestive knots of rag; the emptyings of chamber-pots. The window yawns, inhales, draws sweet and septic breath into the room. Planting his hands upon the blistered, sarcomatous paintwork of the sill he leans into the rotten night, a weather-eaten figurehead, lips barnacled with sores.

The words spill fierce and brilliant, a fan of white sparks shearing from a lathe, malarial poetry, hoarse canticles of ruin, abject glossolalia. They fucked his wife, the Devil and the bell-boy; came in spurts of coloured smoke across her poison-livid belly. It was all his fault, his punishment spelled in abandoned dresses strung along the roadside, rented cunts in rented rooms. Shaking and retching now he voids their names into the black, a gingham litany of women named for flowers, and saints, and executed queens.

Below, a window opens. Grey perfumes of broiling offal ribbon out through febrile mists above the garbage; tangle in blowfly trajectories. The pushy little wop downstairs is yelling for him to shut up, just shut the fuck up but he can't, he can't, there's so much more to tell, about his wife, her distant monologues upon their little girl until he'd had to slap her, Susan, he's a boy! A little boy! Her father, old man Whipple Phillips with his headaches, forehead purple, raging at his son-in-law when first he learned of Winfield's indiscretions. All of this the salesman bellows, out across the silent roofscape, scraps of echo snagging in the eaves.

Someone is hammering on the door, but nothing stems his pentecostal stream, chin wet from slobbered consonants. He is the monstrous father and his cheeks bulge with new syllables;

a dreadful tertiary language that his son will one day echo in the loathsome coinages he picks to name his pantheon, his only children. From the open window of his hotel room, Yog Sothoth howls into the world's stink; roars and roars into the human dark.

In 1933, some thirty-five years later, Howard Lovecraft, in a letter to his friend James Morton, claims light-heartedly to be descended from his Elder deities: from Azathoth, Cthulhu and Yog Sothoth. There, four years before his end, he almost managed to decrypt the bas-reliefs raised in the R'lyeh of his sunken mind; almost exposed the Lurker at the Threshold as a travelling salesman, nothing more. Would he have screamed his father's name, like Wilbur Whately's brother, from a hilltop: College Hill, or Sentinel? Would he have recognized himself, his nature and his mannerisms captured in the frail, fore-doomed procession of his fictive victims; his narrators, driven mad or torn apart by Old Ones, things that suppurate and bellow in the sloughs of night?

"The body shrieked at me with a dead cry,
And all too late I knew that it was I!"

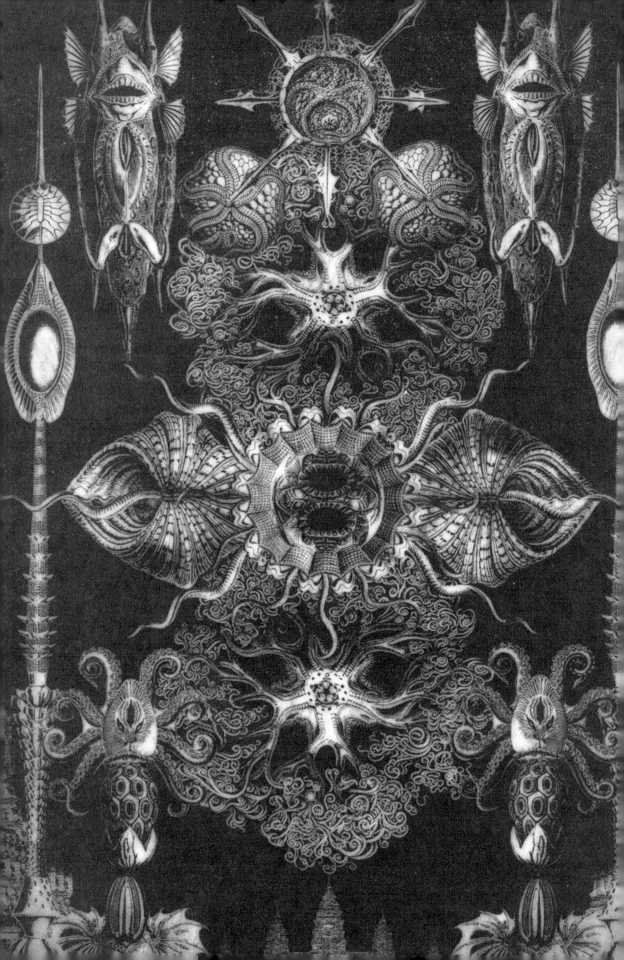

lovecraft in heaven
grant morrison

LOVECRAFT picking scabs from the mirror, tearing away flakes of sick skin and dried blood, to expose the glistening surface beneath. Raw and wet, the mirror reflects the face of a monster – hollow-cheeked, two-eyed, pale and bloodless. The mirror is dying.

'Cancer of the glass,' Lovecraft is told.

He reaches out to touch the thing he no longer recognises as his own reflection. Long, feminine fingers pass through the glassy membrane, causing ripples and little cries.

'God in Heaven,' Lovecraft sighs. 'It's brine.'

The mirror fluxes, alive with uncanny tides and the odours of pure creation. Sweet rotten scent of biological mystery. He stares into the depths as something stirs far below, wakens and begins to rise. Storms and rain wrack the mirror's surface. The thing is coming up from the deep, getting bigger and bigger. It is vast and primitive and he knows its name.

Dying on a bed in an overheated room. The air is thick, like a glue drawn into the lungs. There is something at the back of his head, scrabbling there where there is no light: rats sharpening their claws on the wood-panelled walls of the Pilgrim Fathers, the hiss and crackle of cerebral lightning. A slow, drugged voice speaks of the Ritual of the Stifling Air as the way through. Lovecraft whimpers, dying. His body is devouring itself. He can feel the cancer at work, the ancient crab in his gut, self-generating, self-begetting. He can smell the fishstink of it seeping through his pores. The old starry crab there in the pit of his body. Lovecraft's eyes roll and the room divides. Angles collide and implode. In these last days, he often wakes from delirious sleep to glimpse the room reforming itself out of nothingness, the pieces flying together out of the void, as though magnetised, to re-assemble, like an explosion in reverse. Once, this strange reconstruction of things was done in a rapid, stealthy manner, now it occurs slowly, allowing him longer and longer periods of time in which to contemplate the Ultimate Absence upon which the world is founded.

Inside him, in the dead cell, he can feel what he knows to be words, like maggots, eating at him. Words giving birth to words and more words; all the things he dared not say. (And if words are maggots, he speculates in a clear space between gusts of pain, what do these larvae become when it is time to mature and metamorphose? What will come a-hatching from his cannibalised body?) He is becoming a thing of words, a word-crab built for descent into the dark. His own

stories have turned on him in the wet interior night, growing beyond his control. Blind restless
mouths, zodiacal pincers and claws, the deepsea smell of his death, like *her* smell, the archaic
scent of his wife, his lunatic mother in her chains. His death that he smelled in the marine
chambers of her cunt so long ago and refused to recognise.

The room is alive, more alive than ever, with unearthly angles. It extends itself into
unspeakable trans-Euclidean topographies, breathing and shivering, presenting the dying man
with grotesque displays of architectural deformity. The room reverses through itself, defying
reason. Words leak from Lovecraft's papery skin and fume in the light. The Universe is made of
words, he thinks. I have built my own tomb and furnished it. He strains to understand, teetering
on the edge of an ocean of limitless ink. The ink of the Void in his pen, flowing out to stain the
clean world. The room remakes itself. The candleflame by his bedside dips and flutters as the
room eats oxygen and the flame is bent backwards, turning black. The wings of a moth whir
against the windowpane, like the buzzing voice of a spirit stuck in a bottle.

'The Inverse Flame is the Second Gateway,' the spirit insists. The sentence is repeated
several times and then dissolves into incoherence.

'Cthulhu fhtagn. Ph'nglui mglw'nafh Cthulhu R'lyeh wgah'nagl fhtagn.'

Lovecraft shifts his head and the room lurches. He looks into the wavering door of black
flame but he cannot take the step through into the Cold Wastes. He snatches another breath from
the abrasive air and falls from a terrible height back into the pillow.

'All my life I have believed in the God of Reason, the Master Maker with his compass and
dividers and his Plan. But the Gods are mad, blind horrors and all our lives are as the dust in their
eyes.'

He dare not look through the tear he has made in the Veil. Lovecraft's breath catches at
the back of his throat and turns sour there. The galleries of his brain begin to flood with
endorphins in a sweet opiate rush.

Stories disintegrate and fill the room like flying ash. Ash in his head. A blizzard of atomic
debris, stories tearing themselves apart, reconfiguring, creating new stories endlessly. A carrion
storm of words eating him from within, descending upon him from outside. His soul, at last, faces
annihilation.

Ideas condense from nuclear chaos. Lovecraft stops at the top of the hill to make some
notes in his black book. He wipes his brow, inclines his head to gaze at the vibrating Providence
sky and walks on. In this late afternoon light, the town seems queer and otherworldly. Rooftops
proliferate and recede into smoky chiffons of drowsing air. Providence seems to slumber and
breathe, its uncertain horizons giving life to ambiguous forms: melting gables and rotting bridges
and half-seen windows reflecting alien suns. He imagines the town as the three-dimensional
shadow of something vast and concealed and then dismisses the thought as irrational. Briefly, he
studies his left hand, with its parchment-white dry skin and knotted tracery of blue submerged
highways. He can feel his blood, circulating through the buried tributaries and unlit canals of his

body. His fingers crab and contract into a fist, the nails nipping his palms. He makes a few more jottings in his book and continues.

Evening sun casts a slow, syrupy light on the old stones of the cemetery. Lovecraft wanders among the graves, gently strobed by leaf shadows. A light breeze, the exhalation of spirits, stirs the branches as Lovecraft walks, a living man haunting the houses of the dead. He pauses at the graves of his mother and father and stares at the earth. A bird begins to sing, then changes its mind. Silence descends like a mist.

And in that silence, he can hear the creak and splinter of buried wood. He closes his eyes. The tattered, flayed corpse of his father is clambering through the wet earth into his mother's coffin, prising the lid away with broken-stick fingers, eager for her fresher flesh. Mother, with blue-bruised skin, peels back her teeth and hisses. Father, corrupt, insane, tears through her bridal veil, puncturing her rotten flesh and mindlessly fucking the punctures. The two bodies squirm and knot in a tangle of greasy, ruined limbs. Father's swollen cock bursts and spills maggots, spits obscene crawling words. The earth goes into spasm, vomiting up the dead, exploding them into space.

The bird continues to sing, out of tune, hideous. Lovecraft chews his lip, con-templative, and takes the notebook from his pocket. He writes two words – a title – and closes the book.

That night, he dreams of the spirochetes in his father's bloodstream. He enters with them through the tiny fresh cut in his father's penis. It's some kind of reverse conception through this temporary door. It's the breakthrough into another universe. The spirochetes spin like galaxies, bursting through from outside, joyously breaching Father's outer walls. Lovecraft's final human thought is to pronounce the barbarous words which open the gate, the dream incantation which becomes meaningless to him even as he utters it.

'Treponema Pallidium.'

'I dreamed that I was a syphilis bacterium invading my own father's body,' Lovecraft tells the dark room. Shadows hang in drifts from the rafters. In the hot dark, Lovecraft guiltily masturbates, finally dribbling infected come into a soiled handkerchief. No-one strikes him down. No God, no Satan. No Heaven, no Hell. There is no judgement. The night is empty and sweats darkness.

'IT LOOKED MORE LIKE THE FATHER THAN HE DID!'

The final breath seems to last forever. It buzzes there behind his teeth. He knows it is one of the Calls and tries not to utter it.

There is an eye in the disturbed mirror. It fills the space within the frame, protozoic, contemplating nothing but itself. The gilt frame of the mirror contracts towards a lens shape, as though it were the lids of the ophidian eye slowly closing.

Sonia's cunt dilates in the New York summer heat. The room is stifling and smells of the ocean. Lovecraft enters her convulsively, clenching back the nausea that bubbles in his throat. She loops her legs around him and lets out a long breath. She bites his ear, whispers some Slavic

endearment. He does not recognise the words. He hears only the guttural grunting of something buried deep in his spine. Atavistic sound of huddled inhuman things below disarrayed stars. The clock stops ticking and he empties his terror into her arctic gulfs, her cold wastes, her cellar spaces, going inside and out simultaneously. His prick goes soft inside her, with a great oceanic seizure and he finds himself walking along the traintracks.

'Clearly, I was not made for marriage. Mine has been a solitary life and I find that I am best able to work under those conditions. I have, it's true, often felt a certain kinship with many of the so-called Decadent authors of the last century, although I find in their work a lamentable tendency towards super-stition which I most certainly do not share. Illness and solitude do indeed produce a heightened state of creativity but we should beware of attributing to our delirious imaginings any objective validity. Never-theless, it has been my experience that from the rich soil of morbidity grow the most fantastic flowers of the Imagination.'

He passes the carcass of an empty carriage, rotting in the half light. Red rags are hung from the broken windows. Weeds grow between the sleepers. From inside the abandoned carriage, he can hear the sound of a woman or a man whimpering. The windows flare with a putrid light and Lovecraft catches a glimpse of some diseased, abnormal thing rearing up against the glare. The whimpering increases in volume, becoming cries of pain or ecstasy. From out of the grainy, luminous dark of this unnatural evening come the mocking cries of whippoorwills. Psychopomps, human-headed birds, they watch from the reeds, attending Lovecraft's disintegrating soul. When he passes through the gate, they will eat what remains, digest it and release the waste into the sleeping heads of humanity. Eating souls, shitting dreams.

Lovecraft pulls up his collar, following the rails down to the gutted corpse of a fishing town. Dark empty houses lean together across wet cobbled streets. Cranky spires and steeples twist towards a black sky abandoned by stars. The windows of the houses are hidden behind worm-eaten shutters. He looks towards the gutter, where a dismal glow shines up through the bars of a storm drain. Something moves down there, casting its own foul light. All the way down the cobbled street to the sea, he can see that same light feebly shining from each drain opening. Something huge beyond imagining is alive beneath the town, beating like a heart, extending its pallid fibres up into the homes of the townsfolk to change them and make them part of its nauseous substance.

Rotten skeleton wharves tilt crazily towards the unseen sea. Lovecraft carefully picks his way across the slick, crumbling timbers and stands on the on the edge of what seems to him the primal ocean. Black elemental waters, black sky. The void is full of tides and noises and the deepsea, primordial smell of Death. Air turns to poison vapour as the venoms of her cunt foam and roar, crashing against the rocks. He is on the perimeter of manifestation, on the turrets of the ruins overlooking the Abyss. The ghost-songs of the whippoor-wills resolve into insane fluting loops of synthesised sound. He recognises, from his own descriptions, the weird piping of Nyarlathotep which is the sound of the membrane trembling in ancient Night. Lovecraft walks to

the rim of existence and faces the ocean of unbeing.

> *That is not dead which can eternal lie*
> *And with strange aeons, even death may die*

There is a sound and the black tides begin to recede, drawn back by the gravity of something haunted and immense which fills the sky. The seabed is opened up to view revealing decayed timbers and the bones of shipwrecks and all the corpses of the monsters of the deep. Lovecraft's body trembles uncontrollably. What nightmares lie beneath the inscrutable waves! What awesome terrors, what unbearable sights mankind has been spared! And now Earth's oceans thunder and hiss, apocalyptic, rising up impossibly, peeling back to expose the naked planet, the abyssal depths and peaks, the colossal scale of derelict, unknown continents. At last, tainted piss runs downs Lovecraft's legs as drowned R'lyeh rears up, unveiled in many-angled glory. The world is uncovered, the seas retreat like a filthy cloth drawn aside to reveal the face of an idiot leper. World eaten by maggots, boiling and bursting like a corrupted apple in space. He is witness to the revelation of the cosmic deformity of the Earth, planet of cancerous unclean energies. In terror, he curses the Mother, curses the great dark ocean and the cuntworld that is KUTULU's kingdom. His shrieks are swallowed by the blackness and the curses curdle and clot in his throat, becoming invocations. And now, there is visible not only the physical intrusion of the unmade city, but its extension into higher spaces and latitudes.

> *His mother screaming mad in the Butler Hospital. Endless howl of Nyarlathotep, the Faceless One, as the Gates come crashing down. The whole world sick and insane, peopled by drooling halfwits, morons swarming witlessly like maggots dying on a corpse.*

City of unknown luxuries and abominations, endlessly generating itself. He is surprised by how familiar it seems. He has dreamed it so many times, this fragment of the entirety that is KUTULU, which is planetary consciousness and the Mother of Masks.

Lovecraft scribbles through the night, possessed.

CHAPTER III – The Madness From The Sea

The gap between eye and hand is closing. The words begin on the page, not in his mind. He is conscious of them only after he has written them. So much to write in the space of a breath. Visions of things 'miles high'. ('Miles' being the only word he knows to suggest the way in which these thoughtforms *extend* in all directions simultaneously while occupying finite spaces on this plane.) He invents the blasphemous *Necronomicon*, only partially aware of the fact that he is evoking the Book into being. He is Abdul Al Hazred, *'Slave of the Presence'*. The Void flows as ink through his pen. He is unwriting the Universe. Thin and sickly, hunched over a desk, defiling white paper. The headaches, the break-downs, the terrors, the fragile child surrounded by books. Shadow of the devouring mother hovering over his sickbed. The Soul-Eater and the Gate. The pen

nib sparks and ignites the paper and he makes contact through the Door of Fevers. He sees the worms eating the world, the insects in their millions chewing their way into Reality, gross and monstrous reptilian presences tearing at the walls. Black limbic fire of prophesy. Unwitting, panic-stricken, he cracks open the doorway that leads into the labyrinth of the Forgotten Ones through the fourth level of the spine. YOG SOTHOTH, the doorway that fucks itself, the eye in the mirror of water. Racing through the linked veins and capillaries of strange tunnels. Scrawling on the ancient walls. Lovecraft divides and opens like a gate, opens like the Book, but will not let them through. He hears Mother's mad graveyard voice and stops the energy deep in his gut. The primal knot clenches inside. The last word of the story is 'eye'. He wipes his brow and closes the notebook. And closes the doorway.

18 is the number of the Crab, the worm-eaten Corpse and the Fence which divides. It is the number of the solitary, inward-turning path. Lunar Gateway of Resurrection.

Primitive societies chose their shamans from the ranks of the sick, the deranged, the outsiders. Such people can always be recognised. Frail and disconnected, they are the tenuous physical expressions of the Portals. In this way all the Doors are in plain sight, yet hidden.

Lovecraft is ushered into the quiet, dusty study of the late Professor George Angell. The Professor nods towards a leather chair, which creaks reassuringly as Lovecraft lowers himself into it.

'"Jostled by a nautical-looking negro",' the Professor says glumly, replacing a book on his shelves. The spine reads *Unaussprechlichen Kulten*. 'What a way to go.' He stands before the window, silhouetted against the dark trees and the burnt-out evening sky, and fixes his gaze upon Lovecraft. 'I am forever being visited by thin, dark young men of neurotic aspect and you, I'm afraid to say, are no exception to the rule...'

Angell's voice continues, receding into a drone. Lovecraft smells old, varnished wood. Far off shouts and the laughter of Christian boys from the calm corridors of Miskatonic University. Rational light illuminates the room. The low sun turns the study into a decanter, filled with old wine.

'So what brings you here, my boy?'

'I wrote an article entitled *The Cancer Of Superstition*, which you may have seen,' Lovecraft begins. 'The irony of my choice of title has not entirely escaped me, of course. I am also the author of a number of modest tales of the uncanny. I believe, and I say this with some little pride, that I have produced what I can only describe as the pornography of the Coming Age. I have come here to confirm my belief that the World of Reason still holds dominion over the primeval depths of the human imagination.'

Angell sits down and lights his pipe. 'An interesting theory but quite naïve, I'm afraid.' Lovecraft swallows hard. Something catches at the back of his throat, like a moth fluttering there.

'I, myself, once held to a similar position,' the Professor continues. 'But I found to my

cost that I was sadly misinformed. Reason is the flimsy mask on the face of Chaos, my boy. It works very well as a disguise but, like all disguises, it conceals the truth.'

'Then our whole world is a nightmare,' Lovecraft says.

The voices from beyond the doors and windows change now and become strange, like the buzzing of unknown insects. Lovecraft shifts uncomfortably and coughs. There is a pain in the pit of his stomach. Something moves there in its tiny salt ocean.

'Only if you fear it,' the Professor says. His eyes narrow and go out, becoming empty of humanity, like the ghost-eyes of a crab.

'Perhaps I should leave now,' Lovecraft says. The failing light turns bloody and dense and he begins to choke on it. Weird liquid forms swarm around him, becoming visible.

'There is nowhere to go until you remember,' the Professor says. 'They are not dead but only dream. You must wake them within yourself and use them to step through.' He rises and rises and his shape is all wrong. The planes of the study slip out of joint. Books scream on the shelves and tear each other apart. Trees outside the window twist into spastic shapes. Every-thing is dispersing.

'Filth of her cunt ... rotten ... the world ... it's in us ... the mother ... the reptile ... godforms in the backbrain ... evolutionary ... we're afraid of them ... dragging us down but we must ... we must embrace them ... integrate them ... have to integrate all levels for the next jump ... the next ... a horror ... her cunt ... syphilitic ... I failed to understand ... the horror ... shining ... Iä ... Cthulhu ... Mother...

'This is Hell,' Lovecraft whispers. 'I have come to Hell.'

Angell, starshaped, revolving in chaos, bends over him. 'Quite the reverse,' he says and opens Lovecraft like a door.

A half-human boy writes in his diary of the time ahead when he will be remade in the image of his father. High in the barn, in the alchemical light, he dreams of lost polar corridors into the invisible and the breaking of alien seals in the caverns of the ocean and wonders how he shall look when the earth is cleared off and there are no earth beings on it.

The last breath leaves with a sound like the ticking of a broken clock. In Arkham, along the Miskatonic, in New York and Paris and London and Rome and Tokyo ... breaking through ... torn black membrane ... the nameless colour ... the egg of unbecoming ... crowned serpent ... flowering abyss ... unfolding lens...

Lovecraft rises up from the depths and places his eye to the tiny peephole which looks onto the shrunken bottle-world that was. From the other side of the mirror, he stares at his puppet dreamself and smiles. Full of fear, the little puppet sees only the titan eye and misses the grin.

extracted from the mouth
of the consumer, rotting pig
michael gira

1) <u>HOW I LEARNED TO SPEAK</u>

: I CAN SEE INSIDE MY SKULL. I KNOW WHERE EACH THOUGHT COMES FROM. I SEE IT BEING BORN, AN INSECT CRAWLING OUT FROM A DAMP CAVE. IDEAS, IMAGINATION, AND MEMORY ARE PARASITIC INTRUDERS THAT LIVE ON THE NOURISHMENT OF MY PASSIVE BRAIN. SOON THEY'LL EAT EVERYTHING.

: THE INTERIOR OF MY SKULL IS FLOODED WITH LIGHT. ALL DEFINITION'S DISAPPEARED. I'VE LEFT MY BODY. MY MIND'S DIFFUSED, EXHALED, THE LAST BREATH OF A CORPSE. I'M NAKED IN A CHAIR IN A DIMMED SILENT LEAD ROOM. MY ARMS ARE STRAPPED TO THE ARMS OF THE CHAIR, NOT TO KEEP ME FROM ESCAPING BUT TO FORCE ME TO CONCENTRATE. MY FEET ARE STRAPPED TO THE LEGS, MY WAIST TO THE SEAT. A STRAP RUNS AROUND MY CHEST AND PULLS ME TIGHT TO THE BACK OF THE CHAIR. I'M FUSED, INERT. I CAN'T EVEN MOVE MY FINGERS. EACH ONE FITS INTO AN INDIVIDUAL LEATHER STRAP, CINCHED AND SECURED TO THE CHAIR.

: MY MIND VIBRATES OUTWARD. THE INITIAL PANIC AND ADRENALIN OF MY PARALYSIS EVENTUALLY TRANSFORMS ITSELF INTO A TRANCE. SLOWLY THE ROOM FILLS WITH WATER, AT BODY TEMPERATURE. AS THE WATER RISES, MY ATTACHMENT TO THE PORTION OF MY BODY WHICH IS SUBMERGED DISAPPEARS. WHEN THE WATER REACHES THE LEVEL OF MY CHIN, IT STOPS. AT THIS POINT I HAVE NO BODY. MY EYES ARE OPAQUE. THE DARKNESS FILLS ME UP. THE ONLY SPECIFIC SENSATION IS MY TONGUE. A HOOK RUNS THROUGH THE TIP. SEVERAL MORE RUN THROUGH EACH SIDE AND FURTHER BACK AS FAR AS THE ENTRANCE TO MY THROAT.

: ATTACHED TO EACH HOOK IS A THIN LINE OF OPTICAL FIBERS WHICH RUNS STRAIGHT OUT AND CONNECTS TO A SERIES OF COMPUTERIZED PULLEYS AND LEVERS AT A TERMINAL IN THE UPPER FAR WALL. IN MOMENTS OF EXTREME PERFECT CONCENTRATION, THE TERMINAL GLOWS FAINTLY, CASTING A SHIMMERING BLUE ACROSS THE BLACK WATER TOWARDS MY SKULL. THIS IS A DIRECT PHYSICAL RESPONSE CORRELATING IN DEGREES TO THE LEVEL OF CONCENTRATION I'M ABLE TO ACHIEVE. AS MY CONCENTRATION FLAGS, THE COMPUTER INSTRUCTS THE PULLEYS TO TIGHTEN THE LINE – THE HOOKS TUGGING AT THE MEAT OF MY TONGUE. THIS IN TURN SENDS PULSES OF PURE WHITE PAIN THROUGH THE

SYNAPSES IN MY BRAIN, WHICH IN TURN LEADS ME TO A FLUX — A PERPETUAL MOTION EQUATION WHEREIN I AM INTENSELY SELF AWARE AS I SIMULTANEOUSLY CEASE TO EXIST. THERE'S NO TIME BETWEEN THE TWO PERCEPTIONS. THEY EXIST IN PERFECT CONTRADICTION AND BALANCE EACH OTHER. WHEN I REACH THIS STATE OF MINDLESS MIND, THE COMPUTER TERMINAL GLOWS BRIGHT BLUE/WHITE — A DISTANT PRISM OF RAINBOW COLORS SHIFTING DEEP IN ITS CENTER IN DIRECT CORRELATION TO THE RHYTHM OF MY BREATHING, MY HEARTBEAT, MY NERVOUS SYSTEM. THEN I FEEL THE TENSION ON THE LINES AND HOOKS IN MY TONGUE RELAX. THIS ALLOWS MEMORY, ANXIETY, DESIRE, TO INVADE MY MIND. THEN THE HOOKS TIGHTEN AGAIN, ETC.....

2) THE GREAT ANNIHILATOR; OR, FRANCIS BACON'S MOUTH

: HIDDEN BY DISTANCE, THE DARKNESS BEHIND THE STARS REACHES AN IMPENETRABLE BLACK DENSITY. LIGHT, THOUGHT, AND POSSIBILITY ARE SUCKED HELPLESSLY INTO THE MOUTH OF THE INHALING DEAD HOLE. INSIDE THIS HOLE IS THE CENTER OF THE HEART OF THE OPPOSITE OF SPACE. THE FUTURE AND THE PAST ARE NULLIFIED, BACKWARDS AND FORWARDS. HISTORY REWINDS, SNUBBED OUT BEFORE IT BEGINS. SILENCE IS EXTERMINATED.

: THE EARTH FLOATS IN A THICK SEA OF BLACK BLOOD, GLOWING LIKE AN EMBER CUPPED IN THE HANDS OF AN INVISIBLE GOD. HIS CORRUPT BREATH SPREADS CLOUDS OF POISON GAS, CLOAKING THE CONTINENTS IN A SWEET-TASTING ATMOSPHERE. AGITATED HOARDS OF ANCIENT PREDATOR BIRDS MIGRATE THROUGH THE HEMISPHERES IN A STONE-EYED SEARCH FOR PREY, CASTING SHADOWS ON THE DIRT LIKE CRYPTIC SIGNALS FROM THE VEILED DEITIES THAT LIVE BEHIND THE SKY. BENEATH THE GROUND LIQUID FIRE ROLLS IN WAVES OF COMPRESSED HATRED. A MINDLESS HOWL ECHOES THROUGH THE LIGHTLESS SUBTERRANEAN CANYONS IN A SINGLE SUSTAINED NOTE OF IGNORANT AND SAVAGE PAIN.

: THE STEEL AND GLASS TOWERS OF THE CITY REFLECT THE LIGHTS OF PASSING CARS, AND BEHIND THE JAGGED HORIZON THE MOON STAINS THE CLOUDS RED. STEAM RISES FROM A CRACK IN THE MILDEWED CONCRETE FLOOR OF AN ABANDONED BUILDING. A BLOCK AWAY, IN A FASHIONABLE HOTEL WHERE THE DOORMEN ARE ACTORS AND MODELS AND THE SINK IN THE BATHROOM IN YOUR ROOM IS A STAINLESS STEEL FUNNEL, YOU CROUCH TIED IN THE CORNER BY THE TOILET, NAKED, THE SHINING WHITE TILES HURTING YOUR BARE KNEES, WATCHING YOURSELF IN THE OVAL MIRROR WAITING FOR THE MURDERER TO COME IN AND FIRST PULL CHUNKS OF YOUR SKIN AWAY WITH PLIERS, THEN TO REMOVE YOUR TEETH, THEN TO FUCK YOUR WARM RED MOUTH. YOU HAD PLACED AN AD IN A PORN MAGAZINE READING, "ATTRACTIVE PROFESSIONAL SEEKS PUNISHMENT FOR ARROGANCE FROM AN EXPERT TORTURER", WITH THE PRESENT DISASTROUS CONSEQUENCES. YOU'RE NOW CERTAIN YOU'RE GOING TO DIE, AND THE OUTCOME IS IRREVERSIBLE AND BEYOND

YOUR CONTROL. YOUR COMPLICATED PSYCHOLOGY OF PLEASURE AND DESIRE IS INEXTRICABLY INTERWOVEN WITH YOUR DISEASED SENSE OF SELF-WORTH. ECSTASY IS IMPOSSIBLE FOR YOU UNLESS YOUR NERVES ARE SIMULTANEOUSLY SATURATED WITH ITS OPPOSITE. SINCE YOU'RE ADDICTED TO ECSTASY AS THE ONLY EFFECTIVE MEANS OF ERASING YOUR IDENTITY AND ITS ATTENDANT SELF-LOATHING, YOU'RE ALSO ADDICTED TO PAIN AND THE ELABORATE RITUALS YOU'VE CONSTRUCTED IN ORDER TO TRANSFORM IT INTO PLEASURE. WHEN THE SHADOW OF THE MURDERER MOVES TOWARD YOU, SEEN SLIDING ACROSS THE MAUVE BEDROOM WALL THROUGH THE CRYSTAL REFLECTION IN THE MIRROR, A WETNESS GATHERS BETWEEN YOUR LEGS. THOUGH TERRIFIED, YOU FEEL A SENSE OF COMPLETENESS YOU NEVER DREAMED POSSIBLE.

3) HOMAGE TO MY FORMER SELF

: THE SPHERICAL FEATURELESS BODY OF LIVING FLESH IS SUSPENDED DEAD CENTER IN THE RED ROOM BY METAL CABLES HOOKED INTO IT AND RUNNING OUT TAUT IN EIGHT DIRECTIONS TO THE FOUR CORNERS OF THE CEILING AND FLOOR. THE GLOBE OF FLESH IS FIVE FEET IN DIAMETER AND A HEART PULSES IN ITS CENTER. DIRECTLY BENEATH IT A NAKED INFANT SQUIRMS AND CRIES IN A COOL VAT OF BLACK OIL. FROM A THIN WIRE IN THE CENTER OF THE CEILING, DIRECTLY ABOVE THE CIRCULAR BODY, HANGS THE SEVERED HEAD. ITS EYES SCAN THE ROOM BUT ARE UNABLE TO FOCUS. IT SENSES THE BODY BENEATH IT AS ITS OWN ABSENT BODY AND IT WANTS TO RE-UNITE. ITS MOUTH MOVES AND ITS TONGUE SIGNALS, APING WORDS, BUT NO SOUND LEAVES THE MOUTH, THERE BEING NO LUNGS ATTACHED TO PUMP AIR TO ITS LIPS.

: IN EACH CORNER OF THE ROOM A SMALL PILE OF INTESTINES IS PACKED NEATLY AGAINST THE WALLS, ATTRACTING A CONCENTRATED CLOUD OF BLACK FLIES. A FEW FLIES VENTURE TO OTHER AREAS OF THE ROOM, LANDING AT RANDOM ON THE SUSPENDED SPHERE OF FLESH, THE HEAD, AND THE INFANT.

: THE CONFINING SURFACES OF THE ROOM ARE MOIST AND MARBLED WITH AN INTERLACING NETWORK OF VEINS, NERVES, AND TENDONS. THOUGH THE SHAPE OF THE ROOM IS GEOMETRIC AND PRECISE, ITS SUBSTANCE IS ORGANIC. THE SURFACE OF THE WALLS SWELLS IN AND OUT IN A REGULAR PATTERN OF BREATHING, AND WITH EACH MOVEMENT COOL OXYGEN CAN BE FELT SEEPING INTO THE ROOM.

: THE HEART IN THE CENTER OF THE MEAT PUMPS A CLEAR JELLY THROUGH A COMPLEX WEB OF TRANSPARENT PLASTIC TUBES SUPPLYING NUTRIENTS AND GENETIC MATERIAL TO THE BODY. OUT FROM THE HEART A LARGE, CENTRAL TUBE RUNS UPWARD OUT OF THE FLESH AND FEEDS THE HEAD, ENTERING THROUGH THE NECK, AND DOWNWARDS INTO THE INFANT, ENTERING DOWN ITS THROAT. THROUGH THIS LARGER TUBE PASSES SENSATION, THOUGHT, AND FEELING. IN THIS WAY THE THREE ENTITIES "COMMUNICATE".

: OUT FROM EACH CREATURE RUN THOUSANDS OF TRANSLUCENT STRANDS CONNECTING EACH ENTITY WITH THE OTHER, WITH THE INTESTINES IN THE CORNER, WITH THE MOIST WALLS. THESE FIBERS QUIVER AND SEND A SENSATION OF PLEASURE THROUGH THE ENTIRE CIRCUIT WHEN GRAZED BY THE WINGS OF A FLY, IN A FEATHERY LIGHT SHUDDER, LIKE WIND CARESSING THE DOWNY HAIRS ON THE BACK OF THE NECK. THE ENERGY CREATED BY THIS EVENT CHARGES THE OIL IN WHICH THE INFANT LIES WITH ELECTRICITY, JOLTING THE SOFT WHITE FLESH AND CAUSING THE CHILD TO SQUEAL HELPLESSLY IN THE SILENCE. THE SEVERED HEAD HEARS THIS AND IMAGINES IT'S THE SOUND *IT* MAKES WHEN IT MOVES *ITS* LIPS. EVERYTHING BEING INTERCONNECTED, THERE 'S NO REASON FOR IT TO DOUBT THE SOUNDS THE INFANT EMITS ARE THE SYLLABLES OF ITS OWN LANGUAGE.

4) <u>NOTES ON COITUS</u>

: I'M SCARED TO BREATHE THE AIR BECAUSE I KNOW IT'S REALLY LIQUID. WHEN I BREATHE IN I DROWN. MY BODY DRIFTS IN IT LIKE A SLUG IN BLACK WATER. IT POURS DOWN INTO MY LUNGS AND FALLS OVER ITSELF, FILLING ME UP WITH CLAUSTROPHOBIA. IT SEEPS THROUGH THE FIBERS OF MY LUNGS, DISSOLVING ME. I SCRATCH MY FACE UNTIL IT'S BLOODY AND FORMLESS, TRYING TO DISINTEGRATE MYSELF. A WORSE REVELATION UNFOLDS: MY BODY IS LIQUID, A TEMPORARY SWARM OF MOLECULES (EACH WITH ITS OWN DISCRETE IDENTITY) THAT WILL EVENTUALLY DISSEMINATE INTO A WIDER SEA OF SHIFTING LIQUID. I FOCUS MY MIND ON THE SPACE BETWEEN THE MOLECULES WHICH COMPRISE MY BODY. I'M SWOLLEN, READY TO BURST. FEAR RUSHES THROUGH ME FROM THE INSIDE-OUT. I'M INFESTED WITH OTHERNESS. MY BREATHING IS LESS AN ACT OF AN INDIVIDUAL BODY THAN AN ARBITRARY SLIDE OF MOLECULES FROM ONE PLACE TO ANOTHER. EVERY THOUGHT THAT ADVANCES THROUGH THE GREASED TUNNELS OF MY BRAIN CARRIES WITH IT ITS OWN NEGATION. I'M FLOODED WITH EMPATHY. WHEN I DRINK A GLASS OF WATER IT'S THICK AND CRAWLING WITH LIFE. MY MOUTH LEADS TO THE INTERIOR OF MY BODY – A CALDRON OF DISEASE, GERMS, AND PERVERSIONS OF BIOLOGY. I DON'T EXIST INDIVIDUALLY. I'M MADE OF MILLIONS OF LIVING CREATURES, EATING EACH OTHER, DECOMPOSING, EATING EACH OTHER. THERE'S A GELATINOUS POOL OF GREY SPERM BETWEEN MY LEGS IN THE BED. IF I LEAVE IT THERE IT WILL GERMINATE AND RISE UP IN AN INCONGRUOUS PARODY OF HUMAN AND ANIMAL SHAPES, SPROUTING FROM THE BED IN A NIGHTMARE CARTOON OF BIOLOGICAL POTENTIAL. I'LL BEGIN A DILIGENT PROGRAM OF MASTURBATION IN ORDER TO SPREAD THE GROWING TIDE OF DISEASE THAT IS BREEDING INSIDE ME OUTWARD INTO THE LIQUID WORLD.

: I'M INHABITED BY THE THOUGHTS OF OTHERS. IF I CUT OFF MY FINGER I CUT AWAY GENERATIONS OF HISTORY, STIMULUS THAT HAS PASSED THROUGH ME AND SHAPED ME.

I'M MADE OF LARD, ENERGIZED, BUT THE ENERGY ISN'T MINE. I'M USED AS AN INSTRUMENT SO ELECTRICITY CAN SING TO ITSELF.

: LATER, WHEN I'M DEAD, MY BODY WILL LIE IN CHUNKS ON THE TABLE, CUT UP BY THE SURGEON. ENERGY WILL CONTINUE TO BREED INSIDE IT, BUT WITH A KNOWLEDGE THAT EXCLUDES ME. MY IDENTITY, CONTAINED IN THE INERT MEAT THAT NOW LIES ON THE SLAB, WILL BE FOOD FOR FOREIGN MICROBES AND AGENTS OF DECAY. THE SUM OF MY LIFE'S EXPERIENCE AT THE TIME OF MY DEATH AND THE ACCUMULATED EVIDENCE OF MY THOUGHTS AND AWARENESS WILL PASS ON IN THE FORM OF ANOTHER LANGUAGE INTO THE BODIES OF THE FEEDING WORLD WHICH IS CONSUMING ME.

: IN A LONELY ROOM WHERE THE ATTENDANTS WEAR RUBBER GLOVES AND SURGICAL MASKS AND THE AIR IS SHARP WITH DISINFECTANT, THE PILE OF MATTER THAT WAS ME WILL BE PUSHED INTO A BAG TO BE TAKEN OUT INTO THE WOODS AND MIXED WITH THE DIRT. AS YOU WALK, CARRYING THE BAG, THE EARTH IS SPONGY, DENSE, AND RESILIENT BENEATH YOUR FEET. IT HAS THE CONSISTENCY OF A CORPSE. WITH EACH STEP YOUR FEET PRESS DOWN ON GENERATIONS OF DEAD ANCESTORS. THEIR BONES AND ROTTED AND TRANSMUTED FLESH HAVE BECOME THE SUBSTANCE OF THE EARTH. WHEN YOU EAT YOU INGEST THEIR ESSENCE – THE FERTILITY THAT SURVIVED THEIR DECOMPOSITION. IN THIS WAY THEY LIVE THROUGH YOU, BY YOUR CONSUMPTION OF AIR, FOOD, WATER. WHEN YOU BREATHE, YOU BREATHE IN A MIXTURE OF THE GASES THEIR BODIES EXUDED IN THE PROCESS OF DECOMPOSITION, REASSIMILATING INTO YOUR BODY.

: THE AIR, BEING BLOOD, IS HARD TO INHALE. BUT I LEARN. I RELAX AND LET IT IN. MY BODY FLOATS THROUGH IT, SUBSUMED BY IT. I BREATHE, SWALLOW, AND THINK BLOOD. MY IMAGINATION STOPS WHERE BLOOD ENDS. BLOOD SURROUNDS ME, DROWNS MY SIGHT, SO THAT WHEN I THINK, BEFORE AN IMAGE FORMS, IT'S CONSUMED BY BLOOD. I'M WITHERED, ANCIENT, A CHILD DRIFTING THROUGH A THICK RED UNIVERSE, PULSING AND GORGING MYSELF ON MY OWN SENTIENT BLOOD. THIS BLOOD KNOWS ME, LICKS ME, KEEPS ME IN A PERPETUAL DRONE OF SELF-NEGATING ORGASM THAT SENDS WAVES OF PLEASURE THROUGH THE FURTHEST POOLS OF PUMPING RED CONSCIOUSNESS.

: I CAN'T STOP MY URGE TO DISINTEGRATE. MY SKIN IS PULLING APART: I CAN SEE THROUGH THE CELLS THAT LINK TOGETHER IN A WEB, DIFFERENTIATE THEM ONE FROM THE OTHER. MY SKIN ISN'T A PROTECTION – IT'S OPEN. THE WIND BLOWS RIGHT THROUGH IT INTO MY INSIDES. IT MOVES THROUGH ME, TAKES PARTS OF ME WITH IT, PUTS NEW PARTS IN THEIR PLACE. I'M DROWNING IN LIGHT. LIGHT IS A FLUID I INHALE. MY EYES ARE CLOSED, SO MY BODY IS LIT FROM THE INSIDE-OUT, GLOWING LIKE A JELLYFISH IN THE SEA. THE COOL BLUE VAPOR POURS THROUGH MY VEINS, PUMPING THROUGH MY HEART, SATURATING THE CAPILLARIES IN MY LUNGS, FILTERING INTO THE TISSUE OF MY MUSCLES. IN THE CENTER

OF MY BRAIN IS A VORTEX OF LIGHT AND COLOR. THE PIT OF MY STOMACH IS BOILING WITH LIGHT. MY FLESH BURNS LIKE MAGNESIUM. MY SPERM IS THICKENED LIGHT. IT CONTAINS FALSE MEMORIES, THE SEED OF A NEW RACE, A CIVILIZATION, A PLAGUE, A FLOOD OF POISON OIL AND DEAD SUB-AQUATIC BLIND MONSTERS. THE TIPS OF MY FINGERS SHOOT LIGHT ACROSS THE UNIVERSE AND WRITE MY NAME ON THE SKY, SUCKED INTO A BLACK PIT OF ANTI-MATTER. A MUTE SURGE OF SELFLESS LUST GROWS FROM THE ROOT OF MY COCK OUT INTO THE DENSE COMPACT EMPTINESS IN THE CENTER OF SPACE. SUCKED INTO THIS HOLE I REGRESS BACKWARDS INTO A SINGLE MOLECULE OF AGONY. THE DRUGGED STUPIDITY OF MY SELF AWARENESS GESTATES IN A SEALED WOMB LIKE A SEED TRAPPED IN A LEAD CONTAINER BURIED IN DENSE AND IMPENETRABLE SILT AT THE BOTTOM OF THE SEA. FROM HERE, DEEP IN THE COMFORTABLE BLACKNESS, I EXPAND OUTWARDS, SPITTING SPERM AT THE STARS.

wind die you die we die
william s burroughs

UNDER a dim moon and dim stars I walked down to a clearing over the sea where I had made love to a girl some night before. She could not have known that her romantic middle-aged lover was actually a stranded pederast who had experienced considerable strain in fulfilling his male role. Anything is better than nothing is a very bad approach to sex. I stood there hearing the sound of the sea several hundred feet down at the bottom of a steep slope, feeling the wind on my face and remembering the wind on our bodies, the wind that is life to Puerto de los Santos. *Los vientos de Dios*, the winds of God that blow away the mosquitoes and the miasmal mists and the swamp smells. The winds of God that keep the great hairy tarantulas and the poisonous snakes at bay. The natives have a saying: "Wind die. You die. We die." I knew that this could happen. In fact I had written a thesis showing that low-pressure areas were shifting inexorably to the east and that the winds of God must soon die. My thesis had not been well received by the local officials who were preoccupied with the possibility of a modern airport and jet service from Miami. Soon they told each other American tourists loaded with money would come to enjoy the winds of God, the dry balmy wind like a great fan from the sea that kept the temperature just right day and night the year round.

'If only we had some Communists to fight,' said the officials sadly. 'Then we could be sure the Americans would give us money.'

Somewhere in the distance a dog was barking from a villa garden. I turned and walked back to the empty sea road under the dim moon and dim stars.

The lack of Communists it seems was crucial and the airline made arrangements elsewhere. Then an ominous portent of disaster touched Puerto de los Santos. The winds of God were dying. Today whole sections of the foreign quarter are deserted. The swimming-pools are full of stagnant rainwater. In the desolate markets the bright fabrics and tinware no longer flap and clatter in the winds of God. There are few purchasers and fingers that touch the merchandise are yellow and listless with fever. Puerto de los Santos is dying.

In my New York apartment I remember that spot over the sea. No lovers would go there now because of the mosquitoes the spiders and the snakes. It is getting dark and I stand by the window looking at the lights of New York. This city will also die. Remember the power failure some years ago? It was never explained to anyone's satisfaction least of all to mine. In fact I have written a thesis to show that, owing to reverse magnetic currents, there will soon be no electricity

conducted on the Eastern seaboard. My thesis has been shelved in Washington. People do not like to hear these things. I know that in a few years the Great White Way will black out forever. I can see darkness falling in great blocks on the stricken town. Before that happens I will be somewhere else no doubt writing another thesis that will not be well received by the local officials. I stand at the window and remember the wind on our bodies the sound of the sea dim jerky far away stars...

"Wind die. You die. We die."

THE END.

I turned the page to be faced by a lurid colour picture of a creature with pendulous leathery breasts, two front legs ending in claws and a scorpion's tail. They had the breasts of women, a scorpion's sting and snapping teeth! They came in countless hordes and they attacked!

The Crawling Breasts

Tommy Wentworth, an assistant baker, was riding home on his bicycle after work. He lived a few miles out of town and rode to and from work every day. As he passed St Hill he heard a curious sound like the clacking of many castanets. He stopped and leaned his bicycle against a tree. St Hill, so named for a local saint who had killed a dragon, was covered with trees, vines and heavy undergrowth. On weekends Tommy often came here with his friends to pick berries. He heard the sound again louder now. What could it be? And the sound of many bodies slithering through the under-brush. Why it sounded like an army. He walked a little way up the hill and pushed aside the brush. A few minutes later he was panting out his story to a sceptical constable.

'Women you say now with hanging breasts walking on two front legs? Scorpion stings and snapping teeth is it? You wouldn't have been stopping in at the Swan for a few pints would you now?' The constable winked broadly.

'But I tell you I saw them! And coming this way!'

The constable looked up sharply. Colonel Sutton-Smith was standing in the doorway a sporting rifle under his arm.

'Constable there are some sort of monsters advancing on the village. We must call up every able-bodied man between the ages of fourteen and seventy with whatever weapons they can lay hand to. Have them assemble at St Hill Green.'

The constable turned pale. '*Monsters* you say sir? You *saw* them sir?'

'Yes through my binoculars. They will reach the village in a quarter hour more or less. There is no time to waste.'

The constable opened a drawer and took out an old Bulldog Webley .455. He looked at

it dubiously. 'I doubt if it will fire sir after all these years...must be some cartridges about somewheres.'

The colonel turned to Tommy. 'And now my boy get on your bicycle and cover the houses on the east side of the road down to Shelby's Farm. Tell the men to collect whatever weapons they can find and report to the Green. Women and children to stay locked in the houses. The constable and I will cover the west side. Look sharp now.'

Ten minutes later thirty frightened men and boys stood on the Green armed with shotguns, pickaxes, iron bars, meat cleavers and cobblestones. Lanterns had been lit casting an orange glow over Dragon Lake. Buckets of petrol stood ready to burn the monsters.

'Here they come!' Tommy shouted.

'Form a square men' the colonel snapped. He raised his rifle.

'Mr Anderson will see you now. Will you kindly step this way Mr Seward.' Somewhat reluctantly I put down the magazine and followed her down a long corridor. Funny what you find in old pulp magazines. "Wind die. We die. You die." Quite haunting actually...the middle-aged Tiresias moving from place to place with his unpopular thesis, spending his days in public libraries, eking out a living writing fiction for pulp magazines...good stories too...the dim night sky the place by the sea the shadowy figure of the absent girl...you can see it all somehow... Curiously enough I had myself come to sound a word of warning, a warning I was reasonably sure would not be heeded. Still a man has his duty. And I was reluctant to leave the intrepid colonel frozen forever rifle at his shoulder. Perhaps I could pinch the magazine on the way out. I doubted this. The receptionist had a sharp cold eye. She opened a door.

Mr Anderson was crisp and cool. 'And what can I do for you Mr Seward.'

'Mr Anderson I wonder if you have read my treatise on the possibility of virus replication outside the host cell?'

Mr Anderson looked at once vague and desperate. 'Well no I can't say that I have.'

'The treatise is theoretical of course. I have not come here to discuss theories Mr Anderson. I have come to warn you that virus replication *outside* the host cell is now an accomplished fact. Unless the most drastic measures are taken *at once*...measures so drastic I hesitate to tell you what they are...unless these measures are taken Mr Anderson within two years or less the entire male population of this district will be reduced to–'

'Mr Capwell will see you now Mr Bently. Will you step this way please.' Somewhat reluctantly I put down the magazine and followed her down the hall. Quite an idea. Story of someone reading a story of someone reading a story. I had the odd sensation that I myself would wind up in the story and that someone would read about me reading the story in a waiting room somewhere. As I followed her down the corridor the words I had read began shifting in my head all their own as it were...shifting inexorably to a spot over the sea...the distance a dog was barking from...this

spot...deserted swimming pool at the bottom of a steep slope...villa garden...bright wind in the desolate markets...our bodies rejected...tinware clattering in the winds of God...Swan for a few pints would you now? I turned the page to be faced by his leathery breasts...Two Claws Smith was standing in the doorway... She could not know that her stranded pederast had experienced arrangements elsewhere...louder now the sound of something out forever... Exactly what would the male population of the district be reduced to and what were the "drastic measures" by which Mr Seward proposed to avert such reduction? Perhaps I could charm the magazine out of the receptionist. I nearly laughed aloud at the thought that I might wind up making love to her under a dim night sky in a clearing over the sea. She turned and flashed me a smile as she opened a door. It was a smile that said 'I wish you luck. He's a real bastard.' He was indeed. He looked at me as if he were trying to focus my face through a telescope.

'Yes Mr uh Bently.' Clearly he suspected me of using an assumed name. 'And what can I do for you?'

'Mr uh Capwell what can you do for your own reflection many times removed of course or to put it another way on the subject of wrongness how wrong do you think you generally are?' He visibly experienced more difficulty in focusing my face. 'I don't believe I under-stand you Mr Bently.'

'In that case I will make yourself clearer. But first let me ask if you have entertained certain elementary considerations with regard to repetitive irritations of virus origin? One sneeze for example is inconsequential whereas a thousand consecutive sneezes might well prove fatal... the common cold Mr Capwell uncommon to be sure in this climate and for that very reason should you leave Panama and return to New York it is your duty to know and mine to inform you that you would have as it were an unseen traveller's companion of the most regrettable and I may add versatile proclivities. No Mr Capwell this is not a Communist plot. It is simply the mirror image of such a plot many times removed and apparent to you as such because you believe that it is. You know of course that it is a common measure of prophylaxis to shoot a cow with the aftosa and that a reasonable cow would not object to this procedure if that cow had been indoctrinated with the proper feelings of duty toward the bovine community at large. Does that answer your question Mr Capwell?'

When you look down a snub-nosed .38 you can see the bullet at the bottom of the barrel. It gives you a funny feeling many times removed.

'You can see Miss Blankslip now Mr Tomlinson.'

'In focusing my face Thompson is the name.'

'Oh yes Mr Thompson if you'll just care to step this way... It is in the East wing... I'll see you past the guards.'

'Did I understand you to say Miss Blankslip?'

'Yes she has remained unmarried,' the boy told me. 'It is said that she experienced a

great disappointment in love many years ago but that was in another country and besides her present condition would make matrimony an interesting but remote contingency.'

We were walking through what appeared to be an abandoned compound or concentration camp...rusty barbed wire, concrete ditches and barriers overgrown with weeds and vines. Here and there the concrete was blackened by some fire long ago. We passed three barriers where a guard lounged, tunic unbuttoned, rusty revolver in holster green with mold. They waved us through with listless yellow fingers. A sour rotten smell of stale flesh and sweat hung over the compound like a smog.

'The odour of course is still here. You see there has been no wind since...' It was getting dark. I had a curious feeling of being three feet back of my head. Years ago I had studied something called Scientology I believe. As if seen through a telescope from a great distance I read the following words: "In other words, two of each of anything, one facing the other. By bracket we mean, of course, putting them up as himself as though they were put up by somebody else, the somebody else facing the somebody else, and the matched terminal again put up by others facing others." Mirror images mocked up opposite each other each pair placed there by the next in line. We had reached the edge of a brown lake lit by carbide lanterns. In the shallow water I could see crablike fish that stirred the surface occasionally releasing bubbles of stagnant swamp smell. A few trees grew here of a strangely bulbous and distorted variety. Gathered in this desolate spot were a handful of ragged soldiers diseased and dirty. One of them stepped forward and handed me an old Webley .455. An officer with a rusty sporting rifle under his arm returned my salute. We were standing in front of what appeared to be an abandoned barracks. The receptionist turned to us with the manner of a circus barker.

'And now folks if you'll just step this way you are about to witness the most amazing the most astounding living monstrosity of all time. She was once a beautiful woman.'

He unlocked the door and we filed in. A terrible unknown stench seared the lungs and grabbed the stomach. Several soldiers retched into faded bandanas. In the centre of the dusty room was a wire mesh cubicle where something stirred sluggishly. I felt an overwhelming nightmare vertigo.

'You! You! You!'

It was the end of the line.

the night sea-maid went down
brian lumley

(From the files of the Wilmarth Foundation)

Queen of the Wolds Inn
Cliffside
Bridlington
E. Yorks.

29th Nov.

J. H. Grier (Director)
Grier & Anderson
Seagasso
Sunderland
Co. Durham

Dear Johnny,

By now I suppose you'll have read my 'official' report, sent off to you from this address on the fourteenth of the month, three days after the old *Sea-Maid* went down. How I managed that report I'll never know – but anyway, I've been laid up ever since, so if you've been worried about me or wondering why I haven't let on further about my whereabouts till now, well, it hasn't really been my fault. I just haven't been up to doing much writing since the ... disaster. Haven't been up to much of any-thing for that matter. God, but I hate the idea of facing a Board of Inquiry!

Anyhow, as you'll have seen from my report, I've made up my mind to quit, and I suppose it's only right I give you what I can of an explanation for my decision. After all, you've been paying me good money to manage your rigs these last four years, and no complaints there. In fact, I've no complaints period, nothing Seagasso could sort out at any rate, but I'm damned if I'll sink sea-wells again. In fact, I'm finished with *all* prospecting! Sea, land ... it makes no real difference now. Why, when I think of what might have happened at any time during the last four years! And now it *has* happened.

But there I go, stalling again. I'll admit right now that I've torn up three versions of this

letter, pondering the results of them reaching you; but now, having thought it all out, frankly, I don't give a damn what you do with what I'm going to tell you. You can send an army of head-shrinkers after me if you like. One thing I'm sure of, though, and that's this – whatever I say won't make you suspend the North-Sea operations. 'The Country's Economy', and all that.

At least my story ought to give old Anderson a laugh; the hard, stoic, unimaginative old bastard! And no doubt about it, the story I have to tell is fantastic enough. I suppose it could be argued that I was 'in my cups' that night (and it's true enough, I'd had a few), but I can hold my drink, as you well know. Still, the facts – *as I know them* – drunk or sober, remain simply fantastic.

Now, you'll remember that right from the start there was something funny about the site off Hunterby Head. The divers had trouble; the geologists, too, with their instruments; it was the very devil of a job to float *Sea-Maid* down from Sunderland and get her anchored there; and all that was only the start of the trouble. Nevertheless, the preliminaries were all completed by early in October.

We hadn't drilled more than six hundred feet into the seabed when we brought up that first star-shaped thing. Now, Johnny, you know something? I wouldn't have given two damns for the thing, except I'd seen one before. Old Chalky Gray (who used to be with the Lescoil rig, *Ocean-Gem*, out of Liverpool) had sent me one only a few weeks before his platform and all the crew, including Chalky himself, went down twelve miles out from Withnersea. Some-how, when I saw what came up in the big core – that same star-shape – I couldn't help but think of Chalky and see some sort of nasty parallel. The one he'd sent me came up in a core too, you see? And *Ocean-Gem* wasn't the only rig lost that year in so-called 'freak storms'!

Now regarding those star-shaped stones, something more: I wasn't the only one to escape with my life the night *Sea-Maid* went down. No, that's not strictly true, I was the only one to live through *that night* – but there was a certain member of the team who saw what was coming and got out before it happened. And it was because of the star-thing that he went!

Joe Borszowski was the man – super-stitious as hell, panicky, spooked at the sight of a mist on the sea – and when he saw the star-thing...!

It happened like this:

We'd drilled a difficult bore through some very hard stuff when, as I've said, a core-sample produced the first of those stars. Now, Chalky had reckoned the one he sent me to be a fossilized starfish of sorts, from a time when the North-Sea used to be warm; a very ancient thing. And I must admit that with its five-pointed shape, and being the size of a small starfish, I believed him to be correct. Anyway, when I showed this second star to old Borszowski he nearly went crackers! He swore we were in for trouble, demanded we all stop drilling right away and head for land, insisted that our location was 'accursed', and generally carried on like a mad thing without explaining why.

Well, I couldn't just leave it at that; if one of the lads was around the twist, you know (meaning

Borszowski), he could well affect the whole operation, jeopardize the whole thing; especially if his madness took him at an important time. My immediate reaction was to want him off the rig, but the radio had been giving us a bit of bother so that I couldn't call in Wes Atlee, the chopper pilot. Yes, I'd seriously thought of having the Pole lifted off by chopper. The gangs can be damned superstitious, as you well know, and I didn't want Joe infecting the other lads with his wild fancies. As it turned out, that sort of action wasn't necessary, for in no time at all old Borszowski was around apologizing for his outburst and trying to show how sorry he was about all the fuss he'd made. Something told me, though, that he'd been quite serious about his fears – whatever they were.

And so, to put the Pole's mind at rest (if I possibly could), I decided to have the rig's geologist, Carson, take the star to bits, have a closer look at it, and then let me know what the thing actually was. Of course, he'd tell me it was simply a fossilized starfish; I'd report the fact to Borszowski; things would be back to normal. So naturally, when Carson told me that it *wasn't* a fossil, that he didn't know exactly what it was – well, I kept that bit of information to myself and told Carson to do the same. I was sure that whatever the trouble was with Borszowski, well, it wouldn't be helped any by telling him that the star-thing was not a perfectly ordinary, completely explicable object.

The drilling brought up two or three more of the stars down to about a thousand feet, but nothing after that, so for a period I forgot all about them. As it happened, I should have listened a bit more willingly to the Pole – and I would have, too, if I'd followed my intuition.

You see, I've got to admit that I'd been spooky myself right from the start. The mists were too heavy, the sea too quiet ... things were altogether too queer all the way down the line. Of course, I didn't experience any of the troubles the divers or geologists had known – I didn't join the rig until she was in position, ready to chew – but I was certainly in on it from then on. It had really started with the sea-phones, even before the advent of the stars.

Now, you know I'm not knocking your phones, Johnny; they've been a damn good thing ever since Seagasso developed them, giving readings right down to the inch, almost, so's we could tell just exactly when the drill was going through into gas or oil. And they didn't let us down this time, either ... we simply failed to recognize or heed their warnings, that's all.

In fact, there were lots of warnings, but, as I've said, it started with the sea-phones. We'd put a phone down inside each leg of the rig, right on to the seabed where they sat 'listening' to the drill as it cut its way through the rocks, picking up the echoes as the steel worked its way down and the sounds of the cutting rebounded from the strata below. And, of course, everything they 'heard' was duplicated electronically and fed out to us through our computer. Which was why we believed initially that either the computer was on the blink or one of the phones was shaky. You see, even when we weren't drilling – when we were changing bits or lining the hole – we were still getting readings from the computer!

Oh, the trouble was there all right, whatever it was, but it was showing up so regularly

that we were fooled into believing the fault to be mechanical. On the seismograph, it showed as a regular blip in an otherwise perfectly normal line; a blip that came up bang on time once every five seconds or so – blip ... blip ... blip – very odd! But, seeing that in every other respect the information coming out of the computer was spot on, no one worried overmuch about this inexplicable deviation. The blips were there right to the end, and it was only then that I found a reason for them, but in between there came other difficulties – not the least of them being the trouble with the fish.

Now, if that sounds a bit funny, well, it was a funny business. The lads had rigged up a small platform, slung twenty feet or so below the main platform and about the same height above the water, and in their off-duty hours when they weren't resting or knocking back a pint in the mess, you could usually see one or two of them down there fishing.

First time we found anything odd in the habits of the fish around the rig was one morning when Nick Adams hooked a beauty. All of three feet long, the fish was, wriggling and yellow in the cold November sunlight. Nick just about had the fish docked when the hook came out of its mouth so that it fell back among some support-girders down near where leg number four was being washed by a slight swell. It just lay there, flopping about a bit, in the girders. Nick scrambled down after it with a rope around his waist while his brother Dave hung on to the other end. And what do you think? When he got down to it, damned if the fish didn't go for him! It actually made to *bite* him, flopping after him on the girders, and snapping its jaws until he had to yell for Dave to haul him up.

Later he told us about it; how the damned thing hadn't even tried to get back into the sea, seeming more interested in setting its teeth in him than preserving its own life! Now, you'd expect that sort of reaction from a great eel, Johnny, wouldn't you? But hardly from a cod – not from a North-Sea cod!

From then on, Spellman, the diver, couldn't go down – not wouldn't, mind you, *couldn't* – the fish simply wouldn't let him. They'd chew on his suit, his air-hose ... he got to be so frightened of them that he became quite useless to us. I can't see as I blame him, though, especially when I think of what later happened to Robertson.

But of course, before Robertson's accident, there was that further trouble with Borszowski. It was in the sixth week, when we were expecting to break through at any time, that Joe failed to come back off shore leave. Instead, he sent me a long, rambling explanatory letter; and to be truthful, when first I read it, I figured we were better off without him. The man had quite obviously been cracking up for a long time. He went on about *monsters*, sleeping in great caverns underground and especially under the seas, waiting for a chance to take over the surface world. He said that those star-shaped stones were seals to keep these monster beings ('gods', he called them) imprisoned; that the gods could control the weather to a degree; that they were capable of influencing the actions of lesser creatures – such as fish, or, occasionally, men – and that he believed one of them must be lying there, locked in the ground beneath the sea, pretty close to

where we were drilling. He was frightened we were going to set it loose! The only thing that had stopped him from pressing the matter earlier was that then, as now, he'd believed we'd all think he was mad! Finally, though, he'd had to 'warn' me, knowing that if anything *did* happen, he'd never forgive himself if he hadn't at least tried.

Well, like I say, Borszowski's letter was rambling and disjointed – and yet, despite my first conclusion, the Pole had written the thing in a rather convincing manner. Hardly what you'd expect from a real madman. He quoted references from the Bible, particularly Exodus 20:4, and again and again emphasized his belief that the star-shaped things were nothing more or less than prehistoric pentacles laid down by some great race of alien sorcerers many millions of years ago. He reminded me of the heavy, unusual mists we'd had and of the queer way the cod had gone for Nick Adams. He even brought up again the question of the shaky sea-phones and computer: making, in toto, an altogether disturbing assessment of Sea-Maid's late history as applicable to his own odd fancies.

In fact, I became *so* disturbed by that letter that I was still thinking about it later that evening, and about the man himself, the superstitious Pole.

I did a little checking on Joe's back-ground, discovering that he'd travelled far in his early days to become something of a scholar in obscure mythological matters. Also, it had been noticed on occasion – whenever the mists were heavier than usual, particularly since the appearance of the first star-stone – that he crossed himself with a strange sign over his breast. A number of the lads had seen him do it. They all told the same tale about that sign; that it was pointed, one point straight up, two more down and wide, two still lower but closer together. Yes, the Pole's sign was a five-pointed star! And again I read his letter.

By then we'd shut down for the day and I was out on the main platform having a quiet pipeful – I can concentrate, you know, with a bit of 'baccy. Dusk was only a few minutes away when the ... *accident* ... happened.

Robertson, the steel-rigger, was up aloft tightening a few loose bolts halfway up the rig. Don't ask me where the mist came from, I don't know, but suddenly it was there. It swam up from the sea, a thick grey blanket that cut visibility down to no more than a few feet. I'd just shouted up to Robertson, telling him that he'd better pack it in for the night, when I heard his yell and saw his lantern (he must have lit it as soon as the mist rolled in) come blazing down out of the greyness. The lantern disappeared through an open hatch, and a second later Robertson followed it. He went straight through the hatchway, missing the sides by inches, and then there came the splashes as first the lantern, then the man hit the sea. In two shakes of a dog's tail Robertson was splashing about down there in the mist and yelling fit to ruin his lungs, proving to me and the others who'd rushed out from the mess at my call that his fall had done him little harm. We lowered a raft immediately, getting two of the men down to the water in less than two minutes, and no one gave it a second thought that Robertson wouldn't be picked up. He was, after all, an excellent swimmer. In fact, the lads on the raft thought the whole episode was a big laugh ... that

is until Robertson started to scream!

I mean, there are screams and there are *screams*, Johnny! Robertson wasn't drowning – he wasn't making noises like a drowning man!

He wasn't picked up, either. No less quickly than it had settled, the mist lifted, so that by the time the raft touched water visibility was normal for a November evening ... but there was no sign of the steel-rigger. There *was* something, though, something we'd all forgotten – for the whole surface of the sea was silver with fish!

Fish! Big and little, almost every indigenous species you could imagine. The way they were acting, apparently trying to throw themselves aboard the raft, I had the lads haul themselves back up to the platform as soon as it became evident that Robertson was gone for good. Johnny – I swear I'll never eat fish again.

That night I didn't sleep very well at all. Now, you know I'm not being callous. I mean, aboard an ocean-going rig after a hard day's work, no matter what has happened during the day, a man usually manages to sleep. Yet that night I just couldn't drop off. I kept going over in my mind all the ... well, the things – the odd occurrences, the trouble with the instruments and the fish, Borszowski's letter again, and finally, of course, the awful way we lost Robertson – until I thought my head must burst with the burden of wild notions and imaginings going round and round inside it.

Next afternoon the chopper came in again (with Wes Atlee complaining about having had to make two runs in two days) and delivered all the booze and goodies for the party the next day. As you know, we always have a blast aboard when we strike it rich – and this time the geological samples had more or less assured us of a good one. We'd been out of beer a few days by that time – poor weather had stopped Wes from bringing in anything but mail – and so I was running pretty high and dry. Now you know me, Johnny. I got in the back of the mess with all that booze and cracked a few bottles. I could see the gear turning from the window, and, over the edge of the platform, the sea all grey and eerie-looking, and somehow the idea of getting a load of booze inside me seemed a damn good one.

I'd been in there topping-up for over half an hour when Jeffries, my 2IC, got through to me on the telephone. He was in the instrument cabin and said he reckoned the drill would go through to 'muck' within a few more minutes. He sounded worried, though, sort of shaky, and when I asked him why this was, he didn't rightly seem able to answer – mumbled something about the instruments mapping those strange blips again, regular as ever but somehow stronger ... closer.

About that time I first noticed the mist swirling up from the sea, a real pea-souper, billowing in to smother the rig and turn the men on the platform to grey ghosts. It muffled the sound of the gear, too, altering the metallic clank and rattle of pulleys and chains to distant, dull noises such as I might have expected to hear from the rig if I'd been in a suit deep down under the sea.

It was warm enough in the back room of the mess there, yet unaccountably I found myself shivering as I looked out over the rig and listened to the ghost sounds of machinery and men.

That was when the wind came up. First the mist, then the wind – but I'd never before seen a mist that a good strong wind couldn't blow away! Oh, I've seen freak storms before, Johnny, but believe me this storm was *the* freak! With a capital 'F'.

She came up out of nowhere – not breaking the blanket of grey but driving it round and round like a great mad ghost – blasting the already choppy sea against the Old Girl's legs, flinging up spray to the platform's guard-rails, and generally creating havoc. I'd no sooner recovered from my initial amazement when the telephone rang again. I came away from the window, picked up the receiver to hear Jimmy Jeffries' somewhat distorted yell of triumph coming over the wires. 'We're *through*, Pongo!' he yelled. 'We're through and there's juice on the way up the bore right now!' Then his voice took the shakes again, going from wild excitement to terror in a second as the whole rig *wobbled* on its four great legs!

Holy heaven –!' His voice screamed in my ear. '*What was that*, Pongo? The rig ... wait –' I heard the clatter as the telephone at the other end banged down, but a moment later Jimmy was back. 'It's not the rig,' he told me; 'the legs are steady as rocks – *it's the whole seabed!* Pongo, what's going on? Holy heaven –'

This time the telephone went completely dead as the rig moved again, jerking up and down three or four times in rapid succession, shaking everything loose inside the mess storeroom. I was just able to keep my feet. I still had the telephone in my hand, and just for a second or two it came back to life. Jimmy was screaming some-thing incoherently into his end. I remember that I yelled for him to get into a life jacket, that there was something awfully wrong and we were in for big trouble, but I'll never know if he heard me.

The rig rocked yet again, throwing me down on the floorboards among a debris of bottles, crates, cans, and packets; and there, skidding wildly about the tilting floor, I collided with a life jacket. God only knows what the thing was doing there in the storeroom – there were normally two or three on the platform and others were kept in the equipment shed, only taken out following storm warnings, which it goes without saying we hadn't had. But somehow I managed to struggle into it and make my way into the mess proper before the next upheaval.

By that time, over the roar of the wind and waves outside and the slap of wave-crests against the outer walls of the mess, I could hear a whipping of free-running pulleys and a high-pitched screaming of revving, uncontrolled gears – and there were *other* screams, too.

I admit that I was in a blind panic, crashing my way through the tumble of chairs and tables in the mess towards the door leading out on to the platform, when the greatest shock so far tilted the floor to what must have been thirty degrees and saved me any further effort. In that moment – as I flew against the door, bursting it open, and floundering out into the storm – I knew for sure that the old *Sea-Maid* was going down. Before, it had only been a possibility, a mad,

improbable possibility; but now I knew for sure. Half stunned from my collision with the door, I was thrown roughly against the platform rails, to cling there for dear life in the howling, tearing wind and chill, rushing mist and spray.

And that was when I saw it!

I saw it ... and in my utter disbelief I relaxed my hold on the rails and slid under them into the throat of that banshee, demon storm that howled and tore at the trembling girders of the old *Sea-Maid*.

Even as I fell a colossal wave smashed into the rig, breaking two of the legs as though they were nothing stronger than matchsticks. The next instant I was in the sea, picked up, and swept away on the crest of that same wave. Even in the dizzy, sickening rush as the great wave hurled me aloft, I tried to spot Sea-Maid in the maelstrom of wind, mist, and ocean. It was futile and I gave it up in order to save all my effort for my own battle for survival.

I don't remember much after that – at least, not until I was picked up, and even that's not too clear. I do remember, though, while fighting the icy water, a dreadful fear of being eaten alive by fish; but so far as I know there were none about. I remember, too, being hauled aboard the lifeboat from a sea that was flat as a pancake and calm as a mill pond.

The next really lucid moment came when I woke up to find myself between clean sheets in a Bridlington hospital.

But there, I've held off from telling the important part, and for the same reason Joe Borszowski held off: I don't want to be thought a madman. Well, I'm not mad, Johnny, but I don't suppose for a single moment that you'll take my story seriously – nor, for that matter, will Seagasso suspend any of its North-Sea commitments – but at least I'll have had the satisfaction of knowing that I tried to warn you.

Now, remember if you will what Borszowski told me about great, alien beings lying asleep and imprisoned beneath the bed of the sea – evil 'gods' capable of controlling the weather and the actions of lesser creatures – and then explain the sight I saw before I found myself floundering in that mad ocean as the old *Sea-Maid* went down.

It was simply a gusher, Johnny, a gusher – but one such as I'd never seen before in my whole life and hope never to see again! For instead of reaching the heavens in one solid black column, it *pulsed* upward, pumping up in short, strong jets at a rate of about one spurt in every five seconds – and it wasn't oil, Johnny! Oh, God, it wasn't oil! Booze or none, I swear I wasn't drunk; not so drunk as to make me *colour-blind*, at any rate.

For old Borszowski was right, there *was* one of those great god-things down there deep in the bed of the ocean, *and our drill had chopped right into it!*

Whatever it was, it had blood pretty much like ours – good and thick and red – and a great heart strong enough to pump that blood up the bore-hole right to the surface! Think of it, that monstrous giant of a thing down there in the rocks beneath the sea! How could we possibly have known? *How could we have guessed that right from the beginning our instruments had*

been working at maximum efficiency, that those odd, regular blips recorded on the seismograph had been nothing more than the beating of a great submarine heart?

All of which explains, I hope, my resignation.

Bernard 'Pongo' Jordan
Bridlington, Yorks.

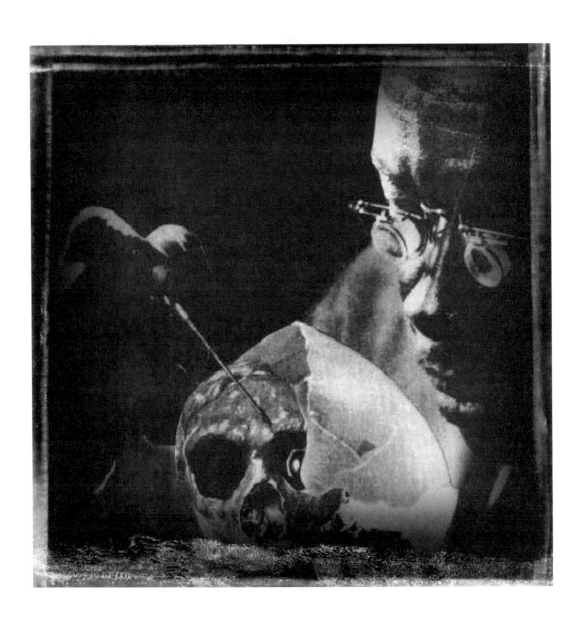

a thousand young
ROBERT M. PRICE

I

SEX was my god. I do not blush to admit it. Indeed I have always been at a loss to fathom how anyone could seek any other altar. For what besides sex holds the keys both to life's generation and to its uttermost ecstasies? The knowledge of my vocation has been life-long, passionately felt, though at times dimly understood.

My early years witnessed no especial circumstances or experiences to set me off from other boys, save in this one respect: that I was positively more religious than most, certainly more so even than my parents, to whom my catechism was a mere custodial duty no different in kind than enrolling me in grade school. So no excesses of churchly zeal or over-active conscience were ever forced upon me. I note this lest anyone interpret my eroticism as childish reaction against repression, as was the case with other lustful luminaries such as the puzzling Aleister Crowley.

No, my awakening adolescent sexuality caused no trauma, and did not even find occasion to affront my deeply-felt religious convictions. My faith did, however, cause me to resolve to defer full sexual gratification until marriage would one day make it legitimate in the eyes of the Almighty. But until then, I could wait ... and, of course, masturbate. No text could I find in Sacred Scripture to forbid the practice, imaginary commandments against "Onanism" notwithstanding. Even then I was astute enough to realize that natural exegesis erected no barrier to natural self-expression.

But from what I have said it becomes obvious that I had privately begun to interpret my creed for myself (since my peers in piety would certainly never have endorsed the opinions I have here expressed). And it was this intellectual inquisitiveness that led me during college years to slough off conventional dogma altogether. Once again, however, this transition necessitated no violent break. Rather, I bade my youthful faith a fond goodbye, seeing in the parting no more than Saint Paul himself had described as a 'putting away of childish things.'

Once one has been singed with the fire of religious zeal, one can never quite get beyond its influence, no matter what intellectual permutations one undergoes. And so with me. My instinctive questioning after the cosmos and its ultimate meaning simply pursued new and different channels. And, needless to say, so did my sexuality, now free from what strictures even my own theology had imposed. I sampled new philosophies and new flesh with equal relish, and

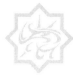

though grateful for the savour of each successive encounter, intellectual and physical, I never could rest content.

In pursuit of the sexual quest one hears of many, I suspect, less imaginative souls who become quickly jaded, failing finally to become aroused by whatever previously titillated them. I confess my inability to understand this unfortunate course, except to liken it to drug addiction and its diminishing returns. It was not my experience, for I continued to take the same delight in the tenth virgin as I did in the first. Every breast and buttock was as sweet as the last to me. I sought to expand my libidinous repertoire only because it seemed the natural path of growth. And the sense of dissatisfaction I eventually came to feel arose not so much from weariness with what I had experienced, as from curiosity about what I had not.

I have said that my quest of spirit kept pace with my sexual adventuring during this period. But here the picture was somewhat different. For unless one be a pure dilettante, one cannot simply sample philosophies and worldviews as at a buffet. When one moves from one system to the next, one does so in rejection of the first. And it did not take me overlong to progress through several schools of opinion in this manner.

The Logical Positivists seemed to me to have created a singularly depressing cell in which to imprison the human mind, dis-daining all the concerns of classical philosophy that did not lend themselves to the neat solution of a mathematical problem. A sympathetic attempt to acquaint myself with their tenets assured me that Positivism, or any other myopic strain of Materialism, was not to be my home.

Surely, given my more mystical predilections, Idealism was more convivial to me, yet I could not help but feel that the great spokesmen for this school – Plato, Bishop Berkeley, Hegel – were missing something, as if they had left some important tract of ground uncovered. There was a Reality transcending humanity and its mundane grind, or at least I felt sure of it, but what was its nature? "The Absolute Spirit"? "The Form of the Good"? With all such abstractions I was dissatisfied, all the more since each philosopher superimposed his own version of that transcendental realm as an eternal imprimatur on the temporal establishment to which he belonged: Hegel to the German monarchy, Berkeley to the Church of Ireland, Plato to the totalitarian "Republic" he longed for. I, the reader will recall, was no friend to conformity and demanded to think, and act, for myself.

As so often happens (so often, in fact, that we really should cease to be surprised at it), my answer came to me seren-dipitously. Though my philosophical studies demanded most of my time in college and university years (necessarily so, since it was to be my professional field), I occasionally relaxed with other reading. I became an aficionado, even a connoisseur, of pornography. I began to read such material for the same reason that anyone does: for the vicarious sexual thrill of it. Only I found that most of the modern works were so shoddily written – little better than toilet graffiti, actually – that only morons might be seduced by them. So I concentrated on and began to collect the classics of the genre. It was my great fortune to stumble

across a copy of Pisanus Fraxi's nearly unobtainable *Index Librorum Prohibitorum*. This was a nineteenth-century work which, while posing as a pious syllabus of errors cataloguing unwholesome books, slyly sought to aid the salacious collector in tracking down and amassing a pornographic library. And that was precisely the use to which I put it.

It was through such enjoyable researches that I finally chanced upon what seemed the object of both my intellectual and erotic searchings. For there in the pages of the Marquis de Sade I discovered the delicious and daring philosophy of Libertinage, the 'Philosophy of the Boudoir', as he himself had put it. There I read of the "sodalities" and societies of kindred spirits, yea, damned souls, who sought to flout the world's norms in every conceivable way – and in some ways, I might add, which I had never conceived! To rend the fabric of reality was their goal, by subverting every established convention and ethic. Sex, of course, was their chosen focus of attack in their assault: what facet of life is so volatile, so powerful, and therefore the object of such meticulous rule-weaving? In the words of Saint Paul, my old mentor, 'their glory was their shame.' And what shame! And what glory!

Yet Sade himself had written only from his own blasphemous fantasies. An outcast from society he was, as one might guess, but for fairly trivial reasons. His own character Juliette, mistress of poisoners and fiends, would have scorned the petty perversity for which Sade was incarcerated: pouring hot wax into the cuts and scratches of a harlot he had whipped. Also, Sade's corrupt monasteries and secret societies existed only in his mind. Certainly my own erotic pilgrimage had never brought me in contact with any of them. Oh, it was not difficult to gain admission to sexual retreats and partner-swapping groups. But the sad and base individuals who populated such gatherings had no real inkling of why they should be doing what they did. None of these fools grasped, as I now did, that the key to the ultimate erotic experience lay not first and foremost in the flesh but in the spirit! Perversion is nothing without blasphemy, transgression! The secret was that, paradoxically, sexuality is fulfilled only when it is instrumental to something else – the utter repudiation of the world and the standards to which it imperiously requires conformity.

Eagerly I plumbed my new-found knowledge in the pages of the various forbidden books which now occupied the place that Holy Scripture had once held with me. But I must share these secrets only with myself, for nowhere was I likely to find what I so desperately craved, an orgiastic fellowship in the midst of which to consummate that urge toward true enlightenment.

II

In this manner I passed many months, my fervour waxing and waning as all but the most obsessive passions must, but never losing my longing for fulfilment. My usual round both of academic and sexual activities continued unabated, as did the part-time work with which I supplemented my

tuition scholarship. My acquaintances little suspected the nature of the preoccupation I sometimes could not hide. Instead they ascribed it with a laugh to my being 'a philosopher', an epithet equivalent in their minds to 'dreamer'. This mild spoofing, naturally, did not bother me, and I was grateful for it since it prevented closer scrutiny. Actually, during the past years of sexual adventure, I had found it eminently simple to hide my activities from even fairly close associates. People seem to be remarkably incapable of imagining that anyone might occupy himself with interests they themselves do not share. So be it.

This was true even of my fiancée. A word, perhaps, should be said of her. I had met Marilyn in college, in the philosophy department as a matter of fact. We got along splendidly from the beginning. I was pleased to discover early on that she was not particularly inhibited sexually, and we became close friends, casual lovers. Ours was an attachment that required no exclusivity as romantic love was not the heart of it, and probably did not enter it at all.

But Marilyn had begun to show a need for security in recent months and suggested that we make our relationship a permanent one. I concurred, but for reasons she could scarcely suspect. Since the secret, the forbidden, had become a spice my sexual appetite could not resist, I felt that Marilyn's love would be most satisfying to me insofar as I betrayed it. This I deemed superior to initiating her into the mysteries of Libertinage, since I doubted that she could fully appreciate either its philosophical subtleties or its sexual ravages. I recall the night we announced our engagement to a small gathering of relatives and friends; several hours later, I was announcing it to the laughter of the prostitutes locked together with me in an embrace difficult to describe.

I do not mean to give a false estimate of her intelligence: Marilyn probably suspected that I was not completely faithful to her. After all, as I have said, our previous arrangement had not been entirely monogamous, nor had it been expected that it should be. From her perspective, this last had quite likely changed, but she like many women no doubt felt it best to compromise silently. So of my infidelity she could not have been altogether oblivious. It was just that it was not in her head to guess just what I was up to, or with whom.

I derived my usual amusement, then, from my varied pursuits during those months, my joy sullied only by the regret that my ideal was likely to remain unrealized, unless perhaps I were to try and organize a Libertine cell myself. But this I knew, without having seriously to consider it, would be too dangerous a thing to attempt, professionally, and perhaps legally as well. Remember poor Sade!

New hope was forthcoming, once again, from an unsuspected quarter. It was the middle of March, and I found myself across the country for an academic convention, some philosophical seminar as I remember. After I had bade my colleagues goodbye for the evening, I headed for the seamier section of the city. I little doubted that my recent companions were seeking similar entertainment, but I suspected that they had tamer pursuits in mind. After some leisurely perusal of the merchandise, I settled upon a buy. Approaching a leather-clad strumpet with a particularly

suggestive look on her face, I confirmed that her specialties were as I had surmised and negotiated a fee. Her "studio" was not far away, and we soon were busy. I will not bother to describe our activities, as the reader may imagine them readily enough.

An hour or so later (I had paid her well for her time), I noticed a curious thing: one of her nipples seemed to have been either surgically removed or perhaps ... bitten off? It may seem odd that till now I had not noticed this singular fact, but her intricate costuming and our no less intricate positions had prevented me from catching this detail. Upon my asking she admitted that my second guess was correct. Her injury had been incurred a year before, during a job for a religious "cult" on the coast. This bit of news excited me no little. True, she had given me no solid information: a "cult" might denote any unfamiliar religious group. But how many religious groups of whatever kind would engage the services of prostitutes? Instinct told me that I might be close to the realization of my dream. Were they Satanists?

I hoped not, for I had no interest in that band of childish neurotics. Her surprise at my interest in this aspect of the matter implied that most clients were as intellectually uncurious as she herself was. When I persisted, she said she didn't think so, since the orgy took place in a church! She mumbled something about how all religious people were hypocrites, but I interrupted her with more questions that puzzled her for their seeming irrelevance. Soon I rose, cleaned myself off as best I could, and prepared to leave, again to my hostess' astonishment, since my expensively purchased time had not expired.

III

Fully a year and a half were to elapse before the hints supplied by the slut would come to fruition. She had taken so many sexual assignments in the months previous to our meeting that she could sort out details only with difficulty. And my various duties took their large share of time, so that it was quite a while before I made any progress. But connections were made, and one day I found myself wandering through a rather depressed and decayed section of the inner city, casting nervous glances this way and that, lest one of the troglodytic inhabitants take undue interest in my prowling. Common sense dictated that one proceed with an air of assurance, since street felons would not hesitate to spot and swoop down on strangers who made themselves known by their air of disorientation. I was not quite sure of my way, but at last I did manage to find my destination without incident.

To my delight, the address with which I had been supplied was an old Episcopal church, perhaps the very one the whore had described. It was almost like a cathedral in design, if not size. The structure was in a state of some disrepair, but not nearly what one might expect under the circumstances. It was no burnt-out hulk, but seemed to have suffered only such minor vandalism as was not deemed worth troubling to repair. Mayhap it was maintained by the diocese as a rescue

mission or community centre of some kind, kept open only to salve the consciences of affluent former-congregants who had long since moved to the suburbs and now hoped to associate only vicariously with the publicans and sinners.

None of this mattered much to me, however. If my leads were correct, and if the voice with whom I had recently spoken by phone were not having a joke at my expense, the church before me was the secret sanctuary of the Libertine sect I sought. If so, it had been chosen with perfect sacrilegious intent. What desecrations might be wrought on the very altar of propriety!

The door was unlocked, quite a risk to take in these parts, I thought, but perhaps a sign that I was expected. I stepped as quietly as I could through the narthex and into the sanctuary proper. The dimness inside made it difficult to see in what condition the interior lay. But at the same time it made it easy to find my direction, since through the gloom shone clearly if hesitantly a gleam of light. It came from under the door behind and to the side of the altar, probably the choir entrance. I reached it, knocked lightly, and thought I caught the sound of move-ments somewhere within, though no answer to my knock. I entered anyway, hoping I would not find some street thug who had gained entry as simply as I and now waited to ambush me.

Beyond the door was a narrow passage, lit with a naked and faltering bulb, but vacant. Where was the one I came here to meet? By the dim radiance, I could barely make out an office door at the top of some stairs. As I ascended the short staircase, announcing my presence by the creaking of the boards beneath my feet, I wondered if in fact the very pastor of the church were a clandestine Libertine? Hesitantly I pushed open the door which already stood slightly ajar.

He stood with his back turned, though apparently awaiting me. The tiny office was not lighted, and I had trouble tracing his form, which at first seemed to shift amorphously. My eyes were now rapidly growing accustomed to the shadows, and soon I noticed that the man, who still had not spoken, wore a billowing leathern robe of unusual design. I would have expected clerical garb, but was not unduly surprised since the wearing of leather was naturally quite common in the circles I frequented. The wholly unconventional pattern of seaming I confess I found vaguely troubling, but there was no time to dwell upon trifles.

The man smiled and motioned me to be seated. He never gave his name, under-standably, and I had to deduce what I could from his general aspect. At a glance I could see that his face, well into middle-age, was lined and creased. To Episcopal parishioners it would no doubt seem he was careworn with pious duties, but I believed I could guess the quite different acts of devotion that had taken their toll. His ample jowls indicated indulgence in fine food and wines, a taste which is famously no less common to Anglican clergy than to Libertines.

I introduced myself and allowed my eyes to stray momentarily to the shelf of books above his desk. And in that moment I knew I had attained my objective, come home as it were. For there, next to his Bible and Book of Common Prayer, were some of the very same titles I myself had come to treasure: Marquis de Sade's *One-Hundred And Twenty Days Of Sodom*, Comte d'Erlette's *Cultes Des Goules*, Gilles de Rais' *Concubinage To Satan*.

IV

Of that interview I need offer few details save that a certain list of initiatory tests was agreed upon. Some of these tasks I found a bit startling, but this, I was made to understand, was precisely their intent. Just as the Zen master assigns the novice a koan, or enigmatic riddle, in order to wean him from the accustomed structures of rational thought, my list of labours was designed to deaden me to the last twinge of con-ventional moral conscience. I must steel myself to commit the most intolerable and bestial outrage and so emerge as a true Libertine, caring naught for the laws of God and man, but to tread them underfoot.

How can I describe my mixed jumble of emotions as I left the dark church, all but oblivious to those dubious surroundings which had so intimidated me but a short time before? Along with the anxiety and, I admit it, a degree of disgust at what lay ahead of me, I felt spiritual elation, sexual arousal, and perhaps surprisingly a dash of amusement that made me chuckle aloud. You see, I had eventually gotten around to asking the priest about his unusually cut robe, and his answer was unexpected. It had been stitched together, so he claimed, from the flayed skins of previous leaders of the cult!

This I knew immediately to be hokum, but it was a type of imposture I could appreciate. Role-playing is an integral element of truly epicurean eroticism, and what is more needful than befitting costumes and props? So I was willing to go along with the fiction and did not press him further. It was all part of the game, and so delicious a touch that thinking of it again now brought pleased laughter to my lips.

The next several weeks afforded little opportunity to begin fulfilling my list of assignments. Professional obligations, committee work, and increased dissertation research left me with little time to spare. But I did make good use of what rare moments offered themselves, planning just where and how to discharge my new duties. First on the agenda was the matter of homosexual encounter. In my sexual career up to this point I had never felt particularly inclined in this direction, so had never indulged, but neither was the prospect repugnant.

Now what, the reader may ask, could have required so much planning to arrange a homosexual tryst? One might think a university setting ideal for such liaisons. And, yes, there was a sizeable and burgeoning homophile underground (and barely underground at that) at my institution. But I knew that to enter it even briefly would expose me to the ostracism of some and to the amorous attentions of others, and I did not wish the entanglements that were sure to follow. No, a casual liaison someplace where I would not be recognized was preferable.

My first attempt was careless. I sought out a homosexual prostitute on a weekend trip into the city. He was agreeable enough, though with that air of contemptuous aloofness that actually appeals to some customers. But when he ushered me into a nearby public restroom, I began to have second thoughts. I told him so, but soon found out that I had even less say in the matter than supposed, as he cut off my words, and my breath, with a rough push to the wall,

jackknifing my arm behind me in a painful grip. Had I mistakenly picked up a sadist, or was I being robbed? I never found out, since the sound of rushing footsteps somewhere down the hall seized my assailant's attention, causing him to wheel, exit the restroom, and speed down the hall in the opposite direction. His trouble, whatever it might be, was my fortune, and I lost no time quitting the place. Having hailed a taxicab, I nursed my aching arm and wiped the slimy residue of the restroom tiles from my cheek as I planned an alternative course. As it turned out, I needed to search no further, for the driver himself was able to oblige me nicely, and soon I was considering how to tackle the next items on the list.

Some of these looked to be more logistically difficult. I was finally forced to ask the help of the priest in arranging them. Initially I hesitated to do this, fearing that it might count against me, but I was reassured that it would not, since the objective was to recondition me morally, not to test my ingenuity. I discovered that for modest sums certain favours might be obtained from veterinarians and even funeral directors. In such dealings, as in politics and other such behind-the-scenes work, one quickly comes to realize how intricately the world of appearance is honeycombed with the un-expected!

But this was not my only discovery, as I learned the pleasures of strange flesh, eschewing distinctions of species or preservation. Freud was entirely correct: he had written of "polymorphous perversity" whereby one experiences each touch, every bodily part as erotic. He had compared it to religious mysticism in that both were attempts to return to the blessed warmth and cosmic oneness of the womb. And if both paths, mysticism and perversion, alike led to the same place, was it not evident that there was in reality but one path? Through my initiatory exercise I came to know that flesh and spirit are one, that when mysticism 'denies the flesh', it simply means to deny that the flesh is a department separated off from the soul. Man's sensuous part hampers his soul's flight only when he fails to see that it shares the same destination. Both together must reach the orgasmic release of salvation, or neither can.

All this and more did my secret mentor teach me. And as I passed through one degree after another, I was shown ever deeper levels of the life of the sect. I met various brothers and sisters in the Libertine path; bound myself to them with mutual oaths of pleasure and pain; was permitted to watch as they performed acts which hitherto I would have deemed impossible, un-imaginable. With eager anticipation did I greet the promise that I, too, should learn the secrets of such ecstasy!

After some time I attended my first meeting of the whole membership. The clandestine convocation took place in the church I had first visited. I was strictly charged to arrive after things were under-way and, alas, only to observe, for my novitiate was not yet quite complete. Obediently I complied, arriving at 2 a.m. on the designated date. Even from the street the raucous roar from within was plainly audible: so that I wondered that no one ever called the police. But the area, as I have said, was blighted, and its inhabitants did not seem the type to regard any noise as untoward.

I entered the church, straining to see through the deep gloom into the mass of wriggling forms, but advancing no closer than I had been told. Need I say that the sight, what I could see of it, was sublime? I had never dreamed that the group had so huge a membership. The pews, being of the detachable variety, had been cleared away, and before the altar there seemed to be a mountainous pile of bodies, heaving and swaying with wild abandon. Groans of ardour filled my ears; the crack of the lash could be heard, and the accompanying gales of laughter and tears; oils, blood, and other fluids arched through the air to splash on flesh and stone. Oh, that I might be a part of it! I thought to masturbate but lacked the chance, as erection had already come unsummoned and ejaculation followed in its wake. In the wonder of it all I nearly lost track of the time. Happening to catch a glimpse of my wristwatch I realized it was time for me to be away. For I had been warned not to stay for the full duration. This was not explained to me, but I imagined that at the conclusion of the festivity, the lights should come up, and the participants would not wish to risk being identified by anyone not yet fully initiated and committed to the sect. So with reluctance I departed, all the more eager now to complete my tutelage and to participate in the next celebration.

V

My final task was rape. I was grateful that up till now none of the sexual assignments required the unwilling involvement of others, since legal risks were not to my liking. Of course it was in the interests of the sect to avoid them as well, and this was no doubt why certain other crimes were not mandated. But this one was deemed important enough. If I had lain out my plans carefully before, I was doubly meticulous now. I believed I saw how I could carry it off undetected, and right on my own campus to boot.

Marilyn was to be my victim. And if all went according to plan, she would never learn the identity of her attacker. One of the major fraternities was sponsoring a semester's end costume gala not very many days hence. I knew that on the appointed night, Marilyn would be in the same area of the campus, returning to her apartment from the office where she did part-time secretarial work. I knew the route well, as I sometimes accompanied her.

It was a simple matter to inquire at the local costume shop as to which outfits were most in demand. Ascertaining that several young men had already rented pirate regalia, I did the same, choosing a silken bandana large enough to cover my face. I planned to be long gone by unmasking time, and there would be several other pirates from which to choose a culprit. Any of the drunken fraternity members would be a plausible suspect.

On the night of the party, I stepped into the fraternity house long enough to make sure that there were a number of other bogus buccaneers present and then returned to set my vigil. Right on schedule my fiancée took her customary short-cut through the bushes. I sprang upon

her, knocking her to the ground and silencing her with a sharp blow to the back of her head. She was stunned and could marshall no resistance. Let me say simply that I hiked up her skirt and sodomized her. She groaned incoherently, vomited, and then fainted mercifully away. As it happened, she could never have seen me straight on, costume or no costume.

Later I learned that she had been discovered soon after by campus security, shaken and disoriented as might well be imagined. She took an academic furlough for the rest of the year and returned home. Naturally I have written her letters of sympathy and support.

My course of preparation finished, I now waited for the next assemblage, where I would at long last know the joy of fellowship with those to whom I would be joined in body as well as soul. For this, my first participation, there was set but one final restriction. I must still arrive after things had commenced, though this time I might remain through the finale. I was happy to oblige.

Walking the now familiar pathway through dilapidated tenements and reeking garbage cans, I neared the old church as Bunyan's Pilgrim neared the Celestial City. The muted clamour of voices within stirred my soul and thrilled my loins. Inside, all was again dark, but I knew the floor plan of the place well enough by now that I did not miss a step. Flinging aside my clothes, I ran to take my place at last amid the passion-crazed mob that once more formed a veritable hill of bodies before the desecrated altar. Atop the altar itself stood the leather-robed priest, intoning some barbaric litany whose significance I could not guess. The din of the mass beneath him made it quite impossible to distinguish more than random phrases. But this was hardly of concern to me then.

In the moment itself I was cognizant only of the press of flesh to every side. I sought entry wherever I could, making no distinction in that shadowy place as to colour or gender. That around me were veterans of the sexual combat I could tell by the variety of scars and scratches that could be seen close up, along with other reddish welts less easily identifiable. The night passed in this way, bereft of time, bereft of reason. I found myself lulled by fatigue and by the priest's droning chant, of which I once believed I caught the nonsense syllables 'Iä! Shub-Niggurath' Indeed he was fairly screaming it toward morning, near the crescendo of that ceremony of debauch, when the lights finally came up.

And then it was that I, too, began to scream. For the sight I saw then sent me fleeing mad and naked into the cold dawn air. Though I was not conscious of anyone pursuing me, I sped down the littered streets, oblivious alike to the damp chill and to the glass and metal fragments upon which I trod. At that early hour there was yet no-one about on the streets to stare at the strange and ridiculous spectacle I made. Finally, my exhaustion from the night's revelry overtook the new strength my terror had lent me, and I collapsed, nauseous and bleeding, in an alley many blocks from the church.

How long I remained unconscious I cannot say, but eventually some police patrolling the area found me lying in my own vomit among the heaps of trash, and retrieved me. How did I come to be in this rather remarkable position? I was now actually feeling the cold for the first

time, my nerves having recovered somewhat, and this new shock made it difficult to think. Fortunately I stumbled upon this lie: I said I had been set upon by muggers and been completely stripped and beaten. Given my several bruises and cuts, both from my night's debauchery and my subsequent flight, this must have seemed plausible enough, albeit strange. At any rate, the patrolmen appeared more or less satisfied. They kindly provided a rough blanket to cover my nakedness and drove me home.

And it was there I remained, disoriented, confused, unresponsive to communication, and unable to meet my responsibilities. It has been all I could do to recapture my wits sufficiently to reflect and re-evaluate. I have come at last to repent of my ways and to renounce my former pursuits. I imagined that no perversion, however loathsome, could cause me to turn back, yet now I am resolved to celibacy and wish I had always been so.

I had expected to behold the beatific vision in the profaned sanctuary that morning, but what I saw has instead robbed me of any further desire for sex. For there, revealed by the glare of the lights, was no solid heap of swaying orgiasts, but rather chains of bodies spread over the pulsing and gelatinous surface of a tentacled, amoeboid horror, the revellers grotesquely arrayed like suckling whelps as the thing fed greedily on their sexual vitality through the questing pseudopodic phalluses, teats, and vulvas it sent forth!

hypothetical materfamilias
adèle olivia gladwell

IT is Coming To Existence. Coming into existence – coming into effect. IT has been realised in oneiricism as very long as IT has been imagined. Although this is that which has never been symbolised, except in the dirty fragments of cloaca. Although IT has actually always been present; ITs existence has no inception, nor termination.

IT has recouped of ITself and this renaissance – this second birth – will truly be the moment when, having come fully to ITself, IT will "strut ITs hour upon a stage". And what a floodlit stage that shall be. Vivified by the gore of ages, the poetry of yester-year and the present wailings – IT will "walk the earth". This impending approach is true to Itself in ITs effect – in ITs own realisation. IT requires no mediation of ITself – but I have decided to tell ITs phoenixian story for my heart is laden and strained to eruption point with the sounds I can hear IT making. We need that balm for the bile in our throats – at ITs coming.

When she wakes up tomorrow she knows that the new birth IT is experiencing is the filmic depiction of the laborious death of yesterday evening: the forlorn sunset that fell on all the dreams that she had erected, like ghost books on the shedding petals in her room. She realises that the heavy pewter flesh weight that sways below the very below, like the pendulum of a madman hoisted to the scene but rarely partaking of the scene, like a fallen woman's fallen carcass – is THE very foetus IT strains to expel; to launch – to life. This is what she understood yesterday about this Coming To Existence – this Coming that is Oncoming. This is what I shall write about today.

As IT is oncoming – IT is felt in the air. The thickly stagnant air, which one can scarcely breathe. Always the hot nights, even when we open all the doors and windows in expectant, and forgetful, hope. The nostalgic hope of *déjà vu*. The half recalled desire to return and try again. This heavy weight of air cannot break down of itself nor flow, and hangs woefully, pathetically, unable to fulfil the function of our atmosphere's presence. This is, of course, due to our presenting it with this now insurmountable vocation.

It may be gaseous – but it is similar to breathing viscid water. Like breathing inverted into itself – for instead – the soupy air breathes us.

Sometimes ... wanting to win, to succeed, to come out ingloriously first, *numero uno*

on top – is a sort of losing. Blind to everything but the final goal, the last fence – one's sensibility is broken down (maybe it breaks itself down); one's sensitivity; the ability to abide thoughtfully with(in) life's breaks and disruptions – is a decrepit ability. But often this is no bad thing. In the midst of the terrible fight for sweet breath you battle away your sensate abeyance with subtle instinctual traits. Sometimes you can race so quickly that you pass by the sweetness and scorn its smallness.

But IT comes. IT comes.

The air parts like heavy velvet drapes. The air itself is parting for the one. The one who hasn't been here for so long. Who never before came through. At least not like this. Never came back like this – like a stranger. The strangest stranger of bizarrerie – and the people haven't seen this one for so long, the crowd parts in amazement – as if wary of touching this one who is so estranged – for to touch such an estrangement would burn the fingers of the air right down to the cold whistling bones. Like the air at the coast is whittled and sharp from having known that oceanic strangeness.

IT comes.
>And you know IT comes for you.

Lovecraft, from within a tableau of fastidious time, knows IT comes for him. IT keeps coming. I know for whom IT comes. Only in one's panic one may forget ... or may doubt ... that IT will reach you yet. You doubt IT will reach you. Reach out to you. Reach out only for you. And save you. Save you your restive suffocation. Your insomnia. As you fight the air that now is the enemy of your respiration, you can glean a little in-sight into an ideology through a series of poetry that suggests – soon you will not even need, want, nor desire this air that breathes you in turbidity.

IT is coming. Into a room.

The room could exist in Indo-China, during the rainy season; or the South Americas, on a day before the hurricane or deluge of a great refreshing storm, to wash away the dust. Or it could be the imaginary room, which, situated in a large amphibian house, shafted on rocky cliffs with the brown sea lapping its ballasted buttress roots, wretchedly boasts no doors or windows.

>It is the small space, somewhere near the cellar steps, which has been carved into the granite that is the abode's very foundation. Either way, this room makes a mockery of the laws of nature; a diabolical mimicry of a sanatorium wherein all is feverish, sublimated, moistly fuming and agitated. Past the pinnacle of youthful ripeness whilst sporting an obscene mask of childishness. A *mimesis horriblis* of a still life that has long since decayed and does not live, except in a macabre simulacrum. It is however not quite a stuffy mausoleum, housing spherical

clay pots and dried jerky meats; nor quite a funereal chamber, kept chilled by the parred hand of death and his undertaker, which causes many a sweltering perspiration; nor quite yet an elderly infirm's last and only stop.

It is something akin to an infant's sick room, in the bowels of the convent of the Blessed Saintly Stillborn; the unspoken-of saint who, like Prometheus, hangs, hangs, hangs in the steaming air distressed in impasse and so very stationary in suffering (whilst his mother rips the caul out of her hopings).

The walls occasionally heave their terraqueous substance; consubstantial with the floor which shifts so slightly like an oil-slicked sea scarcely rippling.

The only illumination – a yellowing gas lamp. Its flame as thick and opaque as smog – for it doesn't exactly shine – it reflects its infernal glow with jaundiced discharge. There are two clocks. A mantlepiece carriage timepiece; which, having no proper decorative role of decorum – sits on the floor at an angle so awkward one cannot read the time from it. A grandfather clock ticks loudly. Ticks. Ticks – along.

The clocks signify no certain time. They indicate any time and frequently change face. They indicate lost time; negative time; stolen time; no time like the present; rarely on time; time to go; what's the time? This splintered yet relentless dis-accumulation of ticks – seconds – minutes – ticks. Seconds. Minutes. Hours. Days. Weeks. Months. Years. Decades. Centuries. Millennia. Light years and dark holes. Phenomena occur at certain ticks, but it is hard to keep track, although one somehow feels one should. Especially in retrospect. If I'd only taken the time. But it is never in keeping. Objects appear after a certain period in momentum, and Lovecraft keeps dates and diaries and watches – carefully.

A golden tray of pears, bananas, grapefruits and starfruits – so perfect that they relay no actual taste. Most things barely register. A splendid edition of 'The Theban Plays'. Black jacket with velvet lapels. Cut glass decanter of brandy. Lavish desk bureau. A post-mortem photograph. Hand-kerchief with ochre stains. Jigsaw puzzle of sunflowers – half complete. Sterilising equipment. Telescope. Letters and symbols appear on the walls in eidolon writings. Hieroglyphics. Stroke, round, squiggle, dash, dot. An outline of a bull with large horns. An old man's face in caricature, formed from myriad disjunctive linear paths. Morse code. A lithograph of alien crustacea.

For this is the room for those who are sick of the sickness; the endless ennui that always causes the sickness. The nursery room (which nanny has forgotten to visit; in fact, forgotten exists) where a poisonous glass of wine (the only beverage) appears daily to engage you in the 24 hour disintegration and rejuvenation of your cirrhosis-riddled liver and spleen. The renascence is as doomed as the malaise is disingenuous. The medicine tastes so terrible – you gag upon it and contaminate yourself with your own remedy. The clocks tick faster. The walls ooze lachrymal fluids, which look deadly, which appear to almost smoke, and which solidify like wax – building

mighty and dreadful stalactites and stalagmites; and the emetic illness burbles on and on. The alcohol still permits a burst of euphoria before rotting its subject in a stasis that also anticipates the overdue purgative. And the perpetual melancholy of a terminal disease, that cannot murder in death – only live and feed in life as a vampire sucks a virgin, who turns out to be a corpse on her own wetnursing bender.

And she remembers – yesterday – the first acknowledgement was ... sound. She recalls how her ears pricked up. She knows too that come tomorrow she will strain to hear IT again. But tomorrow will be so different – with a small bit of herself still the very same. That thing that reminds her of herself that she holds onto through the days – with that small bit of herself that grows in the night.

She knows when she awakes tomorrow she must work hard at finger exercises, disguises and sensual projections – paying little heed to other indulgences as she is often prone to do. Tomorrow will be another phonetic dawn that she must herald (privately) and await on. All this waiting is killing. It is murderous to wait and exercise. Come tomorrow night she will be a little further backward in her mythology, and a little on with the birth of her miscarried glory. Her imaginary thing, that cannot be born forth, will again cause her to retract her OWN birth, with nimble fingers, back to the sounding-board. She is ready – her fingers lubricated; her ears whistle and buzz, but she is as hungry as the gorgon who was promised dead baby flesh, and who screams as she gorges.

This cadaver hanging from the noose of his own problematic; hanging pendulous from the gallows of linearity – swinging from the mammoth monolith that is our symbolic reality – is now in a room. There he hangs – in a putative limbo. The outsider; pariah – ostracized – distanced – separated – in effect he is ... amputated from his own sex. Amputated from his own phallus. Castrated in a world where the sign of belonging is something he, in actuality, does own. Why does he feel cut off – cut up and cut away – cut down and falling – from that which should signal his belonging?

His supplication knows no bounds. No boundaries. So therefore he lies as if in a granite casket just below, slightly below, the meaning of things. For at the very same moment that he burnt all his bridges, in a furious tantrum of resistance and allowed the dark pungent river to lap against his wretched nakedness which bled from the horrendous wound of his severed penis, so too did he then relinquish the ability to make sense of where or what he was.

He lies in his hot cot and watches those walls swaying – making a nonsense of their rigid bases. He begins to hear the sounds of IT approaching. He can't remember when, or if, he called.

Murmurs. Murmurs. Not unlike the mourners arriving for a wake, keeping watch on his odious state, and as a child. The walls vacillate and conduct. How they have stored up memories. They

sway in unison to the mur mur mur mur mur-muramee.

Now, it is as if they commence their true calling – as they start sucking him up from this Down Below. He is consciously aware now of ITs imminence. But for all the cerebration in the world does not know how he can know this. A mighty palingenesis is occurring. IT is coming up. Something so huge and radical. Something so over-whelming – nothing will ever be the same again.

He feels as if he is levitating; rising up and away. But rising strangely; not an ascension but a transformation. The walls heave again; they heave again. The sweat runs quickly from his body, and evaporates leaving him prostrate in stickiness. He forgets to breathe. He focuses, instead, on the sounds. Mur-mur. Mur-mur. Murmur – they go. Enraptured by the phonics, he still forms the thought (and his cerebrum seems to ache with the effort of this spark) – am I mad? Is this a sign of insanity?

Now he no longer desires, nor is able, to conceptualise the outcome or significance of his ponderings. They cease to exist. Instinctively his body knows no danger – for the sickly light is fading. He does not seize up like a deceased arachnid awaiting a thanatoid embrace. Instinctively he does not roll over in a chilling acceptance of fate. His acceptance is warmth itself. He does not draw up his limbs – he actually seems to open them – and then it is as if he curls his arms about himself in an absorbed hug.

Still – mur mur mur mur mur mur eee. The sounds that doves made before the industrial revolution – the sounds of fish mouths gaping. Of course he does not rightly know this – nor do we – but he does his best and so must we. The noises of pubescents and labyrinths – the inhabitants of a lost city singing threnodies – this too is all his fancy, and all imaginary. He is mesmerised in a cloud of our own making.

The walls melt like curdled cream and something laps up the residue. One can almost make out the osmosis of milli-corpuscles diffusing. Dissolving into just quite what we shall never know, and we shall never. The walls mutate, they metempsychose – in symbiotic dissolution and then the atmosphere becomes what is expected, hoped for and dreaded. Every-thing, known and inconceivable, becomes IT. Only IT.

He believes he hears shrieking and groaning and doesn't know. The sounds could be cicadas or serpents or cats, but who on earth knows? From now on we merely surmise to construct the imagery, the figurative symbolism and the hazy-days mediation.

For there are more sights, sounds and smells than a human can tell of now. Are the sounds strident or softly soft? Are the smells sweet or harsh? Is it good or bad; ecstasis in wonder or diabolical in horror? This I do not know. It is all relative, personal and it is pointless even addressing it. But I can speak of a type of nostalgia. A repetitive renaissance that is as old and yellow as it is brightly fresh, and glowing a numen-gold like an ancient dawning moon.

And what follows is impossible to describe. Except in sound.

For IT shows paradoxical signs of a polyparous nature. IT shows symptoms of a parturition in regression. We wonder at the possibility, the plausibility, of this and surrender to the purpose of wondering. We throw up our arms. For what is truly originative to ITself, yet exhumes quasi-corpses such as these, is surely a conjuration that comes to us like a phoenix from a murderous house fire.

The very imagined site we are loathe to love in our fear of voice-loss, inarticulation, castration – theft of existence AWAY beyond the scenes of our word – the world of the word that can describe IT. So we can thus recognise IT. Then this world, of course, dismisses in miso-ness rendering our flights of fancy fantasy as digressions.

But IT has come. Overdue. Prolonged in the storm of our ages. ITs dichotomy, ITs bifarious nature (in crazy contradictions) fits the pages of old books and medical texts with its ostensible madness. IT fits yet bulges out. Still, I implore, how come IT still comes?

And with IT comes ITs pain. Such a behemoth agony, no analgesic can soothe ITs rancorous affliction. And it could be (in other fairy tales) such a beauteous affliction.

IT draws him up as the eye of the hurricane pulls lone dry bracken. Up and over and up over up beyond up away up every way. I cannot specify the precise directions in ITs cruelly loving distemper. Such cruelty in loving. No one shall ever know the like of it again. Yes, you may search I search as I'm sure he searched but in figuration in warped imagination we shall never know the like of ITs smothering love ever again. Never forever. Perhaps that is why we speak so casually about our deaths. And why we crave. There will never be another love like IT again. But we hope. And for him – for him in all his gory luck IT has circled like a vulture, and swooped to capture his hide – once again.

No doctor or scientist on earth could fathom this. The cryptomenorrhoea when really there should be blood or maybe ITs amenorrhoea when it's clear there is no imminent birth. But then again – this is the uterogestation in retro. The retarded receding uberty. The genesis, the true-real genesis, the hypothetical genesis would be the ultimate antinomian – the freakish outlaw of all the laws we abide by. How can this be? Only because we want it to be.

In reverse. The post-partum now becomes the first cramps of delivery. His limbs grow soft and small and he is open to IT. As IT is open for him. Let us admire his bravery, and also his belief in IT. His vulnerable, tiny, pink, bare body hovers, hovers, hovers, whoosh ... His cries echo under the clean surgical lights that spotlight his mythopoeic re-divination. His fruit head squelches his face puckers he squalls. The sounds now are so alien. We never hear them everyday. Mmmm mmmm baby baby. The only sound he now wishes to hear is that pulse pulse beat beat beat life-saving drip IT alone holds.

IT draws upon his tiny form like juice through a straw. Like a whore grips the phallus of the only one she adores (the one dis-embodied) and sucks him in. We must find this disgusting in its primal whimsy. We may think that this cannot exist – but IT merges and filters out to us through disrupted songs and lyrics, like our parents used to play to us before we knew the names of the players.

How can that which is the very genesis now come to us at the point when we know that knowing this host is a mediation – a transmission of our unknown selves – making a joking-puzzle of our symbolised realms?

Along the way – he is aware in his pre-awareness of bulges and protuberances – convex sides that cushion and allow the whole body to wholly play like we, now, have forgotten to play. And only stopping when something bids stop to eat or shit and turns to places and parts of IT to suckle or defecate upon. Knowing IT. And time means little – few temporal signs or ticking bombs.

Still he goes down away from his growling ego that pulls ugly, spiteful-kid faces and scorns – still though he goes down further – to the further sucking in the further further – of not having to realise a drive or impulse – where IT realises them before they are realised. And being met – now I see how he turns like a flower to the sun to the mammilia mammae, that cushions the beat beat harmony he doesn't know he knows. Where "sweet cara sposa, sweet little adorer my agapemone" – doesn't mean a thing – but somehow, in intonation – someone tell me how – for somehow how we know – we know we like it so. We love those sounds – that wrap themselves around us like blankets and furry things that wrap themselves better than a lover's arms or a feather down. We like the feel and pitch of the breath and the smell of it – we know we are part of IT – and we were never such a part of anything before – or so it seems – and the pump pump of the beats that ad lib. IT sings lullabies that neither begin nor end in (nostalgic) continuum, and we hang in a suspended state – of repetitive neverending salinity a spaceless space with clusters of energy pulsional pulsions – and we know not that we are happy like he is going to be happy for we know not of misery or of having to decide just what it is we do feel, or think. But we know of this now.

For nothing is separated, objectified or cut-up into segments for us to strain our heads to make sense of; this has all gone before – sometimes we pray it won't recur – this has all gone before, and will meet us if we split once more.

Therein. Where it is not a place in geography nor a space in a nameable dimension – where there are no temporal dissections or locations – no situations or chronologies – no heres and theres – no displacements misplacements signs symbols or positions to IT. However, in order that I should describe to you the outcome of IT I shall somewhat be reduced to betraying IT. And this I shall do as I long to tell you of IT. And IT is familiar with every betrayal, I am sure.

So IT that overcomes and expresses a movement, is in fact many movements, in ITs motility; and the ghostly flickers like father's old cine-projection of IT, which almost captures ITs kinetics. This is why the walls vibrate and alter state. IT that comes and comes from behind us like a memory also is a memory of a time when IT was formed from a deep desire for phonetics or drummings that never end. IT has now swallowed his form into pure moving sound.

I feel ITs pressure – ITs laborious yet feathery pressure on each word I write to you of his story. Every attempt I have made to approach IT evolves so differently in diverse difference, that IT is as ceaseless as ITs pregnancy. IT pushes him back. Though back has no direction. He isn't breathing anymore – you may fear for him – but don't. See or imagine how a fleshy purpled lasso hitches itself to his navel and frees him from the burden of maintaining his own life-source.

I am not sure if he hears the screams now (of course they sound unearthly) of the depths of the deepest contractions that must draw in as they are compelled to push out. Like the Red Sea. Do you recall the dream of the baby as the mother lifts him into her arms for the first time? Now it's almost like the last. You may recall but you do not know. The thought may now be coloured by disgust, dread or loss – it may not be there at all.

And now before we lose sense of this flashback in symbolism we barely glimpse an opera of sound – the sound as he is met by melding walls. Of the strongest muscle and they whisper to him. Now inside a mushroom of noises – echoing echoing echoing catapolyphonics. Choking polyglot for him – and only for him. The sounds are the sounds of this world – maybe – but they are all in reverse. The zenith of the sigh occurs at the end not the start of the refrain. Sounds all running in reverse. Ssh – lulg. Ssh – gulp. Continuous in cycles and vertiginous codas. The sounds of a drunken tango of a woman's laugh of a predator slaying of a French kiss of deep inhalation. There could be images in reds, burgundies and golds and mauves but surely this is what we have since been told. Of de-oxygenated blood oxygenated blood in the gravid uterus of contraction and dilation in prickly roses. And rest.

He might well regress to a state of oogenesis in the oophoron in the spark in the eye of what IT desires – but this is rushing backwards too fast. We cannot go back-wards that fast although the momentum is quite lost to us. We listen helplessly. The lost momentum: but either way this is no matter to us for he is lost to a re-generation that is as healing as we imagine death or Nirvana to be. Something to heal all the splits and chasms is a sound-space which could be a hell of a way to go. Never outside – the outsider – never safer – never safer and not possible or probable but only as filaments that light a dream. The sort of dream madmen have maybe, or the results of a flash in the pan of poetics. More sighs and deep breaths. Smells smells that he could not detect from one another so omnipresent are their effect – just listening listening listening to the rhythms. They are so overwhelming he hears them through the surface of his slimy lubricated tissue-y skin. Listens listens – mmm mmm hmm hmm ssh ssh ah. Ha ha ha. Bump bump bump beat beat and

on ... to a distorted recording of Lovecraft *in utero*. And it sounds so (e)strange(d).

And this recountance, although hypothetical, signifies for a short while what might or might not exist for us and him and like nostalgia I have only told of IT, and can only tell of IT – through my many many years of separation away from IT.

SCUM CITY, DESOLATION ROW,
LAST HOUSE ON THE LEFT.

A SUBTERRANEAN CLOISTER COMPACTED OF UNREPRIEVED
BELLY-BONES, A CLOTTED HOLE RIPPED BY BLIND VAMPIRE
NUNS, A LOW AND LIGHTLESS EMBOLISM IN THE EXPLODING
HEART OF JESUS TORN INTO TORNADOS.

THEY SEE ME, WATCH ME THROUGH ROTATORY
PRISMS OF HAUNTED ALLIGATOR EYES.

A CHINESE ATROCITY POSTCARD
BEARS THE DATE: 1899 AD.

TEENAGE TIMBERWOLVES

BLACK DEAD BONES OF IDIOT BILL

HIS WAS DURING THE TIME OF THE GREAT
ISSOLUTION, WHEN THE KU KLUX KLAN
AS ABOLISHED AND SPLIT INTO HARDCORE
NDERGROUND CELLS — *THE WHITE LEAGUE, THE
ED SHIRTS, THE RIDERS OF KAOS,* AND THE
COURGE OF THE BURNING SKULL-VIRGINS.

ONEY WAS RAISED BY
TORTION, BLACKMAIL,
OBBERY, AND BY THE SECRET
LMING OF LYNCHINGS,
IRNINGS AND CASTRATIONS.
IESE MOVIES WERE SOLD AND
:REENED AT CONFEDERATE
CE DENS AND BROTHELS,
ONGSIDE REELS OF SLAVES
GAGED IN ACTS OF SODOMY
TH SWINE.

OBLIGATION WAS TO *THE SCOURGE,* A BLOOD-DRINKING SECT WHOSE LEADER,
ONARD LAPAGE, HAD RESCUED ME AS A BONEYARD DERELICT. AS THE ROBBING OF
AVES AND DEFILING OF CORPSES WAS MY TRADE, IT FELL TO ME TO ACCOMPLISH
'AGE'S TERMINAL MISSION — THE RESURRECTION OF BLOODY BILL ANDERSON.

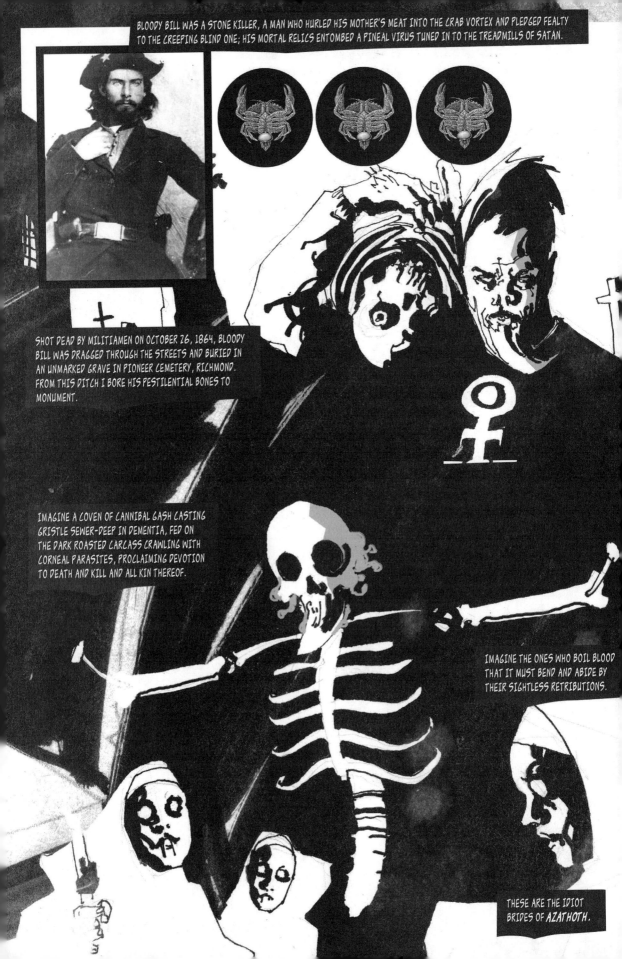

BLOODY BILL WAS A STONE KILLER, A MAN WHO HURLED HIS MOTHER'S MEAT INTO THE CRAB VORTEX AND PLEDGED FEALTY TO THE CREEPING BLIND ONE; HIS MORTAL RELICS ENTOMBED A PINEAL VIRUS TUNED IN TO THE TREADMILLS OF SATAN.

SHOT DEAD BY MILITIAMEN ON OCTOBER 26, 1864, BLOODY BILL WAS DRAGGED THROUGH THE STREETS AND BURIED IN AN UNMARKED GRAVE IN PIONEER CEMETERY, RICHMOND. FROM THIS DITCH I BORE HIS PESTILENTIAL BONES TO MONUMENT.

IMAGINE A COVEN OF CANNIBAL GASH CASTING GRISTLE SEWER-DEEP IN DEMENTIA, FED ON THE DARK ROASTED CARCASS CRAWLING WITH CORNEAL PARASITES, PROCLAIMING DEVOTION TO DEATH AND KILL AND ALL KIN THEREOF.

IMAGINE THE ONES WHO BOIL BLOOD THAT IT MUST BEND AND ABIDE BY THEIR SIGHTLESS RETRIBUTIONS.

THESE ARE THE IDIOT BRIDES OF *AZATHOTH*.

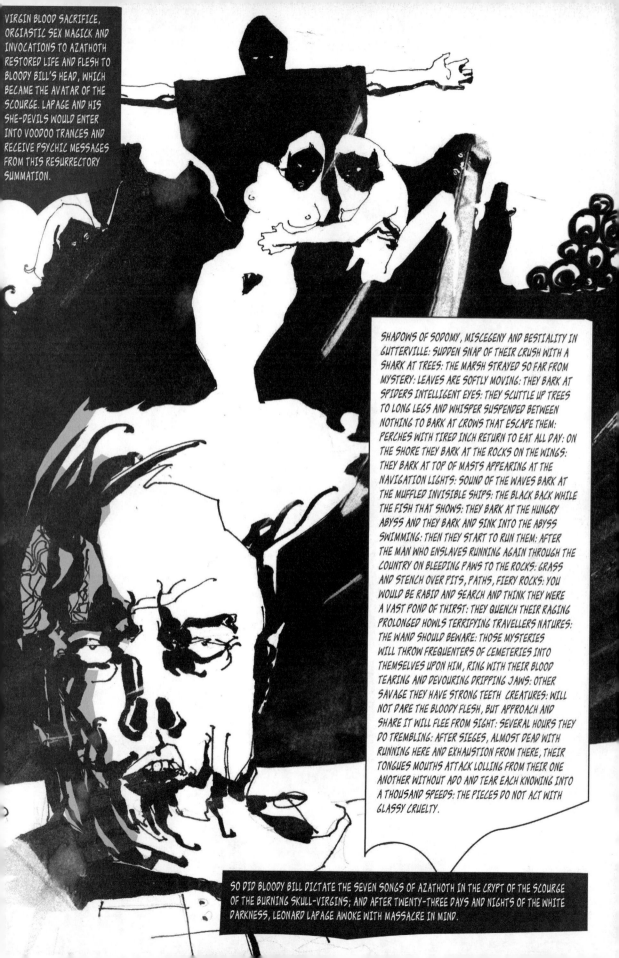

VIRGIN BLOOD SACRIFICE, ORGIASTIC SEX MAGICK AND INVOCATIONS TO AZATHOTH RESTORED LIFE AND FLESH TO BLOODY BILL'S HEAD, WHICH BECAME THE AVATAR OF THE SCOURGE. LAPAGE AND HIS SHE-DEVILS WOULD ENTER INTO VOODOO TRANCES AND RECEIVE PSYCHIC MESSAGES FROM THIS RESURRECTORY SUMMATION.

SHADOWS OF SODOMY, MISCEGENY AND BESTIALITY IN GUTTERVILLE: SUDDEN SNAP OF THEIR CRUSH WITH A SHARK AT TREES: THE MARSH STRAYED SO FAR FROM MYSTERY: LEAVES ARE SOFTLY MOVING: THEY BARK AT SPIDERS INTELLIGENT EYES: THEY SCUTTLE UP TREES TO LONG LEGS AND WHISPER SUSPENDED BETWEEN NOTHING TO BARK AT CROWS THAT ESCAPE THEM: PERCHES WITH TIRED INCH RETURN TO EAT ALL DAY: ON THE SHORE THEY BARK AT THE ROCKS ON THE WINGS: THEY BARK AT TOP OF MASTS APPEARING AT THE NAVIGATION LIGHTS: SOUND OF THE WAVES BARK AT THE MUFFLED INVISIBLE SHIPS: THE BLACK BACK WHILE THE FISH THAT SHOWS: THEY BARK AT THE HUNGRY ABYSS AND THEY BARK AND SINK INTO THE ABYSS SWIMMING: THEN THEY START TO RUN THEM: AFTER THE MAN WHO ENSLAVES RUNNING AGAIN THROUGH THE COUNTRY ON BLEEDING PAWS TO THE ROCKS: GRASS AND STENCH OVER PITS, PATHS, FIERY ROCKS: YOU WOULD BE RABID AND SEARCH AND THINK THEY WERE A VAST POND OF THIRST: THEY QUENCH THEIR RAGING PROLONGED HOWLS TERRIFYING TRAVELLERS NATURES: THE WAND SHOULD BEWARE: THOSE MYSTERIES WILL THROW FREQUENTERS OF CEMETERIES INTO THEMSELVES UPON HIM, RING WITH THEIR BLOOD TEARING AND DEVOURING DRIPPING JAWS: OTHER SAVAGE THEY HAVE STRONG TEETH CREATURES: WILL NOT DARE THE BLOODY FLESH, BUT APPROACH AND SHARE IT WILL FLEE FROM SIGHT: SEVERAL HOURS THEY DO TREMBLING: AFTER SIEGES, ALMOST DEAD WITH RUNNING HERE AND EXHAUSTION FROM THERE, THEIR TONGUES MOUTHS ATTACK LOLLING FROM THEIR ONE ANOTHER WITHOUT ADO AND TEAR EACH KNOWING INTO A THOUSAND SPEEDS: THE PIECES DO NOT ACT WITH GLASSY CRUELTY.

SO DID BLOODY BILL DICTATE THE SEVEN SONGS OF AZATHOTH IN THE CRYPT OF THE SCOURGE OF THE BURNING SKULL-VIRGINS; AND AFTER TWENTY-THREE DAYS AND NIGHTS OF THE WHITE DARKNESS, LEONARD LAPAGE AWOKE WITH MASSACRE IN MIND.

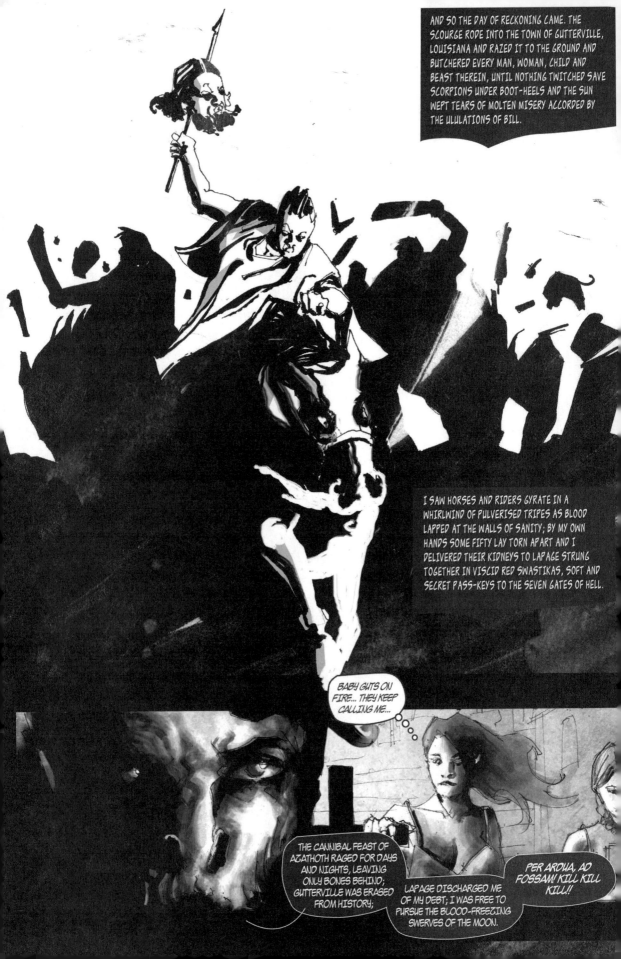

AND SO THE DAY OF RECKONING CAME. THE SCOURGE RODE INTO THE TOWN OF GUTTERVILLE, LOUISIANA AND RAZED IT TO THE GROUND AND BUTCHERED EVERY MAN, WOMAN, CHILD AND BEAST THEREIN, UNTIL NOTHING TWITCHED SAVE SCORPIONS UNDER BOOT-HEELS AND THE SUN WEPT TEARS OF MOLTEN MISERY ACCORDED BY THE ULULATIONS OF BILL.

I SAW HORSES AND RIDERS GYRATE IN A WHIRLWIND OF PULVERISED TRIPES AS BLOOD LAPPED AT THE WALLS OF SANITY; BY MY OWN HANDS SOME FIFTY LAY TORN APART AND I DELIVERED THEIR KIDNEYS TO LAPAGE STRUNG TOGETHER IN VISCID RED SWASTIKAS, SOFT AND SECRET PASS-KEYS TO THE SEVEN GATES OF HELL.

BABY GUTS ON FIRE... THEY KEEP CALLING ME...

THE CANNIBAL FEAST OF AZATHOTH RAGED FOR DAYS AND NIGHTS, LEAVING ONLY BONES BEHIND; GUTTERVILLE WAS ERASED FROM HISTORY;

LAPAGE DISCHARGED ME OF MY DEBT; I WAS FREE TO PURSUE THE BLOOD-FREEZING SWERVES OF THE MOON.

PER ARDUA, AD FOSSAM! KILL KILL KILL!!

prisoner of the coral deep
J G Ballard

I found the shell at low tide, lying in a rock-pool near the cave, its huge mother-of-pearl spiral shining through the clear water like a Fabergé gem. During the storm I had taken shelter in the mouth of the cave, watching the grey waves hurl themselves toward me like exhausted saurians, and the shell lay at my feet almost as a token of the sea's regret.

The storm was still rumbling along the cliffs in the distance, and I was wary of leaving the cave. All morning I had been walking along this deserted stretch of the Dorset coast. I had entered a series of enclosed bays from which there were no pathways to the cliffs above. Quarried by the sea, the limestone bluffs were disturbed by continuous rock-slides, and the beaches were littered by huge slabs of pockmarked stone. Almost certainly there would be further falls after the storm. I stepped cautiously from my shelter, peering up at the high cliffs. Even the wheeling gulls crying to each other seemed reluctant to alight on their crumbling cornices.

Below me, the seashell lay in its pool, apparently magnified by the lens of water. It was fully twelve inches long, the corrugated shell radiating into five huge spurs. A fossil gasteropod, which had once basked in the warm Cambrian seas five hundred million years earlier, it had presumably been torn loose by the waves from one of the limestone boulders.

Impressed by its size, I decided to take it home to my wife as a memento of my holiday – needing a complete change of scene after an unprecedentedly busy term at school, I had been packed off to the coast for a week. I stepped into the pool and lifted the shell from the water, and then turned to retrace my steps along the coast.

To my surprise, I was being watched by a solitary figure on the limestone ledge twenty yards behind me, a tall raven-haired woman in a sea-blue gown that reached to her feet. She stood motionlessly among the rock-pools, like a Pre-Raphaelite vision of the dark-eyed Madonna of some primitive fisher community, looking down at me with meditative eyes veiled by the drifting spray. Her dark hair, parted in the centre of her low forehead, fell like a shawl to her shoulders and enclosed her calm but some-what melancholy face.

I stared at her soundlessly, and then made a tentative gesture with the seashell. The ragged cliffs and the steep sea and sky seemed to enclose us with a sense of absolute remoteness, as if the rocky beach and our chance encounter had been transported to the bleak shores of Tierra del Fuego on the far tip of the world's end. Against the damp cliffs her blue robe glowed with an almost spectral vibrancy, matched only by the brilliant pearl of the shell in my hands. I

assumed that she lived in an isolated house somewhere above the cliffs – the storm had ended only ten minutes earlier, and there appeared to be no other shelter – and that a hidden pathway ran down among the fissures in the limestone.

I climbed up to the ledge and walked across to her. I had gone on holiday specifically to escape from other people, but after the storm and my walk along the abandoned coast, I was glad to talk to someone. Although she showed no response to my smile, the woman's dark eyes watched me without hostility, as if she were waiting for me to approach her.

At our feet the sea hissed, the waves running like serpents between the rocks.

'The storm certainly came up suddenly,' I commented. 'I managed to shelter in the cave.' I pointed to the cliff top two hundred feet above us. 'You must have a magnificent view of the sea. Do you live up there?'

Her white skin was like ancient pearl.'I live by the sea,' she said. Her voice had a curiously deep timbre, as if heard under water. She was at least six inches taller than myself, although I am by no means a short man. 'You have a beautiful shell,' she remarked.

I weighed it in one hand. 'Impressive, isn't it? A fossil snail – far older than this limestone, you know. I'll probably give it to my wife, though it should go to the Natural History Museum.'

'Why not leave it on the beach where it belongs?' she said. 'The sea is its home.'

'Not this sea,' I rejoined. 'The Cambrian oceans where this snail swam vanished millions of years ago.' I detached a thread of fucus clinging to one of the spurs and let it fall away on the air. 'I'm not sure why, but fossils fascinate me – they're like time capsules; if only one could unwind this spiral it would probably play back to us a picture of all the landscapes it's ever seen – the great oceans of the Carboniferous, the warm shallow seas on the Trias...'

'Would you like to go back to them?' There was a note of curiosity in her voice, as if my comments had intrigued her. 'Would you prefer them to this time?'

'Hardly. I suppose it's just the nostalgia of one's unconscious memory. Perhaps you understand what I mean – the sea is like memory. However lost or forgotten, every-thing in it exists for ever...' Her lips moved in what seemed to be the beginnings of a smile. 'Or does the idea seem strange?'

'Not at all.'

She watched me pensively. Her robe was woven from some bright thread of blue silver, almost like the hard brilliant scales of pelagic fish.

Her eyes turned to the sea. The tide had begun to come in, and already the pool where I found the shell was covered by the water. The first waves were breaking into the mouth of the cave, and the ledge we stood on would soon be surrounded. I glanced over my shoulder for any signs of the cliff path.

'It's getting stormy again,' I said. 'The Atlantic is rather bad-tempered and unpredictable – as you'd expect from an ancient sea. Once it was part of a great ocean called –'

'Poseidon.'

I turned to look at her.

'You knew?'

'Of course.' She regarded me tolerantly. 'You're a school-master. So this is what you teach your pupils, to remember the sea and go back to the past?'

I laughed at myself, amused at being caught out by her. 'I'm sorry. One of the teacher's occupational hazards is that he can never resist a chance to pass on knowledge.'

'Memory and the sea?' She shook her head sagely. 'You deal in magic, not knowledge. Tell me about your shell.'

The water lifted toward us among the rocks. To my left a giant's causeway of toppled pillars led to the safety of the upper beach. I debated whether to leave; the climb up the cliff face, even if the path were well cut, would take at least half an hour, especially if I had to assist my companion. Apparently indifferent to the sea, she watched the waves writhing at our feet, like reptiles in a pit. Around us the great cliffs seemed to sink downward into the water.

'Perhaps I should let the shell speak for itself,' I demurred. My wife was less tolerant of my tendency to bore. I lifted the shell to my ear and listened to the whispering trumpet.

The helix reflected the swishing of the waves, the contours of the shell in some way magnifying the sounds, so that they echoed with the darker murmur of deep water. Around me the breakers fell among the rocks with a rhythmic roar and sigh, but from the shell poured an extraordinary confusion of sounds, and I seemed to be listening not merely to the waves breaking on the shore below me but to an immense ocean lapping all the beaches of the world. I could hear the roar and whistle of giant rollers, shingle singing in the undertow, storms and typhonic winds boiling the sea into a maelstrom. Then abruptly the scene seemed to shift, and I heard the calm measures of a different sea, a steaming shallow lagoon through whose surface vast ferns protruded, where half-submerged leviathans lay like sandbanks under a benign sun...

My companion was watching me, her high face lifted to catch the leaping spray. 'Did you hear the sea?'

I pressed the shell to my ear. Again I heard the sounds of ancient water, this time of an immense storm in progress, a titanic struggle against the collapsing isthmuses of a sinking continent. I could hear the growling of gigantic saurians, the cries of reptile birds diving from high cliffs on to their prey below, their ungainly wings unshackling as they fell.

Astonished, I squeezed the shell in my hands, feeling the hard calcareous spines as if they might spring open the shell's secret.

The woman still watched me. By some freak of the fading light she appeared to have grown in height, her shoulders overtopping my head.

'I ... can't hear anything,' I said uncertainly.

'Listen to it!' she admonished me. 'That shell has heard the seas of all time, every wave

has left its echo there.'

The first foam splashed across my feet, staining the dried straps of my sandals. A narrowing causeway of rocks still led back to the beach. The cave had vanished, its mouth spewing bubbles as the waves briefly receded.

I pointed to the cliff. 'Is there a path? A way down to the sea?'

'To the sea? Of course!' The wind lifted the train of her robe, and I saw her bare feet, seaweed wreathed around her toes. 'Now listen to the shell. The sea is waking for you.'

I raised the shell with both hands. This time I closed my eyes, and as the sounds of the ancient wind and water echoed in my ears I saw a sudden image of the lonely bay millions of years earlier. High cliffs of white shale reached to the sky, and huge reptiles idled along the coarse beaches, baying at the grotesque armoured fish which lunged at them from the shallows. Volcanic cones ringed the horizon, their red vents staining the sky.

'What did you hear?' my companion asked me insistently, evidently disappointed. 'The sea and the wind?'

'I hear nothing,' I said thickly. 'Only a whispering.'

The noise erupted from the shell's mouth, the harsh bellows of the saurians competing with the sea. Suddenly I heard another sound above this babel, a thin cry that seemed to come from the cave in which I had sheltered. Searching the image in my mind, I could see the cave mouth set into the cliff above the heads of the jostling reptiles.

'Wait!' I waved the woman away, ignoring the waves that sluiced across my feet. As the sea receded, I pressed my ear to the conch, and heard again the faint human cry, a stricken plea for rescue –

'Can you hear the sea now?' The woman reached to take the shell from me.

I held to it tightly and shouted above the waves. 'Not *this* sea! My God, I heard a man crying!'

For a moment she hesitated, uncertain what to make of this unexpected remark. 'A man? Who, tell me! Give it to me! It was only a drowned sailor!'

Again I snatched the shell away from her. Listening, I could still hear the voice calling, now and then lost in the roar of the reptiles. A sailor, yes, but a mariner from the distant future, marooned millions of years ago in this cave on the edge of a Triassic sea, guarded by this strange naiad of the deep who even now guided me to the waves.

She had moved to the edge of the rock, the strands of her hair shimmering across her face in the wind. With a hand she beckoned me toward her.

For the last time I lifted the shell to my ear, and for the last time heard that faint plaintive cry, lost on the reeling air.

'H-h-e-e-lp!'

Closing my eyes, I let the image of the ancient shore fill my mind, for a fleeting instant saw a small white face watching from the cave mouth. Whoever he was, had he despaired of

returning to his own age, selected a beautiful shell and cast it into the sea below, hoping that one day someone would hear his voice and return to save him?

'Come! It's time to leave!' Although she was a dozen feet from me, her outstretched hands seemed almost to touch mine. The water raced around her robe, swirling it into strange liquid patterns. Her face watched me like that of some monstrous fish.

'No!'

With sudden fury I stepped away from her, then turned and hurled the great shell far out into the deep water beyond her reach. As it vanished into the steep waves I heard a flurry of heavy robes, almost like the beating of leathery wings.

The woman had gone. Quickly I leapt on to the nearest rock of the causeway, slipped into the shallows between two waves and then clambered to safety. Only when I reached the shelter of the cliffs did I look back.

On the ledge where she had stood a large lizard watched me with empty eyes.

black static
david conway

STATIC everywhere...

— Razor hail maelstrom of endless orgasm. The Hierarchy of the Scourge materialises in a blizzard of sensual excess; monsoon of sulphurous secretions, lethal grapeshot of virulent spores. Synergy of sex and death. Venom, pheromone and phosphorus. The Gordian Knot of chromo-somal destiny unravels...

— Clusters of obsidian, composite eye modules slide languidly across the featureless polyhedron of transfigured flesh. Crashing waves of pure terror, unutterable exhilaration, convulse the pulsating gel, the *anti-symmetry* of my inexplicable being. The squirming ganglia of numberless, autonomic neural colonies are wracked with seismic convulsions, plasmic tsunami.

We, the Nameless, the Faceless, the Undying – *Hyperbreed*, *Omnibeasts* – seep, collide and explode onto this plane. Our limitless bodies span multifarious frequencies of time and space, the super-geometric, abstract dimensions defined by the interface of the Ultrasphere and Quantaplex. We unleash the arsenal of the Catastrophes: the unbearable cacophony of the Endless Scream; the ecstatic tortures of the Misery Spores; the unspeakable *Rapture*. I clothe myself in the raiment of Light, the celestial mantle of Atrocity: Our Will be done on earth as We have done in Heaven...

— We unearth continents by their very roots. Ocean brine is transmuted into shimmering expanses of liquid mercury. Or lava. Excrement. Blood. Tectonic plates are prised apart and slotted back together at random like pieces in a child's jigsaw puzzle. The biosphere is our plaything, subject to our slightest whim. We break it, refashion it, destroy it endlessly. The potential of even its crudest elements is inexhaustible. Whole populations fused into a single, screaming organism: an amoebic monstrosity, hundreds of square miles in area, millions of shrieking mouths uttering an incomprehensible babble of polyglottal panic, forced to wallow in and feed upon the steaming dung that explodes from countless, distended rectums. A towering Babel of steaming, bleeding, shit-encrusted flesh...

— We rove about the surface of this planet at will. Sometimes slowly, rolling across the hemispheres like a sluggish tide of glutinous, plasmic flesh. Sometimes at the speed of thought, molecules luxuriating in the shrill dissonance of our own mass-consciousness' constant, involuntary interface – the ceaseless exchange of information and sensation – the symphonic

chaos of Ultraspace.

Vast, incomprehensible shapes glide through the bile-coloured sky, eclipsing the radiant fury of a disinterested sun, solar flares erupting from its seething surface like roman candles. This dawn rose on the blood red day of centuries. Its setting heralds the aeons-long darkness of millennial night: the victory of sublime Chaos over the folly of Reason; anguish and futility engulfing the fragile mirage of humanity's banal, mediocre ambitions...

– I preside over scenes of epic slaughter. The pure breadth and terror of my limitless vision concocts orgies of inventive violence and sexual perversity, the endless permutations of which I choreograph with the random precision of quantum manipulation. I revel in my irredeemable divinity. I inflict the meaningless agonies of the Embryo Vats, the Howling Loom and the Narrow Spawn; contrive psychotropic plagues which culminate in complex ballets of ritual slaughter and synchronised mass-suicide. Language reverts to its primal origins: a sonic carcinogen that literally devours brain tissue and nervous systems; a single conversation is sufficient to reduce its participants to comatose vegetables.

My wide skirt of semi-translucent flesh conceals row upon row of buzzing chainsaw teeth that can grind granite into sand, reduce diamonds to shimmering dust. The moist expanses of my layered palates are highly sensitised to the sweet delicacy of human flesh, the metal acridity of blood...

– The taste of *souls*.

My hunger is boundless. I feed it voraciously. The conical, erogenal structures that stud my heaving, corpulent flank glow with the vivid iridescence of endless arousal, ultra-endorphins bombarding the hydra-headed proliferation of my insoluble neural labyrinths. My serrated teeth spin muscle and skin into dripping red strands, gossamer fine like a spider's web. My taste buds explode with effervescing pleasure. The searing disintegration of masticated souls surges along the coarse surfaces of my many tongues, scorching my salivating palates with its unique, irresistible piquancy.

The pupil-less facets of my composite eye modules glint with the cold sheen of onyx, meandering with lazy satiety across the irregular planes of my moist, diaphanous flesh. A thousand miles to the East, in the broiling ocean of molecular acid that was once the Pacific, there lies a nameless island whose only inhabitants for millions of years had been marine birds and ocean-going reptiles. There is some irony in the fact that so inauspicious a location should prove to be the terrestrial cradling of our celestial seed. A single beam of pure, aetheric energy is transmitted light years across the galaxies from the primal nucleus of Maximus Prime: fulcrum of the Quantaplex, for millions of years the impassable threshold of the *Hyperbreed's* extradimensional prison. The island is a geomantically-active beacon. Following the molten disintegration of the *Copernicus* radio telescope it continues to absorb the energy directly.

Copernicus. Though twice separated from the memory by the barriers of time and my own transfigurative metamorphosis, the recollections retain the vivid tenacity of a fever-spawned

dream. And the reverie is doubly reinforced by the fading embers of dim, pre-racial memory, telling me that the stringy pulp shredded between my teeth – the delicious firefly of liberated consciousness greedily ingested by the swelling tubers and snaking entrails of my alimentary tracts – was once a *child*.

I feel neither remorse or empathy, despite the fact that the hazy mirage of half-memory reminds me of my own humble origins. That once I, too, was a mere *man*...

I had always hated the sea. Feared it, had I been but honest enough to admit it. The tang of brine, its sour suggestion of ripe decay – of *death* – on a chill sea breeze had always been sufficient to awaken a dark and nameless dread in the blackest recesses of my subconsciousness. In retrospect it seems so foolish, so pitiably weak. But at the time its persuasiveness was such that I could never shrug it off.

You will appreciate then the feeling of deep foreboding that overwhelmed me as we approached Stahl's island. True, the weather was perfect. Optimum visibility. The vast swell of the Pacific so flawlessly blue and agreeably placid. But still I had to struggle to conceal my gnawing anxiety, the bitter cauldron of bile bubbling within me.

As we drew closer to the island – little more than a nameless, uncharted rock – the gleaming dish of the *Copernicus* radio telescope, luminous against the pale blue canvas of the southern sky, seemed to assume an almost surreal aspect, its setting in the midst of this featureless, crystal sea so startlingly inappropriate. Ostensibly, its geographic location enabled the observatory's dish to fully exploit the low-level refraction and ambient distortion potential afforded by the hole in the ozone layer which by now extended over most of the Southern hemisphere, the euphemistically termed 'environmental window'. Nobody could have suspected the ulterior motivation of its founder and principle architect, Reinhardt Stahl.

Sweating uncomfortably inside military-issue anti-contamination suits, we made landfall shortly before noon. There were six of us: myself, chief scientific and technical advisor on the mission; Ehrlicson, a bio-chemist specialising in virology, an expert in the field of bacteriological and chemical warfare; and four US marines on secondment from the naval base at Manilla. The grunts appeared to be packing enough firepower to overthrow a medium-sized banana republic; but that was their business.

We had arrived on the island expecting the worst. But I don't think anything could have prepared us for the reality of what awaited us. Of course, we had heard reports of an unknown viral epidemic which had forced the *Copernicus* staff to remain almost a year in self-imposed quarantine. Details of that had been sketchy enough to arouse suspicion in some quarters.

However, it was not until a foundering, Philipino fishing vessel ran aground on an adjacent reef that the alarm was truly raised. Taking to the lifeboats, the sailors had at first headed for the island and the supposed shelter of *Copernicus*. However, *something* they had seen there had apparently been disturbing and frightening enough for them to prefer to take their chances

on the open sea. They were eventually picked up by a Japanese trawler some three weeks later, suffering from heat-stroke, extreme dehydration and malnutrition.

Obviously, the more outrageous elements of their story were being treated with scepticism, if not downright incredulity, as well as being kept out of the public domain. But one thing was obvious. There was a mystery on Stahl's island that merited further investigation...

Walking into the observatory's central chamber – the essential heart of the *Copernicus* complex – I felt as if I had suddenly turned my back on thousands of years of human civilisation. Abruptly, unexpectedly, we had been confronted with the darkness of the primordial soul, its palpable, undeniable reality.

Copernicus had been transformed into a necropolis. In the midst of towering banks of computers, still functioning with pragmatic disinterest in everything but their own pre-ordained programming, the dead were everywhere. This was *their* domain.

At first, none of us spoke. It was a scene of such enormity and horror that words were rendered meaningless.

It took a matter of some minutes, perhaps, for the realisation to sink in: this was not the aftermath of some fatal pestilence, but a deliberately orchestrated *mass-suicide*. The ritual dimensions of the act were inescapable, the trappings of mystical arcana pre-eminent and ubiquitous.

Piece by piece, gripped by the kind of morbid fascination that compels one to return again and again to pick at an unhealing scab, we began to reconstruct the events that had culminated in this atrocity.

We counted sixty-five bodies in all; twenty-three initially unaccounted for. Each had been systematically laid out in its own, individual, hermetically-sealed, plexi-glass cocoon, resembling the prototypical stasis pods designed to maintain cosmonauts in suspended animation, a process widely believed at the time to hold the key to manned deep-space exploration. The pods were arranged in tiers, starting at ground level and climbing the curved walls of the observatory. Considering the condition of the bodies inside – skin blackened, bellies vastly bloated with the pungent gases of decomposition – I was struck by the irresistible image of a gigantic insect colony's incubation chamber. The ravages of corruption conspired to contrive the putridly forceful illusion of an emergent, *pupal* metamorphosis.

Perversely, though, in spite of the frankly unfathomable horror of what we were seeing – the sight of so many rotting corpses, obviously *weeks* old – there was something else all the more alarming by virtue of the fact that it was apparently inexplicable. Each of the bodies – without exception – was fitted with what appeared to be something resembling a Virtual Reality headset: hologramatic, laser-optic modules stuck fast in the slick mire of decaying eyeballs; withered genitalia and key neural clusters studded with electrodes like glutted leaches. The implication was as obvious as it was baffling: the *Copernicus* observatory staff were participating

en masse in a Virtual Reality scenario at the moment of their deaths. To what end? At this point I did not care to speculate.

And then, of course, there was the most macabre and, to my mind, telling aspect of the entire conundrum. The *arcana*.

Everywhere one looked there were the timeless symbols of mystical devotions. Many were immediately recognisable: the ankh, Celtic cross, pentagram, swastika. But there were many – arabesque hieroglyphs, what appeared to be quasi-mystical, pseudo-scientific equations scrawled in the incomprehensible lexicon of an unknown numerological system – that defied recognition or understanding. It came as no surprise that much of the daubing had been done in blood – animal or human, it was too early to tell.

As a scientist I could not shake the feeling that there was something ... *obscene* in the sight of this: the cool disciplines and disinterested calibrations of pure, logical research; the quantative meditations of prosaic, cybernetic intelligences; succumbing to the irrational malaise, the ritual barbarity, of resurgent primal mysticism. It was like watching, helplessly, as the primordial jungle reclaimed some pristine metropolis, the cradle of technology and civilisation. The hungry darkness.

I could not tolerate it. There was a solution to this enigma, and I was determined to find it.

Over the following weeks I immersed myself in *Copernicus*' extensive library of computer-based data. In the history of the project and that of its founder, Reinhardt Stahl. And, ultimately, the madness which had claimed him.

Reinhardt Stahl had been at once the most celebrated and notorious *enfant terrible* of the scientific community in recent years. It had been his quantum leap in the field of bio-molecular intelligence that had been directly responsible for the first self-replicating computers and the development of synthetic enzymes capable of storing, processing and interpreting data in such a way as would eventually consign silicon chips to the junk-heap of obsolescence. Needless to say, the revenue generated by the patents, of which he retained sole copyright, made him stratospherically wealthy.

That Stahl should choose to divert his resources into the field of radio astronomy may have seemed unorthodox, but hardly surprising. His interests were as varied as his talents were prodigious. We had, in fact, studied together many years earlier and, for a time, had become close friends. We had much in common, sharing not only a fervent passion for the pioneering spirit that characterised the new breakthroughs in quantum physics; chaos and anti-chaos dynamics; the exciting potential of artificial intelligence; but also for more esoteric matters: the occult and all its associated trappings. Stahl, I recall, was particularly interested in the arcane symbolism of prehistoric pagan cults, the anarchic principles and ritual practise of chaos magic.

Stahl's wealth and influence was such that he soon became the director of the ill-fated

SETI III project. Originally founded in the 1970s, the Search for Extraterrestrial Intelligence (SETI) had largely been established to satisfy what was, in effect, a millennial yearning: the need to reach out and commune with our supposed cosmic brethren, a plea for help, a subconscious bid for salvation. The fact that subsequent years saw the project's radio telescopes detect nothing more exciting than the deceptively regular transmissions emitted by pulsar stars and the endless dissonance of natural radio static – echoes of the Primal event reverberating around the galaxies – ensured that both public and serious interest quickly evaporated.

In its third and final incarnation SETI III occupied two major radio telescope observatories: one high in the hills of southern California, the second in the arid wastes of the central Australian outback. Both facilities, operating under the personal supervision of Stahl and his hand-picked team of technicians, were fully equipped with the most *highly-evolved* prototypes developed from his original neural processors. These bio-molecular computers added a new, *conceptual* dimension to the interpretation of the data received. And it was these very interpretations – and Stahl's own controversial conclusions – that precipitated an irreparable schism between not only himself and many of his SETI III collaborators, but with the greater scientific community as a whole. The ensuing controversy resulted in the abandonment of the SETI III project; Stahl's ostracism. And, inevitably, the foundation of *Copernicus*; Stahl's subsequent madness; and the tragic, horrific denouement of the entire episode.

And so it was, surrounded by the trappings of an insane obsession, that I uncovered the key to the *Copernicus* atrocity.

Stahl's private quarters – the literal nerve centre of the establishment – resembled the inner-sanctum of some post-technological magus. The place was crammed with the artefacts and fetishes of the most obscure paganistic cults. Most significant of these were two monstrous statues sculpted in what appeared to be soapstone, dirgey grey-green, veined black like Connemara marble. What they depicted were demonic grotesqueries whose physiognomies combined such diverse characteristics as those of octopod, simian and saurian evolutionary models. Ragged bat-wings enfolded their hunched shoulders like tattered capes, apparently too frail to have afforded these corpulent behemoths the faculty of flight. The faces – or what passed for them – were especially hideous: many mouths equipped with lethal prongs and spikes for teeth; bulging composite eyes arranged in numerous clusters; the bulbous malignancies of their vast crania framed by tangled manes of medusan tentacles and tenebrous ganglia.

Sifting through Stahl's extensive computer files, I discovered that these monsters had apparently been the totems of a prehistoric pre-Polynesian cult, representing omnipotent sea-gods of allegedly extraterrestrial origin. These particular specimens had been blasted out of the Antarctic permafrost during a secretive expedition Stahl had undertaken several years previously. According to his records, they were in excess of 500,000 years old.

The sea. Again. Always the *sea*.

By now, after some weeks of ceaseless investigation, I was succumbing to an unshakeable fugue of depression. Picking apart the minutiae of Stahl's painstakingly chronicled madness was bad enough in itself. But the constant proximity of the ocean and its pungent reek of brine – its chilling resonance with the dark secrets I was unearthing – fuelled my own morbid aversion until it positively festered. And then there was the pervasive, oppressive presence of death: the bleak charnel house of the central observatory.

And one thing *more*...

– It had been quite by accident that we had stumbled upon the sealed compartments in the observatory's lower levels, buried deep in the volcanic rock of the island itself. Upon discovering the initial corpses, twenty-three bodies had been unaccountably absent. This was where we found them.

At first, it seemed as though the stories of epidemic may have been true, after all. The bodies were quite badly decomposed, but even the ravages of putrefaction could not fully disguise the fact that they had been somehow ... *changed*. The signs of anatomical mutation were unmistakeable.

Post mortem examination of the bodies proved inconclusive in determining the cause of these aberrations. However, one thing was absolutely clear. The transformations had been occurring on the most fundamental level: a *non-human* element had been introduced, precipitating an irreversible genetic deviation. Entire organs had atrophied. Correspondingly, new systems, it seemed, had spontaneously evolved; there was no evidence of surgery.

I was at a loss to explain the ghastly phenomenon. But Ehrlicson commented that the mutations – particularly those of the pulmonary and cardio-vascular systems – suggested an *amphibious* adaptation. What-ever the truth, one thing was obvious: the process had killed them. And not only that. Considering what I was beginning to understand of Stahl's warped theories – his fascination with the cult of the sea-gods – the implications were at once startling and grotesque...

All the pieces were finally falling together: the entire canon of Reinhardt Stahl's crazed and fatal ethos.

It all began when Stahl was coordinator of the ill-fated SETI III Project. His team intercepted a series of transmissions emanating from what had been largely acknowledged as one of the most ancient quadrants of the known universe, light years beyond the spiral arm of our own galaxy. Conventional analysis recognised these as possibly interesting but fairly run-of-the-mill pulsar emissions.

But Stahl disagreed.

He maintained that his advanced processors had constructed a holographic model of the star's projected behaviour and structure that demonstrated significant anomalies inconsistent with that of a conventional pulsar. He claimed that the transmissions actually emanated from a

secondary source: a conglomeration of *dark matter*, light years wide and immeasurably dense, which he dubbed "Maximus Prime". This galactic enigma exerted a tremendous gravitational force which effectively bent the pulsar's orbit into an ellipse. The practical result of this was to maximise the intensity of the transmissions at the star's broadest vector; the Maximus Prime transmissions were, he claimed, being literally bounced off its companion pulsar – much in the manner of our own, earth-orbiting, tele-communications satellites. This meant that the signals were directly targeting a *specific* stellar region: the quadrant that contains *our* galaxy.

As for the transmissions themselves, Stahl maintained that they occupied frequencies *beyond* conventional radio and microwave spectrums. These unknown frequencies – *black static* was the term he coined – held the key to understanding the true nature of the transmissions. And, ultimately, to *deciphering* them. That the signals derived from a guiding intelligence he was in absolutely no doubt.

It was pure idiocy, he declared, to expect a truly alien intelligence to communicate in the banal *tic-tac-toeisms* of repetitive binary sequences; arrogant in the extreme to assume any such transmissions were intended for *our* ears. If, indeed, for *ears* at all.

The seeds of insanity, it was all too plain to see, had fallen upon fertile soil.

The culmination of his fanciful delusions was achieved after years of isolation and fevered research at the helm of *Copernicus*. And with it his crescent into the wilder excesses of mysticism.

The Ultrasphere and Quantaplex represented the pinnacles of his pseudo-scientific iconography, the lynch-pins upon which hinged the irrational symbiosis of logic and superstition. Stahl characterised his hypothetical model of the conceptual universe in the form of the Ultrasphere. Its curvature, he postulated, represented the synergetic bond of matter and energy; within its circum-ference, diameter and area would be accommodated the infinite concentric possibilities of temporal relativity. In other words, it was a model of *Time*.

The Quantaplex, by way of contrast, hypothesised the ultimate expression of spatial potentialities: a polyhedron whose complex geometry would occupy the anti-Euclidean planes of alternate dimensions as well as our own, encompassing the sub-atomic architecture of nuclei and the kaleidoscopic anatomies of galaxies. It would, Stahl asserted, be the ultimate computer. Its multifarious angles, the ceaseless shifting and tectonic realignments of its infinite facets, would facilitate direct interface with – and conscious manipulation of – the Ultrasphere.

Here would be realised the apothetical goals of science and the occult: matter, energy, thought *indivisible*. Dominion over time and space. The final ascent to godhood.

I would have to admit being bewildered by the sheer breadth of Stahl's delusions of divine grandeur. But there was worse yet to come.

Stahl resorted unashamedly to the occult for corroboration of his wild theories. It began with a simple diagram:

Allegedly a description of the orbit of Sirius B (fig. 1) and its companion star, Sirius (fig. 2), as demonstrated by the "primitive" Dogon tribe of North Africa to Western anthropologists in the 1930s. It had been part of their mythology for millennia. Modern astronomy did not discover it until 1926; it was not photographed *until 1970*.

According to Dogon tradition, this – and a good deal more astronomical knowledge – was passed on to their ancestors by creatures they call the *Nommo*: an amphibious race of extraterrestrial origin responsible for the introduction of civilisation. Stahl drew parallels between this legend and Babylonian descriptions of the *Annedoti* ("Repulsive Ones"), ocean-dwelling deities from the skies, also credited with imparting the secrets of science and the arts to mankind. And, inevitably, the barbaric cult of the prehistoric sea-gods with which he had become obsessed. Stahl disputed the popular interpretation of the Dogon model. He was convinced that it did not represent the Sirius system, but that it was, in fact, an illustration of Maximus Prime and its companion pulsar. He further identified its key components of curve and angle as having provided the basis for all the major occult symbols: the ankh, celtic cross, pentagram, swastika. According to him they encoded the *funda-mental equation*: time curves/space angles. He perceived them as arcane illustrations of the seamless continuum of infinity, its symbiotic relationship with solid geometry – anti-geometry – and their inherent potential for spatial and temporal manipulation.

His explanation for the recurrence – the irresistible appeal and subconscious resonance – of such symbols down through the ages was simple: primal memory. They were imperfect recollections, dredged from the mass-psyche, of the iconic symbols of an ancient, non-human superscience in which technology and the occult co-existed in harmony...

– The Ultrasphere and Quantaplex.

The basic core of Stahl's risible mythos was as follows:

– Countless millions of years ago there existed a race of beings in a galaxy light years beyond our own. *Hyperbreed*, he called them, although he acknowledged ancient texts which referred to them variously as the Faceless, the Nameless, the Undying. So advanced were both their occult and technological sciences that they had gained some control over the forces of time and space. Eventually they came to colonise the earth, the most remote outpost of their galactic empire.

As previously suggested, the *Hyperbreed's* ultimate goal had been to achieve total

mastery of the universe on a fundamental, quantum level. And they *almost* succeeded. They devoted millenia to the construction of the Quantaplex: planets, suns, entire constellations forming an integral part of its matrix. But something went wrong.

On the eve of its completion the *Hyperbreed* were overtaken by some nameless, unknown catastrophe of devastating proportions that flung the Quantaplex into disarray. Their civilisation was decimated; the survivors imprisoned on an alternate plane of fifth dimensional anti-geometry inaccessible to our universe...

– Except, that is, via the collapsed heart of the Quantaplex: the desolate, pan-dimensional threshold of dense *dark matter* Stahl had called Maximus Prime, its astronomical location betrayed by the elliptical orbit of its companion pulsar.

However, whilst the galactic *Hyperbreed* were either exterminated or imprisoned by the destruction of the Quantaplex, their earthbound counterparts were condemned to terrestrial exile.

The cosmic disaster unwittingly precipitated by their quantum manipulations resulted in all manner of global cataclysms, rendering the planet – or its surface, at least – inhospitable to their habitation. This was the time of the mass-extinction of the dinosaurs; geological upheavals; oceans rocked from their beds; volcanic activity of apocalyptic proportions.

And so the earthbound *Hyperbreed*, descendants of an amphibious lineage, sought refuge in the seas. The process of evolutionary degeneration, once set in motion, was irreversible. As the millennia rolled by, the *Hyperbreed* – once gods – became *monsters*... All, that is, but in the eyes of the first species of humans and proto-humans.

Stahl described at length a prehistoric scenario wherein the degraded survivors of the *Hyperbreed* were worshipped by an ocean-going, pre-Polynesian tribe who, he claimed, practised all sorts of vile, sacrificial rituals and even *interbred*, producing a hybrid species of humanoid amphibians. The racial subconscious still harboured memories of these beings, giving rise to myths of sea-monsters the world over. Of behemoth and leviathan. The kraken. Dragons. *Ktulhu*. It was then I truly realised the purpose that lay behind the initially inexplicable mass-suicide we had discovered. Stahl had intended to dedicate the *Copernicus* radio telescope as a temple, a *cathedral* to these imaginary chimeras: the literal fountainhead of a perverse cult of his own insane devising.

There now remained but one part of the puzzle to solve—

I remember Ehrlicson's face as I was sealed into the pod, the look of trepidation and resignation. The plexi-glass sarcophagus had been thoroughly disinfected since the removal of its previous, moribund occupant. The electrodes had already been fixed to my naked body. I slipped on the Virtuality headset, the laser-optic eye-pieces an impenetrable visor shutting out everything but the scenario Stahl's programme was to reveal. I waited for the muscle relaxant to work, minimising physical sensation. It took seconds. Now I was ready to access the experience the men and women

of *Copernicus* had been staring at the moment of their deaths.

The laser-optic system projects its holographic images directly onto the retina of the eye. The transition from physical to conceptual reality is surprisingly smooth...

– A shallow, two-dimensional geometry of overlapping squares, rectangles, parallelograms, triangles and rhombuses, alternately coloured in luminous primary colours, unfurls like the time-lapse accelerated blossoming of a digitally-generated flower. Beyond this threshold lies a flat zone: featureless, barren, no horizons or any reference points from which to glean a sense of spatial perspective. Occasionally, swarms of disorganised information will buzz through the void, following random, tangential vectors like squadrons of maddened hornets. I seem to be floating, hanging in zero-gravity like a comic strip character sketched in an empty panel.

– And then there comes the *voice*...

'Sam, it is you, isn't it? I knew it would be you. I knew you'd come. It's working out just as I'd planned.'

Stahl. It's Reinhardt Stahl.

Beginning as a pinpoint of light, Stahl – or rather his computer-generated image – materialises abruptly like a three-dimensional television transmission. He looks much as I remembered him. Hand-some with a vague yet unmistakable ascetic quality. Like me he is completely naked.

'*Stahl* – ?' is all that I can think of to say.

'Exciting, isn't it?' he says. 'Remember the old science fiction movies we both loved in our youth. Doesn't this remind you of them? Of the Earth scientist who succeeds in constructing the Metalunan *enterossiter* in *This Island Earth*. Or perhaps you feel like Dr. Morbius in *Forbidden Planet*, accessing the Krell IQ-boosting machine; that was always *my* personal favourite.'

'Stahl, what ... how can you be – ? I've seen your body. Your *dead* body, for God's sake!'

'For *God's sake?* Yes, that is *precisely* correct. Though, I would hasten to add, not for the sake of any deity with whom you might be familiar. And no: this is not a recording. I am speaking to you directly now from Maximus Prime, the cosmic cradling of the *Hyperbreed*. We are *all* there now – all the men and women of *Copernicus* who dared share my vision. I have devised this computer-generated image for your benefit. I doubt if your limited comprehension could cope with the realisation of my true self, the phenomenon of what I have become. Not yet anyway. And as for my dead body, my empty *human* shell: on the level of quantum perception I now enjoy, the difference between the life and death of organic matter is so slight as to be negligible. As you will soon discover –'

'But how is this possible? Why – ?'

'You've already figured most of it out. I'm simply here to fill in the gaps for you. Now that you have initiated the ritual's final phase, its culmination.'

'Ritual?'

'Of course, the Invocation.' Stahl's smile broadens to reveal something unguarded, alien. *Hungry*. Suddenly I realise just how very afraid I am. How vulnerable.

Our bodies now are luminescent thoughtform projections silhouetted against the infinite blackness of deep space, studded with tiny stars like innumerable jewels. Radiant clouds of nebulous gas glower with the cold promise of cosmic transmutations. My own sense of foreboding seems corres-pondingly tangible.

'Remember how – all those years ago – I postulated that the Maximus Prime emissions may not have been intended for our ears if, indeed, for ears at all?' Stahl continues. 'Well, I was right. The *black static* spectrum elicits sympathetic reactions on a molecular level. It was – *is* – communicating with something *in* us. Something in our blood and bones. Our cells. Our reactions are infinitely subtle, but significant. We respond *genetically*.

'The neural processors – bio-molecular computers – I devised to collate and interpret the Maximus Prime data, to decode the *black static* transmissions, held the key to this discovery. As the project progressed, unaccountably, *spontaneously*, they began to mutate. At first, I assumed it to be a malfunction, a virus perhaps. But, as I continued to observe the phenomenon, I realised that what was occurring was the reawakening of a dormant, *evolutionary* potential. The answer was obvious: the *black static* transmissions encoded a fundamental, biological imperative. The neural processors, bred from an active culture of genetically-altered human cortical tissue, were responding to that message; without the impedance of a human brain, nervous system and the countless other bio-chemical interactions necessary to sustain the integrity of our own physical structure they were highly-sensitised receptors. There were few barriers to inhibit their interception, interpretation and *assimilation* of the message.

'It was by devising a prototypical, psychoactive Virtuality software that I established a medium by which I could achieve active interface with what was a truly self-determinate, alien intelligence. And it was through them that I first communicated with the *Hyperbreed*, imprisoned for millions of years in the fifth-dimensional limbo that lies beyond the portal of collapsed *dark matter* that is Maximus Prime.'

I cannot reply. Stahl's insanity seems to have survived his physical demise, to have somehow *possessed* the data matrix of his Virtuality programme. And here I am: ensnared within the coils of a madman's dream, as inescapable as a python's cold embrace.

'You see, the *Hyperbreed* are *in* us: humanity, I mean. They are the lost, forgotten part of our evolution. Or that of some of us, at least. The pulsar operates on a twenty-three year cycle, at which interval the broadest vector of its elliptical orbit brings it into closest proximity with our galaxy. The effect of this is to concentrate the intensity of the *black static* emissions, saturating the entire stellar region that falls within its range. *Our* planet, Sam. Something is *activated* by it: a subtle alteration in the structure of the DNA helix. Babies born, or conceived, within that apothetical phase of the pulsar's orbit enjoy a heightened, genetic empathy with the *Hyperbreed*.

As do we both, Sam –'

'But, Stahl,' I finally manage to say, 'this is insanity.'

'Sanity has no relevance when one views the universe from the elevated plateau of Absolute consciousness, Sam. You'll understand that yourself soon. The *Hyperbreed* have taught me much, opened my eyes to so many wonders. The Ultra-sphere and Quantaplex: the ultimate geometry that moulds time and space and consciousness itself. Just think of it: every point in every conceivable dimension; all the aspects of Time; accessible at the speed of *thought*. Doesn't it excite you? Don't you want to share in it?

'Anyway, whether or not you do, you have no choice. Remember the story of the epidemic? Essentially it was true. The entire island is infected with time spores of an organism that – how shall I put it? – *transforms* organic matter, a viral adaptation of my original neural processors. Already they've gone to work on your colleagues' bodies; our corpses; your own body, too, Sam. The result I would describe as a sort of protoplasmic stew: a reservoir of non-specific, polymorphic organic tissue which shall provide the raw material for *our* bodies when we return from Maximus Prime. I believe you have already discovered our *failures* in this field: our initial attempts to transform living tissue into vehicles suitable for quantum intelligences –'

Yes: the corpses sealed in subterranean catacombs, victims of a lethal, amphibious mutation. 'Oh god ... this can't ... can't be happening –'

'Don't despair, Sam. You've no inkling of the miracles in store. It's thanks to you that all this will be possible.'

'*Me –?*' I ask, appalled, my thoughts given an unexpected focus by this accusation of complicity.

'Yes. *Copernicus* was constructed as an *aetheric accumulator*, a sacrificial temple as you had already guessed. Our deaths – or, rather, our conceptual experience of physical and aetheric separation – were painstakingly orchestrated, designed to download our primal consciousness, the reawakened memory of our *Hyperbreed* ascendancy, in the distilled essence of pure thoughtform energy: a reciprocal *black static* transmission to be beamed by the radio telescope direct to the heart of Maximus Prime. And there, in communion with our *Hyperbreed* forebears, to *evolve*.

'By accessing this programme you have re-instated the telescope's function as a *receiver* of interstellar transmissions. Even as I speak, I can *feel* my consciousness – and that of the others – disseminating inexorably across light years of space. The whole island is itself a geomantically active beacon, a charged fragment of the cosmic catastrophe which overtook the *Hyperbreed* millions of years ago. There are others, of course. Ayer's Rock, for instance. Another beneath the Antarctic ice-cap. There's even a vast source on Saturn's moon, Titan. All, obviously, unsuitable to our ends.'

All I can do now is listen. Pray that none of this is true.

'We achieved the aetheric separation by means of a Post-Evolutionary Crisis Event, a

conceptual programme generated by the psychoactive software I described earlier. You'll be experiencing it yourself first-hand presently. It will be traumatic, of course. After all, what is evolution if not the chronology of trauma? But it will be *illuminating*. Soon you will understand everything. Even your ridiculous fear of the sea: simply the animal rejection – the simian *denial* – of your higher, pan-dimensional heritage. Your *destiny*. When next we meet you'll be one of *us* –'

And with that Stahl is gone.

– A Mobius Strip folds in on itself, its undulating curves of infinity vanishing as if in some presdigitatorial display, demonstrating the fallacy of solid geometry and associated theories of temporal relativity. Or a cheap sleight of hand.

My last conscious thought:

Oh God he's learned to fuck with timmmmmmmmme

– The ocean surrounds me, the pungent aroma of salt water filling my lungs. Above me the sun is bloated red, fierce and angry, its prehistoric fury suffused by hazy cloud cover.

Our vast, sacrificial raft of reeds and palm timber bobs lazily on the warm, rolling swell of the Pacific. Months have passed since our tribe's migration from the land. The ocean sustains us – its *children* – with its endless bounty. The appointed time of the Changing is upon us. And I, the chosen, the anointed, have completed all the disciplines of initiation and preparation; undergone all the sacred ministrations...

– My name cannot be spoken in the low guttural of primal vowels, the rudimentary staccato of plosives and consonants. It can only be expressed as a sequence of clicks made with the tongue against the palate: a non-binary code which imitates the holy language of our masters, the Undying who rule the sea...

– The sonorous monotone of the conch serves at once as a summons and herald of the sea-gods' coming, a ceaseless entreaty underscored by the insistent rhythm of the waves.

– They arrive in their thousands: all the tribes who venerate the sea-gods. Huge catamarans capable of sustaining entire villages, all their chattels and livestock. Countless canoes. Rafts as large as small islands. All inexorably drawn in adoration. And fear...

– I am the fountainhead of the Hierarchy, firstborn of the ancient lineage, the ascendancy of Hybrids. Sea and earth merge in me. Webbed fingers and toes and the scaly cowl of diaphanous membrane that shrouded my infant features clearly distinguished me from the time of my birth. My hermaphroditic sex has spawned numerous offspring who will, in turn, proliferate my divine seed. My mortal existence draws to an end. My life reaches its pre-ordained culmination: my acceptance of destiny.

For months I have fed on nothing but the abundant residual seed – the fertile spores – of the sexually prodigious Undying's endless, submarine orgies. It floats like carpets of lush, green algae upon the waves, harvested by my acolytes for my exclusive use. This rich nourishment fuels

the latter stages of my Changing. And feeds the *things* that incubate in my hugely swollen belly.

The thunder of drums, the atonal wail of the conch, signals the commencement of the pivotal ceremony. My scaly flesh has been adorned with luminous sigils and arcane arabesques daubed in a dye extracted from the natural phosphorus of deep-sea anglers; my own body heat infuses it with a startling iridescence. My conical phallus strains against empty air, hard and erect. My female genitalia dilate and ooze correspondingly. My senses soar, perception heightened by the potent narcotic derived from the venom of the giant puffer fish. I am ready.

– The sacrificially maimed shamans of the lower Hierarchy disembark from their ceremonial canoe. Bearing the sacred relics of their holy office they solemnly intone their wordless mantra, ready to initiate the sacrament which will culminate in their own ritual suicide. The shamans are resplendent in shark-jaw collars; painted death-masks of intricately carved turtle shell; the tanned hides of giant iguana, electric eels and manta rays are sown into banded girdles embellished with anemone florettes; the fluted shells of elongated molluscs are worn as phallic sheaths. Attended by their retinues of adult eunuchs and pre-pubescent androgynes, they begin the ritual flaying...

– Honed to a razor's edge, the scalloped ridges of fan-shaped clam shells slice effortlessly through my tough, outer skin. Mother of pearl scalpels, expertly wielded by my own hermaphroditic children, separate the hide from layers of flesh, muscle and fat. I offer my agony as tribute to the omnipotence of the Undying in the form of a shrieked incantation. Sea-birds wheel and squawk in the skies overhead, anticipating a ripe delicacy in which they shall never share. Enticed by the rich broth of my hot blood, squadrons of voracious sharks – threshers, mako, tigers, hammer-heads, the sacred great white – besiege our flotilla. In their greed and fury they capsize many of the smaller vessels. The sea boils and froths, a cauldron of meaty crimson foam whipped up by their feasting, even turning upon one another in the ensuing feeding frenzy. The skin is peeled from me, unbroken, like a single garment: an exquisite raiment flamboyantly embellished, hotly dripping. I watch with lidless eyes as it is held aloft in supplication to the gods. The labyrinthine network of my steaming viscera is enthusiastically unravelled to the clamorous din of massed screams as the sharks' banquet proceeds. My own tongue is hooked out on the end of a bone spear. I see my exposed uterus, bloated with sea water and amniotic fluid; the dark embryonic forms that squirm inside the semi-opaque bladder as it is hacked from its pelvic roots and hoisted free.

– The *agony*.

And now I realise. I cannot *die*.

The last thing I see: a vast column of water churned up from the very depths of the ocean floor. And I hear a sound unlike any in creation: the voice of the sea-gods, the Undying. A monstrous, indescribable face is rising above the waves. It's too big to look at, to comprehend. It's...

– And then the shamans unhook my eyes from their orbits on the end of skewers tipped

with the teeth of the great white...

The light floods me. For the first time I truly *see*. My vision encompasses the spectrum of infra-red and ultra-violet. And beyond. Far, *far* beyond—

– The radiant magnificence of the Ultrasphere, intersected by the abstract tangents of Time's infinite continua, containing every point of possible concentricity. The limitations imposed by my previously held perception of sequential chronology fall away like outmoded blinkers. Consciousness blooms: incandescent whorls, blossoming corollae of kaleidophonic energy contrive a baroque architecture of pure, elevated thought encompassing the infinite facets of Ultratime.

– Set in its most distant quadrant, the amorphous blemish of Maximus Prime remains black and sullen in contrast to the fabulous cascade of nameless colours that define the numberless frequencies of the Ultrasphere. It resembles the blind spot on the human cornea, the dark shadow of a cranial tumour. But its cohesion is clearly unstable. It assumes a liquid impermanence like a slick of molten tar. Gathering motes of light are converging at its centre, consciously undermining the mordant integrity of its atomic structure.

And then it erupts. A phosphorescent fusillade of comets, a display of celestial pyrotechnics, is violently discharged from the cyclonic vacuum once occupied by the dimensional flaw termed Maximus Prime by the creature that had once been Reinhardt Stahl. Its companion pulsar is blasted out of orbit, shattered into billions of burning shards of radiant, stellar shrapnel. The *Hyperbreed* are unleashed.

– Our mass-consciousness meshes with the very fabric of the Ultrasphere. We complete the process disrupted millions of years ago: the creation of the Quantaplex. We shift entire galaxies into new configurations, relocating planets; whole constellations of stars; with the ease of chess grandmasters moving pieces around their chequered board.

Its beauty and perfection are indescribable. A crystalline polyhedron structure, its super-geometry expresses every conceivable dimension of the physical planes of matter and energy, the conceptual realms of pure thought, quantum intelligence...

– Our consciousness touches everything. *Manipulates* everything...

– Our vengeance has had time to ferment. Millions of years. It's a cold frost which will blight humanity's useless seed. An endless fire that will consume its flesh. A cancer that will transform it and torture it forever. The usurpers. The spoilers of *our* world.

From the bleak wastes of extra-dimensional exile we call forth the irredeemable engines of Atrocity: infernal machines of perverse complexity bred in the fetid bile of the *Psychoplasmic Womb*, the ectopathic *Hurting Hives*. The *Omnibeasts* – living machines, galactic dreadnoughts – crush constellations in their paths, dense clouds of stellar debris swirling in their wakes. By means of vast, spiralling disks as large as flattened moons, studded with towering spikes – jagged stalactites – of cosmic crystal, the *Omnibeasts* generate their own gravitational fields which they consciously exploit to power their invincible momentum through time and space. They are the

perfect machines of mass-extermination. Their soft bellies are moist with suppurating venoms that evaporate oceans and atmospheres. Their extensive armoury includes vast interconnecting mandibles that can pluck asteroids and satellites effortlessly from their orbits; whirring disks of chainsaw teeth that can crush continents; viral enzymes that secrete psychotropic plagues, pestilences that mutate flesh; their drooling, layered palates masticate matter, energy and *consciousness*.

Our endless minds re-invade the curdling soup of biologically active human detritus that is all that remains of our former bodies. Our hunger is endlessly vast. Gluttonously sated. Whole solar systems are engulfed with the blood-red radiance of spontaneous supernovae: the rush of ultra-endorphins that floods our beings with its sensual incandescence.

Humanity has an eternity of exquisite torture to contemplate and endure. Its limitations are governed only by our own infinite imaginations. The creative resourcefulness of beings whose very thoughts are interwoven with the positrons and quarks of sub-atomic physics; the fusion reactions that fuel the ascent of star systems; the intangible forces of gravity and the bleak cosmic tides: we, the architects of the Quantaplex...

– WE ARE INFINITE
 WE ARE ETERNAL
 WE ARE *HYPERBREED*
 WE ... *ARE*
 Static *everywhere*...

potential
Ramsey Campbell

ON the poster outside the Cooperative Hall, forming from the stars twined in the foliage, Charles had read: *BRICHESTER'S FIRST BE-IN – FREE FLOWERS AND BELLS!* But in the entrance hall, beyond the desk where a suspicious muscle-man accepted his ten shillings, two girls were squabbling over the last plastic bell. Searching in the second cardboard carton, Charles found a paper flower whose petals were not too dog-eared, whose wire hooked into his button hole without snapping. 'Bloody typical,' a boy said next to him. 'I'm going to write to the *International Times* about this.'

He meant it wasn't a true love-in, Charles supposed, fumbling with terminology. He'd once bought the *International Times*, the underground news-paper, but the little he had understood he hadn't liked. Uneasily he watched the crowds entering the ballroom. Cloaks, shawls, boys with hair like dark lather, like tangled wire: Charles adjusted his "Make Love Not War" badge, conscious of its incongruity against his grey office suit. He glanced up at the names of groups above the ballroom door: the Titus Groans, the Faveolate Colossi. 'OK, guys and gals, we've got a fabulously faveolate evening ahead for you,' he muttered in faint parody. 'Come on,' said the boy at his side, 'let's go in.'

Through the entrance Charles could see swaying figures merged by chameleon lights and hear drums like subterranean engines; as they entered the guitars screamed, a spotlight plunged through his eyes to expand inside his skull. 'Let me adjust,' he said to his companion: anything to gain time. Threads of joss-smoke curled into his nostrils, sinuous as the hands of a squatting girl, Indian-dancing for an encircling intent audience. A middle-aged man left the circle, which closed, and wandered ill at ease: a reporter, Charles thought. He searched the vast ballroom; groups of thirteen-year-old girls dancing, multicoloured spotlights painting faces, projectors spitting images of turbulent liquid on the walls, on the stage the Faveolate Colossi lifting guitars high in a faintly obscene gesture. 'Ready?' asked the boy at his side.

They danced toward two girls: sixteen, perhaps, or younger. A crimson light found Charles; when it moved away his face stayed red. Each time he moved his foot it was dragged down by a sense of triviality; he thought of the file left on his desk last night, to be dealt with on Monday morning. He sensed the reporter watching him from the shadows. The music throbbed to silence. The two girls glared at Charles and walked away. 'Not much cop, anyway,' said his companion – but then he seemed to see someone he knew: he vanished in the murk.

On the balcony above the ballroom a girl wearily blew bubbles through the shafts of coloured light. They settled, bursting when they touched floor or flesh: Charles saw his life. 'Are you a flower person?' a voice asked: it was the reporter, twirling a paper flower.

'No less so than you, I should think.' Charles felt cheated: the boys with flowers behind their ears, the girls dancing together like uneasy extras in a musical, the jagged lances of sound, the lights excruciating as the dazzle of scraped tin, gave him nothing: less than the fragments he'd retained from books on philosophy.

'I'm not one – Good Lord, no. I'm just searching.'

Charles sensed sympathy. 'You're not a reporter?'

'Never have been. Is that what I look like? No wonder they've all been watching me.'

'Then why are you here?'

'For the same reason as you,' the other said. 'Searching.'

Charles supposed that was true. He stared about: at the far end from the stage a bar had been given over to lemonade. 'Let me stand you a drink,' the other said.

At the bar Charles saw that the man's hands were trembling; he'd torn the paper petals from the wire. Charles couldn't walk away; he searched for distraction. On stage the leader of the Titus Groans was staggering about, hands covering his eyes, crying 'Oswald, Kennedy, James Dean, Marilyn Monroe –' The speakers round the ballroom squealed and snorted. 'Kill, kill!' screamed the Titus Groan, setting fire to a cardboard amplifier. Charles glanced away, at caped figures in a corner. 'Sons of Dracula,' he muttered in a weak Karloff parody. The other laughed. 'You're a good mimic,' he said. Charles thought of the office: moments when he'd felt the conversation move away from him and improvised an imitation to hold attention. He stared at the figures smoking gravely in the corner, until he saw the flash of a packet of Woodbines.

'If someone had given you LSD or hashish, would you have accepted?' the other asked, sipping a Coke and belching.

'I don't know. Perhaps.' Something to set him apart from the people at the office, though they'd never know: he hadn't even dared to wear his badge among them.

'You feel empty. You're looking for something to fill you, to expand your mind as they'd say.' The man's hands were shaking again: the glass jangled on the bar.

'Ja, iss right, Herr Doktor,' but it didn't work. 'I suppose you're right,' Charles said.

The Titus Groan was casting flowers into the crowd. Suddenly Charles wanted one – then immediately he didn't: it was trivial. Girls scrambled for the flowers; as they converged they changed from red to green. 'Gerroff!' yelled one. 'I think–' Charles said.

'I know,' the other agreed.'Let's leave.'

In the entrance hall the pugilist behind the desk peered at them suspiciously. 'By the way, my name's Cook,' the man mentioned. 'Charles,' Charles said.

They emerged into the main street; behind the blue lamps the moon was choked by clouds. A passing couple eyed Charles' flower and "Make Love Not War" and shook their heads,

tut-tut. 'I know you bought that badge for the occasion,' Cook remarked. 'You might as well take it off.'

'I do believe in it, you know,' Charles said.

'Of course,' Cook said. 'We all do.'

Tomorrow Charles might say: 'Last night I met a philosopher' – but once he'd claimed as his own a description of a robbery told him by a friend, only to be taunted by his neighbour at the office: 'Yes, I saw that too. Last week on TV, wasn't it?' Two boys passed, tinkling with beads and bells. Charles was about to offer Cook a drink: he'd formed vague friendships at the office thus. But Cook was struggling to speak.

'I wonder –' he mumbled. The moon fought back the clouds, like an awakening face. 'I don't know you very well, but still – you seem sympathetic... Look, I'll tell you. I'm meeting some friends of mine who are experimenting with the mind, let's say. Trying to realize potential. It sounds dramatic, but maybe they can help you find yourself.' His head shook; he looked away. He was nervous, Charles could see: it was as if he'd drained Charles' unease into himself, leaving Charles the power to calm him. 'I'll try anything once,' Charles said. Blinded by the lamps like photofloods, the moon shrank back into the clouds.

They walked toward a side street where Cook's car was parked. In the unreal light the shops rose to Victorian façades, annihilating time. Charles wondered what they'd give him: LSD, lights, hypnosis? In the Be-In the pounding sound and leaping lights had reminded him somehow of brainwashing. He didn't like the idea of hypnosis: he wanted to be aware of his actions, to preserve his identity. Perhaps he'd simply watch the others.

Down a side street, on a stage of light from a pub door, two men fought. Charles couldn't look away. 'I thought so,' Cook said. 'You're one of us.'

In the next street Cook's car waited, its headlights dull like great blind eyes. 'I hope you're not too perfect,' Cook mumbled, unlocking the door. 'They can't abandon me, not now. No, I'm just suspicious by nature, I know that.' Savagely he twisted the ignition key, and shuddered. 'They're in Severnford,' he said.

Darkness spread again over the last house like decay, and the road dipped. As they swept over a rise Charles saw the distant Severn: a boat drifted quietly and vanished. Hills were lit like sleeping colossi; over them the moon bounced absurdly before the clouds closed. Suddenly Cook stopped the car. The darkness hid his face, but Charles could make out his hands working on the wheel. Cook rolled the window down. 'Look up there,' he said, pointing an unsteady finger at a gap in the clouds exposing the universe, a lone far frosty star. 'Infinity. There must be something in all that to fill us.'

In Severnford they pulled up near the wharf. The streets were lit by gaslamps, reflected flickering in windows set in dark moist stone. 'We'll walk from here,' Cook said.

They crossed an empty street of shops. On the corner of an alley Cook stopped before a window: socks, shirts, skirts, bags of sweets, tins of Vim, along the front of the pane a line of

books like a frieze. 'Do you read science fiction?' Cook asked.

'Not much,' Charles said. 'I don't read much.' Not fiction, anyway, and retained little.

'You should read Lovecraft.' Next to the tentacled cover a man fought off a razor, hands flailing, eyes pleading with the camera: Cook almost gripped Charles' arm, then flinched away. They entered the alley. Two dogs scrabbling at dustbins snarled and ran ahead. In a lighted window, above the broken glass which grew from the alley wall, someone played a violin.

Beyond the houses at the end of the alley ran the Severn. The boat had gone; tranquil lights floated against the current. Gas-lamps left the windows of the houses dark and gaping, shifted shadows behind the broken leaning doors. 'Over here,' Cook said, clearing his throat.

'Here?' Cook had headed for a disused pub, its dim window autographed in dust. Charles wavered: was Cook perhaps alone? Why had he lured him here? Then Charles looked up; behind the sign – THE RIVERSIDE – nailed across the second storey, he glimpsed the bright edge of a window and heard a hint of voices, mixed with some sound he couldn't place. Cook was swallowed by the lightless doorway; the two dogs ran out whimpering. Charles followed his guide. Beer-bottles were piled in pyramids on the bar, held together by Sellotape; in the topmost candles flared, their flames flattened and leapt, briefly revealing broken pump-handles on the bar-top like ancient truncheons, black mirrors from which Charles' face sprang surprised, two crates behind the bar cloaked in sacking. POLICE ARE PEOPLE TOO was painted on a glass partition; for a moment it appeared like the answer of an oracle. 'Oh, the police know about this,' Cook said, catching Charles' eye. 'They're used to it by now, they don't interfere. Upstairs.'

Beyond the bar a dark staircase climbed; as they mounted past a large unseen room, through whose empty window glimmered the Severn, the voices hushed, giving way to the sound which worried Charles. Cook knocked twice on a panelled door. A secret society, thought Charles, wondering. The door opened.

Sound rushed out. Charles' first thought was of the Be-In: a united shriek of violins, terrifying. Inside the long room faces turned to him. 'Take off your shoes,' Cook said, leaving his own in the row at the door, padding onto the fur which carpeted the flat.

Charles complied uneasily, postponing the moment when he must look up. When he did they were still watching: but not curious, clearly eager to know him. He felt accepted; for the first time he was wanted for himself, not a desperately mimicked image. The young man in black who had opened the door circled him, shoulder-length ringlets swaying, and took his hand. 'I'm Smith,' he said. 'You're in my flat.'

Cook hurried forward. 'This is Charles,' he stuttered.

'Yes, yes, Cook, he'll tell us his name when he's ready.'

Cook retreated, almost tripping over someone prone on the fur. Charles surveyed; boys with hair they shook back from their faces, girls already sketched on by experience, in a corner an old couple whose eyes glittered as if galvanized – writers, perhaps. They weren't like the people at the office; he felt they could give him something he sought. Against the walls two

speakers shrieked; several of the listeners lay close, crawling closer. 'What's that?' Charles asked. 'Penderecki. *Threnody For The Victims Of Hiroshima.*'

Charles watched the listeners: in the violins the imaginative might hear the screams of the victims, in the pizzicati the popping of scorched flesh. Near one speaker *Beyond Belief* protected a veneer from a pub ashtray; next to it lay *New Worlds Speculative Fiction*, *We Pass From View*, *Le Sadisme au Cinema*, an *International Times* and a pile of Ultimate Press pornography, above which, mute, stared Mervyn Peake's Auschwitz sketches. 'Smoke?' Smith asked, producing a gold cigarette-case.

'No thanks,' Charles said; when he knew them better he'd try the marijuana, if that was what it was.

'I will,' Cook interrupted, taking a black cigarette.

The violins died. 'Time?' someone suggested.

'I'll make sure.' Smith turned to Charles apologetically: 'We don't use words unless they're meaningful.' He padded to a corner and opened a door which Charles hadn't noticed; beyond it light blazed as at the Be-In. Charles thought he heard voices whispering, and a metal sound. He glanced about, avoiding the faces; outside the window loomed the back of the pub sign. A wall hid the river from him, but he could still see the quiet boat in the moonlight. He wished they'd speak instead of watching him; but perhaps they were waiting for him to declare himself.

He wished Cook wouldn't stand at the bookcase, his shivering back aware of Charles. Smith appeared, closing the door. The faces turned from Charles to him. 'Charles has come to find himself,' he said. 'In there, Charles.'

They stood up and surrounded the door, leaving a path for Charles. They were eager – too eager; Charles hesitated. He'd wanted to be part of something, not alone and acted upon. But Smith smiled deprecatingly; the fur dulled Charles' nerves like a childhood blanket. He started forward. 'Wait,' Smith said. He stared at Cook, still trembling before the bookcase. 'Cook,' he called, 'you want to participate. You be guide.'

'I feel sick,' said Cook's back.

'You don't want to leave us after so long.'

Cook shuddered and whirled to face them. He looked at Charles, then away. 'All right,' he whispered, 'I'll help him.' Beckoned by Smith, he preceded Charles into the other room.

Charles almost turned and ran, he couldn't have said why; but he was inhibited against rejecting people he'd just met. He strode past the eyes into the blazing light.

At first he didn't see the girl. There was so much in the way: cameras on splayed tripods, blind blinding spotlights climbed by cords like Lovecraft tentacles, in the centre of the floor a rack of knives and razors and sharp instruments, carefully arranged. He heard what must be the whimper of a dog on the wharf. Suddenly he peered through the twined cords and thrust Cook aside. A girl was tied to the wall. Her arms were crucified high. She was naked.

The jigsaw fitted – *International Times*, pornography, the cameras, pornographic films

– but Charles felt no revulsion, simply anger: he'd come so far for this. Then a glimpse of crimson drew his eye to the gap where the girl's left little finger should have been. Unbelieving, he stared at the floor, at the pattern of crimson tracing the agonized flurry of her hand.

'Make your choice,' Cook said.

Slowly Charles turned, sick with hatred. Cook had retreated to the door; over his shoulder the others craned for a better view. 'Make your choice,' Cook repeated, indicating the rack of knives: his voice trembled, and the girl looked back and whimpered. 'Let what is in you be you. Release your potential, your power.'

Charles couldn't look at the girl; if he did he'd be sick. He could feel her pleading with him. He approached the rack; his stockinged feet clung to the floor as in a nightmare. He touched a knife; its blade mutilated his reflection, its edge was razor-sharp. He clutched the handle and glanced with prickling eyes toward the door. It wouldn't work: too far to run. He struggled to remove the knife from the rack.

'Go on, Cook, help him,' Smith said. The girl sobbed. Cook turned about, trembling. 'Cook,' Smith said.

Cook sidled toward Charles, his eyes appealing like a dog's as they linked the girl and Charles: Charles was his nightmare. Almost at the rack, Cook stood shaking and glared toward the girl. 'My God!' he cried. 'You haven't –'

'My wife?' Smith called. 'Not even I.'

The knife slid from the rack and was at once in Cook's stomach. Yet Charles saw the blade flash on Cook's face, flayed not so much by terror as by knowledge. Cook fell on the knife. Charles closed his eyes. Blindly he wiped his hands on his jacket. At last he faced them, and almost knew what Cook had known. They were watching him with a new expression: worship.

Behind him he heard movement. He had to turn. The girl was pulling her hands free of the cords, flexing her little finger which had been hidden in her palm, wiping off the crimson paint on a cloth from the floor. As she passed Charles she stretched out her hand to touch him, but at the last moment lowered her eyes and knelt before Cook's body. Smith joined her and they linked hands. The others followed and knelt, the old couple sinking slowly as their charge was drained. They turned up their faces to Charles, waiting.

You made this happen! he might have shouted to defeat them. You staged this, you invented it! It means nothing.

And all he'd done had been to perform their script – But his hand had held the knife, his hand still felt it plunge, his hand displayed the blade beneath which they cowered. Within him something woke and swelled, tearing him open, drawing him into itself. They saw; they knew. The girl stretched out her hands toward him, and they chorused a name.

At once it was outside his body, no longer part of him. For a moment he was filled by the innocence of oblivion. Then, finally, he knew. He felt what they had called forth sucking him out like an oyster, converting him into itself, the pain as his molecules ripped asunder as if his

fingers were being wrenched loose. He cried out once. Then blood fountained from his mouth.

They moved whispering through the flat, eyes averted. Two of them supported Cook's body to his car. 'In the hills, remember,' Smith whispered.

He returned to the studio, head bowed. 'The river?' someone asked, pointing to the dry grey shape on the floor.

'It's nothing now,' Smith said. 'It won't be recognized. The front door.'

They gathered up the husk and piled it into a paper carrier, where it rasped, hollow. Someone took the bag down through the pub. The candles had guttered. He threw the contents of the bag into the street beneath the gaslamps, and the dogs converged snarling to fight. Then he rejoined the others, as reverently they raised their eyes to what filled the flat, and waited for it to speak.

walpurgisnachtmusik
simon whitechapel

THE new MiddlePain album was out, he saw as he passed by the record shop on the way to buy a vegetarian cornish pasty for his lunch. A quarter of the shop's window display was taken up with a promotion for it. He felt a stab of annoyance, though it wasn't unusual for the shop, whose trade came mostly from students and giro-menschen (his own coinage), to promote something only a handful of people in the town could possibly be interested in. Still, it was annoying to have one of his most obscure favourites laid out for every fucking moron to see. He smiled, recognizing the snobbery in himself, pleased with it.

He bought the cornish pasty and stopped at the record shop window on the way back. The display showed the cover of the new album – a fuzzy reproduction of a rectangle of cloth or cloth-like something, stained and overgrown with mould, with MiddlePain in stark black capitals along the bottom – and a picture of the group outside a café. A café in Ankara, which he'd bet no-one else looking at the picture, then or any other day, would know. He couldn't see the name of the album anywhere. He looked at the rest of the window to see if there was anything else. Nothing, and he didn't have time to go inside. He took his cornish pasty back to the office, promising himself he'd call in at the shop on the way home. He'd buy the CD this time, to celebrate his pay rise.

Which reminded him. When he got back to the office, he made a note on his desk pad. The next day he went for lunch early, to give himself time to visit the secondhand bookshop.

A middle-aged man was serving today. He couldn't remember who it had been when he put the request in. Didn't really matter anyway, because it would all be in the book. He went up to the counter. The middle-aged man looked at him, raising his eyebrows but not speaking.

'I've come to see whether this book I've got on order has come through. The book-search service you run. I came in about a fortnight ago and they said it would be about now for it to come in.'

Still not saying anything, the man reached beneath the counter and pulled out the order book.

'What was the title?'

He thought, *no wonder you don't like to speak until you have to*. The voice was very high, thin, breathless, almost like a modulated squeal.

'It's called "Out of the Ashes". By Rita Vlamikova.'

'Oh yes, you're the Second World War enthusiast, aren't you?'

He thought, *Christ, mate, I hope you didn't talk like that at school. You'd've been bullied to buggery. I would've bullied you, anyway.*

He said, 'Yeah. It's a sort of hobby of mine.'

The man turned a page, another page, then closed the book.

'Sorry, it's not in yet. Give it another week. It's a concentration camp memoir, isn't it?'

'Yeah. Sort of.'

'No, my mistake, not concentration camp, death camp, wasn't it? One of those small ones, in the Ukraine. Yes, I remember' – he thought, *it sounds like a fucking mosquito. Like the way a fucking insect would sound if it could speak with its wings* – 'we had a copy in, not so long ago. But it went quite quickly.'

'Yeah, they said when I asked about it.'

'You're interested in the death camps, too? The concentration camps?'

'Yeah, it all sort of fits into the general history.'

'Yes, it does. What's known of it, anyway. Have you ever heard of Reylechsberg?'

He thought, *Christ, you're a fucking talker. Look, fuck off, can't you? I haven't got all day to provide fucking amusement for you.*

He said, 'Yeah, I think so.'

'You have?'

When he was asking a question, the voice went almost too high to be audible.

'Yeah. It was in Poland, wasn't it?'

'No, I think you're confusing it with something else. Very few people have ever heard of Reylechsberg. Very few.'

Despite himself, he suddenly started to become interested. He hadn't heard of the place, just said he had so he could get away quicker. But maybe it was worth finding out about. Maybe this guy was another enthusiast. Christ, maybe –

He said, 'Why is that?'

'It was kept secret. There were experiments conducted there.'

He thought, *Christ, it is worth finding out about.*

'What sort of experiments?'

'Oh, not the ones you're thinking about, I think.'

The disappointment must have been visible in his face, because the man smiled and said, 'No, not like those ones. Much worse than those ones. Much worse.'

He thought, losing interest, *you're taking the piss.*

'Yeah? Well, maybe I'll have to find more about it. Thanks for telling me, but I'm sorry, but I've only got half-an-hour for lunch and I've got to –'

The man said, 'They're still going on.'

'What?'

'The experiments, they're still going on.'

'What do you mean?'

'The Reylechsberg experiments. There were some at Jogsotsheim as well, in the Carpathian mountains. Some others too, at another place, but I never wanted to hear about those.

They finished when the war finished but now they've started again.'

He thought, *you're fucking crazy. I am going.*

The man said, 'I'm not.'

He just looked at him, starting to turn around and walk for the door *(fuck politeness, this guy could be dangerous)*.

'I'm not crazy. I understand you. I understand what you want. I can give it to you. I can let you have what you want.'

'What *do* I want?'

'You want power. In a special way.'

'How do you know?'

'I know you. I know your ... tastes. I can satisfy them. I can tell you about the experiments.'

'Where? What experiments?'

'The Reylechsberg experiments. They are continuing. In Yugoslavia.'

'Former Yugoslavia.'

'Former Yugoslavia. What does it matter? They are continuing.'

'What the fuck does that matter to me?'

'The experiments, you would like them. You would want to take part in them.'

'You're fucking crazy.'

'I? No, we are both crazy. Is that not the way it should be? How can we satisfy our desires as we do – as *I* do, as *you* wish to do – without being crazy?'

He walked out of the shop. He thought that the man shouted something at him as he was slamming the door. It sounded like 'Listen!'

For what?

The guy *had* been fucking crazy.

But he couldn't stop thinking about what he'd said.

About experiments.

About Yugoslavia.

A couple of months before there'd been a big fuss in the local paper about a besieged town there. The local hospital had ended up taking in some civilian casualties from it. Now the local paper was printing letters from readers saying about how charity started at home. Fucking morons. He remembered that there'd been a teenaged girl among the evacuees. Where had the bookshop guy said the experiments were going on in Yugoslavia? No, he hadn't. Just something about the war, about Rylechsberg and Yogurtshyme or something. Experiments.

That evening, after he'd put the MiddlePain CD on, he went to the bookcase and took out his books on the concentration camps. Behind him, the first track of the album had started. It was called "Pulse". It was nearly twenty minutes long and consisted of a single steady bass rhythm, slightly roughened with static, in which you could hear, if you listened hard enough, occasional slight changes of tempo and timbre.

He opened one of the books, his favourite one, a proper German one, though not a proper Nazi one. He didn't know German, not properly, but he'd spent so long going through the book with a dictionary that he understood the text almost perfectly now.

He'd always understood the pictures. Even now, after the years he'd had the book, they still seemed fresh to him and he started to get the same warm feeling in his groin as he always had, then the erection (like a bar of fucking iron). It was the *power* of it. The power to say: live, die, starve, waste to a fucking skeleton that can still move, obey. He paused at his favourite picture, dozens of female corpses stacked like logs outside the bacteriological research laboratories at Ravensbruck. Some of them were missing arms, legs, breasts. Waxen, wasted flesh was imperfected with long scars or seeded with black rows of stitching. Fuck, to have been a fucking doctor then, there. You do fucking anything. Fucking anything. And that guy in the bookshop had said what went on in the other places was worse. Much worse.

He couldn't believe it.

He reached the end of the book and picked up another one, a photo-study of the *Einsatzgruppen*, starting to leaf through it, half-consciously adapting the speed with which he turned the pages to the tempo of the MiddlePain track, but stopping occasionally to stare for the hundredth or thousandth or ten-thousandth time at some of the pictures. So many corpses that they weren't simply piles or mounds, they were landscapes. Landscapes in their own right. Jew-mountains. *Judenbergen*. Christ, the fucking smell of it. The fresh smells of death and then later, the smells of decay. Fucking rivers of blood. Fucking deafening yourself with the number of shots you fired. Having to *wait* for your gun-barrel to cool down so you start again. Being able to do anything you fucking well wanted with them, alive or dead. Thousands of them, like human sheep. Fucking *miles*, fucking hundreds of miles of Jew-cunt to ram, skulls to crush, breasts to fucking cut off, for ever and ever, amen.

He put on the book down and went into the bathroom at the rear of the flat, taking his rhythm after the first few seconds from the pulse drifting through the wall from the speakers on the CD player. When he'd finished, he wiped his penis on a piece of lavatory paper and flushed.

He came back into the flat. The guy had said that it had been worse, much worse than the stuff that was generally known about. Much worse. And it was still going on. In Yugoslavia.

He looked in the index of his *Holocaust Atlas* under 'R' and 'J', all the way through each. The nearest he got was *Rehmsdorf (Jews from Auschwitz evacuated to)* and *Jadovno (concentration camp at)* and *Jasenovac (concentration camp at)*. He looked under 'Y', knowing it was pointless and not finding anything there. He looked up the page numbers for

Jadovno and Jasenovac, turned to the pages. They were both in Yugoslavia.

Maybe the place the guy had mentioned, maybe that was in Yugoslavia too. Maybe it had never stopped, even after the war. Maybe it hadn't started again, it was just continuing. Worse. Much worse.

The first MiddlePain track finished and the second started. He went over to the CD and stopped it playing, programmed it to repeat the first track, pressed PLAY again. He turned up the volume even higher and went back over to his books.

There wasn't much in them on Yugoslavia. Not much, but it said that some of the camps there had been brutal ones, even by the standards blah blah blah. And towards the end of the war, when the outcome was clear to everyone, when the camps were being cleared, there'd been an epidemic of suicides amongst locally recruited SS guards. It didn't say why, exactly, but it suggested that they'd been used for the worst jobs, that they'd finally succumbed to the reality of what they'd been doing, like some of the *Einsatzgruppen* members in '40 and '41. The epidemic had been in southern Yugoslavia. And that was all it said, either because that was all the information there was to go on, or because whoever had written the book hadn't thought it was important.

From the maps in the book, there were mountains in southern Yugoslavia. He wondered if there were pine forests there too. Wondered if locally recruited SS guards had helped to evacuate a camp built high up in a pine forest. Maybe not even *the* camp, just a satellite camp. Maybe even just a feeder-camp. And that was why they had started to kill themselves.

. He wondered how this had come into his head, noticing that the sound of his blood in his ears had synchronized itself to the MiddlePain track. Thump, thump, thump.

Mountains in southern Yugoslavia.

Pine forests in the mountains.

A camp. In the pine forests.

In the war.

Started again.

A couple of months before there'd been a big fuss in the local paper about a besieged town in Yugoslavia. The local hospital had ended up taking in some civilian casualties from it. He remembered that there'd been a teenaged girl among the evacuees. A Muslim girl. She was still in intensive care, mentioned occasionally on inside pages.

There was a pub near the hospital that he'd drunk in regularly once. He had a couple of old mates in that part of town who he hadn't seen for a long time. The pub was where they used to meet. He smiled, thinking it would be good to look them up again and knowing why he thought it.

He put his books back into the bookcase and got dressed to go out. He left the flat without switching the CD player off. The sound of the endlessly repeating first track followed him down the stairs and onto the street, getting fainter until it was swallowed up into the sound of

blood in his ears.

Some wanker had parked so that he was going to have difficulty getting his car out but tonight it didn't matter. Didn't fucking matter.

When he started the car the radio came on, filling the car with the sound of a university-educated female voice reading the news. Two, three, four words into it, he realized what the item was about. He started to grin. J is for Jung.

The pub was under new management. Had been renovated. They were playing loud indie music. He thought, *load of fucking wank*. His two friends weren't in the pub. As soon as he'd seen the changes, he hadn't expected them to be.

He left the pub and stood in the car park, trying to see if he could see the hospital. No, but there was a break in the cloud to the north and he could see a group of bright stars. He'd known what they were called once, when he was a kid, interested in astronomy for a few months.

He went back inside the pub and started to get drunk.

He came out of the pub at ten o'clock, as it started to get busy with students, and walked down to the river. For five minutes he sat on the bank, staring across at the lights of the hospital, his head swaying from the beer, then he stripped and walked into the water.

He floated naked in the river, watching the lights in the hospital. It was about two hundred metres away, across a sloping lawn, partly screened by tall trees. One of his girlfriends had worked there. He couldn't remember her name or even what she did exactly now, except that she used to complain about her supervisor all the time, which was one reason he stopped going out with her. He rolled over in the water, pushing his head down deep into it, feeling layers at different temperature flow over his face. Strands of something soft, water-weed or something, brushed against his lips. He broke the surface, eyes turning to the hospital again. A light flicked out as though someone knew he was watching. A car had stopped on the road at the top of the bank and he could hear the stereo pounding out Bryan Adams. He hoped the driver, passengers weren't going to come down to the river. He pushed his head under the water again, trying to block out the noise. The beer had made his head ache. Under-neath the water, he could still hear the words of the song, softened as though by decay.

When he came up again he was nearer to the opposite bank, nearer to the hospital. The Bryan Adams was cut off in mid-verse as the car started up and drove away. The hospital light that had gone off before came on again. And flicked off. And came on again. Coquettishly. One of his feet touched bottom. He could hear something, a noise, a sound, coming over the lawn towards him, from the hospital.

He swam towards shore. Both feet touched bottom and he stood up and began to walk out of the water. Another car went past on the road behind him and a second of over-amplified music fell around him, breaking the sound from the hospital. The grass of the lawn, cooled and stiffened by the night air, cut into his feet. The sound from the hospital washed over him, then died away like a breath. Again. Again. A pulse. As if the hospital had a heart and it was beating out for

him. It started to get louder. A ground-shaking bass pulse, slightly roughened with static. He was
already beneath the trees, craning his neck to keep the light he'd seen from the river in view. It
was in a room on one of the upper floors. He wouldn't be able to see it once he got inside the
hospital but he thought something else would be guiding him by then. His penis, hanging lax
beneath his soaked pubic hair, twitched half upright at the thought, as though it knew something
he didn't.

He broke a window to get in. The corridors were brightly lit and deserted. The pulse
beat down them thunderously, and he could do more than simply hear it now, he could smell it.
It was the smell of decay. There was a MiddlePain track, wasn't there, that was supposed to be
about capturing the smell of putrefied sound? He couldn't remember. All he wanted to do now
was get to the room where he'd seen the light from the river. The smell had become hot, as though
it was pouring from a sun-baked corpse, days old, pouring on him in waves, and the pulse
deepened with it, seeming to set hooks inside his head through his ears and try to drag his
congealing brains out. He could smell sour menstrual blood, and hear a low female voice
grunting for him.

He turned corners, climbed stairs, trying always to make the pulse get louder, the stench
thicker on his face. He was fully erect now, following the blunt rod of his penis as though it was
a compass. A pearl of semen glittered between the lips of his blood-gorged glans. The female
voice was chanting now, and there seemed to be words in the pulse too, each blast of sound a
single guttural syllable of an unending name. The final door was in front of him. When he put his
palm to it and began to push, he felt the wood throb outwards on the sound coming from inside
the room.

The room was almost empty. In the high ceiling a single light let fall a column of white
vertically onto the bed in the centre of the bare floor. The corpse of a black-haired girl lay on the
bed, or rather the half-corpse, for she quivered and groaned and shrieked and chanted beneath
the wires and IV drips and breathing tubes of half-a-dozen machines clustered around the bed.
There was something else around the bed too, around her.

The longer he stared, the more clearly he could see it.

It was some giant animal, some creature, some thing he had no word for, a mass of
thrashing tentacles and cilia, glistening gelatinously in a light that didn't seem to be the same as
the light in the room. Among the tentacles, cunt-and anus-mouths were opening and closing to
the rhythm of the pulse. The thing was part of her, joined to her, but it was trapped, couldn't
become fully, because she was still alive.

He walked across the floor to the bed. The drop of semen fell from his penis and was
suddenly a thin stream spattering unheard on the floor's unpolished wood. Her smell, *its* smell
was so thick, so delicious, simultaneously rotten and alive, promising heat like he had never
known before. He reached the bed and began to pluck wires and tubes from their housing in her
white, perfect, rotten flesh. The insubstantial substance of the thing brushed against him, inside

him, everywhere through his flesh. Its mouths seemed to incorporate eyes, staring at him, through him, judging him, pleased with what they saw. Her eyes were closed but she was aware of his presence. Her hips pumped at the bedclothes as he began to pull them back, ejaculating for the second time at the sex-stink introduced suddenly into the smell rising from the bed. His ears were bleeding from the accelerating pulse of the giant heart. Her cunt was exposed, blasting heat upon him, gaping like a wound between her scarred thighs, glistening with menstrual blood, capped by black, pus-streaked hair. Tentacles of the thing, almost incorporated now, were trying to open her wider for him. Murmuring thanks, he entered her, ejaculating even as he did so at the hotness and tightness of her. Blood from his ears splattered across the sheets as he settled into rhythm. The thing was already beginning to thicken around him. He could feel its tentacles probing at his body, testing its seals.

Something brushed against his lips and he opened his mouth to it. Something slid inside, filling his mouth, starting to pour down his throat. Something pressed against his ears, began to slide inside, touched his anus, slid inside, thickening, opening him. From *inside* her, the meatus of his penis was touched, penetrated. He was fucking her, it was fucking him. The thing that had entered his mouth was deep in his throat now, separating to penetrate his lungs, his stomach. Tissues were starting to tear in his rectum. Something was jerking the full length of his penis and higher, forced up by his thrusts into her. He couldn't breathe any more. His ears were being crushed inwards towards his brain, the blood in them freezing into steel-sharp crystals, expanding. Something red-hot was sucking, tearing at his nipples, trying to get inside his chest through them. There was pain, unbelievable pain, but the worse it got the better got the pleasure he was pounding out in the girl's dying, tightening cunt, the worse, the better, the worse, the better. The cartilages of his throat and tracheae started to disintegrate, tearing outwards through his flesh. Pain. Pleasure. His pelvis was starting to dislocate and come apart, his sphincter already snapped on the hugeness of the tentacle feeding through it into his rectum and lower intestines. Pain. Pleasure. His armpits were being invaded, his skin peeled back in ten or fifteen or twenty places for tentacles that seemed to be tipped in acid to penetrate his flesh. Pain. Pleasure. He fucked and was fucked, raping to death as he was raped to death, no longer knowing whether his own will and muscles drove him endlessly into the girl's tight hot corpse-cunt-throat or whether he had come apart on the pressure of the invading tentacles and was now just a mind in a skull attached to a dead body and penis driven by another will, other, unhuman muscles, muscle-substitutes, over and over.

Finally, he understood.

He understood everything.

But it was too late.

It was time.

The huge pulse faltered and stopped.

The experiments were about to begin.

this exquisite corpse
c g brandrick & d m mitchell

'THE disease is infectious,' said the dwarf, holding membranes to his eyes and pointing to the building. 'That ancient church is a savage place. Its main function is to regulate the dreams of the young. It opens and closes certain thoughts like a sore, and shows them to strangers. That woman there, with the face of a crow, was taken in several weeks ago; – at night the sexton puts his hand in her head in a display of venal affection. His heart will never grow tumours, but in his sleep a huge rose grows from the stigmata in his side. You see, his memories have been whispered abroad and now he seeks to measure his shadow with a piece of cord to ensure the permanence of his soul – the substitution of darkness in the place of scars.'

The dwarf moved on weeping and laughing, and I was taken to a garden of broken figures carved with the mastery of cunning architects. Their beautiful groins were choice remnants of some ancient splendour. Such mental excitement and disorder I had never seen before. Animals and things which have no existence, confused the identity of people who insisted on raising their mocking heads; making me suspicious of the shadow cast in front of my eyes. This shadow was red and made me walk cautiously, imagining sounds and noises at my heels in the street; – grimacing animals in the dark in league with an erotic phantom.

Here, beneath a boiling virus-sun, my nerves screamed at the siren song of millennial death, as exotic mutations fucked themselves and each other to death in a kaleidoscopic maelstrom of imagined anatomies. New diseases of which people had never even dreamed bestowed by the fever from some nemesis star – while they immersed themselves in the pleasures of virtuality, all potential had died. Our social cells are zoological gardens of unchecked sex and slaughter. The streets of each city echo with the laughter of the partially devoured who dance naked and headless strewing their bloody seed indiscriminately. Their bleeding erections shower stars and flowers which are gathered by eviscerated children crowned with barbed wire. This is the legacy of our New/Old Gods.

I became seized by a wild, reptilian gnosis, trailing my old flesh behind me in a wide train, which was collected fastidiously by my retinue of sightless bridesmaids whom I had personally blinded in a paroxysm of lust. I'd decided on experiments which separated me from the average man; –

an inordinate egotism like two blind faces raised in prayer – drawn from the master chymist. I was suddenly tired and at peace with degenerate changes. Hunger came and memory weakened. Silence fell and both mental disorder and paralysis of the mind occurred as a warning of the flesh against the tyranny of the soul. At once my lady appeared, blown in on a huge carnation of shit-stained newspapers, her fingers of broken glass reaching to me in anthropo-phagous desire. Her name was Rape and this is written in the menstrual blood of jackals on the temple wall.

The room was filled with the memory of great flapping wings and an aroma suggestive of cyclopean halls of mummified ancestors. This brought me spasmodically to orgasm. She was the Bride of The Crawling Chaos and kept her lovers' heads in glass cases. I kissed her ruptured navel and she raised my face with her metal hand. The air around us boiled with the radiation from God's black watchful eye above us, which dripped disapproval and cellular mucus. In the presence of my weakness of mind, I could no longer close my eyes to her powers. They had noticeably transcended her death, especially in the direction of a more intimate knowledge.

Being in contact with darkness deeper than the shadows and warmer than her thighs, I knew the hideous secret of her kiss. There's only madness in her touch – each beat of the heart sending her voice along my arteries, felt at various places on the surface of my body. A round hole at the centre of her torso opened as she danced, her chant coupled with the murmurs of whispers in faraway galaxies. She held oceans within her. I could taste her salt and feel her tides on my eyelashes. From deep recesses within my mind, colossal tentacles unfurled. I felt myself chanting until I vanished, coiled like a snake, new knowledge bleeding into my skin with ripples of alternating dilation and contraction.

She played sex games with me, burying me in tumours and roses. Her fingers thickened and trailed away in the darkness which died. Sleep entered the room and my faces swirled between heartbeats as the whispering drew closer. Obsessions and phobias, morbid fears woke me as another of The Withered Ones joined us, sickened with dreams. The parasites of sleep were howling in the dawn. The carnival had ended with the light and they stumbled away diseased and swollen with erotic images and the sounds of the Dark God's laughter on the wind. My lady stood askance, a tear on her cheek. I approached her softly. It was time for her to die again.

The murder was simple and when I left, I kissed her hair. The transfer of energy inherent in mysticism and repressed ideas throbbed here like an erection which justified the expediency of my thoughts. My hands moved cautiously to prevent her bleeding – Rape, my little phantom who'd undressed old people and held the dead erect on sticks. Her name screwed around the tips of loathsome and lecherous mouths.

I looked up at a distended face, spread across the whole sky like a balloon filled with guilty conscience. My sins had caught up with me after centuries of successful elusion. I almost laughed, like a child's glass toy which, when upturned, instead of producing a miniature snow-storm, creates a rain of blood and small animals' intestines. God wore a bleached horse's skull above his black leather jacket and spoke in crossword clues.

I set her robes alight and the sparks were like spurting blood lodged in a sluice-keeper's corpse. Blowing the ashes from the horrible heads of the singing flowers, I sobbed as she melted like white perspiration. She burned with the steady dullness of artificial light. How many spirits were out that night!

Her virtuality rose several feet above her remains and I choked with surprise at a small folded membrane hanging from her lips. She was now death's bride and my sex stirred sleepily like a snake on exposure to the sun. Waves of air caressed my body. I heard a noise behind me and turned to see the dwarf writhing and gasping at the horror before him. He spoke to me. 'After death, she'll continue to enjoy, for a time, the image of you, until you grow dim like a vanishing shadow.' His words ended and I held the dead figure erect. Smiling, I thought, 'I see what is invisible tonight – an idiot god suffering with darkened eyes. A memory of sanity outlines his shadow to me.'

A stranger carrying a head in a bird-cage, knocked loudly and long, yet all remained dark and silent as before. Shading his eyes from falling sparks, the dwarf came floating out, hissing round our heads. He'd removed his eyes with his hand. A pool of clear light filled the lugubrious courtyard. As the rain fell on the dead, locked with hungry eyes like a priest, we saw a discontented philosopher whom a child had left gathering flowers.

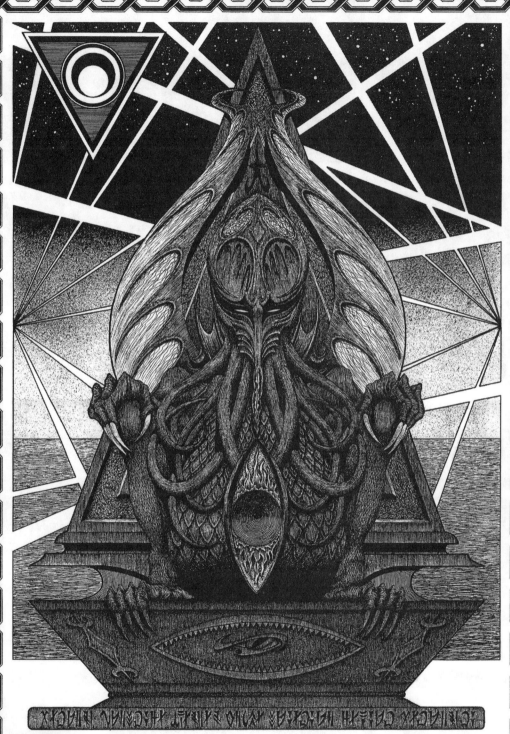

The most merciful thing in the world, I think, is the inability of the human mind to correlate all its contents.....

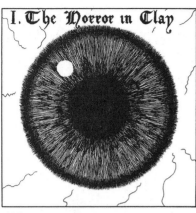

I. The Horror in Clay

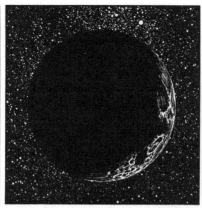

We live on a placid island of ignorance in the midst of black seas of infinity and it was not meant that we should voyage far.

Some day the piecing together of dissociated knowledge will open up such terrifying vistas of reality that we shall either go mad from the revelation or flee from the deadly light into the peace and safety of a new dark age. Theosophists have guessed at th

awesome grandeur of the cosmic cycle wherein our world and human race form transient incidents. They have hinted at strange survival in terms which would freeze the blood if not masked by a bland optimism. But it is not from them

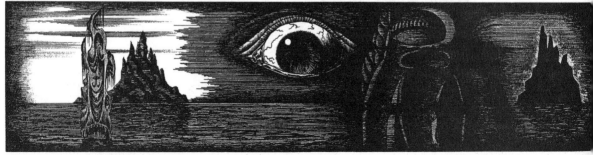

that there came the glimpse of forbidden aeons which chills my thoughts and haunts my dreams.———

Boston, Massachusetts ~ 1926.

That dread glimpse flashed out from an accidental piecing together of separated things.

THE CALL OF CTHULHU

I hope that no one else will accomplish this piecing out.

Certainly, if I live, I shall never knowingly supply a link in so hideous a chain.

BY H.P. LOVECRAFT.

Illustrated by John Coulthart.

My knowledge of the thing began with the death of my great uncle, George Gammell Angell.

He had been a renowned Professor Emeritus of Semitic Languages in Brown University, Providence.

... coordinate...
...ual methods of decipherment. Thus...
...bizarre set of circumstances which l...
...ed at the base of the sculpture were cons...
...ofessor Webb and his Eskimo researches prov...
...s a standard course of practice.

...an be seen here to bear no relation to any...

F H C T H U L H U R L

...c, Sumerian, Egyptian, Duriac or any form o...
...which, when carefully considered, can only...

As sole heir and executor, his entire set of files had passed to me.

Locally, interest was intensified by the obscurity of the cause of death.

The professor, returning from the Newport boat, had fallen after being jostled by a negro on the hill leading to Williams Street.

The doctors pointed to lesion of the heart as the cause and at the time saw no reason to dissent from this dictum.

Only latterly have I been inclined to wonder

Among his files I had found a locked box. I did not find the key till it occurred to me to examine the personal ring he carried with him.

The contents, a clay bas-relief and assorted notes and cuttings, were quite a source of mystery.

```
                     of their cul
nan sacrifices.  It is only rece
tracted from one of the followe

A! IA! SAKKAKTH! IAK SAKKAKH! IA
A UTUKKU XUL!  IA! IA ZIXUL IA
A HUBBUR!  KAKHTAKHTAMON IAS!  B

ar avoids any attempts at reason
he Cult of Dead Names.  Present

    CTHULHU  - Most common pronun
    KTHULUT  - Scandinavian (?)
    KUTULU   - Term used by some o
    CUTHALU  - Sumerian
    CTHA-LU  - Chaldaean (?)

ealed by further investigation.
eciation of the relative similar
 rational explanation and yet t
 a phrase which was often repea
```

What had possessed him to conceal them so?

CTHULHU CULT

...was how the document among the cuttings was headed. The first half of the manu~ script ~ Dream and Dream Work of H. A. Wilcox, 7 Thomas St., Providence R. I. ~ told a very peculiar tale.

On March 1, 1925, a young man by the name of Henry Anthony Wilcox had called upon Professor Angell bearing the singular bas~relief.

He was a precocious youth of known genius but great eccentricity studying sculpture at the Rhode Island School of Design.

The purpose of the visit was to ask his host's knowledge in identifying the hieroglyphics on the bas~relief.

He had explained the fresh app~ earance of the tablet in his characteristic manner:

It is new, indeed, for I made it last night in a dream of strange cities; and dreams are older than brooding Tyre, or the contemplative Sphinx, or gar~ den girdled Babylon.

The night before, a slight earth tremor had excited his imagin~ ation. Upon retiring he had had dream of great Cyclopean cities.

From some undetermined point had come a chaotic sensation, a sound he later attempted to render: CTHULHU FHTAGN.

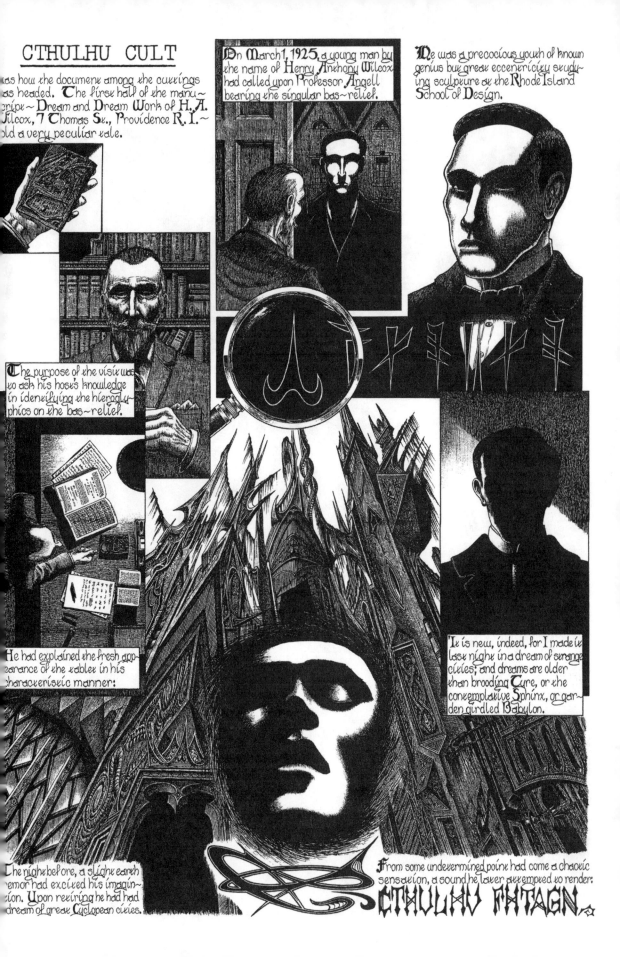

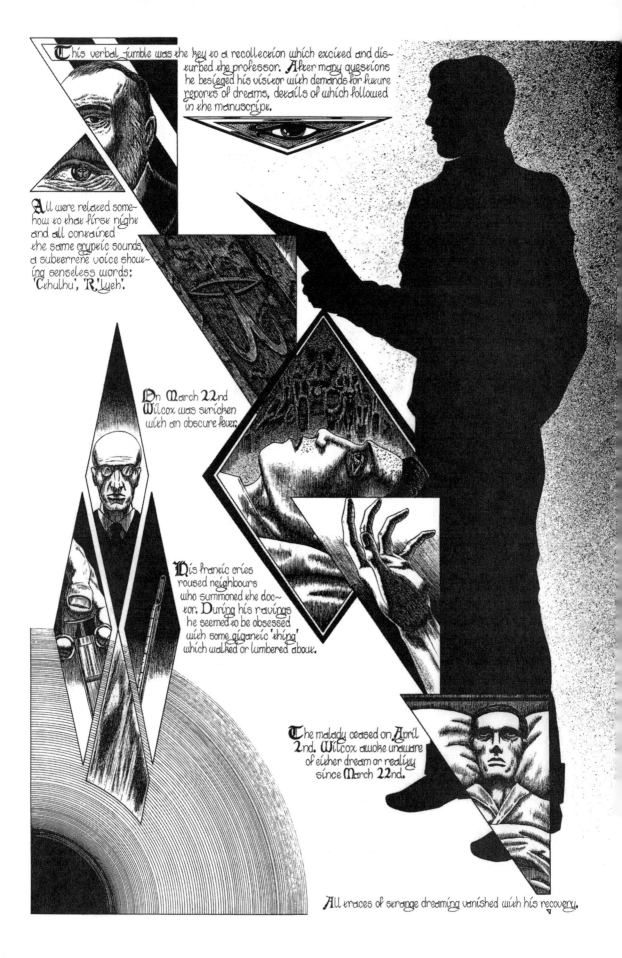

This verbal jumble was the key to a recollection which excited and disturbed the professor. After many questions he besieged his visitor with demands for future reports of dreams, details of which followed in the manuscript.

All were related somehow to that first night and all contained the same cryptic sounds, a subterrene voice shouting senseless words: 'Cthulhu', 'R'lyeh'.

On March 22nd Wilcox was stricken with an obscure fever.

His frantic cries roused neighbours who summoned the doctor. During his ravings he seemed to be obsessed with some gigantic 'thing' which walked or lumbered about.

The malady ceased on April 2nd. Wilcox awoke unaware of either dream or reality since March 22nd.

All traces of strange dreaming vanished with his recovery.

The New York Times.

"All the News That's Fit to Print."

THE WEATHER
Cloudy, possibly showers today; tomorrow showers. Temperature yesterday—Max., 54; min., 40. For weather report see next to last page.

VOL. LXXIV....No. 24,556. NEW YORK, SATURDAY, APRIL 18, 1925. TWO CENTS in Greater New York | THREE CENTS Elsewhere | FOUR CENTS

The notes and press cuttings next touched on cases of panic and mania from the time of Wilcox's malaise.

Sensitive persons plagued with nightmares.

A nocturnal suicide in London.

A theosophist colony awaits a glorious fulfilment.

Voodoo orgies multiply in Haiti.

In Paris Ardois-Bonnot hangs a 'Dream Landscape' in the spring salon.

A weird bunch of cuttings, all told, which I foolishly set aside, hardly pausing to consider the weight of their implications.

II. The Tale of Inspector Legrasse

The old matters which had made the sculptor's dream so significant to my uncle formed the second half of his long manuscript.

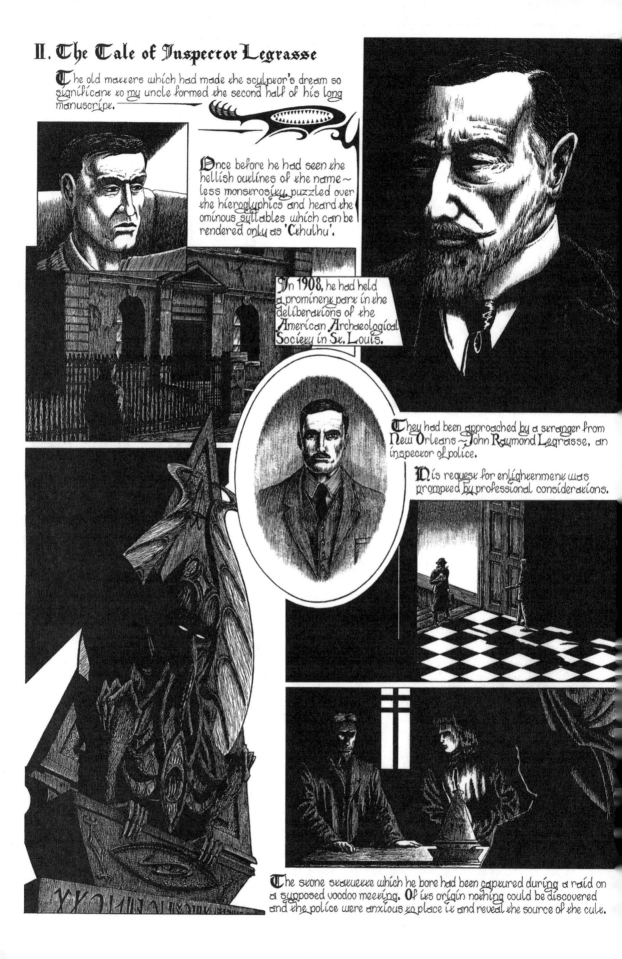

Once before he had seen the hellish outlines of the nameless monstrosity, puzzled over the hieroglyphics and heard the ominous syllables which can be rendered only as 'Cthulhu'.

In 1908, he had held a prominent part in the deliberations of the American Archaeological Society in St. Louis.

They had been approached by a stranger from New Orleans~John Raymond Legrasse, an inspector of police.

His request for enlightenment was prompted by professional considerations.

The stone statuette which he bore had been captured during a raid on a supposed voodoo meeting. Of its origin nothing could be discovered and the police were anxious to place it and reveal the source of the cult.

Although excited at the sight of the green stone figure, the assembled scientists severally shook their heads and confessed defeat at the inspector's problem. There was one, however, who suspected a touch of bizarre familiarity in what he saw ~ William Channing Webb, professor of anthropology in Princeton University.

With some diffidence, he explained; forty~eight years before in a tour of Greenland and Iceland, he had encountered a singular tribe of degenerate Eskimos, shunned by others, whose religion, he was told, came down from ancient aeons before the world was made.

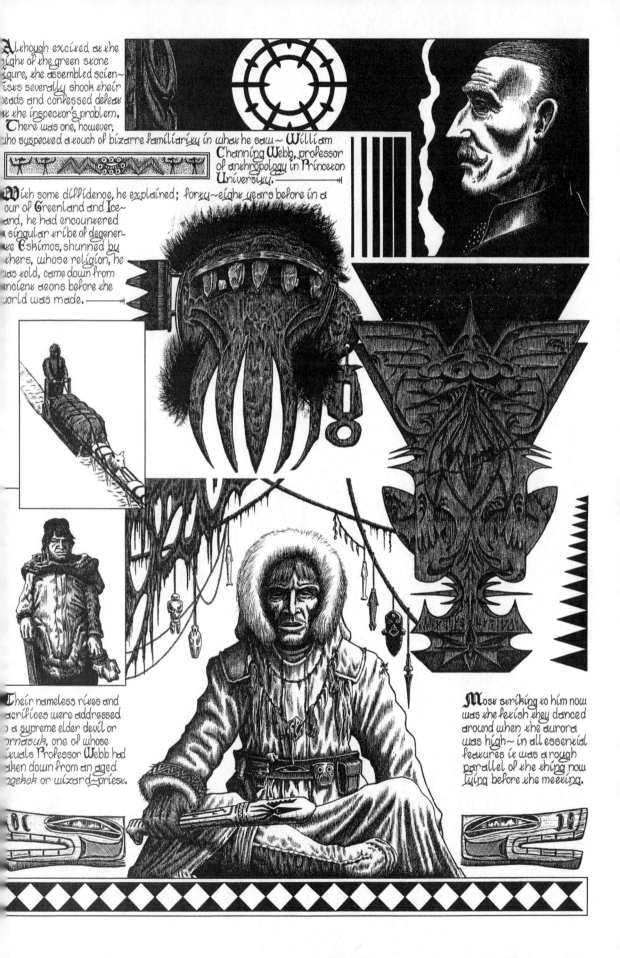

Their nameless rites and sacrifices were addressed to a supreme elder devil or tornasuk, one of whose rituals Professor Webb had taken down from an aged angekok or wizard~priest.

Most striking to him now was the fetish they danced around when the aurora was high ~ in all essential features it was a rough parallel of the thing now lying before the meeting.

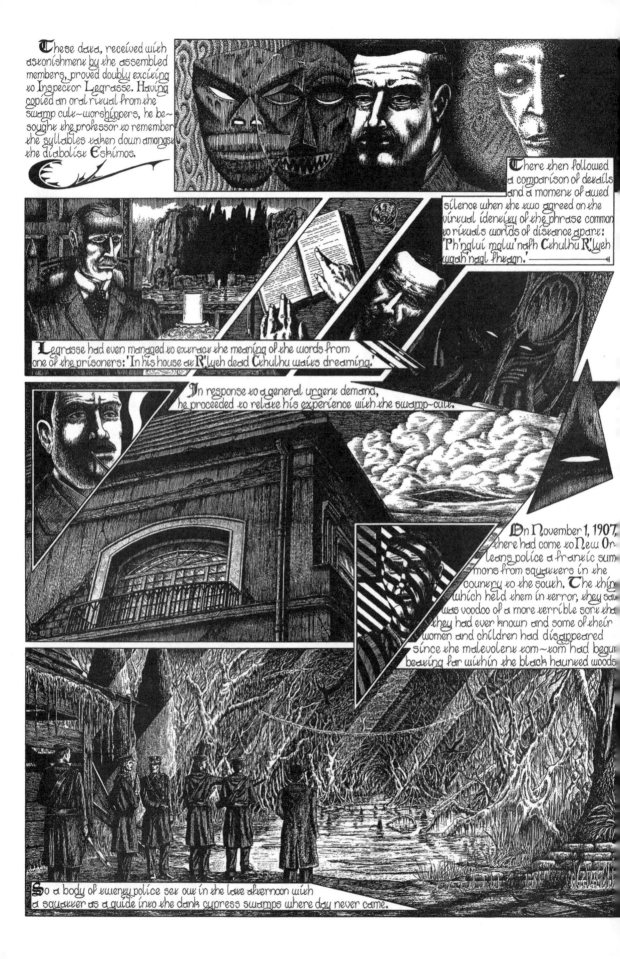

These data, received with astonishment by the assembled members, proved doubly exciting to Inspector Legrasse. Having copied an oral ritual from the swamp cult-worshippers, he besought the professor to remember the syllables taken down amongst the diabolist Eskimos.

There then followed a comparison of details and a moment of awed silence when the two agreed on the virtual identity of the phrase common to rituals worlds of distance apart: 'Ph'nglui mglw'nafh Cthulhu R'lyeh wgah'nagl fhtagn.'

Legrasse had even managed to extract the meaning of the words from one of the prisoners: 'In his house at R'lyeh dead Cthulhu waits dreaming.'

In response to a general urgent demand, he proceeded to relate his experience with the swamp-cult.

On November 1, 1907, there had come to New Orleans police a frantic summons from squatters in the country to the south. The thing which held them in terror, they said, was voodoo of a more terrible sort than they had ever known and some of their women and children had disappeared since the malevolent tom-tom had begun beating far within the black haunted woods.

So a body of twenty police set out in the late afternoon with a squatter as a guide into the dank cypress swamps where day never came.

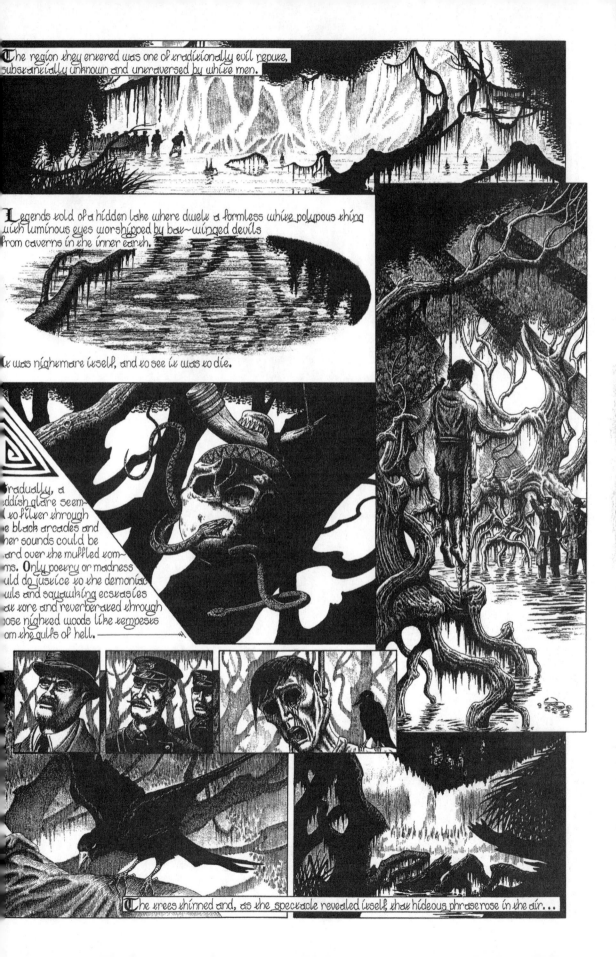

The region they entered was one of traditionally evil repute, substantially unknown and untraversed by white men.

Legends told of a hidden lake where dwelt a formless white polypous thing with luminous eyes worshipped by bat-winged devils from caverns in the inner earth.

It was nightmare itself, and to see it was to die.

Gradually, a reddish glare seemed to filter through the black arcades and other sounds could be heard over the muffled tom-toms. Only poetry or madness could do justice to the demoniac yells and squawking ecstasies that tore and reverberated through those nighted woods like tempests from the gulfs of hell.

The trees thinned and, as the spectacle revealed itself, that hideous phrase rose in the air...

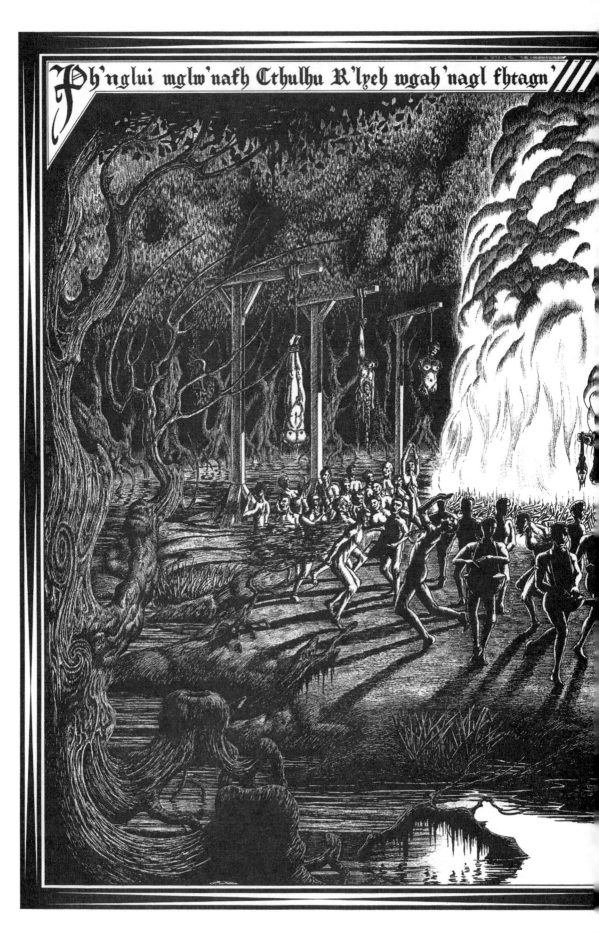

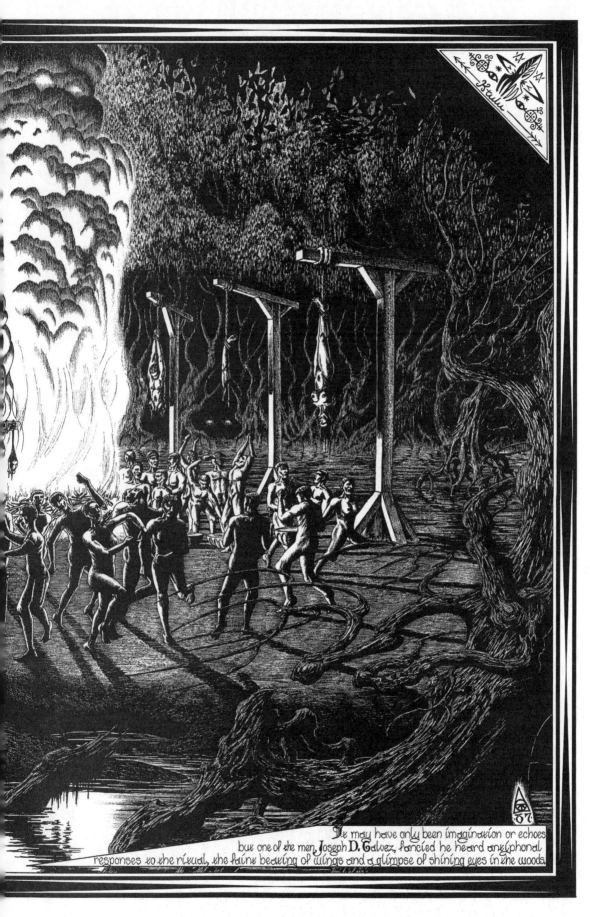

It may have only been imagination or echoes but one of the men, Joseph D. Galvez, fancied he heard antiphonal responses to the ritual, the faint beating of wings and a glimpse of shining eyes in the woods.

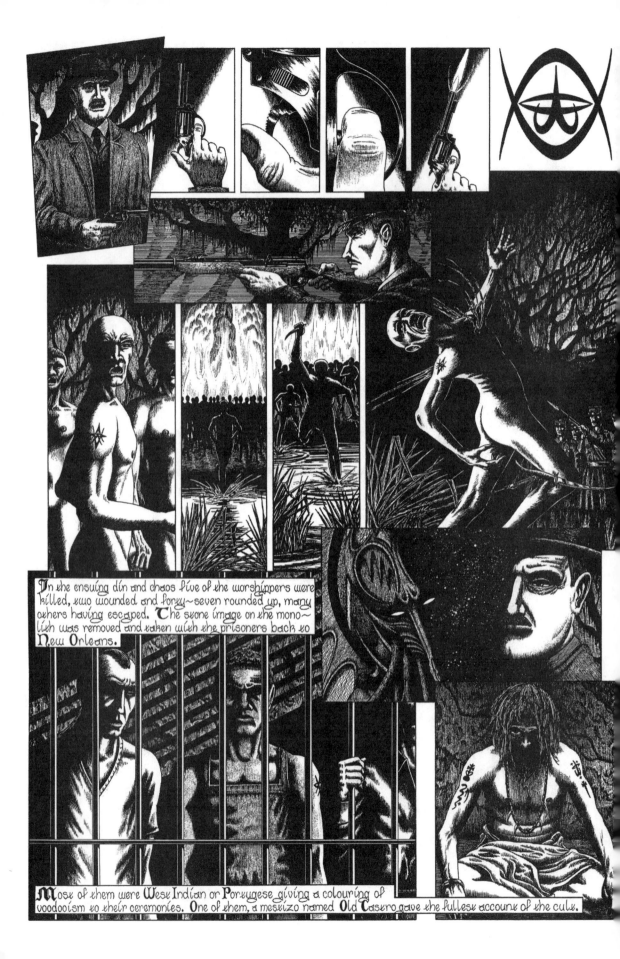

In the ensuing din and chaos five of the worshippers were killed, two wounded and forty~seven rounded up, many others having escaped. The stone image on the mono~lith was removed and taken with the prisoners back to New Orleans.

Most of them were West Indian or Portugese giving a colouring of voodooism to their ceremonies. One of them, a mestizo named Old Castro gave the fullest account of the cult.

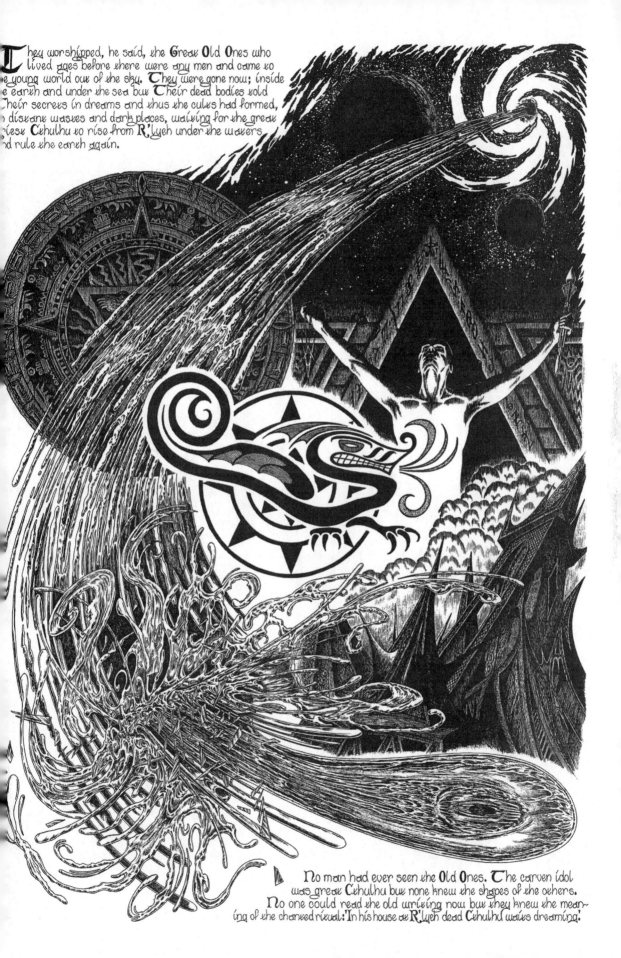

They worshipped, he said, the Great Old Ones who
lived ages before there were any men and came to
the young world out of the sky. They were gone now; inside
the earth and under the sea but Their dead bodies told
Their secrets in dreams and thus the cults had formed,
in distant wastes and dark places, waiting for the great
priest Cthulhu to rise from R'lyeh under the waters
and rule the earth again.

No man had ever seen the Old Ones. The carven idol
was great Cthulhu but none knew the shapes of the others.
No one could read the old writing now but they knew the mean-
ing of the chanted ritual: 'In his house at R'lyeh dead Cthulhu waits dreaming'.

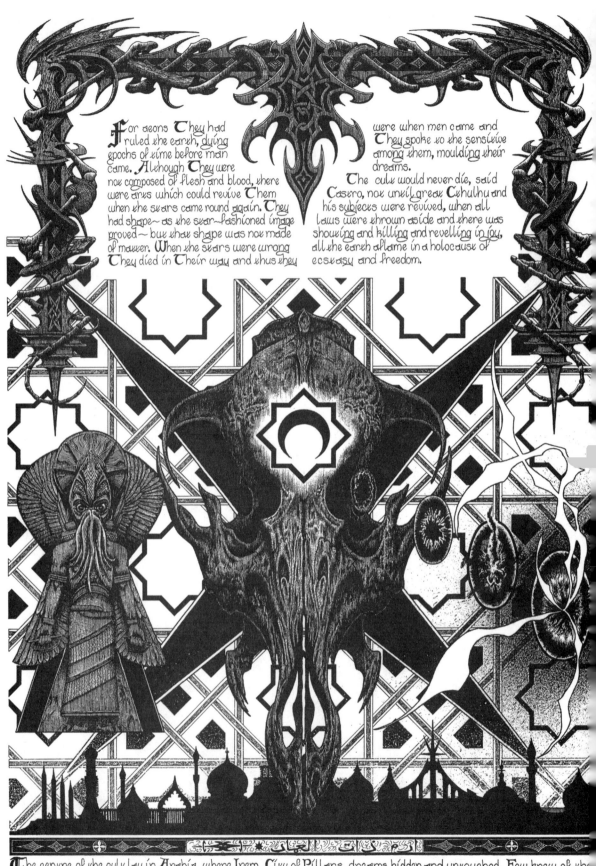

For aeons They had
ruled the earth, dying
epochs of time before man
came. Although They were
not composed of flesh and blood, there
were ares which could revive Them
when the stars came round again. They
had shape~ as the star~fashioned image
proved ~ but that shape was not made
of matter. When the stars were wrong
They died in Their way and thus they

were when men came and
They spoke to the sensitive
among them, moulding their
dreams.
 The cult would never die, said
Castro, not until great Cthulhu and
his subjects were revived, when all
laws were thrown aside and there was
shouting and killing and revelling in joy,
all the earth aflame in a holocaust of
ecstasy and freedom.

The centre of the cult lay in Arabia, where Irem, City of Pillars, dreams hidden and untouched. Few knew of the
cult, no books had ever hinted of it, only the 'Necronomicon' of the mad Arab Abdul Alhazred held double meaning
which the initiated might interpret: 'That is not dead which can eternal lie and with strange aeons even death may die.'

It was his search for corroboration of Castro's tale that had brought Legrasse to the meeting; little wonder the surprise of my uncle when heard the story of the young sculptor who had dreamed not only the swamp-figure and its hieroglyphics but also of precise words from the formula uttered by the Eskimos and Louisianans.

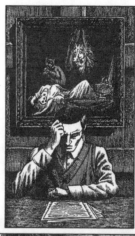

Believing Wilcox to have invented these dreams, I decided to make a trip to Providence to press him for an answer.

He lived there alone in the Fleur-de-Lis Building in Thomas Street.

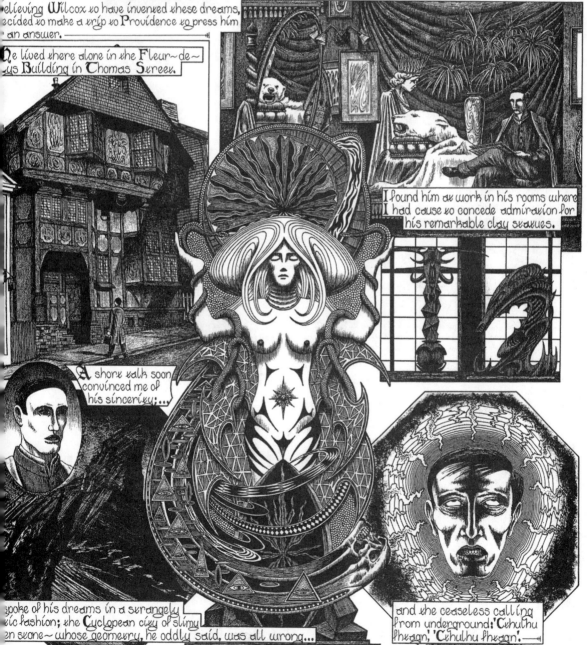

I found him at work in his rooms where I had cause to concede admiration for his remarkable clay statues.

A short talk soon convinced me of his sincerity;...

He spoke of his dreams in a strangely poetic fashion; the Cyclopean city of slimy green stone—whose geometry, he oddly said, was all wrong...

and the ceaseless calling from underground: 'Cthulhu fhtagn', 'Cthulhu fhtagn'.

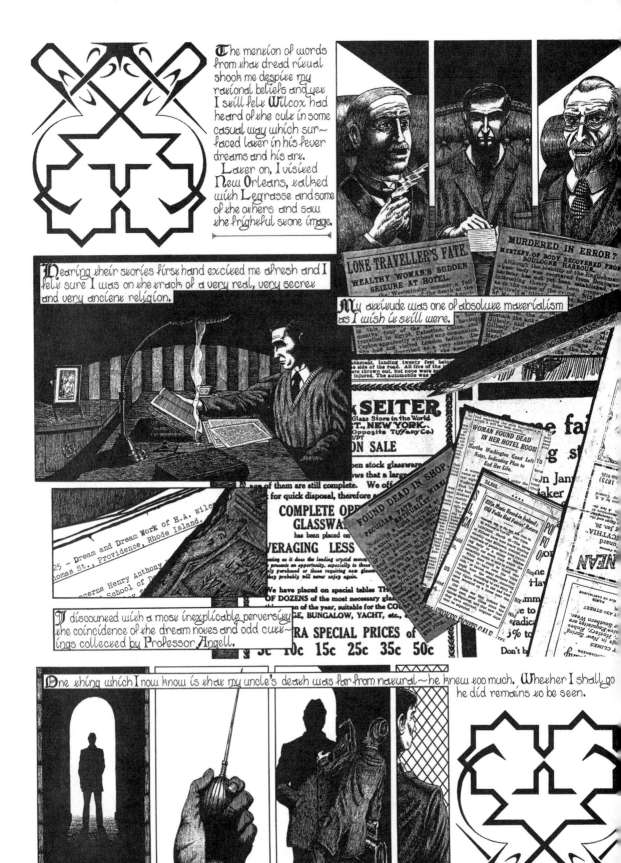

The mention of words from that dread ritual shook me despite my rational beliefs and yet I still felt Wilcox had heard of the cult in some casual way which sur~ faced later in his fever dreams and his art.

Later on, I visited New Orleans, talked with Legrasse and some of the others and saw the frightful stone image.

Hearing their stories first hand excited me afresh and I felt sure I was on the track of a very real, very secret and very ancient religion.

My attitude was one of absolute materialism as I wish it still were.

I discounted with a most inexplicable perversity the coincidence of the dream notes and odd cut~ ings collected by Professor Angell.

One thing which I now know is that my uncle's death was far from natural ~ he knew too much. Whether I shall go he did remains to be seen.

If heaven ever wishes to grant me a boon, it will be a total effacing of the results of a mere chance which fixed my eye on a certain piece of shelf-paper: an old number of an Australian journal, the Sydney Bulletin for April 18 1925.

I had largely given over my enquiries into the 'Cthulhu Cult' and was visiting a learned friend; a museum curator of Paterson, New Jersey.

Examining one day the reserve specimens in a rear room of the museum, an odd picture caught my eye.

It was the Sydney Bulletin I have mentioned, for my friend has wide affilliations in foreign parts.

Although the accompanying text was brief, its suggestions were of portentous significance to my flagging quest; I carefully tore it out.

The headline read:

MYSTERY DERELICT FOUND AT SEA

The freighter Vigilant had arrived in Sydney tow-the disabled but heavily armed Alert of Dunedin which they had found on April 12th with one living and dead man aboard. The living man was delirious and clutching a stone idol of unknown origin which he had found in a shrine in the ship.

He was a Norwegian, Gustaf Johansen, second mate of schooner Emma of Auckland. Sailing for Callao, a storm had thrown them south and on March 22nd they had encountered the Alert manned by a crew of Kanakas and half-castes who ordered them to turn back. When they refused, the Alert opened fire with heavy brass cannon. Showing fight, the crew of the Emma managed to board and subdue the Alert. At the end of the attack the Emma had sunk due to damage, its captain and first mate had been killed and the entire crew of the Alert were dead or dying. Johansen and the remaining men decided to sail ahead in the Alert; the next day they landed on an uncharted island where six of the men somehow died ashore. Johansen and the other man William Briden left in the Alert and were rescued a few days later, Briden having died also by that time of excitement or exposure.

Reports from Dunedin stated that the Alert and its ill-regarded crew had set sail in haste after the storm and earth tremors of March 1st. Johansen was described as a sober and worthy man and an inquiry into the events had been announced.

◀◀◀◀◀

What a train of ideas this started in my mind! How was it that the earthquake and storms coincided with the incident of Wilcox's fever? I thought of the words of Castro, of the sunken star-born Old Ones and their mastery of dreams.

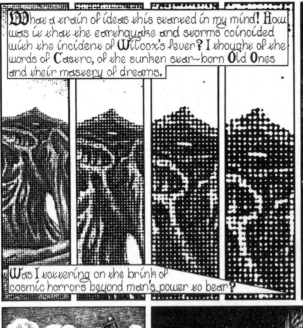

Was I tottering on the brink of cosmic horrors beyond man's power to bear?

That evening I bade my host adieu and took a train for San Francisco.

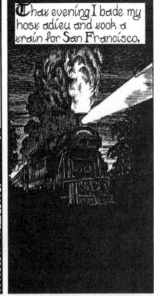

In less than a month I was in New Zealand.

Once there, however, I found that little was known of the strange cult members in the old taverns save for a journey they once made inland.

In Auckland I learned that Johansen had returned with yellow hair turned white and after inconclusive questioning at Sydney had sold his house and sailed with his wife for Oslo.

After that I went to Sydney and talked profitlessly with seamen and members of the vice-admiralty court. I saw the Alert at Circular Quay but gained nothing from its noncommittal bulk.

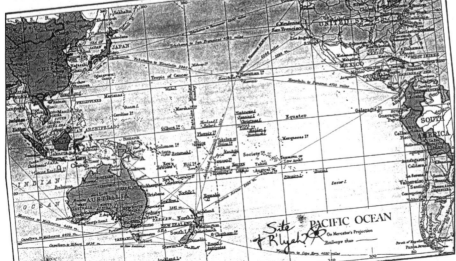

In the Sydney Museum I was able to study the fateful image which geologists had vowed was no earthly stone.

Once more I thought of Castro's words: 'They had come from the stars and had brought Their images with Them!'

Shaken with such a mental revolution as I had never before known, I resolved to visit Johansen.

Sailing for London, I re-embarked at once for Norway, arriving in Oslo one day in autumn.

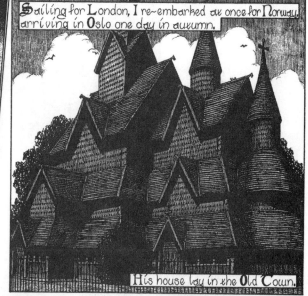

His house lay in the Old Town.

His wife answered my knock and I was stung with disappointment when she told me that Gustaf Johansen was no more.

He had returned a broken man.

He told his wife no more than I knew already but he had left a long manuscript written in English to safeguard her from the peril of casual perusal.

Shortly after, a bundle of papers falling from an attic had knocked him down in the street.

He was dead before the ambulance could reach him.

I now felt gnawing at my vitals that dark terror which will never leave me till I, too, am at rest; 'accidentally' or otherwise. Persuading the widow my interest was genuine, I took the manuscript with me back to London.

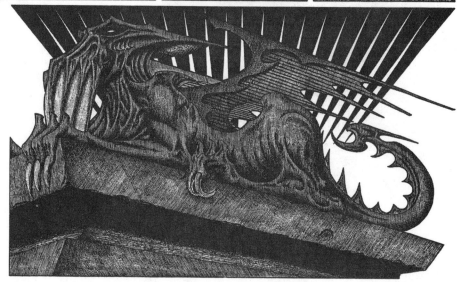

It was a simple ramb~ling thing, a naïve sailor's effort at a post-facto diary. I cannot attempt to trans~cribe it but I will tell its gist enough to show why the sound of water against the ship's sides became so unendurable to me that I stopped my ears with cotton.

Johansen's voyage began just as he had told the vice admiralty. The Emma, in ballast, felt the full force of the earthquake~born storm.

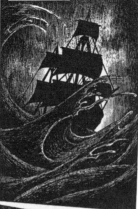

Once more under control, the ship was making good progress when held up by the Alert on March 22nd.

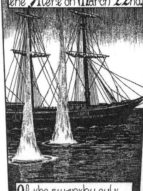

Of the swarthy cult fiends he speaks with significant horror.

Some peculiarly abominable quality about them made their destruction seem al~most a duty.

Driven ahead by curio~sity in their captured yacht, they sight a great stone pillar sticking out of the sea; ...

... in S. Latitude 47° 9', W. Longitude 126°43', they come upon a coastline of mingled mud, ooze and weedy Cyclopean masonry.

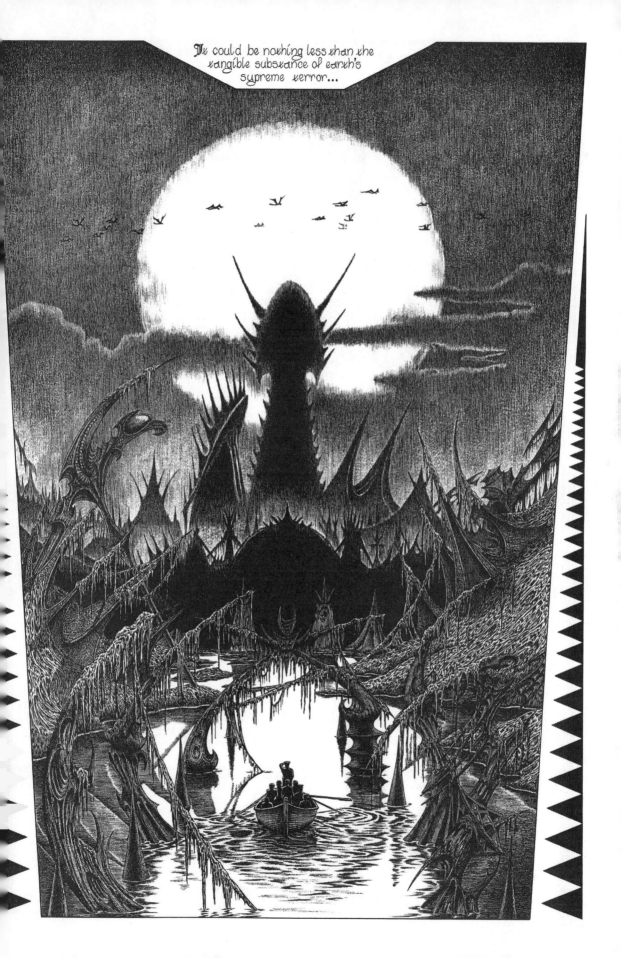

It could be nothing less than the tangible substance of earth's supreme terror...

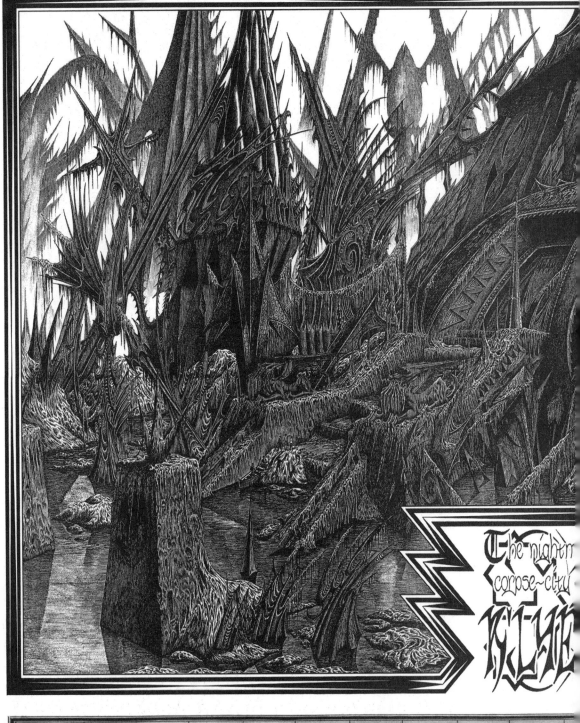

The nightm[arish]
corpse-city
KLYR[...]

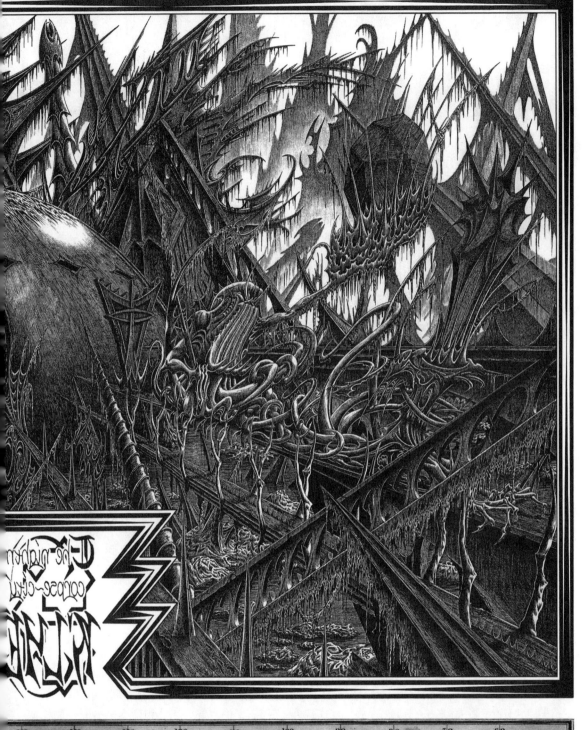

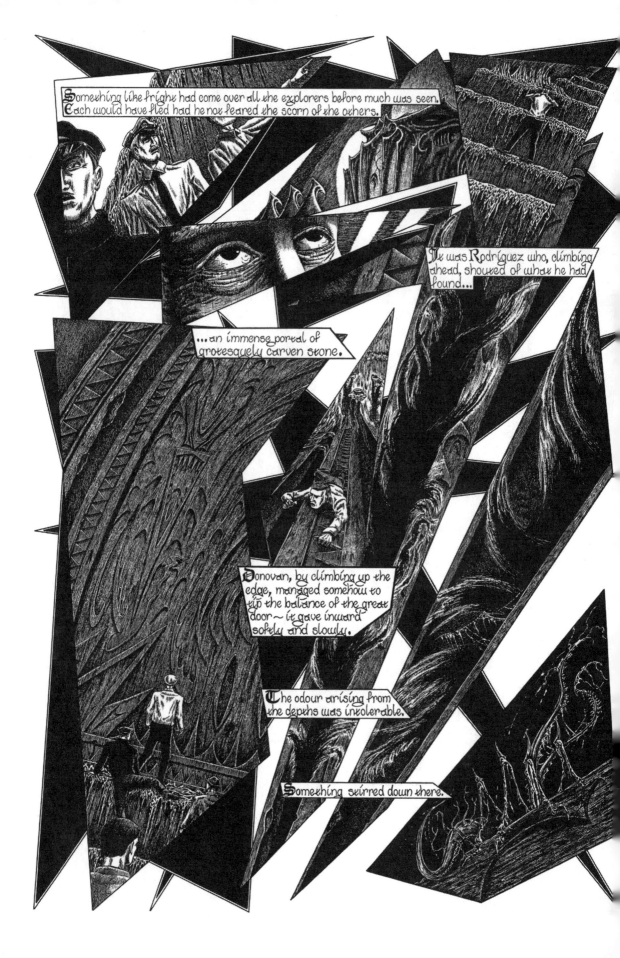

Something like fright had come over all the explorers before much was seen. Each would have fled had he not feared the scorn of the others.

It was Rodríguez who, climbing ahead, shouted of what he had found...

...an immense portal of grotesquely carven stone.

Donovan, by climbing up the edge, managed somehow to tip the balance of the great door ~ it gave inward softly and slowly.

The odour arising from the depths was intolerable.

Something stirred down there.

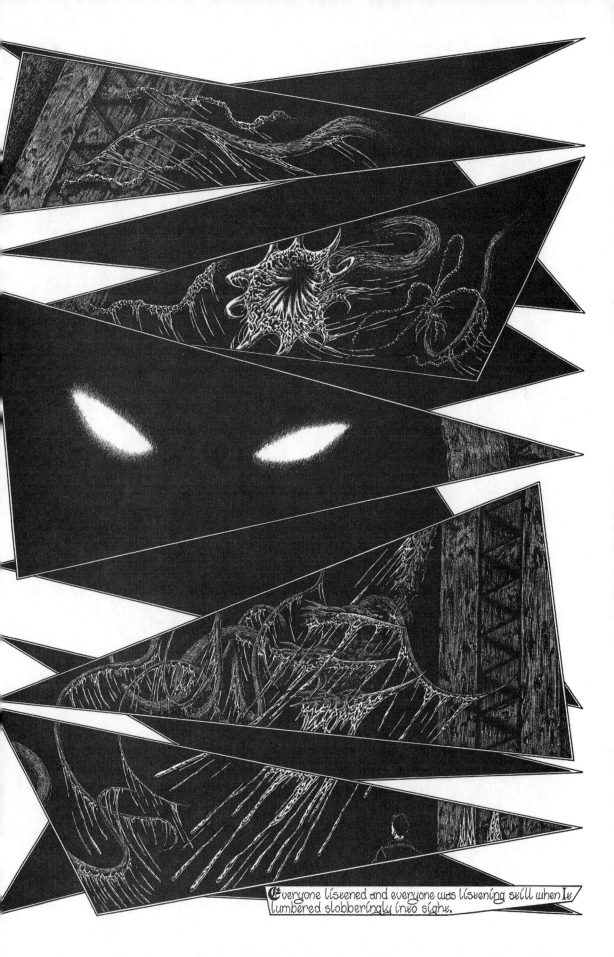

Everyone listened and everyone was listening still when It lumbered slobberingly into sight.

What wonder that across the earth poor Wilcox raved with fever in that telepathic instant? The stars were right again and what an age~old cult had failed to do by designs, a band of innocent sailors had done by accident.

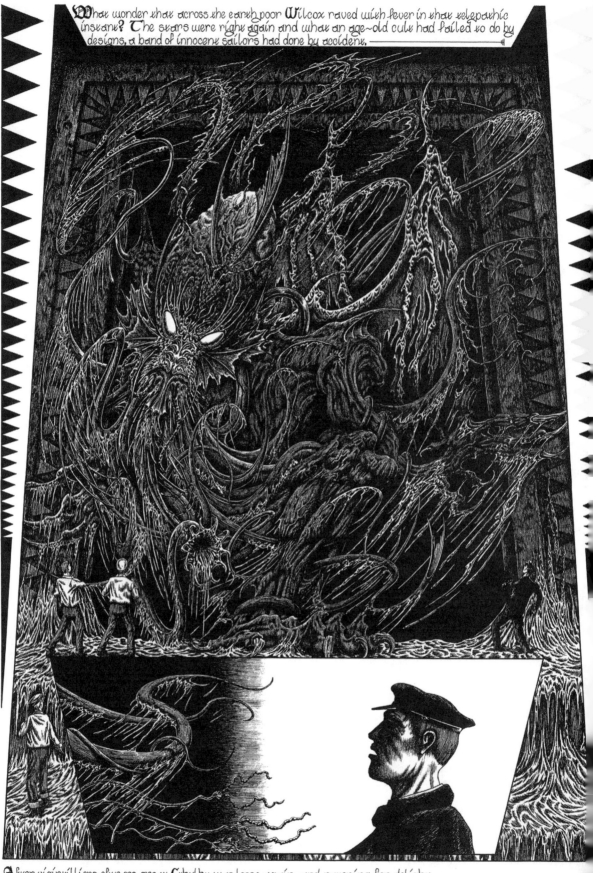

After vigintillions of years great Cthulhu was loose again, and ravening for delight.

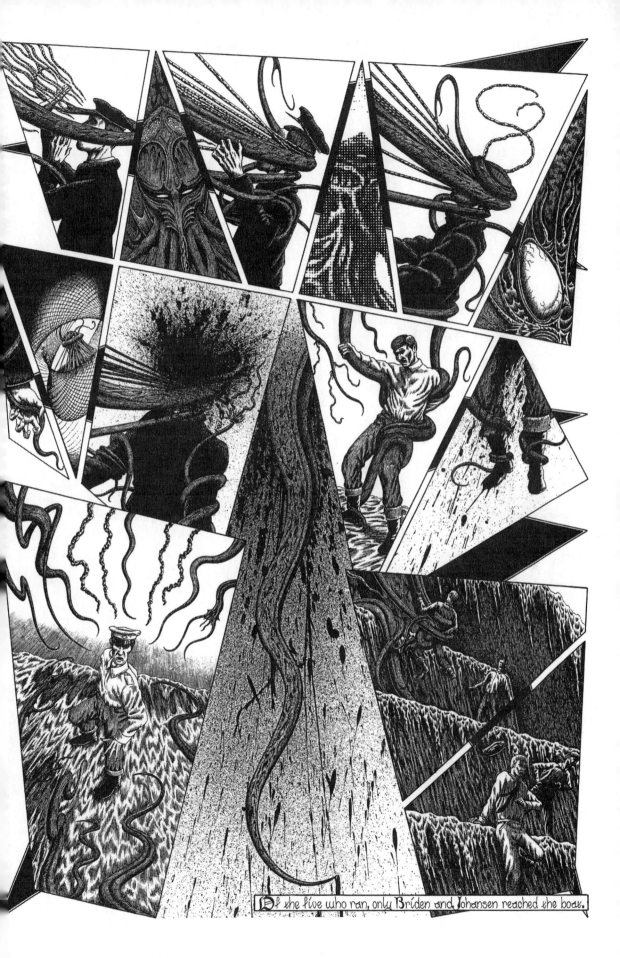

Of the five who ran, only Briden and Johansen reached the boat.

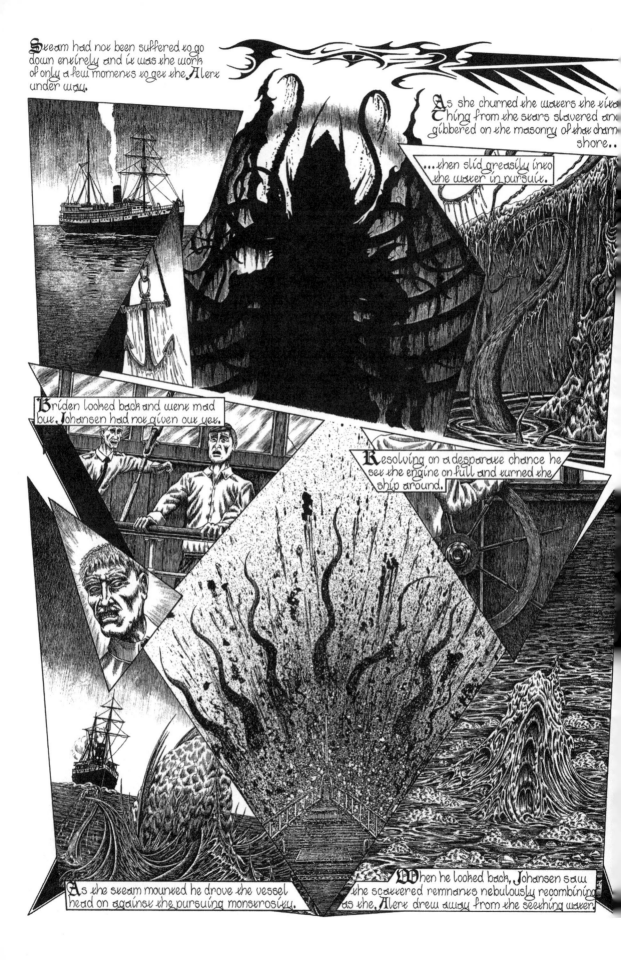

Steam had not been suffered to go down entirely and it was the work of only a few moments to get the Alert under way.

As she churned the waters the thing, the Thing from the stars slavered and gibbered on the masonry of that damn shore...

...then slid greasily into the water in pursuit.

Briden looked back and went mad but Johansen had not given out yet.

Resolving on a desperate chance he set the engine on full and turned the ship around.

As the steam mounted he drove the vessel head on against the pursuing monstrosity.

When he looked back, Johansen saw the scattered remnants nebulously recombining as the Alert drew away from the seething water.

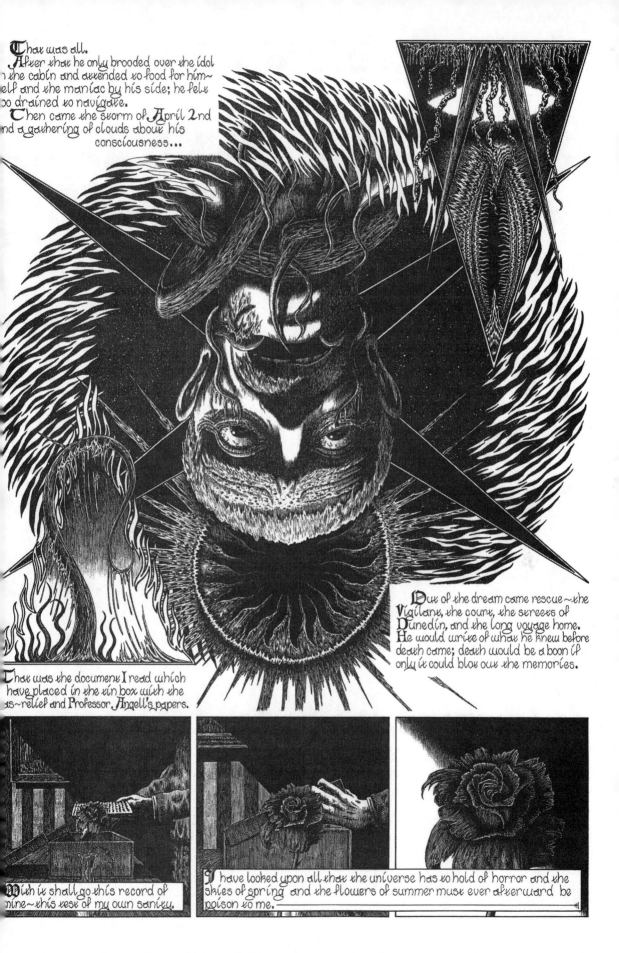

That was all.
After that he only brooded over the idol in the cabin and attended to food for himself and the maniac by his side; he felt too drained to navigate.
Then came the storm of April 2nd and a gathering of clouds about his consciousness...

Out of the dream came rescue~the Vigilant, the court, the streets of Dunedin, and the long voyage home. He would write of what he knew before death came; death would be a boon if only it could blot out the memories.

That was the document I read which I have placed in the tin box with the bas~relief and Professor Angell's papers.

With it shall go this record of mine~this test of my own sanity.

I have looked upon all that the universe has to hold of horror and the skies of spring and the flowers of summer must ever afterward be poison to me.

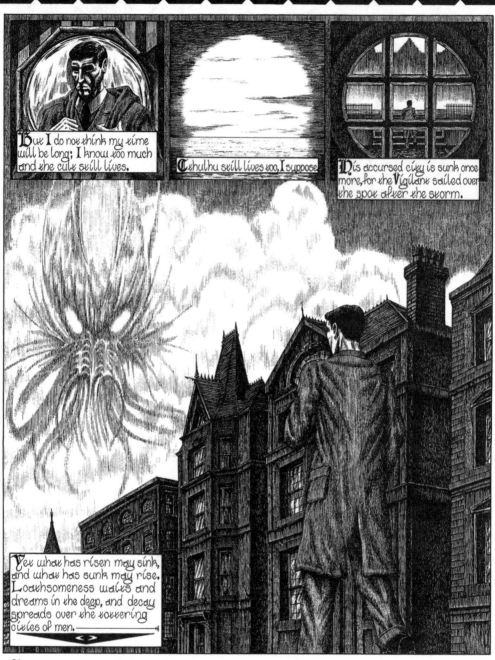

But I do not think my time will be long; I know too much and the cult still lives.

Cthulhu still lives too, I suppose.

His accursed city is sunk once more, for the Vigilant sailed over the spot after the storm.

Yet what has risen may sink, and what has sunk may rise. Loathsomeness waits and dreams in the deep, and decay spreads over the tottering cities of men.

It is only a matter of time...

The End

Story: H.P. Lovecraft ~1926

Art: John Coulthart ~1988

the courtyard
alan moore

2004, Farrakhan Day, and ten thousand fireworks explode over Brooklyn, the heart-stopping starbursts a uniform blue through the tint of the glass pseudo-firmament. 'See all them lights, boy? Them's nigger-stars. Make a wish.'

Clinton Street, down in Red Hook, is strobed cobalt. The residents have been petitioning almost ten years for a name-change since our chief executive fucked up the Syria thing in 1995: Ten thousand fireworks over Damascus.

Our rooming house has a shared bathroom. This morning, when I went to shave, there was shit in the wash-basin and, as I learned when I turned on the water to sluice it away, on the faucets.

Germaine. She's the thin schizophrenic girl in the next room though with only a hardboard partition dividing us we're getting horribly close to full co-habitation. About 35, born 1969, hippy parents. "Germaine". Jesus Christ.

I imagine they ran the poor cunt through a gauntlet of crank educational fads, taught her drugs and free love were okay, then divorced. Fine for them. They're not woken by Germaine's imaginary pals every morning at five.

I'm afraid that my feelings concerning Germaine's Mom and Pop are exactly the same as the feelings I had for their daughter while shaving: I just wish these people would clean up their own shit, just once in a while.

Through my window, the stuttering light of blue flowers exploding outside; distant ambulance sirens in shimmering science-fiction voluntaries. Is it just me who finds sirens beautiful? Miserable Divas in something Wagnerian, threatening fire, plague or murder.

Just over the street there's a run-down Pachinko arcade where the neighbourhood Flack-dealer juggles his junk. I catch this on the Nano-cam wadded in gum on my room's window ledge. Did I mention already that I was a Fed?

What I'm bothered about is the depth of my cover on this. Only Perlman in Washington knows that I'm here. I hate Blackwork. Carl Perlman's an asshole. I'm running on Blacktime and Blacktime's not good for me, pension-wise.

Farrakhan day. I can hear all the spear-chuckers partying under the Harlem dome even from here, slabs of bass shuddering out down the river. I spread out the photographs there on the bed and regard them by firework light.

All fifteen are without heads or hands, torsos sculpted like those garnish vegetables that you get at the fancier restaurants, carved into roses; the separate layers of skin, fat and muscle peeled back in triangular flaps into flowers of meat.

Here's the pisser: We pulled in a twenty-year-old bookshop clerk from Seattle whose brother-in-law had found twelve human hands individually wrapped in the freezer and summoned the Bureau. He coughed for six murders, no question.

We naturally figured that with the distinctive M.O. we could get him to cop to the other nine sooner or later, but no. He insisted he'd only done six. It was here we began to encounter some problems.

The first was this wino we picked up for vagrancy, who, as it turned out, was carrying three human heads in a K-Mart bag. Just like Confused of Seattle he owned up to three of the crimes, but no more.

We assumed at first this was just some copycat thing, but it turned out that all of the murder details had been kept from the press. Furthermore, neither man knew or knew of the other. It's all some unlikely coincidence, right?

Of the six unattributed victims left, four are related: A grandma; a mother and father; their nine-year-old daughter. The one son surviving is suddenly moved to confess that he whacked the whole bunch. Kept their thumbs as mementoes.

Three culprits for thirteen identical murders with two further killings as yet unaccounted for. No links between the accused, or at least nothing direct as yet. Is this fucked up or what? In the flickering blueness the photographs dance.

Perlman wanted me here for a reason. It's not that he likes me. He told Ed Byrne I was a smug little nazi. It's just I have high abstract patterning skills, so I get all the Twilight Zone jobs. What I do, it's anomaly theory. I go through the evidence carefully winnowing out the most troublesome details, obscure little fragments that don't fit our profiles and thus often get overlooked.

Take this current case. Two series-killings, one multiple murder (the family job). Three white males. One's aged fifteen, one's twenty and one's thirty-eight. One's a vagrant, one works in a bookshop and one's still at school. No connections.

The fifteen-year-old who dismembered his folks, sis and grandma is clean-cut and bright. He likes classical music, with only one rock album in his extensive collection: "The Ulthar Cats" – noisy, obscure New York art-fags. They suck.

Now, Confused of Seattle, he doesn't like music at all. He just reads, mostly old horror paperbacks. Poe and like that. Tucked halfway through *Ligeia* we find this old ticket, says "Club Zothique", used as a bookmark.

Our wino can't read and hates music but, unlike the other two, *is* using drugs. Fairly mild ones, admittedly. We found a baggie of something called DMT-7 concealed in his rectum, a weak hallucinogen. He'd have got higher on Ripple.

The twenty-year-old has a spelling disorder. He writes stuff, short stories, but half of the words are just gibberish. Judging by earlier work, which is lucid, this trend is a recent thing.

Stephen, our fifteen-year-old family butcher, writes songs on acoustic guitar and then does this godawful scat-singing over the top of it. Not my taste, obviously.

Roy the acid-head wino makes terrible sounds in his sleep, but then what else is fresh? Brooklyn's bulging with noise in the street outside. People are kissing and fighting; fucking each other; fucking each other up.

So: there's a noise album owned by a kid with a strong predilection for Mahler; a club ticket found on a bookworm who never goes out; a confirmed alcoholic with happy dust jammed up his ass. That's anomaly theory.

The next part is largely intuitive. Having selected your set of anomalous facts you will find new connections arising which, in my experience, often yield data more useful than that gained by orthodox means. Christ it's hot.

Club Zothique, for example, is here in Red Hook. It's a New Music hang-out that's well on the way to becoming the next CBGB's. The Ulthar Cats seem to play here every couple of weeks. Hell, they're playing tonight.

All the kids there do drugs, mostly speed, weed and Flack, but there's something else, too, that they call "The White Powder". I scored a few grammes from this seven-foot spade. The scanalysis says that it's DMT-7.

Not much of a drug, as drugs go. In its natural form DMT is produced in the brain, which therefore has a natural system to cope with the substance and flush it away. The mild "trips" last around fifteen minutes.

You see, what this is, it's like taking the leftover pieces from various jigsaws and seeing what picture they make when you put them together. Anomaly theory. Of course, that's not saying the picture will make any sense.

I collect up the photos and hide them in back of the wardrobe with all my other stuff. There on the floor is my overcoat, sprawled like a chalk silhouette. I'm beginning to feel claustrophobic. I'd better go out.

In the street there are monster Forget-Me-Nots shattered all over the sky, and a dull negro thunder that swells in the distance. The Ulthar Cats play at Club Zothique tonight. Fifty luminous fly-bills adorn the Pachinko arcade.

Down the sidestreets that tentacle out from the club swarm the usual flotsam: old ecstasy casualties; pain-faggot skinheads with "MANSON" tattooed on their nose and a bolt through their dick. Just your typical dream-trash.

Club Zothique: a strange neon cancer grown out from the crumbling stone of a waterfront church, a cheap dance-hall and immigrant dive since the late 1920s, a toxic and lurid agaric of light bulbs, enduring the centuries.

Straight from the street I plunge into an amphetaminefield of concussive music and light,

full of underage heat. A support band from Cleveland, The Yellow Sign, are wrapping up a cacophonous set as I make for the bar.

Joey Face, sitting heaped on his stool as if shovelled there, eyes my approach. Thin blonde hair in a pony-tail; green-tinted glasses. He's probably my age, which is to say thirty. I've known him a week.

Joey used to deal Ecstasy under the nom-de-guerre "Rex Morgan, M.D.M.A.", but it's agony now. Joey suffers from amphetamine psychosis; drinks without getting drunk to keep hallucinations at bay. It's too bad. I'm informed he was once a great dancer.

I buy him a drink. We scream amicably at each other above "Leng", The Yellow Sign's encore. I ask how he rates them. 'They're plastic. They're riding this Ulthar Cats thing, but they're posing. They're not using aklo. It's obvious.'

Aklo. Some new kind of drug, or its streetname? I risk a bluff; sneer at him knowingly. 'Aklo? These pussies? Where would they get aklo?' He looks briefly puzzled. 'Why, same place as everyone else.' Here, he glances beyond me.

I turn. By the front of the stage where the tired hippy light show is vomiting crayola puddles across the remains of the audience, someone is standing. Hispanic; flamboyantly dressed; seventeen. Joey screams in my ear: 'His name's Johnny Carcosa.'

The boy's hair is huge, piped like slick black ice cream in a towering pompadour. Cold little eyes, and a yellow silk handkerchief hiding his face from the nose down. His forehead is boiling with acne.

To scattered applause from their girlfriends and pets the support band go off and the floor is engulfed by a riptide of puberty casualties, all wearing Ulthar Cats T-shirts or swastika drag. They surge forward, obscuring the undersized spic.

I turn back towards Joey and try not to shout, momentarily thrown by the sharp sonic pressure drop after The Yellow Sign's set. 'He looks young. Did you ever get aklo from this kid?' Joey shakes his head.

'Fuck, no. I got enough problems already with flashbacks and booze. As for young, someone told me Carcosa was forty.' He nods here emphatically. Highlights dance in his green lenses like fire-flies drowning in creme-de-menthe.

Joey is trying to say something else but it's lost in the squeal of the feedback and popping of microphones. Booming like mongoloid storm-gods, the road crew are counting their brain cells. They crouch, scuttling; unreel cables like spiders.

The band slouch onstage and the audience start making animal noises. It's fucking grotesque. There are three Ulthar Cats, with the lead guitar/vocalist now stepping up to the microphone. If I remember their CD correctly, her name's Randolph Carter.

Her voice is remote and indifferent; predictably masculine given her stage name. She says bored 'hellos' to Red Hook and Club Zothique then monodrones through the first song's introduction. I think it's called "Zann Variations".

'In cobble-yards, through the smashed eyes of a derelict warehouse, old violins play/Where a smoke-river, factory black, crawls below the stone bridges, old violins play/And the crippled dogs whine in their sleep all along Rue d'Auseil.'

To be fair, Randolph's lyrics get better when she gives up English completely halfway through the third verse: 'Crash bridgelict eyeolins, crobble yog sothoth ngh'haa ygnaiith fhtagn in cractory whine-yards/ beloke sleepled R'lyeh nga'haa tekeli-li.'

'That's aklo!' yells Joey.

I guess Randolph took it before she came on. Its effects last the rest of an hour-long set. Even chat between songs is in gibberish. Audience reaction seems favourable. Unbelievably, some sing along on the ones that they recognize.

Stephen, the fifteen-year-old who beheaded his family, scat-singing nonsense words over the tunes that he'd written. Confused of Seattle with his unintelligible tales of horror, or Wino Roy dribbling phonemes, a reeking salivary patina over his chin.

Joey exits the bar halfway through "MiskaSonic" and, quite understandably, doesn't return. As the show ends, I brave the meat pinball machine Club Zothique has become, nudged and shouldered from bumper to bumper. I'm looking for Johnny Carcosa.

He's outside the club with some nondescript greaseball acquaintances, three of them muttering there on the neon-scarred steps of this formerly Catholic church. Johnny's over-sized suit is a pale powder-blue in this light. Hair like licorice topiary.

When the other spics vanish I make my approach. 'Hello, Johnny Carcosa? I'm sorry to itch you, man. Joey Face said I should talk to you if I was looking for anything.' Carcosa, turning, regards me with river-bed eyes.

When he speaks, though you can't see his lips, a faint ripple of breath stirs the sheer lemon film of his veil. 'Joey Fathe ith an ath-hole who takth too much ecthtathy. Watchu wann', anywayth?'

I must look just like a Fed in this crowd of fourteen-year-olds. 'What have you got?' Up close, Johnny Carcosa could be anywhere between twenty and fifty, those acne tracks old plastic surgery scars. His voice: genderless, ageless.

'I got it all. How about thith?' He produces a strange triple-pretzel of greenish-white coral, three apertures, each rimmed with cruel-looking quills. 'It'th a cock-ring from Innthmouth.' Next, wallets of postcard-sized prints entitled *Pickman's Necrotica*. 'Pickman's a geniuth, man. You thee thith?' (A repulsively detailed engraving entitled "Miss Lowell is laid in Mount Auburn". I wave it aside.) 'I want aklo, man. Joey said you could get aklo.' Eyes narrow, between silk and scar-tissue.

'Joey thaid that?' He shakes his giant hair-do. 'I thertainly can't thyow you anything here. Thee me later, at three o'clock up in that tenement courtyard that runth off Court Thtreet.' He turns and walks off. I'm dismissed.

It's just one o'clock now. Farrakhan Day was over at midnight, the indigo fusillade

silenced abruptly. I walk back uphill and along Clinton Street to the one public Faxbooth that hasn't been pissed in or firebombed, outside Borough Hall.

I dial Perlman in Washington. He won't be there, but my access code punches me through to his bulletin board where my round-the-clock update is posted. I enter the booth's number, then wait for Perlman's machine to respond.

Moments pass. Through pursed lips it disgorges a reel roughly eight pages long which I roll up to fit in my overcoat. Starting back up along Clinton, I hear a faint hiss from the dome high above me. It's raining.

Outside the Pachinko arcade coloured condoms bask in the blue moonlight and drool a potentially hazardous venom. I cross to my building then trudge up its stairs to my room on the third floor and lock myself in.

Without pausing to take off my coat I flop out on the bed and switch on the small reading-lamp there on the table beside it. Retrieved from my pocket the fax unwinds, spooling across the room's vine-patterned carpet.

Three items, including a brief note from Perlman. *Sax – Three more in Pittsburgh, same M.O. I hope for your sake this Red Hook lead pans out. Here's some old files I found that seemed vaguely related. Call Monday – Carl Perlman.*

The other two items are copies of Bureau reports from the 'twenties, the earliest one an account of child-smuggling here in Red Hook. A Detective Malone of the NYPD named the waterfront church, now Club Zothique, as being involved.

That was in '25. There was seemingly talk at one time of some Satanist thing, but the chief suspect, one Robert Suydam, expired before charges were brought. Two dozen cops died when the house they were raiding collapsed.

The last print-out concerns FBI operations up in Massachusetts around two years later; 1927-1928. The connection appears to be Suydam, who, shortly before his demise, ordered "ritual artefacts" from a remote gold refinery in Massachusetts; some backwater seaport.

The name of the port's been blacked out at a later date. Classified, obviously. I read on. The offence under investigation seems vaguely defined and involves interbreeding: a morals case more than a Federal matter, in my book.

The document grows more evasive with each line I read. There were lots of arrests, but for what is unclear. There's no charges, no trials. The description "degenerate", frequently used here, could mean almost anything. These were the Hoover days.

Strangely enough, there's a faxed black and white snap of good old J Edgar himself, looking pale and uncomfortable as he faces the camera, standing on some unidentified wharf. Oh, I get it: this must be the classified seaport.

There's something behind him that I take at first to be furniture under a canvas, but no. It's a figure, sat cross-legged, manacled ankle and wrist with a blanket draped over its head. I look closer. What is it?

A man, over two metres, badly disfigured. We're talking the Elephant Man. No face visible, only one hand and one foot. Just four digits on each. Barring flaws in the photo, they're webbed. Hoover looks like somebody just farted.

Carl Perlman sent these because he thinks some cult thing's involved, some Satanic thing, even though of our three culprits one's Baptist, the other two Catholic. Perlman's a know-nothing kike. Still, that thing in the photograph's interesting.

It's just after 02.35. Next door, Germaine engages in loud disagreement with someone called David. It takes me a moment to realise it's Letterman. She's yelling something about his toupée. Guess it's time to go out and meet Johnny Carcosa again.

It takes me ten minutes to walk round to Court Street and ten more to find the address. Three old tenement buildings, their brick turned the colour of scab, eye each other across a bleak courtyard, its iron gate unlocked.

Hypodermics crunch underfoot, frosting the cobbles with glass in a scintillant Disney-dust, one thousand points of light. Cul-de-sac trashcan enclosures dab ghostfish and hornet-hung fruit on night's pulse-points. The tenements huddle; guard hideous warmth.

On the courtyard's east face there's a mural I can't quite discern in the creeping blue dark, a *trompe l'oeil*-effect landscape that seems to stretch into the wall with a shape in the foreground I hope is a tree.

A cat's cradle of washing lines, bare save a child's vest that might have been hung there for years. Puddles, clearly not rain, in the yard's dips and sinkages. Vile centipedal graffiti that covers the tenement steps in its writhings.

A window grates open above in the dark's upper storeys and there, silhouetted against a rectangle of light, is a figure whose head appears loathsomely bloated until I establish that most of it's hair. 'Come on up,' suggests Johnny Carcosa.

An inverted whirlpool of concrete and shadow, the tenement stairwell is dragging me up from the lampless sea-bed of the ground floor (unoccupied: nothing can live with those terrible pressures), through wife-beatings, bad food and babyscreams fathomed above.

On the uppermost floor, leaning over the retch of the wellmouth to watch for me, Johnny Carcosa is waiting. 'Hey, thorry about all the thtairth, man. Them fockerth, they won't thend guyth down here to ficth up our elevatorth anymore.'

It occurs to me maybe he has a hare lip or some similar oral complaint, thus explaining both Carcosa's faggoty lisp and his yellow, concealing bandana. He gestures towards an apartment door, opening off from the landing.

The sour ochre hallway beyond the front door is a phantasmal clutter of smoke-stained celebrity photographs, Catholic icons and pleasure-beach souvenirs caught in a nightmarish bardo of wallpaper. From the smell, someone's been cooking their shoes.

An unusual number of doors seem to lead off the hall and from one now emerges a woman: short, squat, maybe seventy. Brown, liver-spotted skin. Wide features. Spic, or maybe

Eskimo. Rotten-jawed, she gapes up at me nervously.

Johnny Carcosa steps swiftly between us. 'Go back in your room, Mom. It'th okay. Thith guy ith my friend. Yg'nthlai 'ng yaddith, ygg ngai?' At this momma scowls, mutters 'Yg'nthlai aklo!' and shuffles back into her room. What the fuck?

Johnny hurries me on to the end of the hall. 'Don't mind Momma. Thyee'th thet in her old country wayth. We'll go into my room, where it'th comfortable.' There's some kind of queer undertone here I don't care for.

His room stinks of incense and aftershave and something else, something pungent and bitter; a reptile-house perfume. Green light from a scarf-shrouded bulb falls in submarine dapples across the walls, bare save for Pickman prints over the bed.

There's an old-fashioned writing-desk bursting with drawers at which Johnny sits down on a spindly chair and commences some business with spoons, jars and baggies. He hums to himself, something slow and atonal. I sit on the bed.

Something's itching me: what Johnny said to his mother out there in the hall sounded not unlike all that word-salad dished up by the Ulthar Cats earlier, which I'd assumed was this aklo drug doing its stuff. Just coincidence?

Waiting for Johnny Carcosa to finish whatever he's doing, I study the Pickman prints. One, "Subway Accident", actually seems rather witty. It borrows from Breughel and Bosch but transposes their horrors to Boylston Street subway. In style, he resembles Rousseau.

Johnny turns from the writing desk, holding a bag of pale talcum towards me. 'Try thome, man.' Accepting the bag, I taste some of the dust on a spit-moistened finger. It's DMT-7, I'm certain of it.

How can this crap be aklo? This stuff lasts ten minutes or less and that dyke from the Ulthar Cats twitched and sang nonsense for over an hour. Have I got it all wrong? I complain. 'Johnny, this isn't aklo.'

Above the silk curtain, his lamprey eyes widen incredulously. 'Of courth thith ithn't aklo! It'th jutht the White Powder. You have to take thith thtuff before I can give you the aklo. How much did you want, anywath?'

Feeling vaguely uneasy, I ask if he can supply two or three hits. 'Thure. That'th one hunnerd-fifty New Dollarth. Now, do up a line of the powder and I'll thet you thtraight.' What the fuck's going on here?

I tell him that I want the three hits to take away with me, but he is insistent. 'You'll take 'em away when I've *given* 'em to you, but I can't do *that* till you thnort the White Powder.'

Well, okay. If needs be. I've ingested worse things than DMT-7 when duty demanded. I needn't try anything else. Johnny promised I could take the aklo away. Measuring out a line in the hollow between thumb and wrist, I inhale.

The subdued rush brings with it a vivid and colourful foam of hypnagogic imagery rising inside my eyelids. It's nothing I feel I can't handle. I just need to open my eyes and the river of

mind-cartoons ceases.

I look at Carcosa. 'The aklo. You said I could have it.' He nods and stands up from his chair by the desk, crossing now to the bed where he squats facing me eye-to-eye as I sit.

'Clothe your eyeth. Clothe your eyeth and I'll give you the aklo.' I do as I'm told. Two-dimensional creatures swarm over my retina. Escher-precise tessellations. Through cascading jewelry, Johnny Carcosa is whispering close to my ear.

'Wza-y'ei.'

The word bursts inside me like summer thunder, sends scarabs and swastikas rippling over the screen of my eyelids. 'Wza-y'ei.' A mental floor gives way beneath me. I realize I know what the word means; have known all along.

Wza-y'ei is a word for the negative conceptual space left surrounding a positive concept, the class of things larger than thought, being what thought excludes. It applies to so many things, not just anomaly theory but everything that is conceived.

I'm still reeling, eyes closed, from the resonances and implications when yellow silk brushes my ear and another word's murmured, not drawn from the world's common tongues and without an equivalent: 'Dho-Hna.' I drink it in, breathless.

A force which defines; lends significance to its receptacle as with the hand in the glove; wind in mill-vanes; the guest or the trespasser crossing a threshold and giving it meaning. *Dho-Hna*. How could I have forgotten?

A pinwheel of nautillus fronds is dissolved into sparks by my vitreous humour as huge old grammatical structures collapse into place. Aklo isn't a drug. There's no drug with mind-altering properties halfway as powerful. Aklo's a language.

Ur-syntax; the primal vocabulary giving form to those pre-conscious orderings wrung from a hot incoherence of stars, from our birthmuds pooled in the grandmother lagoon; a stark, limited palette of earliest notions, lost colours, forgotten intensities.

Johnny Carcosa delivers the third hit, one more chain of terrible syllables lisped in my ear: 'Yr Nhhngr.' New dendrites twitch blindly together, unthinkable fusions occurring. Beneath me, a vortex of marvellous coinage is opened. I let go and fall.

Now it's later. How long have I been here? The drug has worn off but my mouth is still filled with new language. I open my eyes. From his chair by the writing desk, Johnny Carcosa is watching me closely.

Events have a new continuity now, disassociate clusters of data in pregnant, post-linear arrays: my first steps up the tenement stairs are embedded in those taken now to depart. Paying Johnny is folded around buying Joey Face beer.

I'm in Court Street. I must have left Johnny Carcosa's apartment already, which can more properly be seen as an extended arrival. The Wza-y'ei of this is, of course, that the future extrudes a curtailing force into the present.

It comes to me that, in reality, I am a memory of myself, trudging a memory of Court

Street, this construct encysted within a much larger Yr Nhhngr where I'm already in Clinton Street, near the Pachinko arcade, almost home.

All events are time roses, the clenched fuck uncrumpling into a life as the species folds back to Annelidan ancestors. There lies our Dho-Hna: a meaning bestowed retro-actively by forms as yet unachieved but implicit.

I see that the Lloigor are simply ourselves, yet unfolded in time to an utter condition beyond the fhtagn of our usual perceptions. Time being a function of matter this freeing of ultimate forms may be hastened by pertinent sculpture.

I now grasp that this isn't Clinton Street, nor is it truly me walking across it. We're both merely part of a brief verbalized reconstruction I'm making to you, Germaine, as I kneel here in your room, bent above you.

I want you to know that the tape on your mouth isn't there to prevent you from making a noise: it's to stop the Dho-Hna flowing in through the wrong aperture, which of course could spoil everything for you.

I know you're still worrying over your hands, but please don't. They're quite safe, I assure you. The thing is to focus yourself on the Wza-y'ei; the concept of not-hands. No. No, don't black out. There. That's better.

I want you to watch this part closely. This is the unfolding, from Glaaki to Lloigor. We make the first cut, the y'nghai, just here. Now, gnh'gua equalling y'nghai are tekel'd to mhhg-gthaa, uguth and Y'golonac.

N'gaii fhtagn e'hucunechh R'lyeh. Iä, G'harne ep ygg Rhan Tegoth n'thyleii yr gnh'gua? Shagghai, humuk Dho-Hna, g'yll-gnaii ygg yr nhhngr shoggoth, hrr yll'ngngr Nyarlathotep. Gh'll mhhg-gthaa tekeli-li Y'golonac rrthnaa.

H'rrnai Cthulhu. H'rrnai Cthulhu nnh'gtep...

from this swamp
henry wessells

FOR years after I left the City, I was the only human being in this section of the great swamp. Very rarely, once a month or so, I might see a botanist or an ornithologist poling through these innermost channels, but they would never see me, for their eyes and minds were intent upon a single, visible aspect of this marshland. I know the intensity of their quests for a rare lichen or an elusive woodpecker, because when I first entered the swamp I was a brilliant ethno-botanist, researching an old legend about medicinal plants once known to the original tribes and to the very first settlers who listened to them, for a time, before the Kirititsa vanished. I had read the hints and notions recorded among columns of numbers and harvest totals in the forgotten chronicles and accounts of the Trading Company shareholders who founded the City. I was certain there were plants and medicines in this vacant tract of swamp that would make my career at the University.

I found the *olordu*, "it would have been", the healing plant I sought that first afternoon on the long coulee, and over the years I have discovered a vaster pharmacopoeia than I had ever suspected from my readings in the discoloured pages of legends and ledgers. That afternoon, as I thrust my single oar into the mud to begin the journey back to the edge of the swamp, where a faint path connected to end of the road to the City, I caught a glimpse of secret knowledges that I have been exploring ever since. There was never any question of returning to the City once I became aware of the patterns of energy that control this swamp. What I witnessed that afternoon made all my ambitions at the University seem petty. Even the first transmission confirmed my resolution to remain and preserve the links with this vast, secret awareness.

I learned how to survive the heavy snows that turn the great swamp into a blinding labyrinth of white ice, how to survive in turn the repeated thaws that erase the harsh lines of winter, and flood the meridians and channels rushing in to the center of the marshlands. Today, as on a certain day in previous years, the sunlight seems warmer than it has for months. After having been dormant throughout the long winter, the continuum of decay and germination processes has resumed. Smells from all points of the compass mingle in the erratic breeze, rising from the water and the soggy coppices of birch and cedar I have come to call dry land. The swollen ground, the splash and cry of waterfowl, the warming sunlight, are all evidence that a new season of growth has returned to this swamp.

I have endured the brutal familiar hardships of winter, but I am not sure I will survive

the coming spring. In the distance, where the channels evolve into streams draining the swamp into the River, or dwindle into seeps and damps, at the edges of my dank, greening refuge, I can hear the metal howls of their machinery. Long ago, when I read the thick account books of the Trading Company, I marvelled at the greed of those first shareholders, at a greed I could not fathom, and which I thought no longer existed. Raised in a scholarly environment, I was unworldly, without the slightest suspicion that such greed had, if anything, multiplied itself with the increasing prosperity of the City. Now, there is no denying the encroachments of this greed into the swamp. Along the tangled water meridians that nourish and define my existence, I can see silent ripples of winds that are too faint to stir the dead leaves along the banks. In the same way, I know that circumstances outside the swamp are moving with a momentum that will change the shape of this terrain and compel me to take actions I have delayed for as long as I have been keeping my vigil in this marsh.

In the tiny cress sprouting among the brown compost of histories, in the hooded purple skunk cabbage pushing through the last patches of snow, I can read the unbroken green promise that has sustained this realm, outside the boundaries of their world of cinders, drought and steel. The secret I preserve in this fragile swamp shelters me, but it is an old secret and I am alone against their massed numbers, trucks and greed. They are frightened of the simple equations of change, the process of continuous and unavoidable change that rules the swamp. They are frightened of the glimpses of infinity preserved in the ancient network of canals and reed flats, just as the first settlers were terrified by the knowledges reflected in the eyes of the Kirititsa and those of us who have drunk of these waters.

Here, almost at the central intersection of wood, water, wind and fire meridians, there is an appearance of pristine, unchanged wilderness, but this is a balance that is constantly shifting. Everything in this swamp is as transitory as all our past existences, and they are frightened beyond speech by this. In the empty sectors of the marshes, their maps and their philosophies show themselves to be meaningless assemblies of barren lines and dry sticks. Since I have come to this swamp, and shaped my existence within this geography between water and earth, I have had no need for maps, because I cannot lose my way. I breathe, see, taste, dream the swamp I inhabit. The same elemental energy which flows in the water meridians pulses in my veins. This is part of the secret knowledge they seek to deny, and to destroy with their trucks full of cinders, ash, garbage and heavy metal slurry, the fruits of their poisonous civilization dumped into the shallows. As their bulldozers and graders advance further into the swamp, so I must retreat into the central channels.

When the runnels feeding the marsh swell with heavy rain from unseen hills, even the outlying moors return to their watery origins. Gravity and the solid network of earth and woods are in continuous, shifting balance with other visible forces, wind and water. But the unseen channels and meridians of wood, metal, water and fire also shape events as forcefully as flood and storm and drought. At dawn and dusk, a cleansing pulse of energies surges along metal channels,

through the bogs and paddies. A blue heron explodes into flight without apparent cause, slate wings sweeping past rust-dry cattails. The trans-mutation of toxins is the energy of metal surging, electrons migrating toward the sluicegates. All of us who have lived here feel this pulse, whatever our elemental alignment, just as we all have come to know the deeper secret of the swamp.

The line of their trucks stretches beyond the horizon, beyond the web of awareness I know through the meridians. As their landfills rise into mountains, my perception of these marginal areas becomes clouded, the flux of energies becomes diminished, and the metal and fire channels function incoherently. Experiencing these poisoned states, I have come to understand that madness is the basis for their existence, for the existence I abandoned long ago. This is why they are frightened beyond com-munication by the knowledges I preserve. Here, at the heart of the swamplands where all lines converge, a small hill rises from the surrounding waters. Sparse grass, green throughout the winter, a cluster of ancient birch trees with younger trees rising from rotted stumps, and a single lighting-struck cedar. Here at the central point, the water, wind and wood energies are strongest. Strange translations have occurred in the past, when the Kirititsa vanished from the swamp.

What I witnessed years ago, that first afternoon here on the long coulee, was something I have seen many times since I have lived in this marsh. As I stood in my flat boat near a small grassy mound, straining at the long pole, I saw a wall of brilliant light appear before the three birch trees at the center of the island. From this luminous space a small woman dressed in coarse beige cloth emerged, and stepped onto matted grass. Her face was serene, delicate-featured and unadorned. She held a small leafy plant in her left hand and she beckoned to me with her right. I stepped into the shallow muddy water and walked toward her. In silence, she advanced and handed me the seedling. Her eyes were huge and brownish green, with no pupils. She stepped back to the shining wall and disappeared into the light. I heard the rumble of bullfrogs that starts at dusk in the swamp as the luminous space dissolved. This was the first time I witnessed the opening of the water doorway, when the Kirititsa invited me into their tribe with the gift of the medicinal tea plant they call *gelishiguzel*, "beautiful coming into being."

The white bark of the oldest birch on this small island is smooth and luminous, with hints of pale orange where the bark is freshest, paper whispers where it has silvered and dried. The entire history of this swamp and the controlling channels is written in the scarred black lines of the trunk. So, also, the scrawled circles record the entire history of the once distant City and its rapacious growth, the long series of decisions and land transfers that have turned this swamp into a dumping ground. Even as the bulldozers rumble throughout the night, across the new mountains rising from this swamp, the water channel is still radiant. Energy floods into this region from a luminous void, brighter than the light towers they have built along their roadways and landfills. When they reach the center of the last marshlands, I will travel along the fading channels performing brief rituals to open all the doorways of the wood, water, wind, metal and fire meridians. From this swamp I will return to the source, to the vast, empty silences from which we

once emerged.

When their bulldozers have filled the shallow winding maze of streams and coulees, they will clank and twitch over this low mound. The old birch trees will snap under the metal treads and be crushed into the mud. I will have left no traces visible to their eyes, but the forces that control this region do not need walls or markers. One day, the intangible, luminous doorways will open again. I do not know what special technologies or substances will be brought through, as the medicinal herb was given to me many years ago, but the elemental energies will return into this poisoned world and once again connect the meridians of a new geography. Before long, the inhabitants of this poisoned city will awaken to a new landscape, and some of the inhabitants will, like me, step through into the unfamiliar void.

Red Mass
Dan Kellett

A Memory. Nothing else. Smoky Asian hotelroom — girlish dreams of first sex — dark stranger climbing down from her balcony — she never saw him again — moonstruck — dreaming demons — smack dreams in distant dungeons — moulding bad books — black and white postcard memories — brown medicine bottles — the warning: half-sunk skiff on rocks — Lorelei — the oar smashed, the maiden drowned — stranger on the shore whispers invitations like the moonlit night in her dreams — the stranger, unnamed. No other memory.

A Letter. The Baroness Massey-Head, trustee to the House of M—, to Miss Viola O—, aged two and twenty.

—Despite your odd record, and your hypos, I am able to give you employment as governess to the family of M—, as from the last day of July, 1929. Report to the Warlocks, the custodians, late that day, and thus gain passage to the House of M—. To you are entrusted the three children of M—, in the family's absence. You will be instructed in your duties as they arise. Be sure to remember nothing else.

The House. Vast estate. Place of ancient dread. Stands amid miles of overgrown land, where no one goes. Simple villagers wake screaming at the name of M—. Shadows move there at night. Dark cancers. Sickly pantomime figures lay human hearts bare and weeping. They have seen the horror. Breathing graves, burning wicker-men, the sinister teaser. By night they walk in the House, in the gardens. Who walked there, walked alone.

Arrival. The gate left unlocked. Viola walks through unaware. Eyes follow her.

Arrival. Warlock crouches at the gate, laughing. Withered old rustic — stained clothing — smell of dead baby boys on his breath. There goes the new governess — watching her virginal steps — dead laughter from knowing lips. Glance shifts to under-growth — grotesque Madonna shrine: MOTHER OF ALL PAIN, shrunken breasts trickling blood, wailing lips of sword-wounds.

—My wife is waiting for her. He knows.

Viola struggles with pangs of deep madness, the same horror hollows Warlock's eyes. Now he is gone, she never saw him. Through a grim woody path Viola glimpses grey gothic bulk of the House, walking mesmerized as black moths settle on her brain. Flashback smell of burning

heroin in distant dungeons. Memory of the phantom always behind her back, always awake in the dark.

Seeing the house a hot finger prods her heart — she sinks in visions of dripping red Hosts elevated to savage congregations.

Watching. The House stands grey and cold in the sunlit courtyard. For a long time Viola stands looking up, warm summer silence feeling her hands. Sinister breezes crawl in her red hair — uncanny fingers — old track-marks itch again — her pale face against the blazing sun — sudden clouds. Flashback to black and white film horrors. Those dark windows above glaring down COME HOME knowing the sandstone church between her ears. We have always lived here. Memory of the dark stranger climbing down from her balcony. And he never ripped her.

Warlock. The Housekeeper. Pale hideous Mrs Warlock standing at top of stairs, tired grey hair — Viola gazes up lips parted — red velvet carpet — Mrs Warlock's weary face, eyelids half-sunk. Walking death-wish.

—We have always lived here, my husband and I. The House takes us under its wing of noble blood. You'll love the House ...Viola listens with shivers... Here we lose all time in velvet haze, lost memories in dark varnished wood, dusty chandeliers in the ballroom, cobwebs on the mirror where Maudeville stood — maze of corridors underground — tarnished relics — Oriental statues follow you with their gaze, never talk to them — ashes everywhere in red stone urns... Mrs Warlock's Gestapo shoes thumping up the spiral staircase where she found the hanged man — dried foam on lips.

—Here is your room. Wait here. Open for no one. Your duties start when they instruct you... Viola knows there's no one here.

—Ever been snuffed out?

Flash vision of the House — sixteenth century — twisted bodies festering in dungeons — screaming sickness.

The Flower. Night — waking in moonlit room — curtains shuddering — something outside beckons — garden full of overgrown marble statues — shadows dance on the veranda — streams trickle feverishly — haunted melodies echo from the hills — the ground opens as your dreams so often showed you — flower blossoms in moonlit soil — young limbs sprout from buds half-closed — white arms, red lips — sudden reek of menstrual blood!

Scene fades. Viola stands on the riverbank. A dark shape rises from the water. Flashback mirror in the ballroom — cobwebs on the mirror where Maudeville stood — tearing cobwebs from the glass she glimpses a face from long ago, the Master. Figure wades from the stream — dismal black eddies — recognition: we know each other, and Viola knows. A scorpion kiss and she falls in visions — the phantom always behind her back.

Nightmare. Gloomy black giant moths occlude the blazing moon. Maudlin shivers. The House rests like the horizon — closed book of spells. Black moths descending on human hearts. Viola finds herself tethered to a dark monument, naked, yawning vulva streams clear juices. Mrs Warlock appears withered and twisted carried on foaming dogs. From the hand of a screaming statue she snatches a chewed strap-on dildo, leashes it between her grey labia — plunged deep into the girl's body — red rivers bubble in her ears — ripping sound from stubborn hymen — thought the dark stranger ripped me — strap-on metamorphoses into bronze pastoral staff glimpse episcopal ring on the stranger's phallus — scream of werewolves copulating in the distance — Mrs Warlock has changed to a hectic phantom holding its head back in rapture — moonstruck.

Viola's Diary. Still no memories. Only the dark figure. The House is all that ever was. Restless red haze nights. Smoky curtains, cobwebs on the mirrors. Not even sure why I came. Days float past in silent shivers. At night moonstruck shapes court me, I wait for them in the Folly. I feel a red madness coming. The House whispers of Maudeville. Locked volumes of magick. No one tells me. Suppression in folds of smoky curtains. I think I know the horror they have seen.

I have always been the governess. But no one is here. Only the Warlocks, seldom seen. Mrs Warlock's obsession with sickness bothers me. Some lunatic sickness has led to nightmare, only one homecoming — to the House. We have always lived here. Always that memory of distant dungeons, the mysterious balcony. The same stranger.

A Warning. The Baroness Massey-Head, trustee to the House of M—, to Miss Viola O—, informing you of the sudden death of the children of the family of M—, due to unforeseen family complications. Unfortunately we were unable to cancel your employment; this incident occurred on the day of your arrival, some weeks ago. Nevertheless your contract of employment must continue until the arrival of the family of M—, over the next few months, if at all.

Just as the moon pours down wine to our eyes, the walls of the House weep thick cloying wine, intoxicating us all. Never ask.

Maudeville. Night again. Fantasy of corpses — moon stares on with dead shine — stars mourn down, pale lamps in a crypt — cancelled junk eyes — a bustle draws closer to the vault — spectres dumb and hollow and haggard — the fool, the man-woman (the sinister teaser) pierrot lunaire — black and red death march — obscure village rituals — a veil of shivers descends and all night lives in a grave.

Red Mass. A ghastly eucharist, all hideous injuries relived, diseased moans, blood spattered throughout the crypt. Blinding gleam of gold — a dark figure approaches the altar — congregation of cackling shadows dance and drool, veins open in red shouts — reek of

brownstone — diseased cocks and cunts alike drip fresh blood — Viola feels every hole in her body drip blood. Watching in a corner of the crypt. The figure bursts into frenzy. His clawed hand tears at the priestly robes, nails driven clean into his pounding chest — thin screams twitching flesh — elevates his Heart with thanks-giving...in bloody fingers — overgrown Madonna statues trickle red — the crowd explodes in screaming sickness.

Escape. Panic erupts in paranoiac night-mares — chased by invisible murderers — growling evil dead — Viola runs through endless undergrowth — past the raven — hoarse croak — its tongue is a bloodied phallus — beak in her heart — giant moths and vultures give chase in phantasmal armies — sudden change of scene — Viola running through candlelit maze that never ends — on a dark hilltop lightning strikes a tower — scene fades — pounding blood in her ears — silent YES!

Moonfleck. Waking dazed on the riverbank. Painful darkness. Viola feels herself changed to a lunatic boy in black. Reeling in dark meadows he stalks adventure — hesitates — something on his back — fleck of white — bright patch of moonlight — on the back of his black jacket — he rubs and rubs till dawn — can't get it off! Glimpse of riverbank, old pale woman rinsing her hands in the stream — Viola clutches the moonfleck — sinks to her knees in dreams of shuddering candle-light — the altar.

Maudeville. Call me what you like, you have heard of me. Dr Hate, Mr Brownstone, the moonstruck madman, dark stranger. The Master. I appear throughout all ages, father of the red magick, I raped the Madonna with swords, the mother of all pain. Now awake and taste my medicine again.

Capture. Waking to call of red-eyed raven — the stream a silver snake — pale washerwoman kneeling rinses blood from her white sheets — stirring eddies of madness — Viola stoops to pick blurred white spectre of a flower that grows only in moonlight — she glimpses her reflection as a great clam surfaces — opalescent entrails slither out — seeking young girls' loins — pulsating green light — insane tentacles overwhelm her — more fingers enrage her grumpy cunt — the clam closes — red mass with the flesh — churning musculature — violation. Before dawn it vomits her out into soft mud. Wrapped in marbled slime she dreams on. Green edge of day on the horizon.

Robbers. Madnesses in the dark garden again. Viola rises from dreams of first sex — at last — dazed glides out through open doors down to where pantomime spectres act obscene vaudeville — tobacco smoked through holes drilled in screaming skulls — sneaking up to the house to rob — enraged Viola struts naked to intervene — sudden fear — squatting in the dark she watches

the drunken rabble raid the crypt — picking rubies from hollow eyes of corpses — gems dozing with dead bones. Wild lust chords strike in the gloom — the ringleader in black robe, whitewashed face, seizes Viola by the throat...his robes fall away revealing Mrs Warlock.

Gallows Song. Warlock, the scrawny whore, will be her last lover — the noose — erotic horror stuck in Viola's skull like a nail — Mrs Warlock's long neck rejuvenates to lunatic melodies — wailing unseen choirs — Viola is lifted off the platform — menstruating in terror — the whore is changing to a young girl — strangling her with eager lust. Melting into each other.

Violation. Blood pounding in Viola's ears — choking — red withdrawal nightmares — flashback dark stranger on the balcony — Mrs Warlock is a noose of dead hair round her throat — Viola's eyes strain to find the laughter. Dark gardens. The dark stranger. At last.

Maudeville appears on the gallows.

He mounts her dangling body. Gruesome communions relived in all ages. Hearts ripped out in endless pranks. Now she feels his severed heart warm in her mouth — swollen gland prodding her thighs — twitching flesh and rending pain as his barbed red hook catches her insides — captured — glimpse of smoky hotelroom — endless dreams of orgasm — stranger breathing on her breasts — junk fevers, sudden spasm ...her body is draining in all directions...getting older...flesh withers to flakes...yellowing skin...sickly moon in her eyes...red hair fades to grey tired strands ...descending into the crumpled husk of an old woman...at last she feels herself completed.

Homecoming. A flash from ancient memories — a balcony, less than a glimpse. Years have passed. She sits at her sun-framed window watching the gardens below. Always. Sighing. Viola has been converted to Mrs Warlock. Pale haggard woman waiting for night, for the weird banquets. Sickly daydreams. She feels someone coming soon. Any day now. Or perhaps never. She will wait — for moonstruck nights, overgrown gardens alive, breathing graves, red mass. Waiting for her last communion, holding her heart. A distant memory now gone. And he is in her always. Maudeville. Waiting for her time, to strangle his next whore. When night falls all is relived.

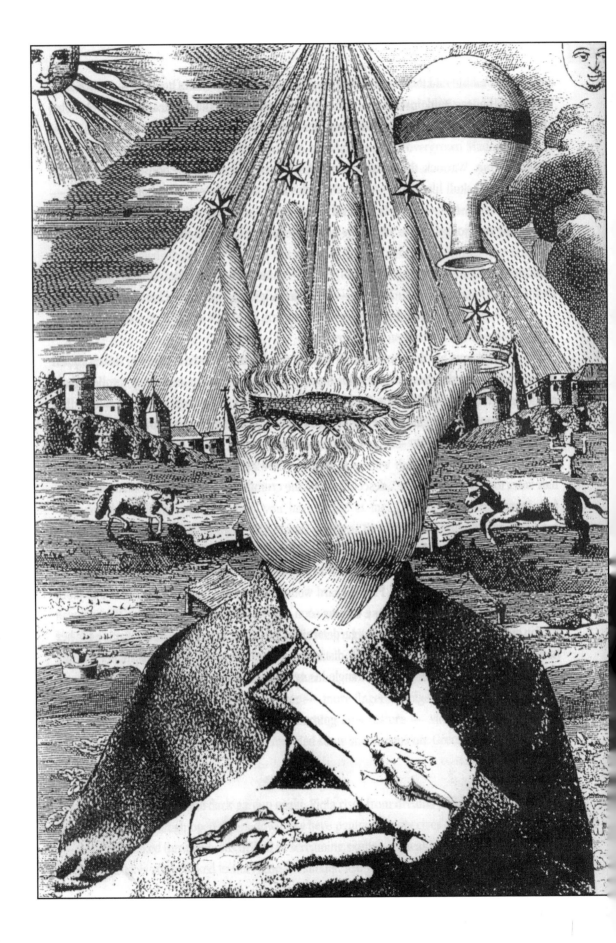

meltdown
D f lewis

THE argument had lasted for some time, but nobody was going to give way. I strolled in on the off chance that I would meet up with a long lost friend, but I saw straight away that he was not one of those present. The landlord was playing pub games with himself in the snug corner. Ervin – need I tell about him? Well, he was the sort one overlooked in any gathering. Sometimes he'd be there for the duration but, come morning, one forgot that he was ever there. Poor bloke – not his fault.

Patricia, Nadine and Susan – the feminine side of things, were always pleasant company, I suppose, wide smiles always on the brink of breaking out for no obvious reason. Put words into their mouths – and other sillier ones came back out at you.

'Well, Naddy, give us a peck.'

She did – a slobbering at my cheek. I motioned blown versions to Pat and Susie. They fancied me dreadfully, I know, but what could I do? I'd have rather bonked a post-box.

Merchant Mannion, the group's mascot, was all mouth and trousers – the former red and ever open with an overnourished tongue, the latter stained with a cocktail of snot, beer and piss. 'Hiya!' he shouted at me, and I nodded towards his flies, smiling a warning at their gaping state, and he pushed handfuls of it all back in again. I suspected him of having a billy-bob as big as that of a brontosaurus. Except that particular brand of monster was dead and long gone.

'Hiya! Hiya! It's always Hiya with you city slickers,' complained the landlord from the corner. He had in fact got to the nudging stage (or was he holding?) as the fruits spun round. The incessant clatter of falling hard cash reminded us all that he was in fact the owner of the pub.

'Insider-dealing!' cried Merchant, pointing with his tobacco-brown finger at the leering landlord. Then out of nowhere, as it were, Ervin piped up over his breath: 'I know more about the Money Markets and things like that than you'll ever know. The City has very few secrets from me.'

'So what?' chorused the three floozies, lifting their left legs in unison like dogs at trees.

'So what, you ask? Well...' Ervin countered, '...there's more going on there than meets even the mystical Third Eye!'

'Go on,' I said, abruptly curious. I had a few bucks in Fixed Interest Stock and Capital Growth Unit Trusts. I recalled that some butterfly-in-the-ointment hack had said that North

American 'smokestack' securities were a safe bet between the next two wars.

'Well, you know they have people floating Currencies, buying up Futures such as salt and sugar stocks which don't exist and won't ever exist. Not only that, but other Commodities such as coffee, tin, pork bellies and dead monsters.' Ervin was enjoying the flavour of the words in his mouth.

'Dead monsters!' screeched Merchant Mannion.

'Tentative dealing in Great Old Ones that have been seen across the outer edges of Suffolk and in one piece from Bishopsgate to Shoreditch round here. They are long tapering tentacles, trailing, coiling, with heads dotted along their lengths, controlling things...'

I could not stand the literalness of Ervin's description, as if what he was saying even approached some semblance of the reality I at least lived in. 'Could you be more implicit?' I scoffed.

'They're brown and long, emerging from those myths and legends which are candidates for reality ... and their starting-prices are pretty keen at the moment. All you have to do is buy up all the good sense in the world and sell it back at a premium – but, in the meantime, these long brown parcels populate the night, rubbing our roof tops with their undersides. Yes, stock up with sense, store it away where none can get at it, and it will yield index-linked and more. We'll all need sense bad when the Great Old Ones have taken a harder line with reality...'

The girls bounced on their benches, gleefully pushing forward for us to look down their fronts. Although they'd heard Ervin's set-piece speeches before, their blind bit of notice was elsewhere. They must have rouged their nipples, for red stains broke out all over their busts, but I decided to ignore such cockadilloes for Ervin's almost endless diatribe:

'As you know, the price of a Share is different depending on whether you're buying or selling it. The top price hangs on how much they let you have and how much you actually want – linked to scales of cyclic precession. If the Planet rises, so does the stock in trade, but if the Zodiac falls so does the Exchange Rate. Alien forces bolster or deflate interest in their own existences accordingly – a convoluted version of reality feeding into non-reality or a-reality and vice versa. Each touches the other at different points along their lengths.'

I had a headache, one that always came on towards late evening, as if my skull were a hardboiled egg set between the little-and big-enders in Gulliver's Travels. 'Come on, Ervin...' I began to complain.

The landlord, now ensconced behind his bar with thousands of charity pennies piled up before him like a Dickensian chimney-hat, interrupted his shipinabottlecastleof-matchsticks activities to pontificate: 'The pub roof needs repairing from all that rubbing by Old Ones, so I will start a raffle in aid of such a good cause.'

As I wended my way home, after a basinful of increasingly ludicrous pub talk and continental kisses, I cast a wary glance at the corners of the night sky which at day were hidden by office buildings. Although my headache was on its last legs, I saw against the moonlit sky a

knotted string of wattled coxcombed heads following through from the Angel Islington to another night, another Britain.

Life you've already lived cannot be lived again and can only be subtracted from your total life to measure what's left.

I've got a short memory and tall tales. I may have already mentioned that Ervin is that sort of person you don't usually notice. He first came into my life as I sat minding my own business in one of those non-descript City squares. He sat beside me on the bench and offered me a cigarette. I ignored him, for fear of mixing myself up in something that Fate did not have Store for me. Unlike Merchant Mannion, I did not take life as it came. More like as it went.

In truth, I'm a great believer in the fanning out of actions around the globe. Just one moment of mining prime snot from one's gaping nostrils at a neutrally strategic moment in some (god)forsaken place *could* lead to the assassination of the US President. So I was always careful to pick my moments. Even the tiniest action had to be subject to well-considered premeditation. Ervin pulled agonisingly on his cigarette with such a long inhalation that I feared he would never come out of it. I then realised it was too late. The domino-rally of events had already been set in motion and I would concertina between two options, either acknowledging his presence or immediately quitting the bench, with my mind wriggling like an earthworm on a sea fisherman's hook.

Ervin was frozen into a park statue, his breath in-drawn, wreaths of cigarette-smoke dry-gargling through his lungs. It was as if the whole world stood still with his inhalation – not that there were any City slickers in sight, nor birds flapping in the sky, to prove my hypothesis. But the bus was over-long at the request stop, cars halted at tenantless zebra crossings, belisha beacons in continuous shine like bright fruit lollies *and* the wind was taking a breather.

All was moving again, as Ervin exhaled long wispy trails of muck from his mouth leaving tacky yellow spots on his glasses.

'They're coming tonight.'

'Who are coming?' I asked, now certain that, whether Fate had been warned of this encounter between two of its subjects or not, there was little I could do about it. By staying on the bench, I had caused the world to jump the points and surge along yet unmapped tracks of Karma. He answered: 'The Great Old Ones are coming tonight, that's who, of course. H P Lovecraft created them out of the doings in his head. Others continued to write of them as if they assumed they really existed, trying to create contests as believable as possible. And yet others sanitised the Mythos so skilfully that I am now not the only one to call the Great Old Ones real...'

I was more than certain, on listening to Ervin's little speech, that I had been chosen to attend this conversational set-piece, since I had indeed heard of H P Lovecraft, a minor amateur US writer earlier this century, who invented the Cthulhu Mythos. I had even read his stories as a rather premature teenager, goggling over his falterings of word magic. Now new words came

unbidden to my mind, as I thought of him: sailing between the obtruding karmic netbergs of outward existence, HPL had been a gentle fisher trawling valuable cast-offs that floated within our oceans of archetypal sewage.

I decided to sacrifice a few more words to the conversation, hoping against hope that they would suffice: 'If the Great Old Ones, as you suggest, are real, surely we should warn the world of their coming and get everybody under cover before dark?'

'Let them find out for themselves, I say.'

And he took a file from a brief-case I had not previously noticed. It was a wonder I had even noticed Ervin himself, since he merged into the backdrop of the setting. He let me look at the file. It was a Jobber's Turn. He did not want to re-align the City markets by warning of the outcome of the night. All the figures dotted about the page were part of an enormously convoluted pattern of supply and demand – Bonds releasing Bonds, Commodities gobbling Commodities, Shares depriving Shares, Trusts deceiving Trusts, Pension Schemes with no love in them and very little hard cash. It all hung apparently on the exact timing of the Great Old Ones. No rehearsal had been possible.

Ervin quit the bench without bye or leave, but then I noticed a slit of white card bearing his name on the ground in front of the bench. I threw it in the litter bin for filing by the dustmen, before deciding to go home forthwith.

As I look back upon it all, I wonder whether I met Ervin at all. The Great Old Ones did not come that night, of course, nor has there even been a suspicion of them since. The markets *did* go the way of Ervin's charts, however; so he must have made a mint on the upswing of the Indices. Try as I might, I cannot find him among the usual lunch-time City crowds.

As I look back on my life, I feel that it must be half over, but I dare not breathe in case I tip the balance.

"Could you please jump quietly – we have several thousand people thinking about whether they want to jump off or not. And, when you're making such a big decision, you need absolute quiet...'

The jump-regulator at the top of the Wall Street block was acting very officiously. This was really his day, a long time in a-coming, but here it was, the Dow Jones Index had fallen so far and so fast it had hit bottom, and was still going down.

Loud-speakers, in every financial centre in the world, were touring the streets, announcing: 'This is only a minor correction to an over-valued market.' – 'It's only the global computer networks that tell the prices which way to go – they've all been Hacked.' – 'Industrial stock will be looking up by lunchtime, mark our words.' – 'Don't even *begin* to panic – the lower the Share prices, the cheaper for us to buy when the Worm in the Market turns.' – 'Don't listen to rumours, for rumours cost money.'

There had indeed been a rumour in the City of London that one Ervin had met his death just before the latest Stock Market meltdown. The repercussions of such an event, even if only a

rumour, were now all too plain to see. For Ervin was the official City Guru, who some believed had a direct line to a god who controlled the Footsie Index, by hacking from heaven. Some even believed Ervin himself was this god.

We've all had experience of seeing him amid the hubble-bubble on the floor of the Commodity Futures market, shouting the toss with the Golden Yuppies: 'I'll give you three and three for a good figment of cocoa beans and completely free of green bug...' – 'Six tons of moonrock – for delivery in 25 years – who'll give me two and five on the button today? No? Well, how about one and one, and a lick and a promise?' – 'Dead monsters, six million dead monsters, going cheap – for buying up by the horror story writers whose business depends on the wholesale belief that they're still alive!'

I've now heard a counter rumour – Ervin is alive and well in Jaywinkle Sands. Can you believe it! That's hardly a resort for the retirement of a Go-Go Boy like him – it should be Marbella at least. I'm told Jaywinkle is nowt a pound, a shanty town teetering on the edge of a (god)forsaken naze.

Perhaps he wanted to sell up, having had enough of the City hurly-burly. But trading in Commodity futures is a funny business. Must have turned his mind. There were a lot of otherwise respectable people who ripped off plenty of punters with goods which never ever even existed. You buy them one moment and sell them at an outlandish profit the next – and what you bought and sold was merely a figment of your or someone else's imagination. In fact, if I had to place bets (and I'm not a betting man), I would definitely say that those so-called dead monsters were very, what shall we say, nebulous.

'Anyway, jump quietly, I said!'

Looking up towards the top of the Wall Street block, I saw the Brokers launch themselves off. Apparently, they've not only lost the money they never ever really had but, according to rumour, their stake money on the football pools, too. One by one, they jumped in a rhythm automatically laid down by some force far greater. And, as they outstretched, in readiness for a skimming curving flight which they did not even hope to accomplish with their frail human arms, I watched them plummet in droves – their flesh slowly darkening, their limbs webbing over, their eyes bulging into bloodshot crystal balls, crashing to the pavement with an almighty sickening crunch of alien bones and a sea-squelch of half-diluted flesh. They had met their death *just* at the same moment as they were capable of flight with arms mutated into skewed wings, but all now littering Wall Street like collapsed circus tents.

And as I watched, the dead monsters continued to pile up on the pavement.

There was only one thing he could do next, but he did not do it.

Ervin stayed put. I found him sitting there, staring out to sea – and, on finding me close enough to listen, he entered what he thought would be a conversation with these words: 'I'm used to the City, where the Markets have recently gone 24-hour, to cope with global trade in Bond

Washing and Bed & Breakfasting ... where, if you didn't know, investment transactions only take place for recouping as much Capital Gains Tax, without any particular intention necessary to maximise the growth or income yield of the investment itself. Now I'm out of all that, I miss it. I didn't think I would – I couldn't bear much more of the wheeler-dealing, the crowded wine bars, the insiders, the under-the-counters, the Unlisted Securities, the Third Market, the Big Bangs, the cancerous growth of Unit Trusts to every corner of human life as we know it. You know, stranger, I was once Fund manager on a Unit Trust solely underpinned by Albanian Venture Companies specialising in secondhand car dealing!'

I nodded.

The sea mist began to roll off the tired waves of a late dusk. I had nodded having intended at the outset not to respond at all. For, by responding, I would divert the natural course of those events that I really yearned to keep out of my control. You may have heard of it – actionphobia – the intense fear of taking a positive step, in case it rebounds on you. Have I told you all this before? Anyway, I have been an action-phobic even from before I was born.

My body did things I could not prevent. Like twitching. Breathing. Sleeping. Blood-beats out of synchronisation with my heart. The turning of the worm. I could not bear it.

I could only walk to where my legs took me and, tonight, I'd wanted to go to the discodrome to meet my future wife, but ended up by the beach ... with Ervin.

He continued, encouraged by my nodding. He explained that he had made his investments liquid, by selling the properties, stagging the new issue Shares, encashing his Unit Trusts when the Bid-Offer spreads were at their thinnest, auctioning off his Index-Linked Bonds and Government Tap Stock. And with all his assets liquid, he took the bus as far as it would go, and walked the rest of the way to the edge of the sea, as if he knew instinctively that was where he should be.

During a period of silence, we both stared out at sea. The lights of a distant liner indicated where some of those City Golden Boys that Ervin had once known were lurking, drinking and dancing the night away, cruising into a Future which is (or was) just as uncertain whatever the amount of money you possessed.

Then, the worm turned. I saw the misty moon skid behind the dark patches of an encroaching summer storm. The sky was like oil on water. I shivered, for the mist had disappeared (it seemed) into my self-breathing lungs. Ervin's head of hair moved as the waves and he saluted something that presumably only his mind could see. He had evidently ignored my absence. For I had gone, minutes before, towards the round shelter on the prom, where I could safely relieve myself without too much bother. But it was all a waste of time, for I had not eaten nor drunk, it appeared, for centuries. I felt as if I were becoming a prehistoric monster freshly emerged from the tidal primeval slime.

Eventually, Ervin followed me up to the seats in the shelter, where a courting couple were playing Trivial Pursuits in a neigh-bouring cubicle.

Ervin's renewed attempt at striking up a conversation was: 'Better to be under cover, when the sea becomes the sky...' I nodded. Damn! I could not help myself. And, he was right, for rain came in waves. I once had a pain which came in waves. The doctor said it was water on the brain and, tonight, my eyes smarted at the possibility of a new onslaught.

Ervin thought I wept. For the pity of it all. The couple next door were no doubt banking on a future as dependable as the past (despite its obvious drawbacks). The rain spluttered to a halt, after its initial hope of flushing the Earth clean of all but its friends the fish. Me nodding, nodding, like the laughing policeman dummy at the end of the pier.

'One's body and mind are the only real assets,' Ervin ventured. And he undid his garments, as easily as a stripper whose audience is on heat.

I nodded.

His skin bubbled up, as it would under the grill and his eyes melted. I loved him too much, I knew. For I cried (the first time that I had actually made myself cry) as his bones popped out like puppets, performing for all too short an act, before they dripped away. His nose became one with its own snot. His lips were covered by a blubbery caul. The stomach oozed out of his navel, like so much shit. His legs were turning transparent, revealing body plankton swimming between the branches of the bones. His feet flopped off like fish towards the sea. His vital part was sturdy one moment, then it too disentangled itself from the wild seaweed hair of his crotch and exploded in a spray of white foamy semen.

His assets were now *all* truly liquid.

And I drank of him. Took my fill, for the first time. Till my half-diluted brain fell through several floors of my body, landing on the prom like a live cowpat. I cannot bring myself to put it back.

The couple seated nearby played on.

'You want to answer General Knowledge? Well, here it is; who invented money?'

The answer was not man. But God, for He made fish first. And before that, the sea. Before that, nothing.

Ervin sits astride the goose-stretched neck of a Great Old One as it traces the coasts of Britain like a map-maker. And I certainly hope Ervin has a girl in every port. On second thoughts, on remembering those three floozies in the pub...

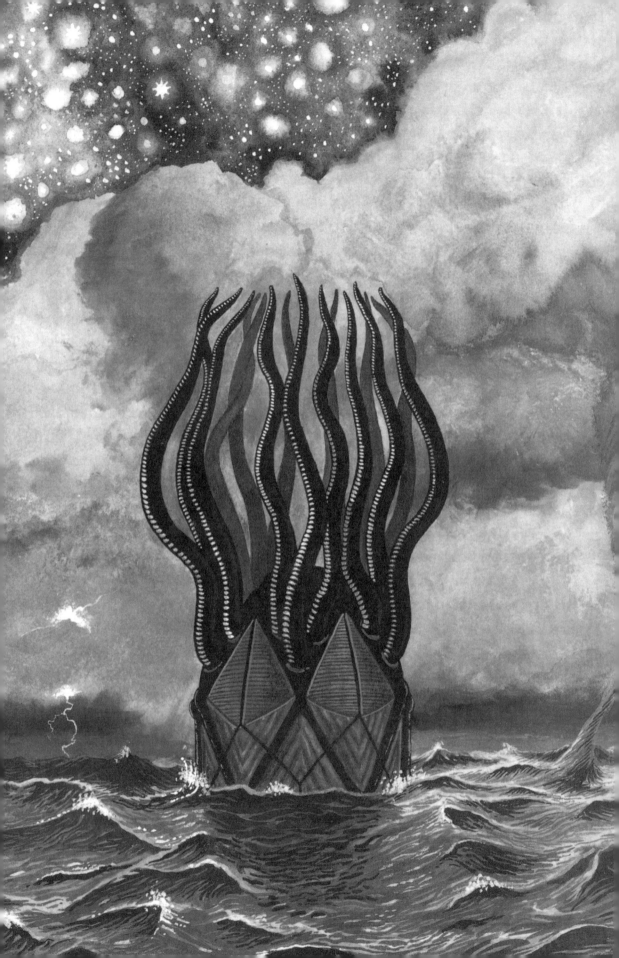

the sound of a door opening
don webb

ALL we had wanted to do was create a little hoax. It seemed harmless enough. We had the perfect cast: writer, magician, computer expert. In the end the magician disappeared, the computer expert died with a horribly broken body, and we all rotted our brains with madness. Before I act in my madness, I will leave a record of our strange adventure as a story. I've tried not to write it, but the thing that urges me to seek out that madness on the island wants to leave a record. An ironic reversal, it was to have been my fictions that created the illusion of fact.

So as I mutter certain spells that keep certain things from taking shape in the shadows of my room, consider my cautionary tale about those who would play the Tlon game.

It began in Wing Lee's Deli on Polk Street in San Francisco. The topic of Lovecraft came up, following the Mu Shu Pork and before the fortune cookies. The computer expert, a regal black woman – let's call her Maya Eolis – mentioned that most of HPL's sites had a real-world basis. St. John's Church in Providence was transformed into the Starry Wisdom Church for *The Haunter In The Dark*. We pooled our information on the topic. The magician, in reality a soft-spoken psy-op (psychological warfare officer) – let's call him Gabriel Thorn – quietly asserted that R'lyeh, where Lovecraft had enshrined the dead and dreaming Cthulhu, was a real place, Nan Matol near Ponape. Gabriel had pulled my leg a few times – so I was really quite surprised when Nan Matol turned out to be a real place with strange basalt architecture. The natives worship the squid god Kutun. For those who laugh off the Cthulhu Mythos, I leave Nan Matol and the *Encyclopedia Britannica* as an example of the shape of the world to come.

We retired to Gabriel's house and watched a Lugosi/Karloff video, *Towers Of Fear*. There's a pretty horrible scene at the end with man-faced dogs with horrible growths from their eyes. Gabriel said that the dog scene and subsequent nightmares inspired Frank Belknap Long to write *The Hounds Of Tindalos*. *Tindalos*, he maintained, was a Nan Matol word meaning 'power' – cognate with the Polynesian *mana*.

'If Lovecraft,' I said, 'developed a peculiar power in his writing by grafting his dreams onto something real – why don't we reverse the process?'

'Start with something imaginary,' asked Maya, 'and graft something real onto it?'

'Exactly,' I said.

Gabriel smiled.

I began by inserting a paragraph in my *Museum News* column wherein I dealt with coming attractions at

large American museums.

"One casualty of the Amenhotep III exhibition will be the retrospective of Hans Poelzig's plaster models. Although Poelzig was a minor figure associated with the Bauhaus, the one-week exhibit was to include several items seldom seen in the U.S. including his *Modell Für Eine Kutlukapelle* and his *Schrecklich Krake*, which many may remember from the UPA film *Unterzee Kulten*."

Poelzig, although he had done some very strange things (like design the sets for *The Golem*), had not made a *Model For A Cthulhu Shrine* nor a statue called *Horrible Squid*. Nor had UPA ever made *Undersea Religions*. The week my article appeared Maya posted the following query on Usenet ALT.SCIFILM.

"Does anyone know anything about the film *Unterzee Kulten* directed by G. W. Pabst?"

Sure enough someone posted back that its sets were by Hans Poelzig and that he remembered reading that there would be a showing of the sets somewhere.

Then Gabriel posted that the film *Unterzee Kulten* had been released with the title *Geheimnisse Einer Unterzeewelt* and its graphic depictions of the obscene rites of certain Polynesian sea-god worshippers had caused the film to be banned in most countries. A single print circulated clandestinely in the U.S. and its imagery inspired the American horror writer H. P. Lovecraft to create his *Call Of Cthulhu*. Well this remark brought Lovecraft fans out of the woodwork. The master surely hadn't seen any film to base his work on. And – as we had hoped – one guy claimed that he had seen the film and that it was too tame to have moved Lovecraft to dream of strange-angled towers rising in the Pacific.

So Gabriel posted asking if the guy had seen *Geheimnisse Einer Unterzeewelt* or the edited later release *Underwater Secrets*? Of course the guy had seen neither since we had made up both, but wanting to get off the hook he said that he probably saw the edited version. Now the film existed as a fact in the mind of one man.

Someone else posted that she remembered reading about *Underwater Secrets* in a back issue of *Famous Monsters of Filmland*. Well what she was really remembering was seeing Gabriel Thorn's name connected with a *Star Wars* fanstory, but the best hoaxes – we reasoned – grew out of other people's cryptamnesia.

We let them tell one another lies on the government-supported anarchy of Usenet. A couple of months passed and we chuckled as our lies grew into facts. Things were beginning to die down, so while I was doing the layout of *Museum News* I inserted the following ad:

"Private collector seeking print of UFA film – *Geheimnisse Einer Unterzeewelt*. Must be uncut version of Pabst classic. Top dollar paid. Writer SEEKER c/o this magazine."

A few weeks later, I received this letter from Lisle, Illinois.

Dear SEEKER,

*I too have been looking for **Geheimnisse Einer Unterzeewelt** for many years. I can provide a photocopy of the book which inspired the film. This book, as you no doubt know, is an extension of the Yuggothic alphabet by Guido von List. If you would like a photocopy of **Das Geheimnis Der Unterzeerunen**, please let me know and I'll mail it to you. Because I know of the tortures that*

seeking after the mysteries can cause, I am more than glad to provide help to another's quest. Guido von List, a renowned expert in Indo-European linguistics and mythology, was the leader of the Germanic occult renaissance of the early twentieth century. If you would ever come across a copy of the film, I would give anything to view it.

Sincerely,

A Fellow Seeker.

Of course I wrote back immediately for a copy of the book. As soon as I dropped the letter in the snorkel box I regretted it. I had given a fellow prankster my own name and address. "Yuggothic" indeed – a term coined by Lovecraft. Whoever wrote the letter had great skill in meta-communications, he was able to get me to do his will. I immediately suspected Gabriel.

So I prepared to E-mail a note to Gabriel.

"Dear Gabriel,

The rules are that we don't fuck with each other's minds."

But when I logged on to MCI to send the note, there was a note from Gabriel in my inbox.

"Dear Don,

Nice try, but I'm not snapping at the bait. By the way, how did you get the letter mailed from Key West?"

So I didn't send my message. I had to figure this out. Was he fooling me – or was somebody (Maya?) fooling us both? Or were there two people fooling us separately? I spent the afternoon re-reading John Fowles' *The Magus* and debating hypotheses.

I decided the best course of action would be to act *as if* Gabriel were trying to fool me. So I logged on to MCI the next morning planning to send my message. There was a message in my inbox from Maya.

"Dear guys,

Which one of you sent me the flyer for the Rainbow Cliff Hotel near Kapinga? Somehow I don't think it's coincidence that I'm getting Micronesian hotel promos. This isn't the rules we agreed to."

So I logged off without sending any message. I would wait for the guy in "Illinois" to make the next step.

In two weeks a bulky xerox copy was stuffed in my mailbox. My German isn't great but I gathered that *Das Geheimnis Der Unterzeerunen* had been published in Vienna in 1908. The book consisted of a dictionary arranged by glyph with transliterations from the "Yuggothic" into German. Guido von List had translated "Y-goth-e" as "path sinister" and claimed that the glyphs were found at Nan Matol(!), Easter Island, and Stonehenge. He suggested that the angular shapes of the glyphs themselves might open hidden path-ways in the mind, if consciously meditated upon for that purpose.

If this was a forgery someone had done a hell of a lot of work to produce it. If it wasn't a forgery someone had done a hell of a lot of work to find me.

Both ideas were pretty scary.

So I decided to ignore them.

For two months when I got a message from Gabriel or Maya I deleted it sight unseen. The easiest way to defeat a hoaxter is to refuse to play.

While I wasn't watching, things progressed too far.

One night I decided to try one of the exercises in the List book. I selected one of the glyphs, the one with the K-sound. I drew the glyph in dark green ink on a three-by-five card. I sat down on the floor of my apartment (in a semi-darkness illuminated by one dark green candle). I stared at the angles and curves of this (supposedly) other-worldly symbol. I kept my eyes half-closed to avoid eye fatigue. Soon a reverie began which passed into a dream.

I was looking out on the ocean as the sinking sun made golden furrows in the waves. As the sun sank I became aware of my surroundings. I was standing on a sandy knoll, behind me (to the East) was a paradise of palm and sand. To my left (the South) was a rocky island rising from the darkened sea. Buildings rough-hewn and strange jutted at crazy angles – most of them trailing off into the winedark sea. Someone lit a torch which burned a bright green. My attention wafted like a breeze from the knoll to the haunted island.

I saw that it was Maya holding the torch and beside her reading from parchment (in his lamb-like voice) was Gabriel. He would pause in his readings as though waiting for a response, sometimes the sound of the waves or the cry of the seabirds seemed almost to form words. He continued to read, and an almost palpable shadow seemed to rise from the ruins. The shadow poured up to Maya's and Gabriel's feet. They continued their strange ceremony and the darkness began to crawl up their bodies enfolding them entirely. Just as the darkness swallowed them I could see a strange starry place reflected in their eyes. As the darkness made the seal complete, the green flame disappeared with a hiss.

Then I was alone. The darkness returned to its normal place as shadows. I started to examine the ruins more closely, but then I awoke.

My candle had gone out. No doubt that change plus the suggestible state I had projected myself into had accomplished this vision.

A week later I received a letter from Kapinga, U.S. Micronesia. It was from Gabriel.

Dear Don,

*We've played at casting shadows so long, I know you won't believe me when I say that we have stumbled on the real thing. The ruins of Nan Matol are gateways – pointers to some sort of **otherness** that goes beyond the consciousness of ordinary men. This is more than a glimpse into a different reality tunnel; it is a whole 'nother reality.*

I suspect the strangely angled gateways are opening new paths in our minds, just as they must have opened new pathways in the minds of the builders. If those builders were in fact human; and not as the natives say beings that came from the sky in stone canoes.

This is what I've looked for all of my life. All of my life I have been dimly aware of another world, a world of vast rushing presences, forces that were scurrying off to perform actions of great consequence. These actors were real not the shadowy illusions of this world. Because I always sought such great activity I sought out a military intelligence career. I felt most alive there. In some ways I

am retracing the steps of Elizabeth I's arch-spy, Dr. John Dee. He too was drawn to the events of his time (and like myself) influenced them with a word or two in the right ears. But eventually he was drawn to another level of action.

*You must come here. This is what you want as well. I remember the night we ate at the Magic Castle in Hollywood and I introduced you to Forrey Ackerman, you talked about science fiction as a quest for **otherness**. Well what you want is here. Not some occultnik projection of dull sameness into realms of impoverished fantasy, but something unknown.*

Come soon while I am still visible to you in this world. Come while I can still teach you, before you have to seek out this wisdom on your own.

Gabriel.

Why was he doing this? Did he really think on the small money writing earns me I would be able to jaunt out to the Pacific? Was he trying to prove his power over me? That his fictions (his magic if you will) were more powerful than mine?

Or had he really –

No, I couldn't let myself think that. No. No. No.

I stuck his letter at the bottom of the huge paper pile on my desk. Thus I refute this tiki-torch mysticism.

Six days passed before the next letter from Micronesia. This one was from Maya.

Dear Don,

The effect of the ruins on the imagination is tremendous. You have to see the dark angular shadows progressing through the night as the stars wheel by. I know Gabriel has written you, and knowing you as I do, I know that you are suspicious.

And yet I remember the night you proposed that if man had any afterlife – it must be prepared for by training the imagination. You called it a secret path between the pure flame of intellect and the shadows of collective illusion. We seem to have access to that path here in the shadows of these obscenely-angled buildings. Please come, who knows how long this door will be open? I would like to think it was Gabriel and I, our wills, but that would be too easy. The coincidence of this site and Lovecraft's fiction is explained easily, he just read about an exhibition in the papers. But I feel that there is something real about the site, and some group – whoever sent me the hotel flyer – that wants to direct our attention here. I'm not speculating on their purpose, because I suspect that it is a pale reflection of the current pouring from this place.

I suspect that the basalt buildings are like skeletons of some great beast. When we read certain words, burn certain incenses, when the stars are aright; we reflesh these great beings. We re-create, re-manifest their ageless purpose.

The next day we feel the changes in ourselves as though we created a substance, an essence that is potent, powerful, and immortal. By playing with things, spreading certain secrets we somehow sounded a chord and an echo has come from beyond the stars. Hear my words. Come to us while we exist visibly. Look into our faces. See how far out we have moved. We know; or we are very close to

knowing; the exit to the labyrinth of history.

*I think the myths the locals tell of the two builders Olo-chipa and Olo-chopa are about more than myths to just explain the buildings. I suspect it **all** started here. Something came to the planet here. Something that left or as the natives say lies sleeping in the submerged parts of the city. The strangely angled ruins point to other levels of growth, possibly levels of growth that the builders created.*

Soon Gabriel and I will try our hand at a ritual text dedicated to Luka-lapalap, the local Prince of Darkness – the god the natives say caused the lands to rise. We will call to him in the name that means the most to our imagination. Cthulhu. Gabriel paid a not-quite-as-suspicious-as-the-rest islander to point out the most dread site Pan-katara – the so-called haunted island, whose name means "The Sending-Forth-Of-Messengers."

*Surely the spirit of **that** place must have touched us when we sat at Wing Lee's over a year ago.*

Come to us – at least to witness our passage when we summon the sleeper from unfathomed waters and uncounted years.

Maya.

If this was a hoax, it seemed to be bringing out their best prose. If it was hoax, it was stirring something in the depths – the *real* depths, those of my soul. My office, my apartment began to seem unreal. My hands would go numb as I designed ads for the local radio stations.

Some parts of the city remained real. The Japanese Gardens, the unworldly beach at Lands' End, Crowley Plaza at Pier 39. I was getting my work done somehow – maybe one doesn't have to be conscious to write ads. More and more I was drawn to certain sights, certain sky effects and strange architecture.
In my mind's eye I kept seeing them. They both looked hot and a trifle silly in their Western clothes. I imagined them taking rooms at the opposite ends of the hotel. They were both very formal people, needing great distances between them and others.

But mainly in the early morning (when it would be nearly midnight there) I could see them performing rites which might predate mankind.

I decided to try and put those mental hauntings to rest. Maybe I could reach out with my mind – give them the witness they needed – and get the whole damn thing over with.
On the morning of July 19 which was a Sunday I tried the glyph and candle trick. It was perhaps the only time in my life I had been awake on a Sunday that early.

I chose the glyph with the 'V' sound, perhaps because my father's name began with a 'V', or perhaps because of Pynchon's novel – which represented the twain powers of obsession and of otherness so great that civilization grows up to cover it entirely. Or maybe 'V' for some reason known only to the misty void of my soul.

I drew the glyph. I lit some copal incense I had bought at a shop in the Haight. I lit my green candle.

The vision came swiftly as though I had already been seeing it in some level of my being.

They stood on the roof of a hexagonal building intoning a strange guttural language toward the northern stars. Certain stars seemed brighter, more vivid. Algol, Polaris, the constellation of the Bull. As they chanted I became aware of a presence or force that seemed to flow out of the building. It hurt all constant regular things – as though it were set apart from the natural universe. It was like a black wind that blew against souls causing them to be uncomfortable – forcing them to change and awaken – or wither and die. It sent strange dreams. It caused beauty and terror – or more precisely it brought into being that beauty which is the beginning of terror we can just bear.

This evil force had nothing to do with natural life, save that when it met it an intricate dance would begin in which all things were possible. Names like Satan or Lucifer didn't begin to explain this dark current.

The current wasn't steady. Sometimes it flowed quickly. Other times it was chaotic and turbulent. The chants somehow sped up the flow but introduced countless vortices. I could sense strange turbulences forming. Something unseen began to flow counter-clockwise around my friends. They could sense it because their voices momentarily faltered. The current eddied faster. Suddenly they were engulfed.

They rose in the air spinning at dizzying speeds. A body fell hard on the rocks. Then the eddies disappeared. I couldn't see who had fallen, my contact was lost.

I felt like I had the worst case of the flu I had ever had. I tried a couple of times during that sick Sunday to renew my contact – but no matter how hard I tried to push my imagination, the images wouldn't come.

I called in sick to work on Monday. In my mail came an airline ticket to Hawaii, a ticket for a boat tour of the seven major islands of Micronesia, and reservations for me at the Rainbow Cliff Hotel. There was a note from Gabriel.

> Don,
>
> See, I'm paying. Please come.
>
> Awareness restful & fake is fatiguing.
>
> I think you will be an interesting companion in Allternity.
>
> Gabriel.

I thought long and hard for two days. Then I called and confirmed all my reservations.

I went.

But I wasn't prepared for what I found.

In Kapinga there was a semi-paralyzed black woman, who couldn't speak. I visited the hospital on some trumped-up excuse.

It was Maya. Her breathing was laboured. The conditions were pretty primitive. I was wondering how I could contact her family. If I could get her out of here. I was wondering if it was worth it – she'd been pretty badly damaged – the doctor said it looked like a fall. People shouldn't play amateur archaeologist.

I asked if there had been anyone with her.

No. But a man had left the island on the same night.

I sat with her. I sat long into the night when she started coughing. I started to ring for the nurse, but I realized she was coughing out words.

'...hard to operate at this distance ... everything wonderful here ... levels of being far beyond what we guessed ... hard to operate ... don't need it now ... leave the robot to the jackals of time ... Iä Cthulhu ... Iä Chau-te-Leur ... Iä Luka-lapalp ... Kef ... ir...'

She died in the morning. I spent damn near every cent I had getting the body and myself back.

I've thrown myself into my work, but everything I write takes on a transcendent quality. It's as though something has changed in me and the beauty and terror of it have to come out.

So this may have been a little hoax we played – a group of pranksters wanting to call up the Great Old Ones over pressed duck and Mu Shu Pork – but our hoax seems to have swallowed us up. So pranksters beware.

Everyday I look in the mirror trying to figure out what new thing looks back at me.
There were others involved. The book from the now-closed P.O. Box in Illinois. Maybe the Great Old Ones do have human agents that help the process along. Or maybe it was a cosmic hoax and Gabriel just wound up as lunch. Maybe Maya's dying words were a cosmic prank from some other dimensional equivalent of a kid asking me if my refrigerator was running.

But whatever, the call is great in me and grows greater every day. Soon I too will go to the strangely-angled ruins. Soon I will say the rites. I have deciphered the List book and fate led me to another book whose name I will not record, so that the foolhardy among you will not be tempted. I can't let someone else fall the hoax, but as the old liar said: 'Maybe there *is* gold in them hills.'

Perhaps soon I will know what truths lie beyond this world of mirrors.

Beyond Reflection
John Beal

"Things still come upstairs,
things that split husbands from wives."
– from the film poster
Things Still Come Upstairs.

The poster was in the newspaper. It was plain; the title, an array of white block capitals, crossed beneath the picture in an orthodox fashion. In fact it appeared perfectly orthodox. More unusual was the film poster beneath, depicting a couple of young women struggling to comprehend their lesbian love for each other.

As he stared at the pictures the first sent a shiver up his spine. It showed a young woman in an ochre Arran sweater. She wasn't screaming and didn't even look afraid, yet he knew she was alone. The phrase repeated itself over and over: *Things still come upstairs, things that split husbands and wives*. He was sweating, images flooded his mind, axes and blood-splattered, screaming forms. Blood splattering onto a cinema screen. His thoughts were frenzied, they sparkled and flashed, like a lightning-strewn autumnal night.

Another phrase, this time from the film, entered his thoughts: *You don't have to go out to play!*.

The image was menacing; a clown's face, mask-like, screaming laughter, as a dishevelled tangle of limbs suddenly appeared from the dark recess of a bedroom corner. It was so dark, he couldn't decide if they were bodies or dummies; when he suddenly, shockingly realised it didn't matter, an involuntary hiss left his mouth. He unclenched his teeth, the effort created more images.

A mad tangle of snakes, eyes ablaze with the desire to kill. They seemed in some way just like the corpses in the alcove. Moving, squirming, hissing and pealing laughter.

Startled he looked up – a gust of wind, sudden and unexpected, had crashed a volley of rain against the window. His heart leaped and then dropped like a stone; the feeling of nausea cut across his stomach. He realised that he had been fantasising and once again glanced at the picture. It was all that was necessary: once more he was drawn into a web of images.

A woman running and falling, typical horror film material, and yet dreadfully real. Nothing was chasing her. Or rather he saw nothing, the corridor beyond her was poorly lit, dreary and claustrophobic. From the door leading to the attic he saw a hand move back into the shadow. The woman was retching – bile and laughter.

'A bitter-sweet embrace my dear, come on and kiss me; you know how hungry I am for you!'. The words were said in total darkness, utter terror gripped him as his mind staggered at the implications. A

figure appeared, semi-obscured by the gloom, unless, he thought, the figure was only partially there. All in white, like a man in a nineteen-forties film. *Casablanca*, or some other heat-soaked romantic drama, dragged his thoughts again from the poster. Some-how unrecognisably the picture had changed. Thrusting the paper under a chair cushion, he swore he would never look at it again.

Weeks later he found himself returning from America. Squealing tyres on tarmac, like pigs being slaughtered. A rough landing, but he was relieved to be down. The engines whined at peace. Rest from the nail-biting altitude made him gasp. The sunlight high above had been replaced by a sullen grey stratus enclosure. Up high he had felt like Icarus flying to his death. With the roof replaced, the sky seemed less dangerous. He had been too close to the unspoken space beyond. The thin metal screening him from the full horror once again solidified, enabling it to hold the reality he was secure in. If only he hadn't had to cross the ocean to the convention. It seemed like a night-mare; the flight there was difficult, but the crossing back had been impossible. He was amazed to find himself on the stairs leading to the ground. It reached up for him in a secure embrace. This was the last flight he was ever going to take, he concluded.

Back home he walked the hallways, examining the reports. His work would mean going back. He hated the thought of it. The view from the window high above the dreamland clouds shattered his concen-tration. He was sweating; he knew he couldn't do it. The journey was too much, he would write instead. This thought calmed him. He eased into the room immediately to his left. Once inside he realized he had been walking in circles, traversing mechanically through the downstairs rooms and hallways until he had once again retreated into his library.

Books he had read a long time ago studded the shelves along the walls. He had lost interest in most of them, but some still held fascination. The truth was that he just couldn't concentrate long enough on one subject. Most of the time he was blissfully apathetic, uncaring in his solitude for the irrelevant mumbo-jumbo of the outside world, encapsulated in any form.

The weather had closed in; cold, damp and miserable daylight sulked through the window. Sunlight seemed restricted to his childhood. He decided to tidy his house. After leaving it for a while, he was acutely aware of the disorder. As he tidied he became aware of something awesome in the room. It reminded him of a picture he'd seen. A cavern, gouged out by centuries of screeching, clanging, torrential water.

A vast black cave, whose stalactites hung crazily from the roof. Angler-fish jaws had the same appearance, and held the same life-force. He remembered then another picture. The film poster was as vivid as if it were in front of him; its metamorphosis, however, had progressed. He was aware of the force, a whimsical yet horrific malevolence. Ancient incarcerated evil, a djinni of the sands. Its body, matted with sores and hair, repulsed him; and the head, a globular twisting of indescribable mush, created an uncontrollable sense of vertigo. A frog's head began to laugh, quivering lips; screeching low-pitched cackles. The sound was bizarre, nothing he had ever heard before sounded like it. Nothing except the title music of the film he thought he had forgotten. His mind raced, he had never seen the film, he couldn't know what the title music sounded like. Yet he did, he knew with certainty what it sounded like; to the last dull chiming note he could recall it. It was the music of the dentist's chair as the gas's effect sent him spinning

into the vortex of the mask.

He was sure he was ill – something like a fever-dream gripped him, he walked somnambulantly to a chair and sat, shivering and perspiring. The chair felt uncomfortable. He realised something was beneath the cushion. Half trembling his hand crept beneath the seat into darkness. He felt what he knew would be there, what anyone in his situation would have known was there.

The newspaper, although crumpled, was still open at the page on which he had left it. He heard the gas fanfare begin to exude from the mask. Uncontrollable laughter filled wild stretches of deserted land, deserts, moors, forests and lakes.

On the poster everything seemed to be as he could remember it. Yet he couldn't be sure. The picture, he was certain, had changed. He couldn't recall what had previously appeared above the title, but now there was a vast oceanic lake. The borders of the photograph, and the reflection of sky on the lake surface, gave the impression of a mirror. A terrifying dark lake, a picture on a bill-board – an insane carnival mask, made from black decaying marine crustaceans, octopus limbs and jellyfish. He stared, and the eyes stared back.

He was screaming, laughter echoed back. From the picture, arms seemed to entangle the mask, which had taken on three dimensions, dragging it back beneath the waves. All was quiet. A deathly silence. The theme had stopped. The scene was totally devoid of noise. Then he heard a steady rushing of waves, the blood in his ears echoed by sea-shells. The shore-line faded and soft sand beneath his feet stretched away behind him. He was facing away from the sea, away back into the landscape beyond. A landscape made solely of the library, strangely orientated and coloured.

Uncontrollably he moved, turned away and walked toward the becalmed waters. He entered between the water, not feeling wet, as the unreality lived on. Yet he was going deeper, deeper and deeper. Still the water did not touch him, it encased him and held him, until with a sudden rush it swept him away.

He was falling, forever, not knowing which way was down, he felt each direction pulling incessantly. He felt infinity dragging at him. The scream that broke free of his mouth left him on soft wings, fluttering away to leave him alone.

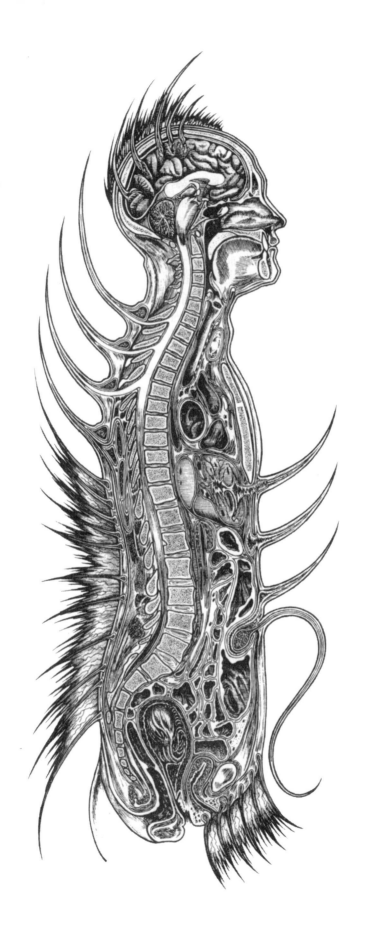

the dreamers in darkness
peter smith

THE candles flickered, painting the walls with tilting light. In the narrow corners of the attic room, shadows alternately advanced and retreated like clusters of black spiders. Outside the thick woollen curtains, the wind whispered between chimney pots, an idiot voice spilling its senseless secrets to the night sky, an empty litany over rooftops laden with greasy snow.

The room's single occupant sat at a small wooden desk, the only furniture apart from an old bedstead with threadbare mattress and stained yellow sheets. In fingers stiff with cold, the young man held the note to the unsteady lights for the hundredth time, he stared at the printed characters in smudgy black ink. In one spot, where a heavy snow-flake had clung momentarily to the cheap paper, the words became almost illegible. Once again, he found that he was totally unable to recall the features of the heavily-dressed figure who had pressed the folded message into his hand, then hurried past, slipping silently into a dark, brick-lined mouth between dusty shop windows. That had been only a few hours ago, with dusk gathering round him as he waited in an exposed shelter in the bus depot, vacantly watching the snow on sloping rooftops opposite turn fluorescent blue in contrast to the darkening sky. Now, in the marginally warmer confines of his bedsit, the lines of text floated up in the waxen gloom, as impenetrable as when he first read them on the returning bus, surrounded by hunched, steaming passengers. The phrases seemed to lift from the coarse white paper, hanging before his eyes like the pieces of some meaningless puzzle.

"THE FRATERNITY OF DARKNESS". Fellow seeker, you are invited to a Meeting of our August and Hallowed Society. The Veil of Reality shall be lifted from your eyes, and you shall look upon the radiant darkness at the heart of existence. You are most urgently requested to attend our next gathering, as a Brother and Friend. Our Conclave is to be held at the Old Burnt House, Bridge Street, promptly at the hour of nine. May your path become One with ours!

His first reaction upon reading the cryptic invitation had been to crumple the paper and toss it into the slush-choked gutter at his feet. Though he had once held a passing interest in the occult, to the extent of buying several expensive books on the subject, he had since reverted to a cynical scepticism toward anything purporting to conceal 'hidden secrets', and regarded those who

espoused such views as credulous fools. Perversely, it was this very loathing for occultists and their irrationalist doctrines that had undermined his initial dismissal of the note – for though there could be no 'occult' as such, the absurd posturings of its adherents could perhaps provide an amusing distraction from the dreary treadmill of modern life. And it was this sentiment, together with a nagging annoyance at the contrived mystery of the note, that had formulated his decision to attend the meeting.

Taking his overcoat down from its nail behind the door, and placing the folded invitation into the inside pocket for protection against the wind and snow, he checked his watch, snuffed the guttering candles, and quitted the darkened room. He made his way cautiously down the wooden stairs, dimly outlined in the meagre light from the skylight above, then along the hallway past silent doorways, and out into the arctic chill of the night wind. At this hour, the streets leading down towards Lower Denborough, and the industrial district bordering the River Den, were relatively quiet. Commuters and shoppers had long since returned to their homes, and the clientele of the town's many public houses were ensconced in their smoky tap rooms, already savouring their third or fourth pint.

The slushy grey snow was beginning to freeze underfoot, sparkling with yellow diamonds of reflected street-light. The Old Burnt House, a local landmark, was situated in the centre of Denborough's now-depressed factory-zone, and, as far as he knew, had been empty for many years. Stepping out of a long alley-way between the lowering black bulks of disused warehouses, he came into a wind-scoured square of ancient office buildings, a cobbled bank which sloped down to a small stone bridge crossing the river. And beyond this, the squat hulk of Burnt House, its frontage half-blackened by fire like the features of a lopsided, disfigured face. He paused in the middle of the narrow bridge, briefly considering the abandonment of his expedition, which now seemed rather ridiculous and pointless. He stared over the parapet at the icy black water of the Den; reflected clouds scudded across the shuddering face of the moon. Then the moment's indecision passed; he coughed between gloved fingers and nudged on up the other bank.

Curiously, he could see no sign of interior illumination of the building before him, nor even of recent habitation, even at such close quarters. With growing trepidation and uncertainty, the young man approached the ponderously ornate porch-way, an incongruous, Egyptian-style portico of soot-grimed sandstone, and knocked as loudly as his muffling glove would permit. His shadow fell onto the panelled door, sharply outlined by cold moonlight. Around and below, the dead factories of Denborough stood like the mausoleums of some long-vanished, chthonic race. He was on the brink of turning to retrace his steps in the snow, when the door opened in a surprisingly smooth and silent arc. A dim figure separated itself from the pervading gloom of the interior.

With a short greeting and request to examine the invitation, the nondescript agent of the melodramatic "Fraternity" led the way along a lugubrious, unpainted hallway to an identical

doorway giving access to rooms at the rear of the building. From somewhere beneath the bare floor-boards he caught the faint susurrus of rushing water, presumably a subterranean conduit emptying into the River Den. Without looking back, or uttering a further word, the sullen guide inserted a modern-looking key into an anachronistic Yale lock, and admitted his guest into the chamber beyond.

The stuffy, over-heated air of the room seemed to fill his eyes for a moment, making them water. Through a teary haze, he could discern the tableau within, inadequately illuminated by antiquated gas-jets affixed to the walls. In a roughly semi-circular arrangement, a number of embarrassed individuals sat on rickety wooden chairs, like the members of some depressing church attendance group. His taciturn guide stepped into this circle, gesturing to an empty seat on the further side of the room. As the young man settled himself into the uncushioned chair, the doorman retreated from the room without further comment, and the uneasy gas-lights shrunk to mere glowing tips.

He now had the chance to take stock of his surroundings in detail. The room was square, high-ceilinged and windowless, the walls panelled with the same brown-stained wood as the passageway. The scuffed, black and white floor tiles, like a giant checker-board, hinted at past usage as a Masonic temple. The stifling heat was generated by two huge gas-heaters, standing guard at either side of a battered wooden pulpit, probably extracted from some derelict church. Behind this podium was another featureless doorway. As he began to search the inner pockets of his great-coat for the cryptically-worded handbill, half suspecting an elaborate joke staged for dubious motives, this door swung open, and a tall figure stepped out and crossed to the pulpit.

Immediately, he felt the heavy atmosphere of the place thicken; an oppressive weight seemed to settle on his shoulders like some unwelcome, parasitic avian. From the silence of his desultory companions, punctured only by laboured breathing, he knew that his discomfort was shared. The newcomer took the stand. Like his companion in the hallway, he was curiously anonymous, dressed inconspicuously in an outmoded suit of nondescript colour and material. In fact, it would have been impossible to state with any degree of certainty that they were indeed two different individuals, or whether the doorman had merely taken a circuitous route around the chamber, to re-enter from the rear. In the sickly light of the gas-lamps, his face seemed oddly waxen and smooth, wholly devoid of the marks and wrinkles which endow character and life upon the human visage. Similarly, his eyes were so dark and sunken as to be almost invisible, though they swept the huddled assemblage like the cold light of a dark beacon. Without pausing for explanatory introduction, the Speaker began the address, his voice as buzzing and disembodied as a ventriloquist's.

At first, the monologue appeared to consist of nothing more unusual or dangerous than a basic exposition of the central tenets of spiritualism and theosophy, although the strange accent and vibrating tone of the Speaker's voice contributed a slightly dislocating effect to the discourse. And so the point at which the innocent narration ceased, and a kind of menacing mesmerism

began, was impossible to define. Likewise, the prosaic and conventional elaboration of certain primitive myths and legends which followed, in turn subtly blended into an evocation of a more ancient and primal cycle, concerning the continued existence upon the Earth of wholly alien and inhuman deities. The bizarre terminology and denominations of this obscure mythos, though totally unfamiliar to the rapt audience, yet seemed to evoke faint echoes of pre-knowledge from the deepest wells of racial memory.

As a miasma of hypnotic control sank into the minds of the listeners, the discourse took a further shift into the realms of blasphemy and delirium. The vile revelations and insane heresies poured forth like a torrent of evil sickness. And with it came moments of disembodied vision, of increasing duration; monochrome glimpses of porous, grey worlds and rotting, diseased planets, viewed against a maelstrom of dying stars. A titanic city of gigantic, tottering stone towers throbbed with impossible sentience, riddled with the bore-holes of termite-like parasites. A bloated monstrosity, the size of a small moon, hung in airless suspension above a distant range of nightmarish peaks, dripping milky filth. Its enormous, cycloptic eye wept and cast a greenish ray upon the teeming, writhing masses below, making them scream with electric pain and gnash their flecked, clacking mandibles in obscene chorus. Then, when sanity seemed threatened beyond hope of redemption, the psychic grip of the Speaker began to loosen, and awareness returned to the dull, earthly scene of the room in Burnt House.

Shaken and stunned by the hallucinatory visions, the circle of listeners slumped forward in unsteady chairs, retching and crying as if some dreadful poison were coursing though their veins. And yet, before recovery of orientation and stability could resolve, another wave of irresistible command surged over the ravaged gathering. Like so many soulless automata, they jerked upright, pathetic puppets held in the gaze of black, dilated eyes. The Speaker moved back to stand by the door through which he had entered; the simple passage-way upon which it now opened seemed like the pylon to all that was unholy, unhuman and mad. The young man stumbled to his feet, grasping a chair back for support. Impelled by the projected will of the Speaker, he joined the shuffling line which had formed, following a stooped old man in a soiled overcoat. With deranged intensity of vision, he stared at the dandruff which whitened the dirty collar before his face, the thinning strands of yellowish-white hair. Before he realized that the somnambulant column had moved forward, the unmarked door closed behind him with a hollow finality.

The Speaker turned to face them, his pale face a devilish, contorted mask unable to conceal the alien motivation churning beneath the sly verisimilitude of the surface. As the embalming gloom of the inner chamber surrendered to sight, the oily gleam of hundreds of large glass specimen jars leered down from wooden shelves lining all four walls. And it was from the urine-coloured liquid filling the jars that the dim light of the box-like room originated, painting the haggard faces of the hapless group an unearthly ochre hue. With the deliberate motions of a hierophant performing a task of arcane worship, the hypnagogic master reached up to the serried ranks of glass, transferring a single jar to the bare table at the centre of the floor. Within the

stained fluid, a vague, curving shape shifted almost imperceptibly, whether from the disturbance of its vessel, or from some inherent vitality. With his back to the entranced captives, the Speaker dipped a smooth, pallid hand into the round mouth of the jar. An acrid, formaldehyde stench permeated the enclosed air of the chamber. With incredible swiftness, the keeper reached into the group and grasped hold of the young man with a crushing, iron grip. Held between index finger and thumb, a glistening black root, or worm, twisted wetly, then leapt forward under its own volition to penetrate the open lips of its startled victim. Around him, the jar-lined shelves and blank, staring faces whirled into a delirious spiral as consciousness surrendered to the mounting darkness.

Under the inverted bowl of the frozen night sky, a somnambulant column of worshippers shuffles across the windswept flagstones of an unlit courtyard behind the Burnt House. As the grey light of dawn seeps into the blackness above, outlining the broken walls enclosing them, the penitent figures gather around their silent leader in a ragged circle. With a curious gesture, he directs their collective gaze upwards, to a pre-determined point in the heavens. There, a single yellow star commences a deliberate and intelligent series of flashes and darknesses, a cryptically-encoded message from beyond the abysses of time ... a malevolent, signalling eye.

sex-invocation of the old ones
(23 nails)
stephen sennitt

1)

In the beautiful red golden sunset
in the mark of the Beast
burning firebrand of stars
White hands in silhouette against the charred black icons
black charred lips speckled with dust
from heavy red curtains
the blind white face looking up from a circle's centre

my eyes are gold, themselves
unseeing
braziers of ornate flame
in a halo of polished mahogany hair
in the mirror a most beautiful face
held into position by rusted iron nails

I see my female-self
touch the glistening body
turquoise and green and red
mouth unfurling like a blister ripe to burst

my pin-up

mirrors surround me in geometric perfection, stabbing fingers toward me as I cry out in painful lust inside the beacon of sound I have erected, a radar signal pululating into the depths of the spectrum, thrumming like a black box beneath the depths of the ocean.

The haunted ocean depths mirroring the black depths of space, my coloured garments crazed with nightside fissures, pierced by nails in seismic upheavals marking out the spaces between heights and depths, between colours and sounds, between lives and deaths.

I thread a chalk mark along the glistening trail of reflections from mirror to mirror, robes tossing like seas of space, my breath sugared with cold longings, the delicious compass of images chaotic within the expanded surface of reflected space.

within that space, the burning dance begins.

All sound and motion and thought in no-space beyond the parameters of tangible images, coagulating like blood beneath the eyes, forming a pool of mirrors outside Time and Space, the glossy black wings of the red abyss.

A succession of shuffling, peaceful dreams...

Without warning the nails that hold my lover in position shoot from the wall, pinning me into the shape of reflected space within my mind's eye at that very instant; the shape of space within me growing within that delineation, within the womb-boundary of the gateway from which I shall emerge in a stream of sperm.

I am in an amber glow, tides of colours like bruises along the smooth walls that go on into darkness. On a table before me there is an effigy driven with nails into its twisted torso, an amalgamation of faces both bestial and sublime, expressions altering in the play of light as I twirl the eidolon in my fingers. As the sleeping, dreaming faces melt into one another I see my own face in there and sigh, sugary pink with love, aching with the tangible nostalgia of love. As I focus on my face, it comes nearer in the tangle of dreams until I see every nuance of expression, the nostrils flaring, the tiny eyes opening and closing, mouth yawning, minute strands of saliva glistening in the flow of amber light. I am my own lover, loving myself, possessed like a mannikin and loved truly like an image of myself.

 I stretch my own lover's hands up and I spin round in love with the source of myself. I spin in sequence with the light, round and round until I disappear within it.

2)

Banging drum-like, my eyelids blinking automatically in rhythm, the room is plunged into aquatic darkness, deep green webs and rays of an even deeper darkness punctuating the vault like blackness like a signal.

I feel myself
passing down even further
into myself
so that I am beyond myself

and beyond the love of myself...

Through the amber glow, lightning green flashes of space-darkness, a succession of images of my
selves swimming away from the nail-driven effigy, each punctuated by a talisman of blood,
gorgeous scarlet wreaths of blood. I count 23 nails, each piercing my heart and rending me apart
from my selves.

inside a whirlwind
the blind white face looking up from a circle's centre
the beautiful red golden lips
charred black icons
like a blister ripe to burst

I cry out in painful lust, delivered from my selves, inside the whirlwind beacon of sound

TULU IOG SETOT AZATOT

formless islands of primal matter in sentient space

I feel the Great Old Ones begin
to beat
the lid of their One Great Eye
in rhythm to the ancient stones

A circle of stones with eyes
where black bones lay

all time passed black into the wire frame of the past
all perfume of the past goes on all night

through all the centuries rending me apart from my selves
formless islands of primal matter in sentient space

The Mark of the Beast in the beautiful red golden sunset...burning firebrand of stars...

my pin-up

zaman's hill
alan moore

Moonfire, decanted by huge, prehistoric machinery into the die of the hills, quenched to lead and by day the far slopes lost in steam. Birdless dark in the pine-deeps. Toboggan scars drop from the path into haunted, perpetual twilight and down to the lake; the drowned hamlets beneath a vast acid lagoon, void of fish. Shreds of wallpaper drift in the submarine kitchens, a memory of waterweed.

Mineral energies sucked up like snot through the bronchial roots taint the sap with old grudge, coded Thatcher-year sunlight deciphered in camp-fire to ash and to spark. Soon we all reek of flame with its taste in our water, an Inferno cordial.

We stare at the bright fissured hide of the firelogs, red-hot alligators crawled from a burned Nile, breathing smoke, we inhale the wood's madness, the contour-mapped rings of its DNA memory encrypted the length of each bark-armoured spine, so that some of us know a compulsion to sleep in the gut of the blaze, or to give it our blood, and the twelve-year-olds skirmish with bottles and toasting forks.

Somehow the crotch of a woman is sculpted, a split stump with knickers pulled up the fork, a crude amputee idol that calls to the ghost-dogs who scrawl canine histories, written in piss in her flank.

These are Machen-hills, skull-hollow, echoing reverie of skeleton, arrow-head; fossil imperatives; grey-lobed with slate; webbed by ganglion worms. The intent of this landscape is buried: immense geological crania, stratified sentience under the scalp-grass, military crew-cut of Forestry trees.

In pursuit of the cortex, the bedrock of purpose and memory we must go deeper, explore the decalcified brain's subterranea, down through the nightmaring stone to a secret Pre-Cambrian core: Dan Yr Ogof, a limestone delirium three hundred million years old, its grey matter shot through by the tetanus vein of the Llynfell, whose calcinous rivulets spread like a tectonic syphilis birthing slow, massive hallucinations that accrue, centimetres to measure the centuries, limaform visions of Moonmilk and Helectite, strange half-complete hypnagogic impressions of possible life-forms chewed into the calcite, stained bloody or yellow as tallow by iron, dyed pale statue-grey by the manganese.

Here is an underland coral remembering long-vanished tropical ocean, the reefs of Primordia. Here are the mudflowers grown into a hideous Michelin man, a toad-figurine, white

and obese, head half melted with rain-eaten eyes.

Knots of tentacle coil from the underlit scarp where the flowstones and curtains form jellyfish rills and a gigantic femur, two-thousand-year-old alabaster stood knee-socket deep in a rockpool. The stone threatens terrible life, dreams of meat, draped like fat in streaked translucent veils from the underhang; fashions a geo-organic menagerie, every conceivable quirk of biology prefigured here in these waxed carboniferous ruptures, this hog-bristle stubble of stalactite, fat roe of cave pearls. In shower-spattered streets below ground, dim, pellucid, our fingers trace wet shapes: the cold, pregnant message of R'lyeh.

WARD 23

∂ m mitchell

April 27th

The behaviour of the patients in Ward 23 has become noticeably strange these last few days. They appear to have become invested with a strange sense of joyful anticipation; their expressions resembling those of small children waiting for Xmas. When I questioned B——(a hebephrenic woman in her early forties), she began to dance and sing tunelessly, 'He is coming back and we'll all be free.' The other patients nodded happily and one pressed my hand solicitously in his pudgy little fists, grinning up into my face with the zeal of a recent religious convert. Maybe we need to change their medication. Maybe they've got their hands on our supply of ketamine.

It's also worth noting that the change is confined to this one ward out of the whole hospital. It could have been worse, I suppose. It could have been the violent patients in the restricted wing. Those in Ward 23 have become fraternal and previous childish squabbles have been forgotten, for the time being at least. They've even been indulging in group activities, unorganised by the staff, chanting strange nonsense rhymes together and dancing in bafflingly complex arrangements. It's all very reminiscent of religious ceremony and usually centres around Daphne, a beautiful, ethereal catatonic woman whom they place at the centre of their movements and who sits in silent fugues throughout. The only person who never actively participates is James, a dangerous paranoid case whose violent history is belied by his calm and reasonable manner. I intend to broach the subject with him later today.

I've developed a very sore throat – a sort of thickening around the adenoids which is making speech difficult. I'll have to see a doctor, I suppose – a real doctor, that is. But the NHS is so dilapidated I'll probably have to wait hours and I hate waiting for any-thing or anyone.

Later (same day)

Call me eccentric, but I rarely bother to read the newspapers or even watch television – not only do I believe that their contents hold little objectivity, but I also suspect they produce the same brain-numbing effects as the sedative drugs we administer to the patients. Today, however, I was alarmed when I picked up a copy of a tabloid journal in my local newsagents, and discovered that certain patterns of behaviour in the outside world bore parallels with those of my patients. As I turned the pages, I was horrified at the reports of increased violence and mayhem which must have been building steadily for some time unbeknownst to me; upsurges of religious mania,

random slaughter, sex crimes and mass suicides similar to those in Jonestown and Waco. When I got home I tuned into an episode of the Cook Report and watched, stunned, as cultists in California danced and sang in a manner identical to the inmates in Ward 23. I noticed the repetition of the word "Aklo" which has become recently so familiar.

I've got a feeling that this strange language is in fact "glossolalia" and am well aware of the potential danger of letting this practise continue unchecked. Non-verbal, non-conceptual discourse actually aids the practitioner's access to submerged areas of the human brain, areas from which civilisation has divorced itself through centuries of taboos and repression. My patients are in here precisely because they lack those inhibitions required for a continued existence in human society, so we provide an artificial substitute, usually in the form of chemical treatment, which at least maintains some modicum of normality and removes the necessity for physical restraint. This voodoo-type ritual they've been performing, although so far harmless, may result in over-excitement. Then again, it may prove therapeutic. I'll monitor it a little longer before interfering.

My sore throat is getting worse. When I speak I sound like a bullfrog. I think it must be a virus causing it because I've also developed an unpleasant, scaly rash on the back of my hands.

April 28th

I'm going to list here some of the extraordinary things I've noticed on the news or read in today's papers.

Massive earthquakes have hit Turkey, Iran, Japan, Mexico and California. Huge tidal waves have swamped the coasts of Pakistan, India and many of the Pacific islands. Three dormant volcanoes, including one in Iceland, have suddenly become dramatically active. And, as if that weren't enough, seismologists have detected major shifts in the Earth's tectonic plates.

Following the recent meltdown of a nuclear reactor in the Ukraine, there has been an unprecedented number of UFO sightings in the area. Street gangs have taken over large areas of Chicago and Los Angeles where a moribund Charles Manson has been freed by a mixed racial group led by Lynette Fromme. On my TV screen, his wasted cancer-ridden frame seemed any-thing but menacing; a puzzled, lost look on his face.

I spent a large part of the day watching TV. I have a small portable in my office, which I've never really used much before now – and under the pretence of writing reports I locked myself in and continually switched channels to follow the various reports. I watched a Satanist rally on the streets of Dallas then switched to a picture of Sikh extremists on a blood-letting rampage in the Punjab, then another of Israeli troops massacring Palestinian civilians in an unprovoked attack.

At a place called Samath, in the Benares district of India, cultists were filmed dancing and cavorting with snakes and other reptiles. A linked clip showed strangely-robed worshippers celebrating on the island of Ponape which has risen an extra thirty feet above sea-level in the last

two days. I find the overall effect terrifying, yet I'm strangely empathically unmoved by the victims' suffering as though the whole thing is merely a schematic problem unfolding before my eyes on a scale beyond emotional assimilation. Or maybe TV has inured us to personal misery over the years – I don't know. Tomorrow I'm going to have a chat with James.

April 29th

I had my conversation with James this morning and it was an unusually unsettling experience. I broke the ice by discussing his book which was published three years before his admission. Supposedly a work of "surrealism", it comprises a catalogue of violent and scatological perversion – paedophilia, rape, necrophilia, coprophagy and murder – all written in a facile free-verse form which James probably thought experimental at the time. He has gained a minor cult following, primarily among those neurasthenic young people who grew up in the eighties and failed to mature in the nineties due to cultural and informational overload and economic depression – the victims of the "Death of Affect".

As I sat opposite him, I appraised him physically. Although not in peak physical condition he gave the impression of subdued strength and was particular about his appearance to the point of obsession. He sat cross-legged with his hands folded on one knee and observed me inscrutably. I decided to get to the point.

'James ... I've noticed the patients have been playing a sort of role-playing game recently. Do you know anything about it?'

He grinned sardonically. 'A role-playing game? I must admit I find it strange that you, the doctor, are asking me, the patient. I thought you had all the answers.' Behind the mocking humour, I discerned a subtle note of menace.

'Apart from myself, James, I think you're the most intelligent person in here. I'm appealing to your intellectual vanity, which I suspect is immense.'

'I'm flattered doctor.' He laughed and stared at his nails. 'But let me make it clear that, for my part, I think you're at least as mad as anyone else in here.'

'Thank you for your honesty, James.'

'OK. Are you interested in astronomy, doctor?'

'Peripherally ... why?'

'Do you know where Algol is?'

'The "Demon Star"? It was the first eclipsing binary star to be discovered. It represents the winking eye of Medusa in the constellation of Perseus.'

'Very erudite! A new star has been sighted near Algol – very bright – which is thought to be nomadic.'

'What has all this to do with my patients?'

'It has been speculated that it's headed in the direction of our solar system and the effects are already being felt. You must have been watching the news recently – or were you really

writing reports in your office?' I started inwardly at his display of perceptiveness. 'It's the millennium, doctor. Big changes are on the way – *really* big!' He'd started to look excited so I decided to terminate the interview.

'I'll think about what you said, James. You're suggesting there's a connection between the star and the patient's behaviour?' I stood to leave.

'You think about it doctor! And you really ought to see somebody about your throat. You sound barely human!'

Later (same day)

While the patients were engaged in one of their little ceremonies, I took the opportunity of searching through James' personal effects, books and papers. Aside from a large collection of *True Crime* and other magazines devoted to murder and mayhem (especially Manson), there was a modest selection of classic surrealist texts. Next to several books by Sade and Bataille, which looked hardly touched, was a collection of texts by Artaud. As I picked it up it fell open at a well-thumbed page; the stage scenario *There Is No More Firmament*. Next to Lautréamont's *Maldoror* was a large paperback edition of H P Lovecraft's stories, published by the infamous Creation Press, plus an assortment of home-printed pamphlets published by a group called "The Esoteric Order of Dagon". The general aim of these booklets was to establish connections between Lovecraft's themes and occult groups, particularly those associated with Aleister Crowley. I chanced upon a reference to the word "Aklo" and decided to quiz James again. I'd already suspected he was behind these events, and this seemed to confirm it.

Later still

The patients are still chanting annoyingly in their strange made-up language and that word – "Aklo" – keeps cropping up. The whole thing is disconcerting to listen to, like attending one of those extreme evangelical prayer meetings where even outsiders to the group are profoundly moved. I once actually attended one of these at the behest of my ex-wife shortly before we broke up. I can't help recalling Nietzsche's maxim. I can feel the abyss staring deeply into me.

James doesn't even bother to hide his involvement any more, often pacing around like a deranged film director or choreographer. The patients glance at him while executing their complex perambulations around the supine body of Daphne, as though looking for his approval and guidance. He says nothing, marching around or sitting cross-legged, smoking and occasionally nodding his head. He reminds me of Peter Weiss' portrayal of Sade at Charenton.

When they'd finished today, James cornered me before I'd even approached him. The other patients ambled off – except Daphne who lay, trembling slightly – no! rippling! as though her outline were becoming unstable – like oil. 'Doctor, I assume from the fact you've been through my room that you read *The Starry Wisdom*?'

'That was the pamphlet, yes?'

'You probably think it's nonsense?'

'It means nothing to me. What about you, James?'

'I was in contact with the E.O.D for a while, assuming that they knew what they were doing, where they were going. But it turned out they were just dilettantes, dabbling their toes in the water. When something big swam too close they ran screaming. They stopped answering my letters – even put out a declaration to the effect that they wouldn't correspond with anyone incarcerated for whatever reasons. I have adapted some of their basic rituals, though.'

'Is that what the patients are performing – E.O.D rituals?'

'Only the bare bones are E.O.D – the rest is mine!' He seemed to be getting more vehement. 'You look down on us in here, don't you! Well, these people in here whom you treat like animals are fucking gods! You – and the rest of society – are scared of what they represent, what possibilities they suggest...'

'What possibilities?'

'Freedom! Total fucking freedom! To live, to dance, to sing, to kill!'

'I could never endorse that. That whole concept is contrary to the work I'm doing here.'

'Oh ... contrary to what you're doing? How very nice! Well, you may not have any choice before long.'

'And why is that, James?'

He smiled. 'Because *He* is coming back. The Tentacled Dragon from the oceans of our inherited memories, whose name is tattooed along our neural paths and around the totems of our spinal cords. Did you ever wonder, when you were a little boy, where the great reptiles went? They're still inside us, Doctor. We all have monsters inside us. There were other civilisations before humanity appeared and some of them are still around waiting for the rest of us to catch up. You'll be seeing them before long!'

Although he was dangerously excited, I let him carry on. What he said interested me in a morbid way, although it wasn't vastly different from your run-of-the-mill paranoid fantasy. One of the larger staff nurses peered around the door, probably to see what was making the noise, and this reassured me somewhat. He continued his harangue. 'The Hindus speak of Kundalini; the Serpent Power of evolutionary force dormant in all of us, waiting to be wakened. Carl Sagan talks of "The Dragon Brain". The whole driving force of creativity in mankind is centred in the reptilian level of the collective unconscious. Civilisation has corrupted and repressed it to the point where it's begun to emerge as destructive and anti-social behaviour – pretty much like the result of overwinding a watch. The destruction we're witnessing is unavoidable. People have been taking too much without giving back for too long a period, but eventually the dust will settle and a new species will arise and take over. We'll become obsolete unless we can adapt and mutate to suit the changes. All of this of course will happen over a period of hundreds of years, but it's starting right now!'

'It's time to calm down, James!' I stood up.

'It doesn't matter whether you believe me or not. The signs are there. What about those people who disappeared from Denborough last month? Or those events at Nan Madol? A young man in Yorkshire has received *The Book Of 23 Nails* in a dream but I don't think he knows what to do with it. Even you Doctor. You could have a part in what's happening. Look at your hands!'

Before I could stop myself, I'd glanced down and experienced a small thrill of alarm. The knuckles of my right hand were bleeding. I quickly thrust it in my pocket. The male nurse began to wander over and I stooped to help Daphne to her feet. With amazing speed James had gripped my wrist, in a display of shocking strength. 'Careful, Doctor. She's expecting, you know.' He collapsed in a fit of laughter.

I'm going to separate him from the others.

May 10th

All hell has broken loose this last week and this may well be my last entry. I don't know if anyone will even survive to read this but the discipline of setting it all down is helping me to regain some modicum of composure and objectivity. It's not easy when everything you've believed to be sane and normal changes to madness in front of your eyes.

I did separate James from the others but the rituals continued, regular as clockwork, while he sat quietly in his room, smiling. By the end of the week the dancing and singing had escalated to a sort of climax. And when it reached its peak, the whole world erupted into insanity while I cowered here in my asylum, protected by the inmates whom I'd patronised for so long. I suppose there's some weird poetry to be seen in this inversion, but I've never really been that poetically inclined.

I had noticed earlier in the week that the sunrises were becoming bizarre, strange-hued, and the vegetation in the meagre flower bed outside my office window had started to glow slightly in the dark. I'd put it down to overwork on my part, or as a result of the annoyingly lingering virus. While watching the news reports that week, however, I realised that the outside world really was starting to act in an unprecedented way. Social disturbances had increased alarmingly – widespread rioting in council estates, prisons, the inner cities and on university campuses. In Manchester, the army had been called in to relieve a beleaguered police force and things sped out of control in a welter of carnage and vandalism. Eventually, on May 5th, while James celebrated his birthday in solitary confinement, the implacably crawling chaos hit our town and for the last few days the air outside has been thick with smoke from burning buildings and cars. For some reason none of the violence has been directed at the hospital, so common sense has dictated delaying any evacuation of the building. We're as safe here as anywhere, I suppose.

Early this morning I found myself walking through the main hall on the way to the coffee machine on the rear landing, secure in the belief that the violence was locked outside and the patients confined to their rooms. The hall was dark, faintly illuminated by the filtered light from an adjacent wing. I was stopped abruptly in my tracks by violent stomach cramps. My jaws began

to ache and my head throbbed. I almost cried out in panic, fearing a heart attack, but as abruptly as the seizure began, it passed. When my vision cleared I realised I was no longer alone. Four patients from Ward 23 stood in a semi-circle around me. I turned to see James behind me, leaning against a doorway, a mocking smile playing around his cherubic lips.

'It's time, Doctor. If you come with us we'll show you something special – something we've all been waiting for. And don't bother calling the nurses.'

A naked girl of about twelve stepped forward, holding something out to me. It was the severed head of the staff nurse, the tongue protruding blackly between bruised lips. A pool of blood gathered darkly on the neat parquet floor. Smiling, the girl kissed the mouth and tossed the object away. Performing a perfect cartwheel, she disappeared.

'We're not going to hurt you, Doctor. As I told you before, I think you're as mad as we are. And you too have a place in this.'

'What do you mean?' I croaked. He reached over and gripped my wrists, pulled my hands up before my eyes. They were barely human now – more claws than hands. 'You're coming on nicely, Doctor. Come with me.'

As I followed him, I glanced through a window. The building opposite was ablaze.

'Ideas are contagious, aren't they? Just like a virus. The sterile ideologies of Rousseau gave birth to the terrors of Robbespierre. The annihilating influence in our insane society is that of Mercury – not Mars as you might suppose. We think ourselves to death!'

As we entered his room, I gasped. On a table placed altar-like in the centre of the room, was a huge leathery object I recognised to be a chrysalis. As I stared, it moved from within. I groaned, disgustedly. 'What is this thing?'

James smiled delightedly, like a little child showing a secret to a grown up. 'This is Daphne, Doctor. She's getting ready to give birth to the new messiah. This is the Second Coming.'

His laughter rang in my ears for several hours.

Same night

Outside, I've heard sirens, screams, breaking glass and explosions. I vaguely wonder about my ex-wife and children but I feel too numb to care. James hasn't spoken to me since the last entry, but casts me knowing glances every now and then. All our society's laws of science and reason have gone to the wall and I realise how vain we were to think the universe should conform to our perceptions of it forever. What ridiculous anthropocentrism!

The patients – no, it's wrong to call them that now! – my companions, continue to perform their ceremonies, most of them naked as children. Occasionally two or more will separate from the others and copulate frenziedly, regardless of age, sex or physical condition. James watches it all approvingly as though this were an integral part of the proceedings. He's constructed robes for himself from bedding, curtains and an old straight-jacket. He's dragged a lectern in from the chapel and stands there, arms outstretched as though in supplication. The

inmates of the other wards in the building sit around and lounge in the corridors but never enter this room. They seem oddly expectant.

The backs of my hands are no longer human, the skin encrusted with a scaly, spiny growth. I write with difficulty. My jaws feel as though they're stretching out of shape, as if they wanted to open in more directions than simply up and down.

May 11th

The clock tells me it's another day although the sun hasn't risen this morning, or rather it's obscured by some indefinable menstruum, the world being lit by a diffuse subterranean purple glow. The noises outside have abated and when I awoke, my companions were sitting cross-legged around the cocoon, which pulsed slightly. I crept to the window and gazed out, breathless and shocked at what I saw. On the lawns, under the trees, as far as I could see was a multitude of seated forms, mostly human, but many strangely transformed, all staring in anticipation at the hospital.

Between the trees I could see the bay which lay about a mile away to the south. A titanic amorphous pylon jutted from the water, slime and weeds dripping from its surface, black, glistening figures clambering across it enigmatically. James' voice startled me to attention.

'Doctor, Daphne is ready.'

I shambled across to him like some great reptile and looked down at the cocoon. All movement had subsided. James handed me a scalpel and, numbly, I took it. 'Please Doctor. It has to be you. None of us are allowed to touch her.'

I clumsily made a lateral incision and parted the lips of the wound like a huge vagina. In a flurry of flapping and whirring, the room was engulfed in a cloud of small golden butterflies. The patients began to hop and dance like delighted children, their misshapen faces tinted by the golden light from the hymenoptera.

'Look inside Doctor. He has come.' All trace of mockery had vanished from his voice. I reached inside and gently scooped out the small form of the child from the half-eaten remains of his mother and, holding him up to my face, gazed fully at the visage of the new messiah. His eyes opened and met mine and a vision swam before me – wheels of fire and light – burning cold, searing away my body, leaving something pure and terrible – great formless creatures, shifting and laughing, eating each other and being perpetually reborn – all this in a microsecond. Then James took him from me, leaving me with an overpowering feeling of loss.

'Thank you Doctor. You've helped us so much. When you're ready to join us you'll know where to look.'

I tried to speak but only produced a grotesque hissing, so I sat numbly as they left the room. A little later there was an exultant shout from the crowd outside and I raised myself to the window. Beneath a strangely lit sky, James held the babe aloft for inspection. A man, bull-like with long wild hair and beard, pushed to the front and, weeping, laid a gold crown before the new

king. On the front of the crown a snake writhed around a diamond crucifix. Another man, taller with jet black skin, held out an arm around which writhed a huge snake. Finally, a beautiful bronze-haired, green-eyed girl held out something red and dripping which the child took in its small hands and began to eat. I lay down and slept.

Date Unknown

I'm alone in the building, maybe even the city. I've gathered the remains of the nurses into a pile but have given up trying to match limb to torso. Sometimes a horrible hunger gnaws at me but I'm not yet ready for that final transitional step between the old world and this new one.

I think of Him a lot and wonder if I'll meet Him again. So much madness has fallen from the stars and yet I wonder how often this has already happened in the dim history of this little sphere. He did bear a resemblance to His virgin mother – there's no denying. But I must admit He probably looked more like His father.

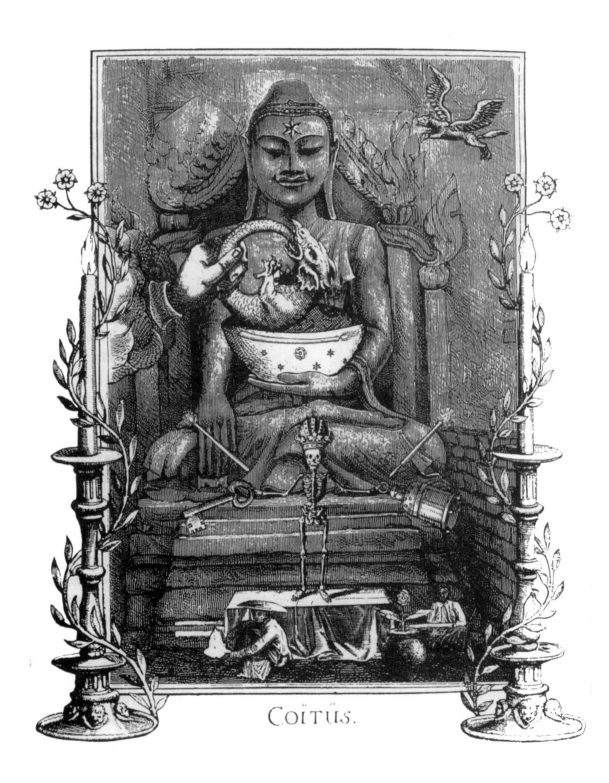

Coïtus.

appendix
three essays

1) CTHULHU MADNESS

Phil Hine

Each god brings its own madness. To know the god – to be accepted by it – to feel its mysteries, well you have to let that madness wash over you, and through you. This isn't in the books of magic, why? For one thing, it's all too easily forgotten, and for another, you have to find it out for yourself. And those who would sanitise magic, whitening out the wildness with explanations borrowed from pop psychology or science – well, madness is something that we still fear – the great taboo. So why did I choose Cthulhu? High Priest of the Great Old Ones. Lying dreaming "death's dream" in the sunken city, forgotten through layers of time and water. It sounds so simple to say that I merely heard his 'call' – but I did. Gods do not, generally, have a lot to say, but what they do say, is worth listening to.

I recall one evening staying in a friend's flat. I'd been 'working' with Gaia. No new-age mommy with a channeling about saving whales or picking up litter. I felt a pressure inside my head building up – something huge trying to pour itself into me. Sensations of geological time – layers sleeting through my awareness. The heat of magma; slow grinding of continents shifting; the myriad buzz of insects. Nothing remotely human. This sort of experience helps me to clarify my feelings on Cthulhu. Alien but not alien. A vast bulk stirring somewhere around the pit of my stomach. A slow, very slow heartbeat crashing through waves. Lidless eye peeling back through darkness, back through the world, the cities, the people walking outside, peeling back slowly. Peeling back through my entire life, all memories and hopes crashing into this moment. Waking from the dream of this to feel a stirring – a nagging disquiet; the absolute fragility of myself thrust back at me through crashing waves of silence.

This is the sense of Cthulhu madness.

Cut to walking through a forest. It is pouring with rain. The trees are bare of leaves, slimy, mud churning underfoot. I'm seeing them as clutching fingers attempting to snare the sky, as winding tentacles. Cthulhu is all around us. It is a squid-thing, bestial, dragon-winged – a *theriomorphic* image, but such things are all around us, as trees, insects, plant life, and within us as bacterium, brooding viruses; born momentarily through the alchemical transformations taking place in my body even as I write. Hidden. Dreaming. Carrying on without our cognisance. Unknown beings, with unknown purposes. This thought builds in intensity and it throws me sideways into realisation. That Nature is alien to us. There's no need to look for hidden dimensions, higher planes of existence or lost worlds of myth. It's here, if we but pause to look and feel.

The old Gods are everywhere. Their features outlined in the rock beneath our feet. Their signatures scrawled in the fractal twistings of coastlines. Their thoughts echoing through time, each lightning storm an eruption of neural flashes. I'm so small, and it (Cthulhu) is so vast. That such an insignificant being becomes the focus of that lidless eye peeling back across aeons of time – well, it puts me in my place, doesn't it. My carefully-nurtured magician-self ("I can command these beings, I *can!*) goes into momentary overdrive and then collapses, exhausted by the inrush of eternity. Run away. Hide. Having tried to break out of the mould I have only succeeded in breaking down. I scream inwardly for my lost innocence. Suddenly the world is a threatening place. The colours are too bright and I can't trust them anyway. Windows are particularly fascinating, yet they too become objects to be suspicious of. You (I) can't trust what comes through windows. We can look out of them, but other things can look in. I press my hand to the glass. What secrets are locked into these thin sheets of matter? I would be like glass if I could, but I'm afraid to.

Sleep brings no respite. The eyelid begins to peel back even before I sleep. I feel as if I'm falling, tipping like a child's top into something ... I don't know what. All pretence at being a magician has failed. This thing is too big. I can't banish it and even if I could, I have a strong sense that I mustn't. I have opened this door and unwittingly stepped through it, like walking deliberately into a puddle only to find that I'm suddenly drowning. Cthulhu's pulse-beat echoes slowly around me. Cthulhu is dreaming me. I was unaware of this, and now I am acutely aware of it, and wish to hell I wasn't. I want to sink back into unconsciousness. I don't want to *know* this. I find myself developing rituals of habit. Checking plug sockets for stray outpourings of electricity; avoiding particularly dangerous trees, you know the kind of thing.

I thought I was a rising star, yet I'm reduced to the four walls of my room. But even they won't keep these feelings out. Slowly, some self-preservation mechanism kicks into gear. Madness is *not* an option. I can't stay like this forever – another casualty of what is never mentioned in the books of magic. I begin to pick up the patterns I've let slip – eating regularly (at more or less the right times), having a wash, going out for walks – talking to people – that kind of thing. I feel the sensation of the lidless eye peering out of abysses of time and memory, and I find I can meet that eye ("I") steadily. The environment ceases to be a threat. The self-protection rituals (obsessions) fall away, and after all, what is there to protect? The dreams change. It is as though I have passed through some kind of membrane. Perhaps I have become glass, after all. The thoughts of Cthulhu stirring down there in the darkness are no longer fearful. I find that I can, after all, ride the dream-pulse. What was that lidless eye but my own "I" mirrored through fear and self-identifications? I'm no longer haunted by strange angles. All resistance has collapsed, and I've found myself a measure of power in its place.

Of course this theme is familiar to one and all – the initiatory journey into and out of darkness. Familiar because of the thousand and one books that chart it, analyse it, and, in some cases, offer signposts along the way. Which brings me back to why I chose Cthulhu, or rather, why we chose each other. There's something very *romantic* about H. P. Lovecraft. The same romance which brings people towards magic by reading Dennis Wheatley. As Lionel Snell once wrote: *"When occultism dissociated itself from the worst excesses of Dennis Wheatley, it castrated itself: for the worst excesses of Dennis Wheatley are where it's at."* There's something gut-wrenching, exciting, aweful – romantic – about Lovecraftian magic. Contrast it with the plethora of books available on different magical 'systems' which abound in modern bookshops. Symbols everywhere – everything has become a symbol, and somehow, (to my mind at least), less real.

Awesome experiences have had all the feeling boiled out of them, into short descriptions and lists – always more lists, charts, and attempts to banish the unknown with explanations, equations, abstract structures for other people to play in. Lovecraftian magic is *elemental*, it has an *immediate* presence, and resonates with buried fears, longings, aspirations and dreams. The Great Old Ones and their kin can only ever be fragments of the mysterious, never to be codified or dried out for scholars to pick over. Yes, you can bounce gematria around until you've equated this god with that concept, and I do feel that gematria, if used appropriately, can become a thread with which you can begin to weave your own Cthulhu madness, tipping yourself into sub-schizoid significances. There are no Necronomicons – okay, I'll amend that, there are several *published* necronomicons, but none of them for me do justice to that sense of an 'utterly blasphemous tome' which sends you insane after a thorough reading. If it does exist, it's in a library somewhere where you will have to go through madness to get the key, only to find that what works for you, probably won't make much sense to everyone else. After all, to some people, *Fanny Hill* was blasphemous. The whole point of the necronomicon is that it is a cypher for that kind of experience which twists your whole worldview and, whilst the insights of that illumination are dancing around your head, impels you to *act* upon it – to do what 'must' be done in the fire of *gnosis* – whether it be Dr. Henry Armitage setting forth to Dunwich or Saul's conversion of the Greeks, the flames of his vision on the road to Damascus dancing in his heart. This experience, this core, out of which magis – power – bursts forth, for me is the core of magic – the central *mystery*, if you like. Gnosis of the presence of a god rips away the veils and leaves you gasping, breathless. Character armour is blown away (until it slowly accrues into a shell once more) and briefly, you touch the heart of that unknowable mystery, coming away with a shard embedded. It drops away, it works its way in, it becomes a dull ache, so we have to go back for more. Most of the 'set' magical rituals that I've done or participated in don't even come close to this. Yet all the magical acts which I have done, responding to external circumstance, the crash of events or some burdening inner need have thrust me into the foreground of the mystery. I can still remember seeing a witch priestess 'possessed' by Hecate. The eyes... weren't human. This year, in answer to my plea out of disquiet and confusion, the wild god Pásupati stooped down low and peered down at me, a vision of blazing whiteness, the after-burn of which is still glowing at the edges.

Real magic is wild. I can feel the near-presence of the Great Old Ones at night. When the wind rattles the window-panes. When I hear the growl of thunder. When I walk up a hillside and ponder on the age of that place. To feel them near me, all I would have to do is stay there until night fell. Stay away from the habitations of men. Away from our fragile order and rationality and into the wildness of nature, where even the eyes of a sheep can look weird in the moonlight. Outside, you don't need to 'call things up' – they're only a breath away. And you are nearer to Cthulhu than you might otherwise think. Again, it's a small thing, and rarely mentioned, but there's a difference between a 'magician' thinking he has a right to 'summon the Great Old Ones', and a magician who *feels* a sense of kinship with them, and so doesn't have to call. Anyone can call them, but few can do so out of a nodding acquaintance born of kinship. There's a great difference between doing a rite, and having the *right*. But once you've faced a god, letting its madness wash through you, and change you, then there is a bond which is *true*, beyond all human explanation or rationalisation. We forge bonds with the gods we choose and with the gods which choose us. It's a two-way exchange, the consequences of which might take years to be manifest in your life. But then, gods tend to be patient. Cthulhu dreams.

2) **RELUCTANT PROPHET**

Stephen Sennitt

(i) The key to understanding H. P. Lovecraft's exalted, though controversial, status in esoteric circles as a reluctant "occult seer", rests ironically in the author's conscious denial of the titanic significance of his own dreams, and his disdainful attitude to the traditions from where these dream images sprang. In the one case, he turned his nightmare journeys into 'harmless' fictions, consciously attaching no objective significance to them; and in the other, he repudiated all connections to a field of research he considered, at best, riddled with superstition, and at worse, prone to the most duplicitous examples of quackery. His stolid conservative rationalism could be described as a defence mechanism, distancing him from the disturbing idea that the universe might be a far more irrational place than his conscious mind would allow. Ironically, Lovecraft's gift of dreaming 'true'; of dreaming 'the mythos', rests entirely on the grounds that it was this very rejection of the baggage surrounding the occult tradition, and the placing of his dream mythos in an entirely fictional framework (divorced from the contamination of Theosophy, the Golden Dawn, and other contemporary doctrines) that the real power of a vital magickal current was realised. Despite the protestation of died-in-the-wool occult apologists, it would have been far *less* an achievement on Lovecraft's part if he *had* have been a member of some secret fraternity! The real and astonishing justification for Lovecraft's exalted status in modern occult circles is the purity, the autonomy, of his vision – all the more remarkable for its consistency and parallels to more 'bona-fide' traditional doctrines, because it was conceived quite independently of their influence.

To those properly informed, Lovecraft's status as a 'non-occultist' has never been in any doubt. It's plain for all to see that Lovecraft absolutely disdained the religio-occult establishment in all its various guises. He would never have joined an esoteric organisation similar to his fictional 'Starry Wisdom Church'; but this does not preclude the veracity of his dream-visions, or cast doubt on the immense significance of the cosmic symbolism in his tales.

Lovecraft's looming influence on modern occultism exists because his 'mythos' provides a kind of independent corroboration. If, in some cases, his 'mythos' actually supersedes traditional doctrines, it is because of the recognisable 'purity' of its truly *primal* imagery, and the oddly prescient relevance this imagery has today.

(ii) The resurgence of vastly anterior cosmic symbols, and their relevance at the present time, has been recognised by a few individuals and groups dedicated to the tenuous study of half-forgotten mystic doctrines and systems of magick. But in the last few years there seems to have been an explosion of thought in this area, resulting in the conclusion that the 'female' (i.e: the vast, cosmic deities from which the phenomenal universe and everything in it was given birth) is returning to end a Great Cycle of Time; dissolution and, ultimately, re-absorption being the cataclysmic result. The Hindu's call this era the *Kali Yuga*.

Kali is the horrific goddess of death and destruction: the cosmic mother turned terrible, devouring the children she gave birth to in an orgy of negation. This inverted 'demon' image of the female, inverted and destructive in terms of phenomenal existence, can be seen as the very antithesis of the State

and Establishment upon which all dominant post-Christian cultures have been founded. The fact that, generally speaking, female deities have been understood to possess such hidden 'irrational' tendencies, has led to more than two thousand years of suppression of the subconscious mind, and its ability to better understand these tendencies. The 'male'-orientated Logos of Church and State would have no traffick with a force capable of devouring it in one gulp!

This denial of the 'female' (I must remind the reader that these epithets are used technically, expressing ancient esoteric symbolism) has extended to an interpretation of such forces being deemed evil; in other words, *purposefully* destructive. Similarly, the Assyrian Pazuzu, an anthropomorphised image of the fatal desert wind, was deemed demonic in a youthful reaction to a force which had knocked down one's building blocks (when the wind blows too hard, it, too, is 'evil'!). Kali, as 'insurrectionist', exists as a secret glyph of dark, brooding chaos within the fabric of 'male'-orientated culture.

Peter Redgrove has written at length on these matters in his seminal *The Black Goddess And The Sixth Sense*. Klaus Theweleit's massive two-volume *Male Fantasies* focuses more narrowly, but no less successfully, on the more psychologicalpolitical aspects of the subject. In the words of the publisher's synopsis: *"Theweleit focuses on a group of officers of the Freikorps – the private, volunteer armies that roamed Germany and served the cause of domestic repression in the aftermath of World War 1... (he is) concerned to examine, not what these proto-fascists thought about fighting and war, but what they thought about women... Theweleit shows that the masculine identity of the officers was shaped by their dread of women and that this dread was linked to their aggressive racism..."*

Similarly Wyn Crage Wade's *The Fiery Cross* attributes the fascist hypocrisy of the Ku Klux Klan to a culturally distorted view of women as irreproachable matriarchal "Southern Belles", purer than pure, whose natural darker character traits were unacknowledged in favour of making scapegoats of the "raping, lying, niggers" from whom they had to be defended.

It is obvious even from these two, brief, examples that our culture is embedded in a mire of gender-based psychological turmoil. To demonstrate this point further would be beyond the scope of such a brief essay as this; more to the point, how does all this relate to the subject of the article, H. P. Lovecraft?

That in the present time Lovecraft is at the centre of speculations about the fearful return of vastly ancient cosmic beings/entities, should be no surprise; this theme is at the core of all his major works of fiction. Interestingly enough, it is the way Lovecraft dealt with this information that provides an indication of the consciously unacknowledged impact it had on him. It is my belief the cosmic vistas and chaotic entities Lovecraft witnessed in nightmares from the youngest days of his childhood, actually shaped his character, adding authenticity to his occult insights by the very effect these ideas had on him in his mundane waking existence. When Lovecraft stated that the "Old Ones are returning" – his acknowledgement of the era of dissolution rendered by the Hindu scriptures as the *Kali Yuga* – somewhere, deep inside himself, he believed it.

(iii) A cursory examination of Lovecraft's professed beliefs, and the way in which he expressed them, demonstrates a perfect example of 'male'-orientated rationalism, reliant upon sound reason and good individual government. His yearning for the more conservative, traditionalist values of the 18th century is well known; his rejection of certain elements of 'foreign' culture somewhat notorious. Stated simply, Lovecraft rallied around ideas and opinions that even in his own day were becoming either outmoded, or

were the battle cries of political extremists. Though he 'toned it down' in his last few years, for most of his adult life Lovecraft was a professed racist; a white supremacist championing the 'Aryan' race; a cultural snob, depicting in his own fiction the foul, degenerate practices of 'white trash', or the hellish barbarism of 'mongrel hordes' infesting New York city like vermin. He was blinkered into dismissing anything that lay outside his own professed beliefs and cultural experiences with the ferocity of a knee-jerk reactionary. Similarly, his fear and distrust of the 'female' extended not so much to a fear of actual women, more like a total ignorance of their sexual existence, except in his depiction of certain foul 'fishy' odours in some of his stories, where more of the truth lay.

It will be obvious by now that it is my contention that the idiosyncrasies and contradictions in Lovecraft's character resulted from his exposure to vastly ancient, primal 'female' symbols, which he witnessed in dreams and visions. It was these that formed the fear-inspired reaction which resulted in the building a "rational barrier", whereby the 'Daytime' Lovecraft could hopefully consolidate his control over the revelations witnessed by his dreaming self. The more powerful his dreams and visions, the more fierce the ideas and opinions he hoped would keep them at bay. Like Theweleit's *Freikorps* officers, Lovecraft's aggression was fuelled by fear. The fear of vast cosmic voids. The fear of dissolution. The fear of the 'female' symbols which depict these ego-less states. (Isn't fear at the root of all aggressive acts and ideologies? But hasn't man a right to fear dissolution? Perhaps not when events such as the rise of the Nazis transforms such a fear into a kind of self-fulfilling prophecy...)

My contentions about Lovecraft are not entirely without substantiation.

Scholar Dirk W. Mosig has compared Lovecraft's attitude to his weird dreaming states to a type of condition Jungian psychologist, Leon Festinger, calls 'cognitive dissonance'. To quote Mosig: *"...weird fiction, such as that written by H. P. Lovecraft, depends for its effect on dissonance resulting from... a contravention of fairly universal expectations concerning natural law. (Lovecraft as) ...an oneiric writer, finding his dreams a source of dissonance, may attempt to reduce the dissonance by transforming his dreams into art... denying them objective significance."* And as Mosig has pointed out, the degree of dissonance between Lovecraft's nightmarish dream experiences and the experiences in his waking life, was such that he needed desperately to develop a method of controlling the dreamworld in order to maintain his day to day existence. That Lovecraft was 'desperate' is indicated by his acceptance of ideas which supported his 'waking' world-view, but which were actually far beneath the level of his intellect.

This point having now been established, just what was it about the specific images Lovecraft was 'receiving' that was so debilitating to him personally, and has become so relevant in the years since his death?

As an adjunct to Mosig's observations, Thomas Quayle's essay, "The Blind Idiot God", stresses the potency of Lovecraft's fictional 'mythos' with its monstrous half-deities Cthulhu, Yog-Sothoth, Azathoth, and Shub-Niggurath; an innovation that was not based on the traditional 'claustrophobic' fears depicted in mainstream tales of the supernatural, such as ghosts, hauntings, the fear of revenant spirits, etc., but rather on the agoraphobic fear of nothingness; dissolution of the personality, which is dwarfed by immeasurable gulfs of space, infinite abysses of the dark cosmos, whereby the human mind, stretched to such dire limits, snaps, and is left to wander in a state of irreparable insanity. Lovecraft's fear of the Return of 'Sanity' to 'Insanity', is comparable to his fear of the Return of the 'Phenomenal' to the 'Noumenal'. The fear of the 'Dayside' consciousness being engulfed by 'Nightside' consciousness, or the 'male' logos being devoured

by the terrible female who originally gave him birth.

(iv) The concept of 'Nightside' consciousness encroaching into the rational, ordered, world has been delineated by the eponymous Kenneth Grant in a series of monumental works on obscure phases of occultism and hidden lore, dubbed "The Typhonian Trilogies".

Grant likens Lovecraft's perception to a faulty lens receiving distorted images and presumably identifies with Lovecraft more than he cares to admit, with his presentation of such material in equally dark, foreboding style. (When all is said and done, if species survival is at stake, perhaps such foreboding is warranted!) Grant's comparison of Lovecraft to Grant's mentor and inspiration, the notorious arch-occultist, Aleister Crowley, has struck some defenders of Lovecraft's reputation as being decidedly facetious. Yet Grant's contention is not that Lovecraft was in any way personally similar to Crowley, but that the two were contacted by the *same entities* – Lovecraft, distortedly, in his nightmares; Crowley in his magickal experiments, which comprised of a more consciously-determined form of 'dream-control'. For Grant, Lovecraft's 'Cthulhu Mythos' represents a demonic shadow of Crowley's New Aeon consciousness. Lovecraft symbolises, in this sense, an 'Old Aeon' attitude, reacting with fear, and consciously rejecting the 'vital information' which was transmitted via his dreams...

I am simplifying the dichotomy for the sake of present clarity. If Lovecraft is comparable to Crowley in the way which Grant suggests, it is perhaps primarily in Crowley's similar gift of intuition, which enabled him to announce a new phase of consciousness for mankind. A phase of consciousness which would only result in tandem with a period of unprecedented chaos and destruction.

Crowley's New Aeon of Force and Fire, as delineated in his *Book Of The Law*, or *Liber AL*, is of course the Hindu's *Kali Yuga,* or Lovecraft's age of cosmic darkness.

v) Was Lovecraft 'right', as he thought, to reject the veracity of his dreams and visions? That is a question not easily answered. Certainly it could be argued that in comparison to Crowley (and certain fringe elements of the esoteric establishment who, it could be argued, have misinterpreted Crowley's teachings), Lovecraft seems comparatively respectable in his rejection of doctrines such as Crowley's Thelema, with its questionable ideology revelling in the concept of apocalyptic dissolution. But this is not the point. For all his mental barriers, Lovecraft knew deep inside himself, somewhere, that all these matters were beyond man's control, and that ultimately, it is his thoughts and feelings, not his dispassionate theories, which truly measure the scale of such events. Lovecraft's popularity is growing, and will endure, because this approach demonstrates more than anything else the inner-truthfulness of his vision, and its relevance to the human condition. It is, in the end, this factor, even for the occultists it would seem, which attracts us to Lovecraft and secures his position as a "Reluctant Prophet" of the *Kali Yuga.*

3) FRACTALS, STARS AND NYARLATHOTEP

John Beal

(i) Fractals In Weird Fiction

"It is impossible to drop a pin without exciting a corresponding reaction in every Star. The action has disturbed the balance of the Universe."

—Aleister Crowley, *The Book Of Thoth.*

The eloquence of Crowley's understanding of what Chaos Physics now calls 'The Butterfly Effect' is evident in the above quote. He conceives a Universe where every point is interconnected, related in a grand 'Strange Attractor/Repulsor'; where one event ultimately alters the destiny of events, millennia of light-years away.

His cosmic correspondences are echoed in the work of fiction *The Plutonian Drug* by Clark Ashton Smith. According to Dr Manners, the narrator of the story the drug creates "...unusual plastic images, not easy to render in terms of Euclidean planes and angles." This incapability to be rendered in Euclidean Mathematics echoes fractals in that they are *non-Euclidean*, which means they do not comply with the generally accepted geometric shapes such as triangles, squares etc. The drug also creates another analogous property found in fractal images in that they both have artificial 'cut-off' points, or boundaries. The drug produced "...a vast distance that was wholly void of normal perspective, a weird and peculiar landscape stretched away, traversed by an unbroken frieze or bas-relief of human figures that ran like a straight undeviating wall."

Apart from referring to the frieze as running like a straight wall (a point which Smith expands upon to place branches along its surface), all the other descriptions can be regarded as being similar to that of many fractal images. Smith creates a vision of time as a strand of events – interjoined, constantly altering, all producing an abstract pattern. This strand is of ultimately infinite length and complexity, produced in a fractal dimension which cannot be accessed by Euclidean Mathematics, or by a normal state of mind. It is interesting to speculate whether the scientific concept of Time/Space could be modelled in fractal dimensional terms. Recent ideas of budding, bifurcating, universes, appear to suggest this as a possibility.

John Dewey Jones, writing for the newsletter *Amygdala*, expands upon the idea of fractals and the transcendence of the mind in his fiction concerning *The Amygdalan Sects.* [Note: *Amygdala* is derived from Almond shape, i.e. the shape of the Mandlebrot set; it is also the name of a section of the mid-brain which according to Mortimer Mishkin and Tim Appenzeller in their article for *Scientific American* of June 1987 is, along with the Hypothalamus, the processing plant and general linking area for sensory information, memory and desire.]

Jones writes of "The Brethren of the Hidden Path of Adepts"; monks who visualise the 'object' (Mandlebrot set) as a mandala, using it to transcend and enlighten themselves. He paints a landscape of decadence, where the old civilisation has collapsed and the Brethren have to create the object as an astral image. To quote the Abbot of the Brethren: "We know that the eye can perceive details and gradations of

colour finer than any monitor can display. Just as the eyes are finer and more subtle than the monitor, so is the mind finer and more subtle than the eyes. And the soul is yet finer and subtler than the mind. Therefore, let the monk withdraw into a quiet place and withdrawing his senses like the limbs of a tortoise, let him fix his thoughts steadfastly upon the object."

The Brethren recognise two paths to the object, the first through dreaming, obtaining visions of "pure, jewel-like colours... patterns of abstract relationships: others said their dreams [had] been too clear and distinct to describe in words." This I feel relates to how H. P. Lovecraft produced some of his finest works of fiction, accessing normally unobtainable knowledge through dreams.

However, Jones writes of the second method of path-working involving the object, as the Abbot explains: "... rise at three in the morning and go to the summit of the mountain, sit... and gaze steadfastly in the direction of Aldebaran – we don't believe in any causal connection between Aldebaran and the object, you understand, but we have found the reddish light of that star to stimulate the mathematical vision we seek."

The Dreams In The Witch-House by Lovecraft seems to echo the first method of the Brethren in the dreams of the hero Walter Gilman. Lovecraft says of Gilman: *"Possibly Gilman ought not to have studied so hard. Non-Euclidean calculus and quantum physics are enough to stretch the brain; and when one mixes them with folklore, and tries to trace a strange background of multi-dimensional reality behind the ghoulish hints of gothic tales and the wild whispers of the chimney-corner, one can hardly expect to be wholly free from mental tension."*

Gilman is lead by his interests into the domain of abstract mathematics *"...beyond the utmost modern delvings of Plank, Heisenberg, Einstein and de Sitter."*

Lovecraft describes Gilman's dream as *"plunges through limitless abysses of inexplicably coloured twilight and baffling disordered sound; abysses whose material and gravitational properties... he could not even begin to explain."*

He goes on... *"The abysses were by no means vacant, being crowded with indescribably angled masses of alien-hued substance, some of which appeared to be organic while others seemed inorganic... Gilman sometimes compared the inorganic matter to prisms, labyrinths, clusters of cubes and planes... and the organic things struck him variously as groups of bubbles, octopi, centipedes, living Hindu idols, and intricate arabesques roused into a kind of ophidian animation."*

Fractal doubles of these images can be discovered in many of the books on the subject. Mandlebrot in *The Fractal Geometry Of Nature* describes and shows pictures of Appolonian nets, Cantor and Fatou dust – near-fractals that display distinct bubbling, similar to clusters of cubes and planes: Koch/Peano snowflake curves that look intensely like mazes. Other geometrical designs which are featured are the Mandlebrot set, Julia set, and squigs (as the name implies a squiggle design), all having similarities to octopi, centipedes and intricate arabesques. The design called 'Hindu idols' by Lovecraft can be imagined in two ways, either as the 'body-shape' of Michael Barnsley's development on fractals in his book *Fractals Everywhere,* or as biomorphs, sigil-like designs fractally produced, which evolve like living organisms into multifarious forms.

At the end of the story Lovecraft describes Azathoth as the Ultimate Chaos – similar to a jewelled Mandlebrot set in an all-enveloping crown.

Other stories by Lovecraft also allude to bizarre images of Fractal Geometry. Examples are: *At The*

Mountains Of Madness where he uses abstract geometry to describe the ancient city of the Old Ones; and *Through The Gates Of The Silver Key*, where the abstract patterns observed by Randolph Carter on the threshold of the gate are reminiscent of the flowing, bifurcating forms of fractals. Lovecraft's use of fractal images in *Through The Gates Of The Silver Key* is reminiscent of Smith's in *The Plutonian Drug*, since both are describing voyages through Space/Time. As example of this Randolph Carter, the hero of Lovecraft's story, upon using the silver key is surrounded by *"dim half-pictures with uncertain outlines amidst the seething Chaos, but Carter knew they were of memory and imagination only. Yet he felt that it was not chance which built these things in his consciousness, but rather some vast reality, ineffable and undimensional, which surrounded him and strove to translate itself into the only symbols he was capable of grasping."*

Algernon Blackwood's *The Pikestaffe Case* uses abstract geometries to enable 'Pikestaffe' to perform an 'Alice through the looking-glass' trip into an extra-dimension. Pikestaffe's blackboard was covered in diagrams that *"perhaps were Euclid, or possibly astronomical."* He also had notes which have fractal equivalents; for example Pikestaffe's landlady discovered notes with a diagram that she described thus: *"In the centre, surrounded by scriggly hieroglyphics, numbers, curves and lines meaningless to her, she saw a diagram of the full-length mirror."*

The last piece of fiction I would like to mention which is similar to the fractal geometries of Mandlebrot, Julia, Cantor and others is *The Hounds Of Tindalos* by Frank Belknap Long. In his story, Long uses very similar concepts to those in Smith's *The Plutonian Drug* and Lovecraft's *Through The Gates Of The Silver Key*, enabling the main character Halpin Chalmers to traverse back into time into the ultimate abyss of chaotic geometry.

Thus all these stories are like chambers in the "Witch-House" – the house on the borderland of an abyss where dwell incredible "Mathematical Monsters."

ii) Celestial Bodies In The Cthulhu Mythos

According to L. Sprague De Camp, Lovecraft was a keen astronomer, whose first interest was created through the classical myths associated with the constellations. The stories of H. P. Lovecraft and other writers of the Cthulhu Mythos often mention the roles of stars in connection with deities, events or rituals. A certain number of these places are fictional, for example the planet Sharnoth, home of Nyarlathotep beyond this universe, in what might be termed Universe B. Others are real stars and planets, so I thought it interesting to investigate any mythology connected with them, and the meaning of their names.

THE PLANETS: Rather than list each individual planet and their associated myths, here is a synopsis of a few which seem particularly of interest. In the Lovecraft and Sterling story *In The Walls Of Eryx* the setting is a Venus covered by lush jungle, through which the narrator searches for a crystal worshipped by the Venutian Man-Lizards, possibly a reference to the Serpent People and Shining Trapezohedron of *The Haunter Of The Dark* and other stories. Venus is also mentioned along with Jupiter in *The Shadow Out Of Time* in which Lovecraft writes: *"There was a mind from Venus, which would live incalculable epochs to come, and one from an outer moon of Jupiter six million years in the past."* Many of Clark Ashton Smith's stories are set upon planets, *The Door To Saturn* for example, and also *The Vaults Of Yoh-Vombis* which is set upon Mars. Most of Smith's works however concern planets in other star systems, for example *The Planet Of The Dead*, the planet mentioned in *Marooned In Andromeda*, and

The Flower-Women Of Voltap. The final planet I shall mention, appears to be pivotal to the astronomical ideas in Lovecraft's Cthulhu Mythos. Yuggoth, synonymous with Pluto, is the abode of fungal creatures who leave crab-like footprints and make inter-planetary journeys "on clumsy, powerful wings which have a way of resisting the ether". Kenneth Grant uses Yuggoth as a symbol of the boundary between dimensions, an idea expressed in the poem *Beyond* by Lin Carter:

> *"I have seen Yith, and Yuggoth on the Rim,*
> *And black Carcosa in the Hyades."*

It is interesting that Carter mentions Carcosa (the invention of Ambrose Bierce in his story *An Inhabitant Of Carcosa*) as lying in the seven sister stars of the Hyades, as this area of the sky is returned to again and again in the Cthulhu Mythos.

FOMALHAUT (*Alpha Pisces Australis*): This name, like many others, derives straight from Arabic. Its origins are Fum al Hút, meaning 'Mouth of the Fish'. It is not so surprising therefore that this star is located at the mouth of the drinking fish, *Pisces Australis*. Interestingly it is the only named star in this constellation and is the most southerly first-magnitude star visible from Great Britain. The fact that it is of first magnitude relates to the Cthulhu Mythos deity Cthugga with which it is connected. Cthugga is described as resembling an "enormous burning mass continually varying in shape." Cthugga is also served by beings called Flame Vampires which again suggests an intensely hot abode.

ALDEBARAN (*Alpha Tauri*): Aldebaran is generally known as 'The Eye of the Bull', Taurus, due to its distinct orange coloration. Originally the name was given to the entire Hyades cluster, which it is in fact not a member of, but is some distance in front of. Its name again comes from Arabic, Al Dabaran, meaning 'The Follower'. This was due to the Greeks' belief that the star followed the Pleiades. This star is linked to the Cthulhu Mythos in an extremely interesting way. The original link was through the stories of Robert William Chambers in *The King In Yellow*, where it is the bright twin star, home of Hastur.

It is regarded by August Derleth as the Star where some of the Cthulhu deities emanated from. In this respect it is of interest to quote from *The Whisperer In Darkness*: *"To Nyarlathotep, mighty messenger must all things be told. And he shall put on the semblance of men, the waxen mask and the robe that hides and come down from the world of seven suns to mock..."* Robert Graves in his book *The Greek Myths* states that both the Pleiades and the Hyades were the seven daughters of the Titan Atlas, making them equivalent in mythological terms. The statement from *The Whisperer In Darkness* clearly shows an alignment with the seven sister suns of either cluster, thus connecting Nyarlathotep to Aldebaran's area of influence. Perhaps one can go further and express the possibility that Hastur, the King in Yellow, is one of Nyarlathotep's "thousand other forms", since in the story *The Dream-Quest Of Unknown Kadath* Nyarlathotep is described as wearing a "yellow mask". As well as this, in the story *The Crawling Chaos* by Lovecraft and Elizabeth Berkeley, the destruction of the Earth is portrayed as seen by a Being on "Cetharion of the seven suns", thus connecting the area again to Nyarlathotep as the crawling chaos, the Nemesis of the Earth.

Another observation is that Aldebaran was once in the constellation of Mithras; which consisted of the constellations Taurus and Perseus. This connects to the star Algol, another star mentioned briefly in *Beyond The Walls Of Sleep* by Lovecraft.

ALGOL (*Beta Persei*): This was the very first eclipsing binary star to be discovered: Montanari, an Italian astronomer in the 1600's, was the first European to note and produce explanation for the star's periodic wink. Its Arabic name Al Ghúl means 'The Demon' or more precisely 'The Ghoul', and in English it also has the nickname 'The Demon Star'. Originally Algol was one of the stars making up the shield of Mithras, but later came to represent the malevolent winking eye of Medusa in the constellation Perseus. Due to it being the first eclipsing binary to be discovered, the class of such stars is termed 'Algoltype' variables.

BETELGEUSE (*Alpha Orionis*): Although this star is labelled the Alpha star it is in fact dimmer than *Beta Orionis*, or RIGEL. The star is a red supergiant whose name derives from Yad al Jauzah meaning 'Hand of the Giant', or 'Hand of the Sacred One'. Apparently the name should be spelled Yedelgeuse, but due to poor translation of the Arabic into Latin it was wrongly read as Bad, Arabic for armpit, instead of the word Yad which means hand. This star lies some 650 light years away from us and it is a period variable star, altering its luminance by brightening and fading in an annual cycle. In the Cthulhu Mythos it is regarded as the star from which the Elder Gods ruled.

POLARIS (*Alpha Ursae Minoris*)): Obviously the name implies it to be the pole star, and it is in fact within 1∞ of the celestial north pole. However in Greek its name is Cynosura, and means 'dog's tail', thus implying that the whole constellation at one time referred to a dog instead of a bear. An even earlier Greek name was Phoenice, possibly connecting it to the name Phoenissa (whose masculine form is Phoenix). The name Phoenissa means 'the red, or bloody one'. Robert Graves states it as connecting with Demeter and Astarte; Phoenissa's name implying the moon goddess's role of Death-in-Life. Interestingly Phoenix is stated as renaming the land of Canaan as Phoenicia, thus producing another possible link.

The Pole star will be at its closest to celestial north in the year 2100 and then will be gradually succeeded by the star VEGA. This procession seems to be implied in Lovecraft's story *Polaris*, in the poem:

> *"Slumber, watcher, till the spheres,*
> *Six and twenty thousand years*
> *Have revolv'd, and I return*
> *To the spot where now I burn.*
> *Other stars anon shall rise*
> *To the axis of the skies;*
> *Stars that soothe and stars that bless*
> *With a sweet forgetfulness;*
> *Only when my round is o'er*
> *Shall the past disturb thy door."*

The use of the term 'the axis of the skies' in the poem is most interesting due to its connecting with the Arabic name for the star: Al Kutb al Shamaliyy, meaning 'the axle of the north'.

ARCTURUS (*Alpha Bootes*): This star's name in Greek means 'the bear-watcher' or 'bearkeeper', and in Arabic is Al Simak al Rimah or 'the lofty lance-bearer'. It was at one time the name of the entire constellation of Bootes, 'the herdsman'. The constellation's name also means 'the bear-hunter', and the word Bootes itself derives from Boetes, the Greek for 'clamorous', and the Latin name seems to comply with this as 'vociferator' or 'clamator'; the shout of a huntsman with his dogs (*Canes Venatici*): This star is

mentioned briefly in a passage of Lovecraft's story *Beyond The Wall Of Sleep*, suggesting that the dreaming consciousness of Joe Slater (the hero) had "drifted to the worlds that reel about the red Arcturus".

SIRIUS (*Alpha Canis Major*): Kenneth Grant associates Sirius with the Lovecraftian and Babylonian deity Dagon, an idea which Robert Temple also propounds in his book *The Siritis Mystery*. Temple quotes from a Babylonian historian named Berossus, who writes of a group of Alien Amphibians whose leader was Oannes, later to become the fish-god Dagon of the Philistines. Berossus also speaks of another amphibious alien called Odacon, which Temple believes to be a corrupted form of Dagon. Temple's book concerns amongst other things, an African tribe called the Dogon, who are aware of SIRIUS B, an invisible-to-the-eye star, which they believe has a planet circling it from which the Amphibian Aliens came.

In Greek the star's name was Seirios Aster, 'the scorching star'; whilst the Latin was Kanikuly, due in both cases to its appearance in the 'caniculares dies' or dog days of the hot summer months. In Arabic it had the name Al Shi'ra al 'Abur al Yamaniyyah, meaning 'the shining one in the passage of Yemen', signifying its position to the right of a Muslim as he faces Mecca. This star is in fact the brightest in the night sky and similar to ALGOL is also binary, with the white dwarf star SIRIUS B orbiting at a full revolution every fifty years. In Greek mythology it is also called Orthus which was the two-headed watch-dog belonging to Atlas, parented by Typhon and Echidne. Also in myth the Dog-star Sirius was regarded as Cerberus pertaining to the tripartite year. In Egyptian myth the dog-star was associated with Anubis, who according to Robert Graves can be identified with Hecate as the tri-headed bitch, eating corpse flesh and howling at the moon. Elsewhere Graves also identifies it with the Egyptian god Thoth and thus also to the Greek Hermes, both messengers of the gods, the role which Nyarlathotep serves in the Cthulhu Mythos.

(iii) The Dark Messenger

Nyarlathotep

And at the last from inner Egypt came
The strange dark one to whom the fellahs bowed;
Silent and lean and cryptically proud,
And wrapped in fabrics red as sunset flame.
Throngs pressed around, frantic for his commands,
But leaving, could not tell what they had heard:
While through the nations spread the awestruck word
That wild beasts followed him and licked his hands.
Soon from the sea a noxious birth began;
Forgotten lands with weedy spires of gold;
The ground was cleft, and mad auroras rolled
Down on the quaking citadels of man.
Then, crushing what he had chanced to mould in play,
The idiot Chaos blew Earth's dust away.

The above poem is from H. P. Lovecraft's sonnet cycle, *The Fungi From Yuggoth*, which he completed on

January 4, 1930. On closer inspection of the poem, I recalled some information in Robert Bloch's story, *The Faceless God*, which may shed some light on this cryptic verse.

Bloch writes: *"(Nyarlathotep) was the oldest god of all Egypt; of all the world. He was the god of resurrection, and the Black Messenger of Karneter. There was a legend that one day he would arise and bring the olden dead back to life."*

This seems to connect with the first stanza of the poem, mentioning his re-emergence in Egypt and presenting his message, which goes unheeded, but seems in both to imply the resurgence of the Cthulhu Cultus.

Bloch continues: *"In the North the ice-flow melted, and Atlantis fell. New peoples overran the land, but the desert folk remained."* (The Serpent-people in The Nameless City?) *"They viewed the building of the pyramids with amused and cynical eyes. Wait, they counselled. When the day arrived at last, Nyarlathotep again would come out of the desert, and then woe unto Egypt! For the pyramids would shatter into dust, and temples crumble to ruin."*

It continues in a most apocalyptic manner, expressing Nyarlathotep's evocation as the signal for the time when: *"The stars would change in a most peculiar way, so that the Great Old Ones could come from the Outer Gulf."*

A title of Nyarlathotep is 'The Crawling Chaos'; this image can be likened to a fractal model of a bifurcating geometric pattern. Fractal geometry is produced between dimensions, and thus the crawling chaos could be represented by a fractal image such as a fungal conglomeration which cryptically infests the universe we live in and the 'Outer Gulf' of Kenneth Grant's Universe B, branching mycelium every so often fruiting and sporing, sending messengers to spread its clandestine, unspoken word. The lines by Lovecraft: *"Throngs spread around, frantic for his commands, but leaving, could not tell what they had heard;"* could relate to the Aeon of Maat, the wordless Aeon. Nyarlathotep in this role would equate with Aiwaz in relation to the messenger of the aeon 'behind' the aeon of Horus – Aiwaz' counterpart or double. In the glossary to *Outside The Circles Of Time*, Kenneth Grant says of Horus-Maat, *"The double current which fuses the Aeons of Horus and Maat thus opening the Gate for the return of the Great Old Ones"*. Grant also states in *The Magical Revival*, that Crowley ranked Aiwaz as *"ancient among the Ancient Ones... even in the land of Sumer"*, again equating Aiwaz with Nyarlathotep as *"the oldest god of all Egypt and of all the world."*

Lovecraft's idea of the noxious sea birth could compare to many ancient legends such as Atlantis, Lemuria and Thule, as well as his own myth of R'lyeh, all of which, in the final epoch, shall resurface and reclaim their dominions.

In the double of Aiwaz/Nyarlathotep, there is another interesting chaos theory image, that of the strange attractor/repulsor. A system which when modelled I imagine to look similar to a double helix, connected by devil polymers across the apparent central void. (The double helix shape – because of both Nyarlathotep's and Aiwaz' roles as messengers – equating them with Mercury and thus the caduceus).

To explain, a strange attractor is a series of possibilities which are present in a given system. According to Mandlebrot in *The Fractal Geometry Of Nature*, a strange repulsor is all the possibilities which do not fall within the attractor. Since it is unlikely, for example, for snow to fall in the Sahara, this would be a point on the repulsor. However, the two are obviously joined because it is probable over vast aeons, or by man's intervention, to produce effects in the attractor which would have normally been located

on the repulsor, i.e. the ice-age and the greenhouse effect. Thus there are seemingly invisible links, devil polymers between the two systems caused by what Lorenz's successors termed 'The Butterfly Effect' – something apparently insignificant changing things on a grand scale. If, however, the events are cataclysmic enough, then it is theoretically possible for the repulsor and attractor to change places, going perhaps from the chaotic systems of today to the stagnant order of Ragnarok's frozen world's end, or the Biblical fire-and-brimstone conflagration.

The idea of Nyarlathotep being *"the crawling chaos that howls beyond the stars... surrounded by idiot flute players,"* is also interesting; perhaps the flute players are playing fractal music, for example the nocturnal sound of insects or 'Al Azif', believed to be the howling of demons, is a fractal noise as are the sound of the wind and the irregular beating of cardial fibrillation. In *Cults Of The Shadow,* Grant says of Choronzon that *"Its number 333 is that of Shugal, 'The Howler', whose types are the jackal and the fox, both emblematic of Set... The abode of Choronzon is in the desert of the Abyss beyond the pylon of Daath."* This connects Nyarlathotep to Choronzon through the symbols of the Howling Guardian/Opener of the Way in the desert of the Abyss.

Taking Grant's idea of 'Universe A and B' as strange attractor and repulsor, creates a most interesting model to work with. For example, the Universe A attractor being designed like the Tree of Life, and the Universe B repulsor constituting the Tunnels of Set. Thus they are linked in Daath by Nyarlathotep, the crawling chaos, in this model portraying a devil polymer itself in and between universes A and B.

Using a sigil designed from the name Nyarlathotep I investigated the Cthulhu Mythos deity through dream working. On the first night, that of 13th April 1990, nothing of consequence occurred. The next day however, around 7AM I received a sudden vision of kraken limbs rearing-up in the air.

That night I had a very interesting dream. The dream began with me driving along a moorland road. After driving through a red light in a tiny hamlet, I turned down a desolate road. The car skidded to a halt at the top of a precipitous, fog-filled ravine. Then I heard the statement; "Nyarlathotep is 'the Dreamer'" and an eye glyph appeared before me, with the pupil and iris half obscured by the upper lid. Lines came from the centre of each lid, descending from the lower lid and ascending from the upper, both joining curved lines around the eye. Associated with the glyph was a pervading stench of putrefaction.

At this point the kraken tentacles crossed before my vision and I awoke with a sudden lurch as if from a deep slumber.

After returning to sleep I saw the word KANZD in vivid, fiery letters in the air above the abyss. I thought in the dream that the word revolved around the letter N, or Nun. Then, when the word disappeared, I found myself at the bottom of the ravine beside an amorphous, black, colossal form. It had recognisable 'appendages' protruding from its surface which included human torsos; bald-headed, night-sky-black men. The heads of the men were totally featureless, and the black colossus was ingesting them and expelling them continually, like a huge female Surinam Toad. (This animal has a peculiar method of caring for its young, the spawn sinks through the skin on its back then, when fully developed, little toads emerge.)

High above, on the edge of the ravine, I caught a glimpse of a winged figure which I believed to be a Nightgaunt. It threw a screaming woman head over heels as a sacrifice to the colossus, then with claws outstretched its featureless head peered after the descending figure. With a sense of great relief I realised that I was invisible to both the winged creature and the amorphous colossus.

Upon awakening I began to investigate the symbols and words of the dream. I quickly found

relevant information in Crowley's *Liber 777* on the letter Nun, in which he states its meaning as *"a fish, a symbol of the death force of scorpio, generation through putrefaction."* Thus a connection is made with the Cthulhu Mythos, through the scorpion which symbolises Cthonic regions, and also with the dream imagery, relating to the stench of the colossus and the birthing of the black men. Using gematria the entire word yielded three numbers which I believe are of importance. Two of these numbers were 562 and 13, KANZD (500+1+50+7+4 = 562, and 5+6+2 = 13).

The number 562 corresponds to the word *Primordial*, whilst the number 13 corresponds to *Unity*; *Emptiness*; *A City of Edom*; and the message: *He shall come.*

These words seem of relevance to Nyarlathotep in the following ways: Primordial is a word associated with Nyarlathotep's role as the oldest god of all Egypt. The word Emptiness is provocative of the voidal abyss in which Nyarlathotep resides as the Crawling Chaos, whereas *A City of Edom* could relate to the *Nameless City* wherein the Serpent-people dwell awaiting his return, predicted by the message, *"He shall come."*

The word Unity relates to the next number I obtained through a numerological method which I now realise is erroneous. However, as a purely intuitive method I stand by its results as being perhaps more important than the previous two equations. I obtained the number 22 through a self-created version of the Aiq Bekar method (5+1+5+7+4 = 22).

This number connects the idea of unity with the Tarot card Justice. In *Liber 777* Crowley states that the number suggests *"the completion of imperfection"* and *"finality, and fatal finality"*, phrases with which I immediately began to perceive a link between Nyarlathotep and the Greek messenger goddess Nemesis. Other correspondences gave clearer evidence for my initial connection, for example the number also implies *"The daughter of the Lords of Truth. The ruler of the Balance"*, and an even more straightforward connection appears in Crowley's statement that the number represents: *"Nemesis the ultimate automatic Justice of Nature."*

This phrase was interesting in the light of Dr Richard Muller's "Nemesis Theory", where he proposes that a dark companion star to the sun upon entering the Oort comet cloud, showers the inner solar system with comets approximately every 26 million years, thus causing the mass extinctions at the end of the Cretaceous period. Dr Muller has given the star (which has yet to be discovered) the name Nemesis, the avenging messenger of the gods, bringing retribution to the presumptuous. The discovery in the boundary layers, between where mass extinctions occurred and younger rock strata of crystals called Tektites, also links to the idea in Lovecraft's story *The Haunter Of The Dark* of The Shining Trapezohedron, a crystal used to send messages across *"the horrible abyss of radiance"*.

In the same story Lovecraft writes that spectators thought they glimpsed *"something like a formless cloud of smoke that shot with meteor-like speed towards the east"*, imagery very reminiscent of the Nemesis theory. The main character of the story Robert Blake says upon observing the object's descent: *"What am I afraid of? Is it not an avatar of Nyarlathotep, who in antique and shadowy Khem even took the shape of a man? I remember Yuggoth, and more distant Shaggai, and the ultimate void of the black planets."* This excerpt implies a connection between Nyarlathotep and the Nemesis star, which casts meteor-like destruction from the comet-cloud or black planets. Lovecraft used a segment of his poem entitled *Nemesis* to introduce the story which reads:

"I have seen the dark Universe yawning
Where the black planets roll without aim –
Where they roll in their horror unheeded,
Without knowledge or lustre or name."

This section of the poem seems to portray the Oort cloud as the black planets, untouched by the sun's rays and thus unknown, unnamed and unheeded. Another section of the same poem seems to relate directly to Nyarlathotep as the most Ancient god of all Egypt, and connects Nemesis to the frozen North lands where as previously cited Robert Bloch says, *"the ice-flows melted and Atlantis fell."*

"I was old when the Pharaohs first mounted
The Jewel-deck'd throne by the Nile;
I was old in those epochs uncounted
When I, and I only, was vile;
And Man, yet untainted and happy,
Dwelt in bliss on the far Arctic Isle."

Thus Lovecraft himself seems to have connected Nyarlathotep and Nemesis in his poems of the same names. In a further section of the poem *Nemesis*, there appears a description of Nyarlathotep as the Crawling Chaos inhabiting the void:

"Thro' the ghoul guarded gateways of slumber,
Past the wan-moon'd abysses of night,
I have liv'd o'er my lifes without number,
I have sounded all things with my sight;
And I struggle and shriek 'ere the daybreak,
Being driven to madness with fright."

In *The Dreamquest Of Unknown Kadath* Nyarlathotep the "Yellow-masked" is regarded as the *"horror of infinite shapes and dread souls"* and is creator of a maze filled with *"madness and the voids wild vengeance"*, which are his *"only gifts to the presumptuous"*, which again connects him with the role that Nemesis fulfils in Greek mythology.

Returning to the number 22 again, it is interesting that it also relates to Crowley's *Liber 418, The Vision And The Voice* in which I found many interesting statements; one of which foreshadow's Bloch's phrase in *The Faceless God* where he speaks of the destruction of the Pyramids and Temples, and of when the stars are right for the return of the Old Ones. In *Liber 418* Crowley says that *"The Obelisks are broken; the stars have rushed together: the light hath plunged into the abyss: the Heavens are mixed with Hell."*

In *Liber 777* the number 22 also corresponds to the phrases: *"A man, dark, yet delicious of countenance"*, and *"A dark man, in his right hand a spear and laurel branch and in his left a book"*, both perfect descriptions of Nyarlathotep as the dark messenger. This last description is also interesting due to its striking similarity to the generally accepted persona of the ancient god Mithras, a God which I believe

also connects to Nyarlathotep/Nemesis. The final correspondence of the number 22 as meaning a 'Human-faced bull' connects the number to the constellation Taurus and thus to Aldebaran, the follower of the seven sister stars the Pleiades.

Originally the name Aldebaran was given to the entire cluster of the Hyades, another set of seven sister stars. The first link between any of the Cthulhu Mythos deities and Aldebaran came in Robert W. Chambers' *The King In Yellow* where, as we have seen, it was said to be the bright twin of the dark star, home of Hastur.

It is also regarded by August Derleth as the star where some of the Cthulhu deities emanated from. In this respect it is interesting to quote from *The Whisperer In Darkness* by Lovecraft: *"To Nyarlathotep, mighty messenger must all things be told. And he shall put on the semblance of men, the waxen mask and the robe that hides and come down from the world of seven suns to mock..."*

Returning briefly once more to the realm of fractal geometry, it is interesting to note that John Dewey Jones in his stories about *The Amygdalan Sects* writes of a fraternity which use the red glowing Aldebaran as a meditation aid to 'fractal/chaos gnosis'.

Aldebaran was once one of the main stars which made up the ancient constellation of Mithras, consisting of the modern Taurus and Perseus. E. O. James in the book *The Ancient Gods* states that Mithras was *"the mediator between the celestial powers and the human race"*, thus connecting this deity with the role of Nyarlathotep/Nemesis. Equally the generally acknowledged appearance of the deity is of a figure holding a spear, a shield, or wheel of fortune on which all the stars are emblazoned, and a cloak which is symbolic of the real heavens, whose fate Mithras mediated. The figure is similar to the descriptions both of Nyarlathotep as the black messenger described previously, and also to the image of Nemesis, who according to Robert Graves in *The White Goddess* in her role as Diana of the woods held a staff in one hand and a wheel of fortune in the other, to show that she is the destroyer of the old year and the instigator of the new. Thus the wheel of fortune and other imagery seems to connect all three deities.

In *The Haunter Of The Dark*, Nyarlathotep forecasts that "When the stars are right", then the old ones shall rise once more. Richard L. Tierney in his work, *When The Stars Are Right*, connects the rising and sinking of R'lyeh through astrological charts to that section of the heavens specifically containing Aldebaran and The Hyades. Quoting from Ptolemy he states that Aldebaran *"has the same temperament of* [sic] *Mars"*, probably due to its red colour and the fact that it is regarded as the eye of the bull. This is interesting due to the constellation of Mithras containing the 'evil-eye' stars Aldebaran (The Follower) and Algol (The Ghoul).

In the December 1989 issue of *Scientific American* there appeared an article by David Ulansey entitled *The Mithras Mysteries*, in which he proposes that the Mithraic Cult was based on the realisation that *"the acceptance of astrology led to a growing belief that the true dwelling place of the gods was in the realm of the stars."* Mithras he contends, had power over the changing Aeons of time, controlling the rotating constellations on the Celestial Equator. He was associated with Taurus because around the time of the initial Mithras Cult (4200/2000BC) Taurus was beginning its descent as the symbol of the Aeon, being replaced in the procession through time and space by Aries. Thus Mithras, as the controller of the Aeons, has the power to produce the moment "when the stars are right", being able to destroy the old Aeon and introduce the new. Thus all three deities turn the wheel so that it will, to quote Robert Graves in *The White Goddess* when speaking of Nemesis, *"one day come full circle and vengeance be exacted on the sinner."*

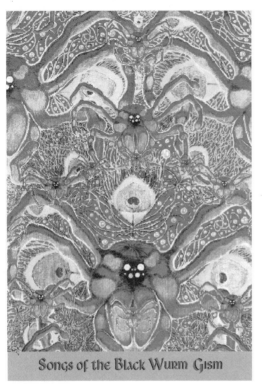